The Darkroom Handbook

The Darkroom Handbook

MICHAEL LANGFORD

Photography Consultant
Tim Stephens

EBURY PRESS

The Darkroom Handbook was conceived, edited and
designed by Dorling Kindersley Limited,
9 Henrietta Street, London WC2

Project editor **Jonathan Hilton**
Art editor **Michelle Stamp**
Editor **Judith More**
Designer **Debbie Lee**
Managing editor **Joss Pearson**
Art director **Stuart Jackman**

Picture research **Elly Beintema**

First published in Great Britain in 1981 by Ebury Press
National Magazine House, 72 Broadwick Street, London W1V 2BP
Second printing 1982

ISBN 0 85223 188 1

Typesetting by Owl Creative Services Limited, London and
Qwerty Typesetting Limited, London
Reproduction by F. E. Burman Limited, London
Printed and bound in Italy by A. Mondadori, Verona

Contents

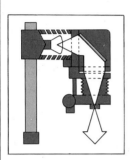

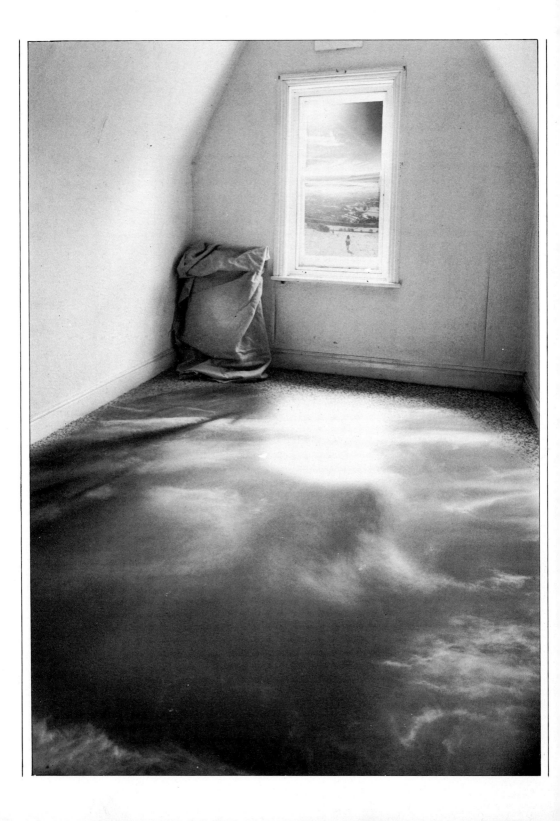

Preface

This is a practical book, designed to help you in two main ways. Firstly if you are a beginner it will show exactly what is involved in having and using a darkroom. Secondly if you already know the basics, it will lead you into new areas where, even with your present equipment, a wide range of unusual and individual results can be produced – in black and white and color. The book is therefore both a teaching manual and a collection of techniques and visual ideas – in all cases with detailed step-by-step instruction.

The Introduction shows a range of some of the creative work made possible by post-camera aspects of photography. It is followed by the four main teaching sections. The first one maps out, in order of priority, the equipment, materials, and facilities you will require for various levels of work. There are also suggested darkroom layouts, ranging from the temporary adapted bathroom to a full-scale professional darkroom complex. Most black and white and color materials are described in this section and their functions explained (a selection of current brand names appears in the Appendix).

Section two takes you through tank loading and the processing of all the main types of color and black and white camera films. It explains the controls possible in processing and helps you assess results. Section three is a beginner's course in black and white printing. The making of contact prints and enlargements is covered here, along with basic printing controls, such as choice of paper grade, cropping, shading, and burning in. The next section teaches color printing – again right from basics, in case you want to start straight with color and leave black and white to later. It shows all the main methods of making enlargements from color negatives or slides, and explains different ways of color filtering.

The next four sections are more loosely structured, and designed for "dip in" use. If you are already competent in processing and printing you will find plenty of ideas and techniques to explore here. Section five concentrates on important manipulative procedures and use of new darkroom materials. The exploitation of grain, combination printing, screens, high-contrast films, and various chemicals are all introduced here, and form a foundation for the more advanced manipulations in section six. There, topics range from making photograms, shadow masking, sandwiching, and posterization to photo silkscreen printing. The next section shows most of the image changes you can make at the post-darkroom stage – working in normal light. These include toning, airbrushing, retouching, montage, instant picture manipulation, and even embroidery of photographic images. For the final section, a range of old printing processes are presented. Those that can still be safely practiced with chemicals available today have been tested and explained step-by-step. An appendix containing reference information on materials, techniques, and formulae, and a full technical glossary, are also provided.

Multiple print by Hag
This surreal image of a room with a sky for a floor is the result of the careful printing of three different black and white negatives on one piece of paper. The main room image was printed first with the floor and window areas shaded out. Next the sky was printed in, and then the outside view seen through the window.

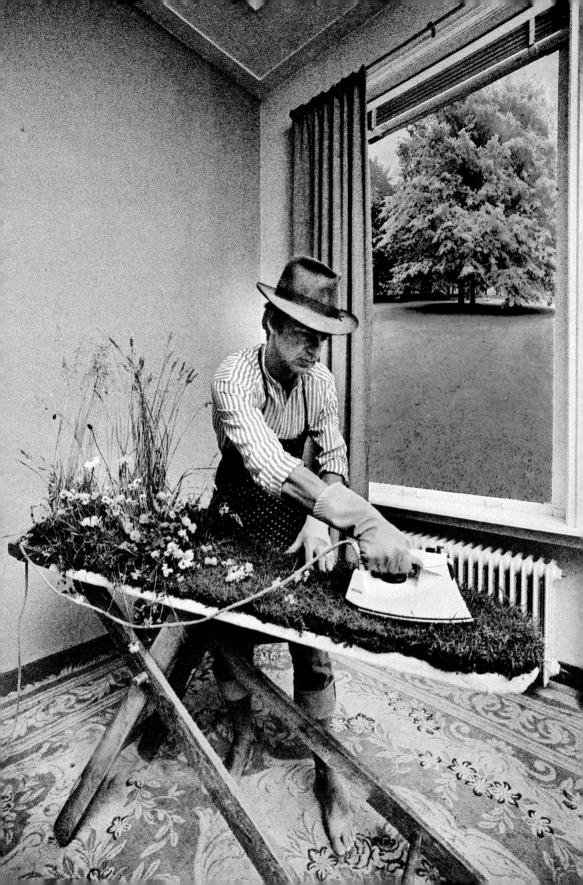

Introduction

Just what role should the darkroom play in photography? Is it mostly a service function to carry through your camera work with unvarying reliability and technical excellence? This is surely the main requirement for objective, "pure" photography like the picture below, in which nearly all the creative decisions have been made by the clicking of the shutter. Or should the darkroom also concern itself with the world of manipulated and impossible images, like the fantasy situation shown on the facing page?

Like all documentary photographers, Cartier Bresson firmly insists that the darkroom continues his basic integrity, even to printing the whole negative. Other photographers, like Uelsmann, play tricks with that very integrity to give highly subjective results. While many see the darkroom as a workshop for the experimental production of a wide range of abstract images.

The pictures on the following introductory pages show some of the varied ways in which creative workers have chosen to use post-camera aspects of photography. You will meet all the processes and techniques again in the practical sections of the book.

Still life by John Goto
The warm brown image produced by printing on chlorobromide paper (see pp. 60-1) enriches the tonal range of this essentially "straight" photograph.

"Electriclawnmowing-iron" by Paul de Nooijer
This bizarre, surreal composition was partly set up in front of the camera. In the darkroom the view through the window was added by the use of double printing (see pp. 224-31), then the black and white print was selectively hand colored (see pp. 280-3).

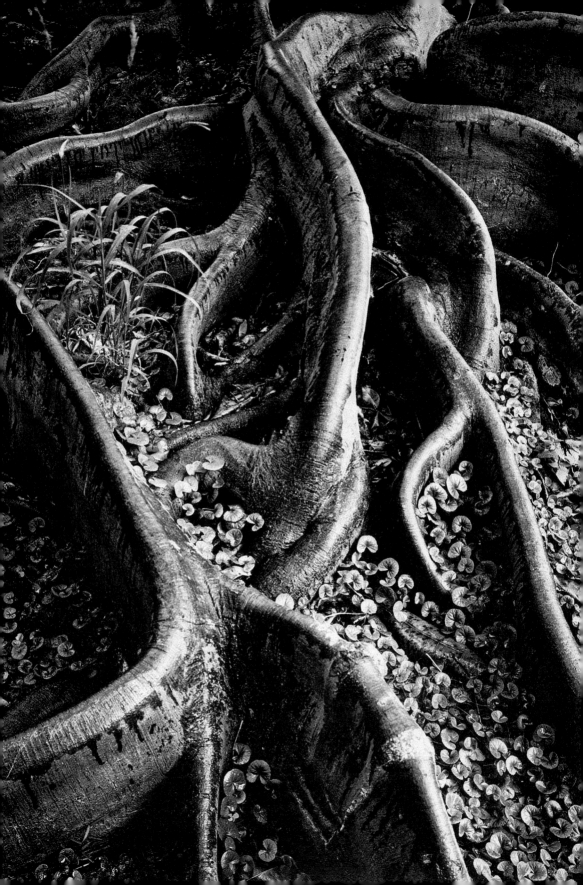

**Landscape by
John Blakemore**
*Blakemore believes that
photographs give intense
delineation of reality, but
also act as metaphor.
Pictures such as these
reflect the external world
plus his own inner
response to it.*

**"Roots, Foster Gardens"
by Ansel Adams**
*As an original member of
the Group f64, committed
to realism, Adams identifies
key aspects of photography
as: 1 its ability to record
detail, 2 the way it captures
lighting, and 3 the way
subject surfaces are
rendered by photography's
superb gradation of tones.*
Courtesy of Victoria and
Albert Museum, London.

It can be argued that artists should make full use of the special qualities
of their medium. Photography has the superb ability to resolve fine
detail and to show the action of light on form by its subtle range of tones
and colors. Look at the way the two photographs, above and facing
page, reveal subject pattern. It is a purity of approach that dates back to
Edward Weston and the California modernists of the Group f64. In both
cases, full tonal range negatives have been printed to retain all the
visual qualities of the original subjects that attracted the photogra-
phers. Like the rock formation picture on p. 14, the natural details in
these prints would be degraded and destroyed by any obvious manipu-
lation. The link between the original subject (as seen by the photogra-
pher) and final print (as seen by the viewer) is as direct as possible,
retaining every relevant quality photography can offer.

Where manipulations such as dodging, shading or filtering have
taken place during the printing stages, they have been used mostly to
compensate for errors in the process itself, or to emphasize gently the
particular natural forms. With pictures such as these, anything more
would inevitably destroy their inherent balance. The printing stage for
such pictures is so extremely critical that often the photographer must
undertake it himself — not being able to entrust to anyone else the
interpretation of the resulting film image. Craft skill and self-set stan-
dards of excellence are essential to conjure up every ounce of quality,
and convey the spirit of the subject, without lapsing into the picturesque.

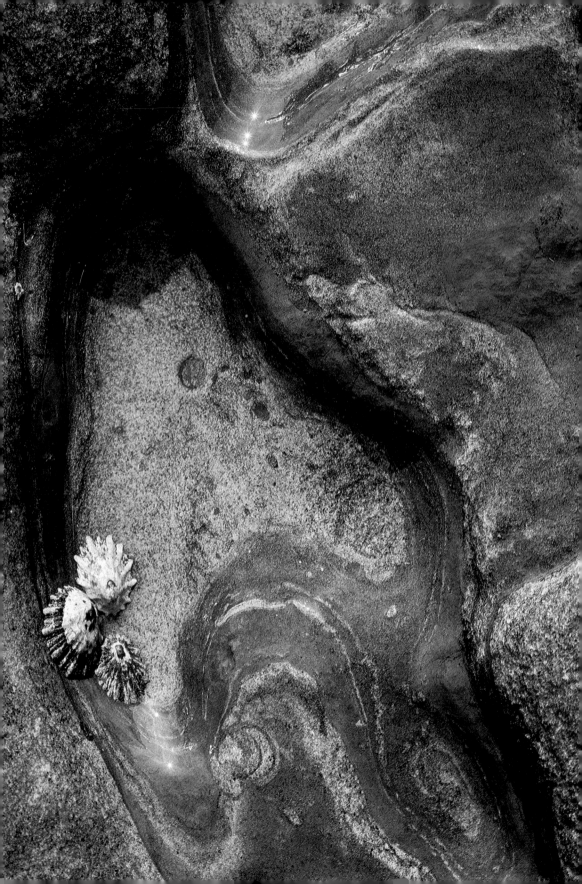

Seashore still life by Dennis Brokaw
This superb example of straight photo-graphy and color printing, makes strong use of natural tone and color values. It uses photography's ability to resolve fine detail to the full.

Screens
Earliest color transparencies, like this 1898 Joly still life (left), were forced to carry a mosaic screen. Courtesy of Science Museum, London.
Today, screens are used for effect. The print above by Andrew Watson was printed through a grain pattern screen. In the example below, Richard Shirtcliffe enlarged his negative along with tissue paper. (see pp. 208-11).

Commercial screens
*This example of a news-
paper advertising picture
makes use of a mezzotint
printing screen (see pp.
158-63).*
Courtesy of Michael Smith
/David Fitzgerald & Co.,
London.

Sometimes the "direct link" of straight photogaphy is intentionally
avoided by photographers. For example, printing through a patterned
screen (see p. 15), or just using a grainy film makes the person viewing
the picture conscious of the "fabric" of the image. Pictures of this type
appear to have a distinct, flat, front surface — instead of presenting a
"clear window" on the world. Another reason for moving away from
straight processing and printing techniques is mostly pragmatic – the
business of improving resolution and clarity. The advertising picture
above, printed through a special half-tone screen known as "mezzotint"
(see p. 159) and converted to line (see p. 146), reproduces boldly and
clearly even on the cheapest quality paper such as newsprint. Stark,
simplified images like this have an immediate impact and achieve a
strong visual communication.

Photograms, such as the two pictures on the facing page, could
possibly be described as the purest form of photography. Objects are
placed directly on sensitive paper and record their own shadows when
lit. At the same time, reversal of tone gives ordinary objects a strange,
abstract appearance. Images like these became popular in the 1920s
under the influence of the dadaist movement. Photograms still have a
special place, and anyone interested in interpretative images and ab-
stract design should explore them. In their own terms they, too, rely
very heavily on the inherent qualities of the photographic medium —
especially tonal range and contrast.

Photograms
The example right by Lazlo Maholy-Nagy made in the 1920s, and that above by contemporary photographer John Goto, both use objects placed in direct contact with black and white printing paper (see pp. 184-95).

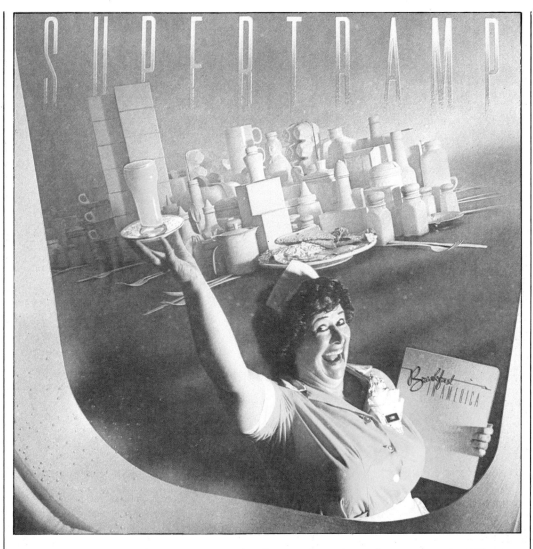

Record sleeve for "Breakfast in America" by Supertramp
This bold image uses a combination of photography, montage (see pp. 288-92), drawing, and airbrushing (see pp. 284-7). Courtesy of A & M Records, London.

Color photogram by Luigi Veronesi
This cameraless picture was made by placing glass spheres on reversal color material (see pp. 184-95).

Today you can make photograms using color paper or sheet film too, like the picture on the facing page. Mostly these "cameraless" pictures form ends in themselves – impressionistic records of color and light, with no two results exactly the same. Even the most mundane household items can be used to produce exciting, abstract designs.

Another reason for constructing images is to give a light-hearted glimpse of the impossible. This is much used in advertising, and especially for record album sleeves (see above). These pictures are high-budget productions involving the montage of several specially staged photographs, plus extensive artwork. Results can be breathtaking, provided photographer, designer, and artist all work together with well-directed effort. Most of these jobs have extremely precise briefs – the format, lettering, and images calculated exactly, to appeal to a heavily researched market. The album cover above won the Grammy award of 1980 for best design.

Surrealism has a long history in art, producing images based on the subconscious mind and vision. A number of photographers interested in unexpected juxtaposition have found constructed prints an ideal working medium. Given an idea – perhaps (as here) from observation of common forms in dissimilar objects – a high level of technical skill must be used to carry it through to a convincing conclusion. It is the very conflict between an extremely realistic image and the impossible situation it appears to show that prompts the question "What does it all mean?" Pictures can be constructed by carefully exposing several images or parts of images on the same piece of paper. They are wholly created in the darkroom – once you have a range of potentially interesting camera images on film. For this type of multiple printing you should build up a file of suitable picture elements, which you review and update frequently.

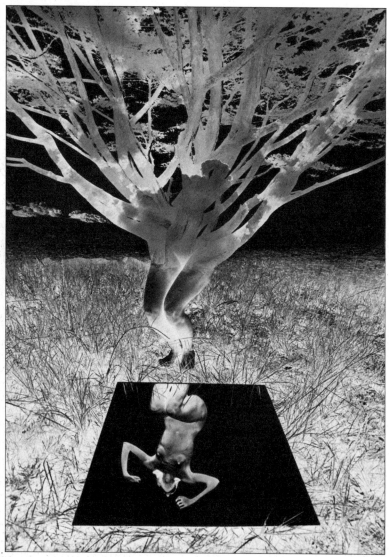

Multiple prints by Jerry Uelsmann
Both these prints were produced by printing several negatives or positives on the same sheet of paper (see pp. 224-31). Uelsmann is a master of this type of darkroom manipulation. He creates a surreal, dreamlike world from a constantly updated stock of film images – blending them under the enlarger using a method he calls "in process discovery".

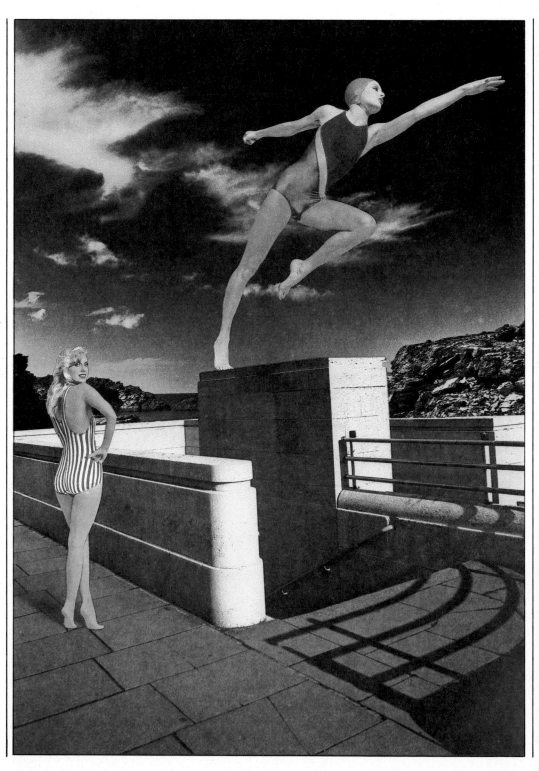

Montages
A hand colored editorial magazine illustration by Bob Carlos Clarke (facing page) links 1930s style swimwear to architecture of the period. "Polaroid Series 79" by Jean Ruiter (below) is built from a studio shot of a girl printed on negative/positive paper (see pp. 116-23), with the two framed pictures montaged in (see pp. 288-92). Floor lines and shadows were added to the print with an airbrush (see pp. 284-7).

Cut and stick montage prints offer still greater flexibility and freedom, especially if you are trying to produce a fantasy situation. Pictures of this type form a strong editorial illustration (see facing page), expressing the idea rather than the reality of a particular topic. Fine artists use montage freely, combining portions of existing pictures, related to one another perhaps in content or structure, and sometimes joined by incongruous painted backgrounds and foregrounds. This technique was much used by the cubists, who at first stuck newspaper cuttings to their canvases. Today it has become sufficiently respectable and familiar to be used by organizations such as advertising agencies (as in the example below) to add extra interest and impact to their pictures, and to make the public look twice at the product on sale.

Often a montage or collage moves into the realms of pop art by presenting photographs as photographs – one of today's artefacts and products of modern life. Hence, Polaroids, small prints, and photographs clipped from advertisements become the subjects as well as the means of expression. Attaching photographs to photographs is also a convenient means of introducing new apparent planes and dimensions into a composition.

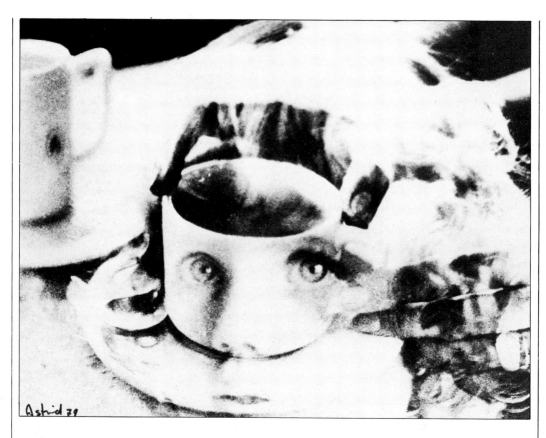

One of the great pioneers of the manipulated photograph, Man Ray, was producing striking images in the early 1920s. This was a period of great intellectual and artistic ferment, much influenced by the deliberate irrationality of dadaism and the weird visions and structures of surrealism. Ray experimented with a wide range of techniques, from montage and superimposition to the "abuse" of photographic materials, for example by solarization. With other dadaists, his aims were revolutionary – the overthrow of set "Establishment" modes of presentation. Strangeness of form and experimentation generally were to be preferred to the gilt-framed pictorial exhibition image. As painter and photographer Ray believed that the imaginative and creative qualities of photographic materials and processes took priority over strict adherence to orthodox technique. Photographers should be dreamers as well as craftsmen.

Another fertile area where photographic and painting skills often overlap is in silkscreen printing. Printmakers such as Richard Hamilton use silkscreen as a medium for pop art compositions (see p. 27) because of its striking colors, and its potential for changes and additional workings, almost without limit. It is an ideal medium for mixing drawn and photographic images, and much less complicated for amateurs to use than techniques like etching or lithographic printing. In all these areas, individuals have found ways to turn photography away from realism, often changing its reproduction of familiar forms into flat shapes and solid, unnatural colors.

"Fragile" by Astrid
This evocative example of double printing relies on elaborate lighting techniques of the individual components to accentuate the strange and unrealistic nature of the work.

Solarization by Man Ray
This solarized portrait of the 1920s is one of the earliest examples of this particular treatment. Results have mixed qualities of drawing and photography (see pp. 236-43). Courtesy of Sotheby Belgravia, London.

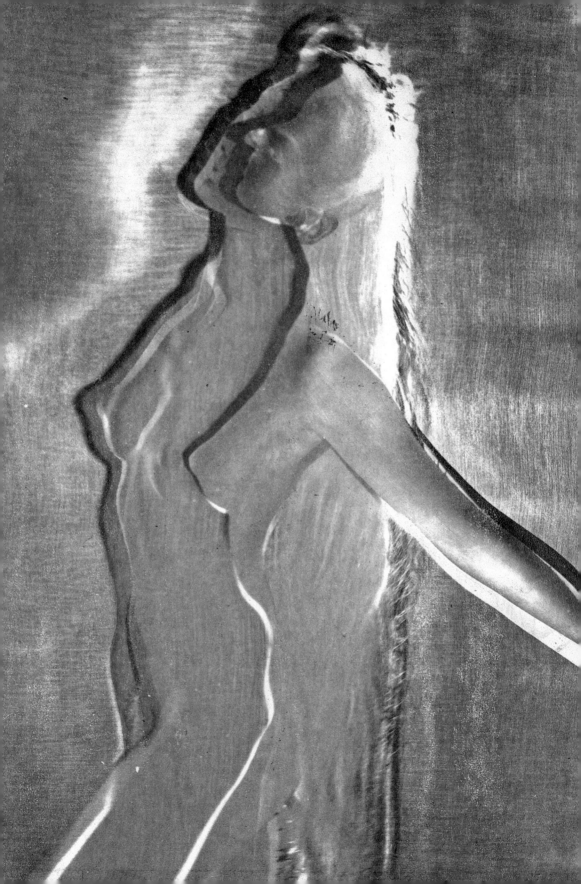

"My Marylin" by Richard Hamilton
This 1965 example of silk-screening (see pp. 260-4), is based on a set of contact prints marked up by Marylin Monroe herself. Courtesy of Tate Gallery, London.

Scene by Pete Turner
The example of color masking, right, has been used to produce areas of flat color and to suppress photographic qualities (see pp. 218-23).

Nude by Erwin Blumenfeld
For this strangely portrayed figure, Blumenfeld used a combination of very precise studio lighting, plus careful darkroom control of the resulting image.

Today, guidelines on what does or does not form "acceptable" use of materials have been swept away. Never before has art been so identified with self-expression – making the boundaries between "artist" and "photographer" no longer relevant. Photographs are printed by silk-screen, or exposed on light-sensitive canvas (see facing page). Black and white photographs are color toned or dye tinted (see pp. 30-1) not just to achieve realism, which is best done by color photography, but to give a totally controlled "intensification" of selected shapes and objects. Even old processes, with which early photographers were forced to struggle, have been brought back for their own special image qualities.

From a modern viewpoint it is hard to understand the arguments that shook the Royal Photographic Society when daring photographers of the 1800s tried using something as innocuous as soft focus for their work. The fact is that fine art photographers now work to satisfy themselves. A more liberal public interest in photography has enormously increased the number of one-man or one-group shows.

Inevitably a great deal of junk appears along with the riches. There is always the temptation, for the novice at least, to flitter happily from one technique to another, without having much to express through any of them. But on the other hand, like an introductory course in any subject, initial dabbling in various image-forming media should give you a broad competence. It is a chance to identify the most promising way to present your type of image – be this totally objective and straight, or completely abstract, or surreal, or with the main emphasis on the material and structure of the picture as much as its content.

Silkscreen by Todd Walker
This process simplifies tone values, turning gradated tones into solid areas of one value (see pp. 260-4). The result is one stage from photographic realism.

Collage by Henk Meyer
This example is a mixture of techniques. First he sticks prints on a photographic background, then copies the result and prints it on photo-sensitized linen (see pp. 293-4), and finally colors the results using dyes (see pp. 280-3).

Black and white images
can be transformed by
color aftertreatments.
Giuliana Traverso's stark
study of washing was
basically a grainy print.
She repeatedly bleached
and toned it to form this
combination of blue and
sepia (see pp. 268-75).

The picture, top, is a rare hand colored fashion study by Cecil Beaton (see pp. 280-3). Courtesy of Sotheby Belgravia, London.

The chemically toned image above, by Ceri Norman, is an example of selective toning (pp. 268-75).

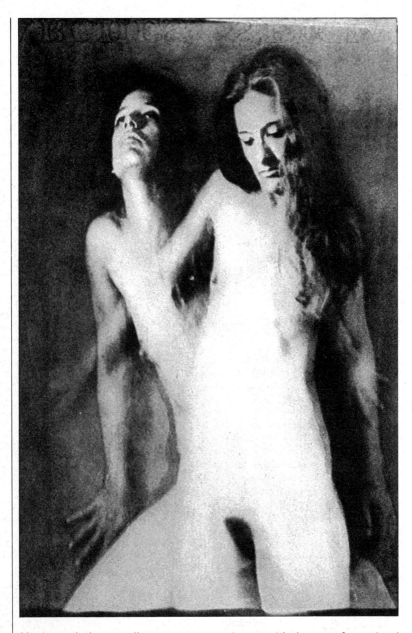

Gum bichromate by Todd Walker
Numerous old processes like this one (see pp. 318-22) have become popular again because of the unfamiliar qualities they can give to today's images.

Having a darkroom allows you to experiment with dozens of new (and old) processes. The modern enlarger used with today's ever-widening range of color materials means that new technical possibilities occur all the time. Never before has such accuracy of detail and color been possible – but every material and process is there to be exploited too. Unorthodox methods lead to unorthodox images. None of this of course can be a substitute for ideas and the ability to recognize a promising image when it occurs. But it is all good fun!

Darkroom
equipment

Introduction

This first section introduces you to the tools and materials you will require for all processing and printing. It shows how an enlarger works and then compares various different types. The layouts of working darkrooms are also discussed, together with a wide range of processing and printing equipment for black and white and color – listed in order of priority. Most of the main processing solutions you are likely to want to use are identified, explained, and compared in practical terms. You will also find black and white and color photographic materials described in principle and comparisons made between the choice of routes available to you from exposing the film in the camera to your final image, either on paper or film.

There are sound reasons for starting darkroom work with a good grounding in this sort of "nuts and bolts" information. Any new craft – and craft skills are important in creative photography – is best learned by first understanding the basic tools and materials. A logical and reasoned approach is essential for successful results. Some of the routines are repetitive and mundane, but there is plenty of scope for extravagent and original ideas.

Having your own darkroom

The crucial advantage of doing your own darkroom processing and printing is the direct influence you have over the results – the sort of fine control not normally available from a mass-production commercial laboratory. The darkroom is a place to express your ideas, and to experiment and explore. On the other hand, it should provide you with the best possible technical back-up to your camera work, allowing you to produce clean, good-quality results – every time. Your own darkroom also provides you with the opportunity to practice and improve these "craft" skills to the point where you can use them creatively and with confidence. By doing this, you make discoveries, develop individual touches, and slowly evolve a particular style.

You may not, of course, be able to afford to equip a darkroom by yourself – at least initially. This is where you can use a community darkroom at a college or school to obtain first-hand practical experience. It will probably whet your apetite for more – a lot of the processes and techniques are easier to master than it often seems when you can only read about them in print.

Do not, however, expect to save much money through doing your own darkroom work. As a low-volume user of materials and chemicals it is difficult to beat the cost efficiency of a big laboratory. You may also find that you tend to make more and larger prints. You must also be prepared to make mistakes when learning, in order to improve later. One method of cost cutting on materials (and some equipment) is to form a co-operative of like-minded people. In this way you will be able to order paper, chemicals, etc. in larger quantities, and you may be able to share more specialist pieces of equipment, such as glazers and dry mounters.

Materials and equipment

In the early days of photography darkrooms were awkward, messy places full of dangerous chemicals. Poisonings and explosions were not unusual, and photographers were earnestly advised to have a good grounding in chemistry before ever venturing into this area.

All this has changed in recent years. Manufacturers have made real advances in streamlining processes, packaging chemicals as simple dilute-and-use solutions, and designing equipment so that you can use it with the least disruption to normal living conditions. Practical arrangements for printing in color have become even easier than for black and white.

Having decided, in principle, to set up your own darkroom, think carefully about just what you want to do – then buy equipment and adopt a working procedure that is easy to expand to cope with the extra processes you may want to develop. Making the wrong decision at the start may involve you in replacing or duplicating equipment quite soon. For example, you may wish to begin with black and white printing, but it is a good idea to buy an enlarger that has a filtering head suitable for color printing as well – or one you can easily adapt. Take a sensible attitude to the amount of money you have available for materials and equipment, and spend most on the really critical items – probably your enlarger lens. There is little point in using a sophisticated, optically correct camera lens if you print the resulting images through an inferior enlarging lens.

The trend in color printing is to spend the least possible time actually in the dark. You need only to have the lights out for the length of time necessary to take a piece of paper from a box, expose it under the enlarger, then slip it into a processing tank and close the lid. All the actual processing takes place in normal room lighting. So for color printing (and all film processing, which also takes place in light-tight tanks) all you require is a dark closet in which to house your enlarger.

Black and white prints, however, are still generally processed in open trays. You will also find that most of the manipulations in this book call for the use of a darkroom. Sooner or later, therefore, you will require a fully equipped room – but with good planning you can "grow into" this, taking all the equipment you have bought previously and just adding extras as necessary.

Forward planning is one very practical reason for trying out as many different types of papers, darkroom films, and chemicals as possible. They will help give you an overall picture of the sort of materials you might be using now to good effect, and in the future.

Another good reason for awareness and use of a wide range of products is that it broadens your concept of what type of images are possible. Each type of material has both "official" and "unofficial" image-forming potential – those which are de-

signed to happen and potentially interesting side-effects. Make it your business to learn the factors that control results in each process.

Basic principles

A craftsman in any field has to gain gradually the "feel" of his materials, using tools and processes almost to coax out a particular effect. In photography your basic material is a coating of silver halide crystals. These are held on a paper or film base in a thin layer of gelatin. (The gelatin swells to allow the entry of processing chemicals and the exit of soluble by-products.) Silver halides and gelatin together form an "emulsion". When these halides are struck by light, they begin to break down into finely divided black silver. After initial exposure this change is too small to be visible. But when treated by one of a range of developers – mostly derived from benzine – an enormous amplifying process occurs. Working on the few atoms already affected by exposure to light, the developer forms a black silver image several million times darker than the original change. You complete the processing sequence by clearing the unused silver halides and by-products from the emulsion to leave a permanent image.

Fast, light-sensitive emulsions form images in larger specks of silver or dye than slow films. Development can be chosen to increase this coarseness, and by enlarging from a small negative, fine image details are softened and made more impressionistic. Contrasty emulsions, which form few if any tones between black and white, give a stark graphic look to pictures. These and many other fundamental aspects of photographic materials are important to grasp if you are to master your craft.

New directions

In color materials, and some recent black and white films, the silver image is removed during a later stage of processing to leave a final image in dye. In color work, this use of dye is necessary to produce a final color result. New black and white dye-negative films have a normal silver emulsion, plus several dye layers. Development forms the silver image as well as the dye image. A later bleaching stage removes all silver leaving only the dye. Dye has a finer molecular structure than silver. Therefore, with dye-negative film, the range of exposure that will give an acceptable result is greater.

The microelectronic revolution has already started to produce a new generation of automatic enlargers, exposure/filtration analyzers, and very accurate temperature maintenance controls. Used properly these can only be of benefit to the darkroom worker. But, for most creative darkroom techniques, the automatics must be turned off and the decisions left to the individual to make.

Historical background

Although silver salts have been used since the earliest days of practical photography, the method and convenience of processing have changed enormously. In the 1850s and 1860s most photgraphers worked the "wet plate" process. This involved using sticky collodion (soluble guncotton dissolved in a mixture of ether and alcohol) to attach silver halides to glass. The speed of these glass plates was approximately 2 ASA. Having coated your own plates in the darkroom, you had to expose and process them before the collodion mixture dried hard (this took about 15-20 min). So, when the photographer was working away from the studio it was essential to take a darkroom tent, containers of water, silver salts, collodion, glass plates, as well as various developing and fixing chemicals. The ether used in the collodion preparation formed a heavy inflammable vapor, which was easily ignited by the candle safelights used by the photographers when coating their plates and processing. Fires and explosions were, therefore, part of the hazards of photography.

In the 1870s gelatin was discovered to be an alternative to collodion for attaching the silver salts to glass (and later to film). This discovery made the "dry" manufacture of photographic materials possible. There were still hazards associated in the processing of these new materials though. The crude developing agents indelibly stained dishes, trays, and fingers. You could recognize a photographer instantly by his blackened finger nails. Potassium cyanide was a popular substance used for fixing the photographic image, instead of harmless "hypo" (potassium thiosulfate). This added the risk of poisoning and sudden death to the problems already facing the photographer.

Until the 1870s all printing was done by contact – pressing the negatives against a light-sensitive paper in frames left to be exposed by sunlight for about 20 min. To make large photographs you had to use a large camera and large negatives. The faster, more light-sensitive, silver bromide papers made "enlarging" possible by using

Enlarging lantern
At the beginning of this century all enlargers were designed to work horizontally. Many of them could also be used for magic lantern shows. This 4 × 5 ins (10 × 13 cm) model was powered by gas.

apparatus fitted against a window so that daylight acted as a light source shining through a negative and magnifying lens on to paper. Later this system was replaced by a gas "lime light" in an elaborate enlarger lamphouse arrangement.

All these enlargers worked horizontally (see above) and you pinned your paper to a vertical easel. The general introduction of electricity in the early years of this century made it practical to use an electric enlarger lamp. This allowed the equipment to be redesigned vertically, saving space and making paper handling easier. Acceptance of enlarging as opposed to contact printing, plus improvements in camera optics, led to the introduction of new miniature camera designs, such as the Leica (1924). As a result of these innovations the whole scope of photography widened and changed, becoming far more accessible to the amateur.

The enlarger

The enlarger is the most important single item in your darkroom. Basically it works like a vertically mounted slide projector (see right); the higher you raise the head on the column, the greater the degree of enlargement you will obtain. A tall column offers the greatest potential degree of enlargement, but make sure it is sturdy–any slip or shake will result in blurred pictures.

The enlarger lamphouse should illuminate the negative evenly, without undue heat, which might buckle the negative, or any spill of light, which might fog the paper. Some enlarger types use a diffusing sheet between the lamp and negative to spread the light, while others use a large condensing lens (see facing page). Almost all enlargers offer some type of system for introducing color filters (used in color printing, see p. 38).

Below the lamphouse lies the negative carrier, which holds the individual negatives flat, and an enlarging lens. Moving the lens toward or away from the negative brings the image into focus, at each size of enlargement. Finally, most enlargers have a movable red filter (used for printing in black and white, see pp. 92-3).

Enlarging lens

Your enlarging lens should be of a focal length approximately equal to the diagonal of the negative. If you use a different format negative, you should change focal length.

Reflex lamphouse

Lamp cooling vanes

Front silvered mirror

Lens

Some enlargers use a 45° mirror between the lamp and negative. This reduces overall head size, improves ventilation, and suits dial-in filters (see p. 38) used when color printing.

Counter-balance cable

Inclined column

Lamphouse door

Adjustable lamp

Movable supplementary condenser

90° head rotation lock

Filter drawer

Main condenser housing

Height control

Flexible bellows

Focus control

Enlarging lens

Red safelight filter

Height scale

Voltage stabilizer

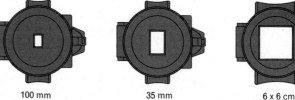

35 mm negative carrier

Heavy duty baseboard

Negative carrier and adaptors

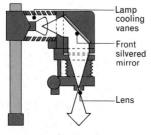

100 mm

35 mm

6 x 6 cm

A negative carrier holds the negative flat between two plates with a cut-out aperture. Some use glass over the aperture to guarantee perfect flatness. Other negative carriers enable you to use a range of negative formats, each held in an individual adaptor, see above.

Size range

With all enlargers, the bigger the enlargement you require the higher you must raise the head, see right. Some enlargers will make same-size or reduced-size prints too – useful for slides and manipulation work. The table below shows how to achieve specific degrees of negative enlargement. To work out your own ratios, subtract (B) from (A) and divide by (B).

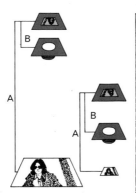

Magnification ratios

Negative height above base- board (A)	in	19.8	14.4	8
	cm	50.4	36	20
Distance of 50mm lens from negative (B)	in	2.2	2.4	4
	cm	5.6	6	10
Ratio of image to negative		8:1	5:1	1:1

Negative illumination

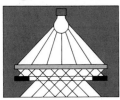
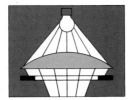

Enlargers fall into two main types, depending on the way the enlarger lamp illuminates the negative. Diffuser enlargers scatter light using an opal sheet (see above). This minimizes negative scratches and grain, and slightly reduces image contrast. Most color head enlargers require diffusers to mix light thoroughly that has passed through various color filters. Condenser enlargers (see above) exaggerate grain but give maximum contrast and brilliance, particularly if they have a small "point source" lamp.

Even illumination

Your enlarger must give even illumination. Any off-center darkening, see right, forms light areas on all your prints. You may have to reposition condenser or lamp when you make very small prints, or when you change the lens or negative size.

Adjusting condensers

In a condenser enlarger, condenser lenses posit-ioned above the negative concentrate and direct light into the enlarging lens. This gives a brilliantly illuminated negative, see below. Every time you change negative format you must change the position of the condenser and lens, see below right. You must also change the focal length of the enlarging lens. And you may have to raise the con-denser or lower the enlarger lamp when making same size or smaller prints, because of the position of the lens.

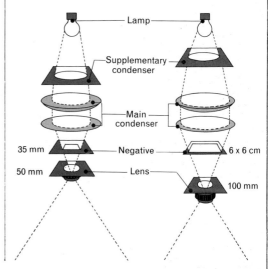

Making large prints

The greater the distance between the enlarger head and the paper, the bigger the print. But the increased distance can require excessive exposure times. To avoid this, it is best to buy an enlarger that will accept a high-output lamp when making very large prints. Three ways of increasing enlarger "throw" are shown on the right.

Moving the enlarger head to the top of the column normally gives a large enough print.

Some enlarger heads can be reversed to project down on the floor. Clamp the baseboard securely.

Alternatively, turn the enlarger head through 90° and project the image on the wall.

Enlarger designs

All enlargers have the basic features shown on pp. 36-7, but different types use different methods to vary the color of the light for color printing. Simple enlargers have a lamphouse filter drawer which holds colored acetate filters. This method is cheap, but slow and awkward (you select filters from a set of twenty or so). Most enlargers use some form of "color head". This has up to three built-in movable filters which you can "dial in" mechanically or electronically. Color heads allow continuous variation of filtration, to give exactly the color you require (see below), instead of the abrupt steps given by changing filters in a drawer. Both the drawer systems and the simpler color heads use dyed filters which absorb light. These eventually fade and must then be replaced. More costly dichroic filters (see p. 340) reflect unwanted color and so work more efficiently and remain fade-free. You can use all these color enlarger types for black and white printing, too, if you select zero color filtration. Most color head enlargers use diffused negative illumination (see p. 37), to scramble the color elements of the different filters and produce even color, see right. Diffused illumination also gives a less contrasty image which suits color papers, particularly when you are printing from slides. Other optional features offered by some types of enlarger (see facing page) include automatic focusing; perspective corrections; interchangeable heads for black and white, color and copying; and interchangeable lenses and negative carriers for different film formats.

Scatter box

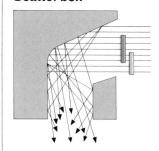

In most color heads you move filters partially into the light beam produced by the lamp, as shown above right. The colors mix thoroughly inside the matte white interior of the scatter box, and the light passes through a diffuser to the negative as even-colored light.

Filter drawer head

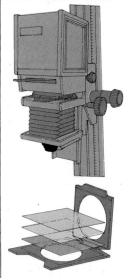

Non color head enlargers generally have a filter drawer fitted between the lamp and negative carrier. For color printing you will require a wide range of colored acetate filters in various tints and strengths, cut to fit your drawer. By selecting one or more of these filters you can control the color of the light to suit your color negative (see p. 115).

Two-filter color head

Some color heads use two dyed filters—yellow and magenta. Each filter moves progressively into the light beam as you shift its external control (scaled in filter strength numbers, see above). The range of color changes is limited with this method, but it suits most negatives. You can insert extra filters in other colors in a drawer provided.

Tri-filter color head

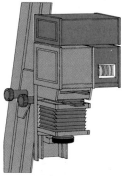

Most color head designs use three filters and three scaled controls to move filters into the light beam. This system costs more than a two-filter head, but allows a wider range of color changes. Often these heads use a quartz halogen lamp which maintains consistent color throughout its life. The scaled controls may be illuminated.

Tri-lamp color head

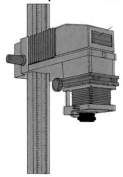

This design uses three separate but closely grouped lamps, each one permanently filtered in a different color. There are no moving parts—you control the color of light by dimming or brightening each lamp from a baseboard control panel. You can link this system with electronic devices to measure exposure and filtration (see p. 128).

Autofocusing

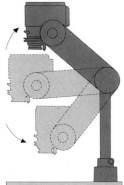

Tilting movements

Modular enlarger units

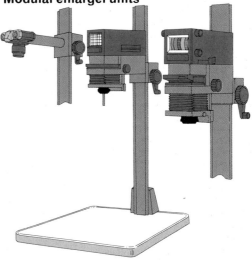

When you change enlarger height to alter image size you must refocus the negative. In an autofocus enlarger height and lens controls are linked, refocusing automatically so that the image remains sharp. This saves time when you make several varied size prints from one negative.

Some advanced enlargers allow tilting of the negative carrier and lamphouse unit independently of the lens panel, see above. You can use these movements for correction purposes, for example to realign converging verticals without loss of sharpness (see p. 206).

Enlargers often have interchangeable heads. You can convert a condenser enlarger for black and white work to a diffuser color head en-larger by changing the lamphouse. And, as above, you can replace the head with an attachment for copying (see p. 180).

Choosing an enlarger

	Basic design features	Worthwhile extra features
Lamphouse and illumination system	This must illuminate the negative evenly at all image sizes. Choose a diffuser system for color, especially if you print from slides.	Interchangeable heads—condenser for black and white, diffuser for color. 90 degree rotation for making oversized enlargements.
Type of filtration	A color head with easy-to-read filter values up to 200 is most versatile; a filter drawer system is cheapest.	A "white light" lever instantly removes all color head filtering for composing/focusing. Red swing-over filter for black and white.
Negative carrier	This must hold negatives perfectly flat, without scratching. A rotating carrier turns negatives for a vertical or horizontal image.	Carriers (and lenses) for other negative sizes extend the enlarger's scope. Make sure that lamp still gives even illumination.
Lens	Purchase the best lens you can afford, with f settings that you can feel in the dark. Focal length must suit your negative size.	Interchangeable lenses to suit different negative sizes are necessary if you use more than one film format.
Height and focusing controls	The height control must allow for the biggest enlargement that you regularly make. Height and focus controls must not slip.	Autofocus is useful for fast, accurate printing. The ability to make reduced-size prints as well as enlargements is an advantage.
Column and baseboard	These must be sturdy enough and large enough to prevent image shake, especially at the largest magnifications you regularly use.	An angled column prevents obstruction of baseboard when making enlargements. Reversible columns allow projection on to the floor.

Enlarger accessories

If you are setting up a darkroom for the first time, start with the bare minimum of equipment (see p. 46). You can always add more as your technique becomes more demanding. The enlarger is the only really essential piece of equipment, but there is a whole range of accessories that will make the exposure side of printing easier and more reliable, as can be seen on these pages. The list below gives basic items, in order of priority, for black and white printing. If you intend to start printing in color, you can omit the safelight, but then the timer becomes more important (see pp. 116-17). And if your eyesight makes it difficult to check image sharpness on the enlarger baseboard, you will need to use a focus magnifier (see facing page).

Basic equipment

Safelight You can use an orange or red colored safelight with black and white materials, as they are insensitive to light of these colors.

Masking frame This is a useful aid to both black and white and color printing (see facing page).

Timer With a timer, you preset the exposure time, and it will switch on the enlarger for the exact required period.

Compressed air Use this to remove dust from all delicate surfaces.

Vignetters and dodgers These are easy to make (pp. 104-5) and important for local print control.

Voltage stabilizer This prevents electricity fluctuations affecting the performance of the enlarger.

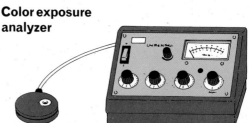

Enlarger

Voltage stabilizer

Timer

Masking frame

Safelight

Vignetters and dodgers

Compressed air

Programmed printing control unit

The memory store of this printing control unit can retain information on the speeds of each grade and type of paper you are likely to use. Linked to the control unit is a light-measuring probe, which you place on the enlarger baseboard. When you have placed the negative in the carrier, switched on, adjusted the head height, and focused, the probe relates the grade and other characteristics of the paper you are using to the particular negative and level of illumination

present. You can then read off the correct exposure. The unit can also be programmed to time a test strip exposure series automatically, giving exposures ranging either side of the time it estimates to be the correct one.

Color exposure analyzer

This electronic analyzer measures and sets the correct exposure and filtration for color enlarging. A probe (above left) measures the projected image either on the baseboard, or from the lens fitted with a diffuser. You must first set the analyzer

(see p. 128) for your enlarger and color paper batch (found by making a test print). Once set up, the analyzer reads out the filter values required and calculates the correct exposure for any negative. Although expensive, it does save time and paper.

Contact printing frame

A contact printing frame consists of a sheet of glass hinged to a rigid base. Plastic guides on the underside of the glass form channels for several strips of negatives. After you have loaded the negatives, emulsion-side down, you place a sheet of printing paper, emulsion-side up, on the base. Then you lower the glass on to the base, making certain that the negatives and paper are in contact, and expose the frame to light (see pp. 92-4).

Test strip frame

You can obtain a special frame, which allows you to print five different exposures on the same piece of printing paper. The frame is particularly useful when making a color test strip (see pp. 121-3) in complete darkness. You fold down or lift up the flaps in turn in order to produce a range of equal-width exposure strips. Some types of test strip frame print thin black lines to separate the strips clearly from each other.

Focus magnifier

This focusing aid enlarges and brightens part of the projected image, so you can focus the image finely. There are several different designs (see below). Stand the magnifier near the center of the light path and look through the eyepiece. The image is reflected up on to a viewing screen by an internal mirror. Check the screen as you focus the enlarger, until the negative grain appears sharp.

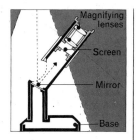

The diagram above shows how the focus magnifier works. Both the screen and the base are the same distance from the mirror.

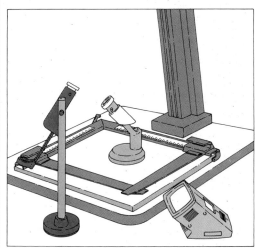

Masking frames

Masking frames are designed to position and hold a sheet of printing paper completely flat during exposure. The frame produces a white border on the finished print. Frames with adjustable margins are invaluable in determining where to crop a picture to improve composition. The best types allow a choice of border widths on all four sides. Fixed masking frames, however, are useful if you are likely to want to crop a lot of prints to the same picture area. When using doubleweight paper, you should focus on a piece of waste printing paper placed in the frame, instead of focusing on the frame base.

Fixed-format frames are designed for one paper size only. They produce prints of a fixed size with even white borders.

Adjustable-format frames have hinged metal flaps and movable paper stops, which allow you to alter the picture size.

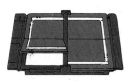

Frames divided in four allow you to print four pictures on the same piece of paper, so saving on chemicals and time.

Film processing equipment

Film processing, in color or black and white, always involves using chemicals in liquid form. Your equipment, therefore, must be made out of materials that are non-corrosive and will not affect the silver-reactive chemicals used. You can save a little money by utilizing some non-photographic items – such as PVC bowls, and glass bottles. But avoid any products made from zinc, aluminum, brass, polyurethane, or anything chromed or silver plated. In general, it is far safer only to use equipment specifically designed for film processing, as shown here. You will find that some items can be used for print processing as well (see pp. 44-5).

The equipment below is roughly grouped in the order in which it is required during the processing sequence, from film processing tank to drying unit. The list on the right summarizes the essential equipment you should have if you are processing film for the first time. You do not require any sort of permanent darkroom; a temporarily blacked-out room will do.

Film tanks

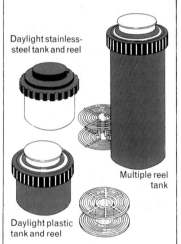

Daylight stainless-steel tank and reel

Multiple reel tank

Daylight plastic tank and reel

Daylight tank A plastic or stainless-steel tank is essential for developing most camera films (see pp. 68-9). The tank is fitted with a lid that allows you to pour solutions in and out, without letting light reach the film. After you have loaded the film (in darkness) on the spiral, you can carry out all processing under normal lighting conditions.
Tank spiral (or "reel") Plastic tank reels are usually adjustable to accept film of different widths. Metal tank reels are not adjustable, but they are easier to keep clean, and permit the closer temperature control at high temperatures you require when processing color film.
Multiple reel tanks Extra long tank bodies are available in plastic or stainless steel. These accommodate two or more rolls of film for processing at the same time. They are worth having if you regularly process film in batches.

Containers and graduates

Graduates Graduated measuring cylinders, in plastic or glass, are essential for accurate film processing. You will nearly always buy chemicals in concentrated liquid form, and so have to dilute and measure them before use.

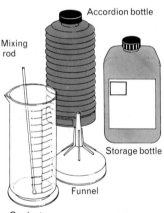

Accordion bottle

Mixing rod

Storage bottle

Funnel

Graduate

Mixing rod You should always use a plastic mixing rod for mixing and dissolving any powdered chemicals (used in some color processing kits). Never use a thermometer for mixing – it breaks easily and will contaminate the processing solutions.
Storage bottles These are required for any chemical solution that you can use more than once. Accordion types, which you compress as the liquid level goes down, are best for developers. These exclude any air in the bottle, and so prevent the chemical oxidizing.
Plastic funnel A plastic funnel is useful for pouring solutions back into narrow-necked storage bottles.

Time and temperature controls

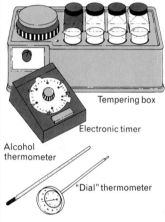

Tempering box

Electronic timer

Alcohol thermometer

"Dial" thermometer

Thermometer A good darkroom thermometer should range from about 59°-104°F (15°-40°C), and be accurate to within ¼°C if you intend to use it for color processing. Choose one that is easy to read – an alcohol thermometer, for example, or, better still, an electronic digital read-out type.
Tempering box This temperature control unit contains an electric heater and either water or a fan to circulate the air. It should be big enough to hold all your bottles, graduates of solution, and the film tank itself. A thermostat in the box will hold all solutions at an even, required temperature – typically, 68°F (20°C) for black and white, and 100.4°F (38°C) for color.
Electronic timer The best type audibly signals the end of any period of seconds or minutes you pre-set. They assist in attaining more consistent and reliable processing results.

Recommended

Apart from the essentials, the following equipment is well worth having. It will allow more consistent results, and make the whole processing sequence less time-consuming.
- Accordion bottle for developer solution
- Mixing rod
- Tempering box
- Programmable timer
- Water filter
- Film dryer
- Magnifier

Extras

There are a great many extra items designed to make film processing easier. Depending on your working conditions, some of the following may be useful, even essential.
- Loading bag (see p. 68)
- Cassette opener
- Film loader (a clip-on device made for some tank reels)
- Chemical-proof coveralls
- Squeegee tongs
- Negative album

(Left column list:)
- Rubber gloves (especially important for color)
- Photographic thermometer
- Minutes timer (an accurate kitchen one will do)
- Length of rubber hose
- Film clips and nylon cord
- Negative sleeves or slide mounts
- Scissors

Handling and washing equipment

Rubber gloves These give protection from chemicals. Black and white chemicals are usually fairly harmless, although some people may have an allergic reaction. Always wear gloves, though, when handling color chemicals—this applies especially to bleach or stabilizer solutions.

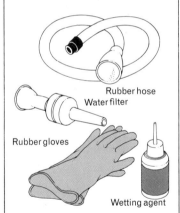

Rubber hose
Water filter

Rubber gloves

Wetting agent

Rubber hose A length of hose is required for the final, wash stage of processing. Rubber hose sold for this purpose fits over the faucet and has a short tube that you push down into the spiral of the tank.
Water filter A filter between the faucet and hose will remove any grit in the water, which may damage the film emulsion.
Wetting agent A few drops of wetting agent added to the final rinse will prevent water droplets clinging to the film and forming marks when the film is dry. These are very noticeable when it is printed or projected.

Drying equipment

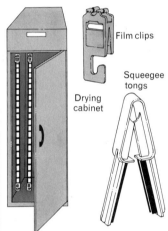

Film clips

Squeegee tongs

Drying cabinet

Squeegee tongs Use these tongs for black and white film drying. They have inward-facing soft wiper blades, which you pull down the film surface to remove excess water. Their hinges contain a safety stop to prevent you putting too much pressure on the film surface. It is best not to use tongs with color films, as the wet emulsion is too soft.
Film clips Photographic film clips prevent curling of a length of drying film. The top clip grips the film in stainless-steel teeth. The bottom clip is weighted to pull the film straight. Do not use plastic clothes pins, as these often harbor water droplets, which may run down the part-dry film, leaving streaks.
Drying cabinet A thermostatically controlled drying cabinet is the quickest method of drying film. The top unit is the controlled warm-air blower. Below this unit is the film hanging cabinet.

Storage, mounting, and viewing equipment

Storage sleeves Paper or plastic sleeves, large enough to hold a strip of five or six negatives, are an immediate and effective way of protecting your negatives.

Storage sleeves

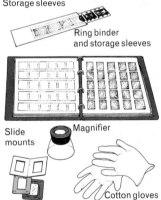

Ring binder and storage sleeves

Slide mounts

Magnifier

Cotton gloves

Storage sheets These contain enough sleeves to accommodate a whole fiilm. Each sheet has punched holes to fit inside a ring-binder, and you can file each one facing a similarly punched contact sheet.
Slide mounts Cardboard or plastic slide mounts are the best system for transparencies. Cut the film into individual frames. Take care not to cut into the image area.
Cotton gloves If possible, wear clean, lint-free cotton gloves when handling film.
Magnifiers Choose a magnifier that covers at least the whole of a 35 mm format image at one time. Magnifiers which incorporate a transparent "skirt" allow in enough light to view small paper prints as well as film images.

Black and white print processing equipment

Processing black and white prints is much more demanding of space than processing film. You require a temporary darkroom, at least, and you must make sure that your working area is properly sealed against white light, which will fog your printing paper, and suitably safelighted. Use the lists at the bottom of the page to plan your requirements–only buy another piece of equipment when you are sure you can make full use of it. Some of the equipment below is common to color print processing, see facing page.

Lighting, timing, and temperature control

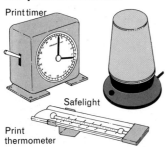

Print timer

Safelight

Print thermometer

Safelights These special units contain low-wattage bulbs and interchangeable colored screens. You must use safelighting when handling black and white papers. Most black and white paper is sensitive largely to blue light and can therefore be handled under orange safelighting. Orthochromatic material, though, has a wider range of sensitivity and must be handled under deep red illumination. Safelights can be free standing or wall mounted.
Print timer This has to show the passing of minutes–most developing times being around 2-2½ min. An electric clock with a sweep second hand will do.
Print thermometer This is different to the film processing types–it has large, easy-to-see figures mounted on a back plate.

Trays, tongs, measuring, and storing equipment

Trays You use open trays to process black and white prints. You require one tray for each processing solution–making three in all. Buy the trays in different colors, and make sure the same chemical always goes into the same tray.

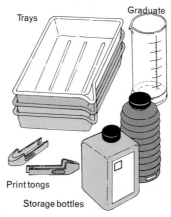

Graduate

Trays

Print tongs

Storage bottles

Print tongs You need two sets of print tongs–one for the developer and one for the stop and fix. Tongs have rounded ends and should always be used to transfer prints from tray to tray.
Storage bottles and graduates These are the same type as used for film processing (see pp. 42-3).

Washing and drying equipment

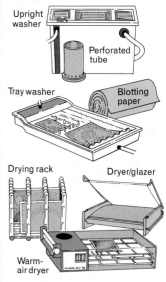

Upright washer

Perforated tube

Tray washer

Blotting paper

Drying rack

Dryer/glazer

Warm-air dryer

Print washers These are available in a variety of designs. Tray washers direct a fast flow of water across the print surface. Upright washers have a larger print capacity. You can also convert a washstand by placing a perforated plastic tube over the outlet.
Drying rack A simple rack is all you require for resin-coated paper.
Warm-air dryer This electric unit is also designed for resin-coated paper, and dries two or three prints in about five minutes.
Photographic blotting paper You use this to remove excess moisture from fiber-based papers.
Heated dryer/glazer This electric dryer is designed for fiber-based paper. It clamps down on the print and prevents it from curling.

Essentials

The equipment listed below is the bare minimum you must have for processing black and white prints. (See also pp. 42-3, as several items are common.)
- Three trays
- Containers for print solutions
- Graduate
- Watch or timer
- Thermometer
- Safelight
- Drying rack or photographic blotting paper

Recommended

Although they are not essential, you should aim to buy the items listed below as soon as your budget allows.
- Print washing tank or resin-coated paper washing tray
- Easy-to-read tray thermometer
- Luminous darkroom clock
- Electric dryer/glazer or resin-coated paper warm-air dryer
- Print tongs

Extras

All these items will probably be useful, especially if you try some of the more advanced image manipulations in later sections.
- Safelight screen for orthochromatic materials
- Storage bottles for toners and bleaches
- Mixing rod
- Tray warmer (heated panel for developer)
- Print squeegee

Color print processing equipment

As color paper is sensitive to the whole visual spectrum, and requires very accurate temperature control, you usually process it in daylight print drums. Once it is inside the drum, it is relatively easy to maintain the correct solution temperature, and you can work in normal light. It is possible, though, to process color prints in open trays, like black and white prints. If you decide on this method, use a very dim safelight as recommended for the product—not those used for black and white printing, which will fog the paper.

Print processing equipment

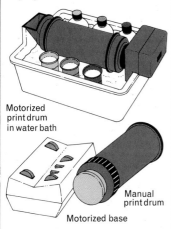

Motorized print drum in water bath

Manual print drum

Motorized base

Daylight print drum You use this to develop color prints. The very close temperature control required, and color material's sensitivity to the whole spectrum, make open tray processing difficult. The print drum is light tight and uses a minimum of chemicals. However, because of this, you must roll print drums to and fro to keep the solution in constant contact with the paper.
Motorized drum This does the same job as the simple print drum, but automatically. Some models rotate the drum in a thermostatically controlled water bath.

Temperature and timing

Photographic thermometer An accurate thermometer is necessary. It should be able to read temperatures between 74°-105°F (23°-41°C).

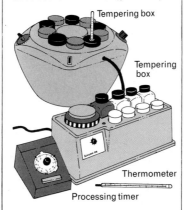

Tempering box

Tempering box

Thermometer

Processing timer

Tempering box Units designed specifically for color print processing hold a set of small graduates, each containing the quantity of solution required for each step. With all types of color processing, solution temperatures are fairly high and must be exactly as specified if you are to achieve consistent results.
Processing timer You can use your film processing timer if it can be programmed for the different stages of print processing.

Washing and drying

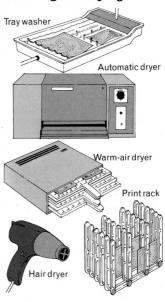

Tray washer

Automatic dryer

Warm-air dryer

Print rack

Hair dryer

Print washers You can use the same washers for color printing as you use for black and white printing (see facing page).
Print dryers Most color printing papers today are resin coated and can be dried in the same way as resin-coated black and white paper (see facing page).
Automatic dryers These expensive units are capable of handling large quantities of prints. Motorized rollers remove excess water, and then a slow-moving belt draws the prints through a blow-heated compartment.
Hair dryer At the other end of the scale, you can use an ordinary electric hair dryer if you do not want the expense of a commercial unit.

Essentials

If you are already processing your own color films or resin-coated papers, it is likely that you will already have some of these essential items.
- Manually rotated print drum
- Bottles and graduates for each solution
- Thermometer
- Timer
- Rubber gloves
- Watch
- Print washer
- Bowl for water bath

Recommended

The more sophisticated your equipment the more reliable and consistent will be your results. It is much easier to start with the following equipment in addition to (or instead of) the essentials.
- Motorized print drum with solution temperature control unit
- Timer with programmable intervals
- Drying rack or heated drying unit

Extras

These items will be particularly useful if you start producing large amounts of color prints.
- Additional print drum (will allow one drum to be used while the other dries)
- Easy-to-read digital thermometer
- Automatic print dryer

Basic darkrooms

Making a darkroom usually means temporarily adapting an ordinary room (see below). If you are lucky, you may have a small closet, which you can keep exclusively as a darkroom (see facing page).

Different processes require different amounts of space—black and white printing (because of open-tray processing) is the most demanding. With film processing and color printing, once you have loaded the exposed material into the tank or drum you can work in normal light.

Any darkroom must have light-tight windows and doors and an electricity supply. Running water is convenient, but not essential. When setting up your room, separate the wet (processing) and dry (exposing) areas. Arrange your equipment so that you move in a logical sequence around the room.

Darkroom safety

Pay particular attention to safety in any room where you use electricity and liquids near each other.

- Keep all electric cables away from wet areas.
- Use cord-operated switches in all wet areas.
- Ground all electrical equipment.
- Fuse plugs at the lowest correct rating.
- Keep all chemicals away from children.
- Use gloves when handling color chemicals.
- Avoid cables and furniture you may fall over.
- If in doubt, have an electrican check all wiring.

Bathroom conversion

The bathroom is an obvious choice for a temporary darkroom. And apartment bathrooms often have no window to black out. Use a fitted board to convert the bath tub to a bench. Make sure it is the right height for convenient use and leave room underneath for your wash tray. Arrange processing trays on pads of newpaper to absorb any spillage. If you have to run power cables across the room, make sure that they are well away from any source of water. Make doors light tight with black foam insulation. To cover a window, see pp. 48-9.

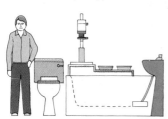

Build up the board over the bathtub to a convenient bench height. Raise the enlarger so that it is slightly above the trays.

Arrange enlarger, trays, hand basin, and towel in a logical sequence. Keep electrical equipment grouped furthest from taps.

Cabinet unit

You can build a darkroom unit (see below) to stand in any convenient room. Unlike a bathroom conversion, all your equipment can remain in one place. If you do not have running water, you must remove your prints in batches to wash elsewhere. The "wet" bench should have a laminated top. In case of spills, it is best to lay protective plastic over carpet or floorboards. Paint the inside of the unit (around the enlarger) matte black to minimize reflections. And if the room has windows, you must black them out (see pp. 48-9). You can buy units, like the one below, but with fold-out ceiling and walls.

Cabinet ready for use

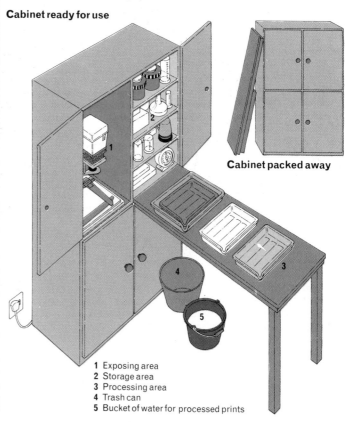

Cabinet packed away

1 Exposing area
2 Storage area
3 Processing area
4 Trash can
5 Bucket of water for processed prints

Closet darkroom

You can leave this type of dark-room area permanently blacked out (with everything undisturbed) between sessions. Generally, you will have to adapt some area of the house not used by the rest of the family. The attic is not really suitable—it is hot in summer and cold in winter. The basement is a better location; it has a more stable temperature and a firmer floor. The diagram below shows the layout for a permanently adapted closet area under the stairs. The low ceiling means that you must locate the enlarger at the furthest point from the stairs themselves. And to minimize vibrations, attach the enlarger bench to a side wall, not

the underneath of the stairs. Build all work benches at normal working height (about 36 ins/91 cm, depending on how tall you are). If they are too low they will not be comfortable to use for any length of time. Finish bench tops with white laminate so that you can see items easily in safelighting. Paint the area around your enlarger matte black, but the rest of the room in a light neutral color to reflect the safelighting. In a small darkroom you will require some form of ventilation. Either make a box-lid vent to fit within the door (see below), or fit an extractor fan in a side wall.

Box in the underside of the stair-case to seal out dust. Position the wet bench far enough forward to avoid hitting your head. Make the dry bench higher than the wet bench in case of spills.

1 Storage area
2 Exposing area
3 Light-tight door louvers
4 Processing area

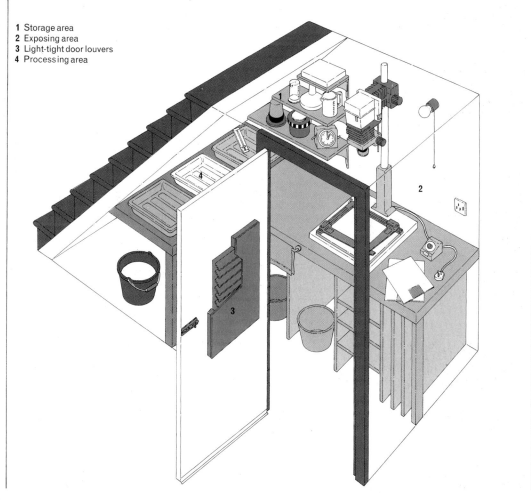

The permanent home darkroom

If you can permanently convert a room in your apartment or house, you can build up a fully equipped darkroom. If you arrange your darkroom along the lines of the one illustrated below, you will be able to tackle anything from film processing to dry mounting. Divide your room into separate dry and wet areas (see below and pp. 46-7). Install vents to draw fresh air into the room, and a wall fan to extract foul air. Air conditioning is important in very hot climates. Two wall safelights, as well as a centrally-hung ceiling safelight will provide adequate lighting for black and white printing. Run a cord (above head height) between the walls, so that you can switch on white light anywhere in the room with wet or dry hands. Choose a practical, hard-wearing floor covering (such as seamless PVC). If your room has windows, you will have to black them out completely (see below).

1 Safelight
2 Wallchart
3 Contact printing frame
4 Light box and magnifier
5 Film spool
6 Daylight film tank and reel
7 Storage area

The dry side

The dry side of your darkroom is for all functions before you start using chemicals. Use it for loading film in processing tanks, sorting out negatives for enlarging, exposing printing paper, and dry mounting. Make sure your hands are dry in this area.

Window blackouts

To make your window light-tight, you can use an opaque blind encased in wooden channeling.

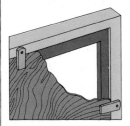

A cheaper method of blacking out your window is to use wood secured against black foam plastic.

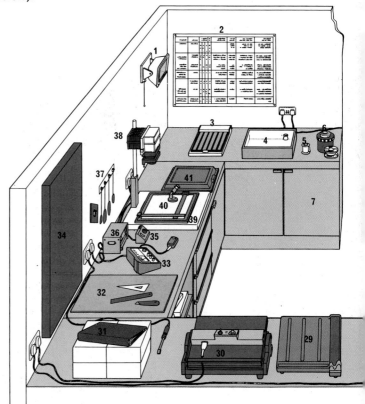

29 Rotary trimmer
30 Dry mounter
31 Negative and slide files
32 Trimming board and equipment
33 Color analyzer
34 Blacked-out window
35 Enlarger timer
36 Voltage stabilizer
37 Masks and dodgers
38 Enlarger
39 Masking frame

40 Focus magnifier
41 Paper safe

8 Film drying cabinet
9 Color-corrected light
10 Thermostatically controlled tempering box
11 Refrigerator
12 Spare trays and print tongs
13 Storage area
14 Ring-around
15 Extractor fan
16 Print drying rack
17 Safelight
18 Timer
19 Spare tanks and reels
20 Graduates

Economy of movement

When planning your darkroom, visualize the movements you will make when carrying out different jobs. Then lay out the room so that you minimize your walking, and each piece of equipment comes naturally to hand. The floor plan right, relates to the darkroom below. Brown arrows show movements when processing and drying film. The gray arrows trace work flow when printing.

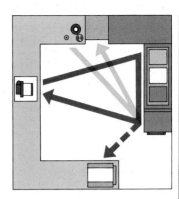

The wet side

The wet side of your darkroom is for all processes involving chemicals or wet prints or films. Keep all your tanks, trays, print washers, and film dryers on this side of the room. Never leave dry negatives or prints here, or they may be damaged by splashes.

Photographic sink

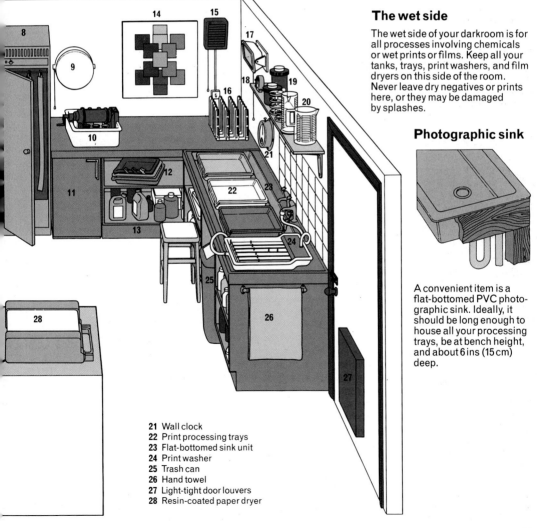

A convenient item is a flat-bottomed PVC photographic sink. Ideally, it should be long enough to house all your processing trays, be at bench height, and about 6 ins (15 cm) deep.

21 Wall clock
22 Print processing trays
23 Flat-bottomed sink unit
24 Print washer
25 Trash can
26 Hand towel
27 Light-tight door louvers
28 Resin-coated paper dryer

The darkroom complex

Most professionals use highly mechanized dark-rooms laid out to allow easy access for a number of workers. The complex shown below is part of a unit servicing a large advertising studio. Black and white films are processed by hand in large tanks. An automatic roller transport machine processes color slide films. This machine and the color paper machine accept exposed material in darkrooms, but deliver dry, finished films or prints to a general white-light area. This area contains print and transparency viewing desks for checking results. In the black and white darkroom a roller transport machine processes resin-coated prints within five minutes. There are also (not shown here) a color negative processing room, and a mixing room from which replenishment chemicals are piped to each machine. All areas are air-conditioned.

1 **Revolving space-saving door,** completely light-tight
2 **Automatic processing machine** for negative/positive color paper
3 **Viewing booth** with 5000K (daylight) illumination for assessing color prints
4 **Light box** for sorting processed film

12 **Color enlarger**
13 **Roll paper masking frame** – exposed rolls feed into the print processor
14 **Desk color printer** – rapidly proofs color negatives at a fixed-size enlargement

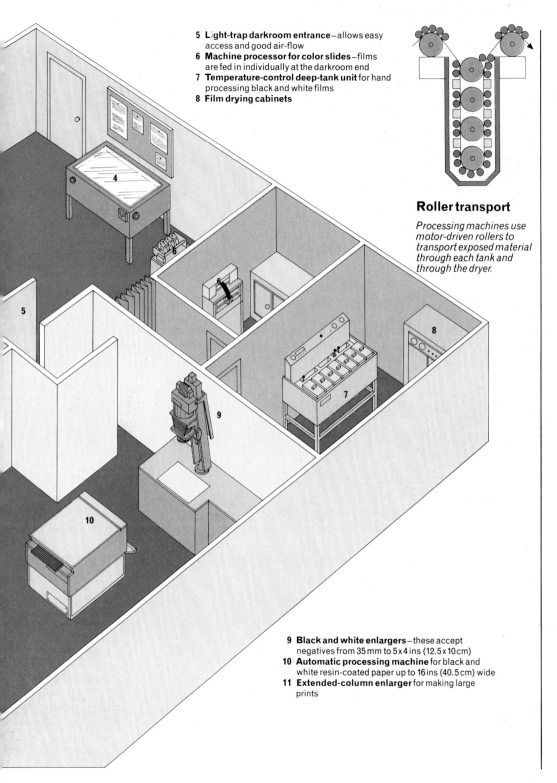

5 Light-trap darkroom entrance – allows easy access and good air-flow

6 Machine processor for color slides – films are fed in individually at the darkroom end

7 Temperature-control deep-tank unit for hand processing black and white films

8 Film drying cabinets

Roller transport

Processing machines use motor-driven rollers to transport exposed material through each tank and through the dryer.

9 Black and white enlargers – these accept negatives from 35 mm to 5 x 4 ins (12.5 x 10 cm)

10 Automatic processing machine for black and white resin-coated paper up to 16 ins (40.5 cm) wide

11 Extended-column enlarger for making large prints

How black and white films and papers work

Before you start processing you should understand the basic changes that film must undergo before it is ready to produce a set of prints on paper. All photographic materials contain compounds of silver known as silver halides. These halides will respond to light by gradually blackening into metallic silver. The type, size and thickness of the halides determine a material's sensitivity (or "speed" of response) to light (see p. 78). When you take a photograph, light reflected from the scene passes through your lens to the film. Photographic materials are designed so that you expose them to light just long enough to create tiny changes in the halide structure, producing a few atoms of metallic silver–this forms an invisible or "latent" image. Then, keeping your material in the dark, you amplify these silver atoms millions of times by treating them with a chemical developer. You develop most black and white films into negatives–images with subject tones reversed. When you enlarge your negative on to silver-halide-coated paper, then process the paper in a similar way to film, you create a "negative of a negative". You can give some ordinary black and white negative films "reversal" processing (see p.79). This will form a direct positive image on the film, which you can project as a black and white slide.

(see p.78) ... (see p.54) ... (see p.79)

Dye negative films

Some newly introduced black and white films produce a final image in dye instead of black silver. Silver halides are still used to form the latent image (as described left), but the film is designed for color negative type processing (see p.54). This causes a dye image to develop, and also bleaches away all the film's silver. The resulting monochrome negative (brown-black or reddish, depending on brand) prints with improved image resolution. Dye image negatives have much greater tolerance to exposure errors than regular film types.

Negative film

1 Latent image

2 Development

3 Negative

Subject

Sunlight illuminates the **subject** above and, as a result, various tones in the toy reflect different amounts of light and shade toward the camera lens and film.

The camera shutter briefly exposes the light-sensitive film to the image. Silver halides record a **latent image** in atoms formed by the light. **Development** amplifies these atoms, forming a visible image.

Until you dissolve away unused halides in fixer, film is opaque and impermanent. After washing and drying it carries a **negative** image.

Transparency film

1 Latent image

2 Development

3 Bleach/Fog

4 Development

5 Transparency

With some black and white films you can convert the **latent image** formed by exposure into a positive result. First **development** produces a black silver negative image. Next, instead of fixing, you **bleach** the film to remove the silver

image–this does not affect the remaining undeveloped halides. Then you **fog** these halides to light (or treat them chemically), and blacken them during **development.** Finally you must fix, wash, and dry the film.

Reversal processing records only the dark parts of the original image as black silver on the film, giving a positive **transparency.**

Black and white film structure

Black and white film resembles a multi-layer sandwich, as shown on the right. The emulsion, or image-recording layer, is a mixture of light-sensitive silver compounds suspended in a gelatin binding agent. The emulsion is supported by a flexible, durable base material–commonly a cellulose ester known as triacetate. Under the base there is an anti-curl layer, and also an antihalation dye, which is dissolved during processing. The dye prevents light reflecting back from the film base. The film emulsion is covered by a

Gelatin
supercoat
Emulsion

Triacetate
base

Anti-curl layer
+ antihalation
dye

gelatin overcoat. This protects the delicate surface from most handling damage.

Black and white paper structure

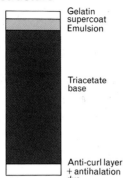

Supercoat
Emulsion
Baryta

Paper base

Supercoat
Emulsion
Resin coat

Paper base

Resin coat

Anti-static
backing

Fiber-based paper has a layer of intensely white pigment called baryta underneath the gelatin and silver halide emulsion. The pigment provides the maximum amount of reflection. A gelatin overcoat protects the emulsion surface.

Modern resin-coated papers are made with paper fiber, sandwiched top and bottom by water-proof layers of plastic. They do not have a layer of baryta. The silver halide emulsion is coated on the top layer, covered by a gelatin overcoat.

Positive print

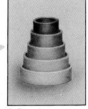

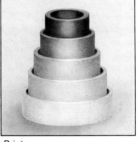

1 Latent image

2 Development

Print

When you project a negative, left, on a sheet of silver-halide-coated paper, light passes through transparent parts of the film to create a **latent image** on the paper. **Development** then produces similar changes as with film.

The final result records the dark and light areas of the original image as a similar range of tones. This forms a positive **print** on your paper, as shown above.

Formation of the silver image

The light-sensitive coating on photographic materials is a mixture of silver halides and gelatin. The gelatin allows the liquid processing chemicals to affect the halides without disturbing the image, as well as enabling you to wash out unwanted by-products. Halides are minute in size–the illustrations on the right represent halides magnified thousands of times. Exposure forms a few

Latent image

atoms of silver, mostly in the high-sensitivity, larger silver halide crystals. It affects more grains in the bright parts of the image, less in the shaded areas. These

Developed halides

silver traces attract developer chemicals, which begin to form millions more atoms (above), until most or all of each light-affected grain converts to black

Fixed + washed negative

silver. Fixer dissolves the remaining un-darkened halides into invisible salts, which you then remove by washing.

53

How color films and papers work

All modern color materials have three black and white silver halide layers (see pp. 52-3). In manufacture, each layer is designed to respond to a limited band of spectrum wavelengths—one to blue, one to green, and one to red light. Processing produces a dye image in each layer, in a color complementary to the color sensitivity of that layer. With negative film, you develop the latent image (exposed silver halides) to produce black silver combined with a color dye in each layer. With transparency film, you first develop the latent image to produce a black and white negative in each layer (corresponding to dyed image areas on negative film, see below). To produce the "positive" image, you must expose (either to white light or chemically) previously unexposed halides. You then color develop the resulting positive silver image to produce dyes in these areas. The principles involved in forming a positive image on color paper (facing page) are much the same as for film.

Color relationships

The color of visible light depends on its wavelength. White light is a mixture of all the different wavelengths of visible light, and therefore of all colors. You can see this when a beam of light is split passing through a prism. The three primary colors of light are red, green, and blue—and you can form all the other colors by mixing these primaries in different combinations. A mixture of blue and green light, for example, produces cyan. The complementary of any primary is a mixture

of the other two primaries. The color wheel, above, shows these relationships. Colors placed opposite on the wheel are complementary–yellow is complementary to blue, magenta to green, and cyan to red.

Transparency film

1 Latent image

2 B & W development

3 Color development

4 Bleach/fix

5 Transparency

Subject

Black and white development forms a negative silver image in each layer, representing either blue, green, or red. After

fogging, **color development** forms yellow where blue was not present, magenta where green was absent, and cyan where red was absent.

The **bleach/fix** stage allows all silver to be washed away. The remaining dye images combine to form the **transparency.** Where yellow and magenta coincide, for example, red appears.

Negative film

1 Latent image

2 Color development

3 Bleach/fix

4 Negative

Exposing the subject
Various parts of the colored toy reflect different colors in white light. These strike the film to form latent negative images in the 3 silver halide layers.

Color development forms silver plus dye image negatives in the appropriate film layers. The **bleach/fix** step

removes all the silver, leaving the three images as dyes recording the subject in complementary colors.

The orange cast on the **negative** is there to compensate for deficiencies in the dyes formed. These deficiencies are corrected during color printing.

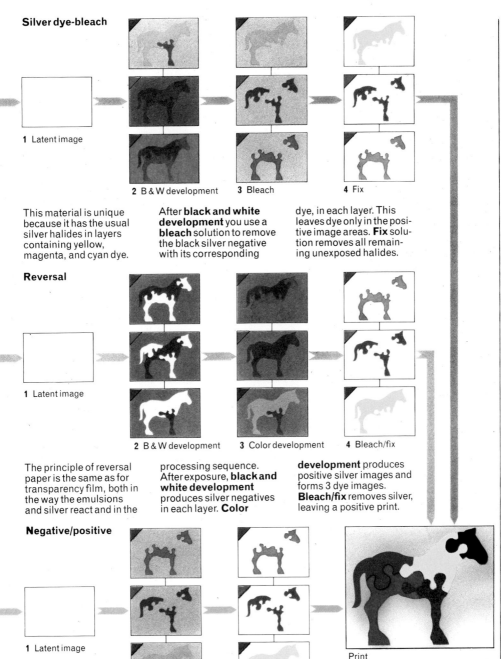

Silver dye-bleach

1 Latent image

2 B & W development **3** Bleach **4** Fix

This material is unique because it has the usual silver halides in layers containing yellow, magenta, and cyan dye.

After **black and white development** you use a **bleach** solution to remove the black silver negative with its corresponding

dye, in each layer. This leaves dye only in the positive image areas. **Fix** solution removes all remaining unexposed halides.

Reversal

1 Latent image

2 B & W development **3** Color development **4** Bleach/fix

The principle of reversal paper is the same as for transparency film, both in the way the emulsions and silver react and in the

processing sequence. After exposure, **black and white development** produces silver negatives in each layer. **Color**

development produces positive silver images and forms 3 dye images. **Bleach/fix** removes silver, leaving a positive print.

Negative/positive

1 Latent image

2 Color development **3** Bleach/fix

Print

Negative/positive paper works in a similar way to negative film. **Color development** forms silver plus dye

images. But because these reverse the colors of the negative, the image is correct after the **bleach/fix.**

Whichever process you use, the 3 dye images superimposed on the printing material will reproduce the subject's original colors. However, during enlarging you can use exposure time and colored filters to exercise fine control (see p. 115).

The structure of color materials

Color films and papers basically consist of three silver halide emulsion layers (each sensitive to either blue, green, or red light) coated on a plastic base (see below). Light selectively affects the film's or the paper's emulsion layers, to form latent images (see pp. 54-5). Most manufacturers combine chemicals known as "couplers" with each layer. A coupler has the potential to form a dye, which is complementary to the color sensitivity of the layer it is in. All couplers are colorless until color development, when certain chemical by-products transform them into their different dyes. This system of color forming is known as "chromogenic".

Unless immobilized, coupler chemicals tend to move out of their layers and into others during manufacture. To stop this, some manufacturers use tiny oily molecules (type A chemistry), others use long-chain molecules (type B chemistry). In principle, both types are the same, but they require different processing chemicals. (Type A materials look bluish when wet.) All films with integral couplers are called "substantive", and you can home process them. Some films are "non-substantive", in that they do not contain couplers. These must be processed by the manufacturer, as each layer has to be fogged and coupled in separate chemical stages.

Color film structure

Proctective overcoat
Blue-sensitive emulsion (+yellow coupler)
Yellow filter

Green-sensitive emulsion (+magenta coupler)

Interlayer

Red-sensitive emulsion (+cyan coupler)

Antihalation layer
Film base

All films contain several layers. The top one consists of protective gelatin. This is followed by the first, blue-sensitive, emulsion layer with its yellow-forming couplers. Next comes a yellow filter, which blocks any blue light reaching the lower layers. Under the green- and red-sensitive layers comes an antihalation layer, which stops light reflecting back from the film base.

Chromogenic paper

Protective overcoat
Red-sensitive emulsion (+cyan coupler)

Green-sensitive emulsion (+magenta coupler)

Blue-sensitive emulsion (+yellow coupler)
Paper base

Papers for color printing using chromogenic dyes also have color couplers in their silver halide layers. The cyan forming layer is at the top to improve image sharpness and there is no filter.

Silver dye-bleach paper

Protective overcoat
Blue-sensitive emulsion (+yellow dye)
Green-sensitive emulsion (+magenta dye)

Red-sensitive emulsion (+cyan dye)

Paper base

SDB paper is unique in that it has actual yellow, magenta, and cyan layers of dye built in, rather than colorless couplers. After exposure, you use a special bleach process to reveal a direct reversal image (see p. 55). The presence of the dyes gives a very rich image, but a slow paper "speed".

Color couplers in reversal film

The diagram (right) shows a color-sensitive emulsion layer before exposure and processing. It contains the silver halide crystals (triangular shapes) and the color coupler chemicals anchored in oily globules, evenly dispersed in gelatin. No colors are present at this stage.

This diagram shows the effects of the first processing solution—black and white development. Where halides have been struck by light (lower half of circle), they are converted into black silver. If you fixed the film at this point it would show a black and white negative image only.

This next stage shows what happens after fogging and color development. Two changes occur. Fogged halides develop into black silver, then oxidized (exhausted) by-products of development combine with the local coupler to form the appropriate colored dye—chromogenically.

The bleaching and fixing stage is essential to remove all the silver, which has now served its purpose. The bleaching and fixing chemicals do not affect the colored dyes. Notice that color has formed in the areas of the picture where the silver was not originally exposed.

Film types and results

Whatever your original camera film, you can produce your final image in a variety of forms. The chart below shows the range of options available between the camera and possible results. Some alternatives will introduce you to intermediate materials, which change one type of result into another. Color internegative film, for example, has contrast-reducing properties for making color negatives from slides. Bear in mind quality, speed, convenience, and cost when planning your result. For maximum quality, always choose the most direct route between camera film and final image. If you are unsure of the type of result that you want, it is best to use negatives. They will leave you the widest range of options. For details of materials see pp. 60-3.

Flowchart

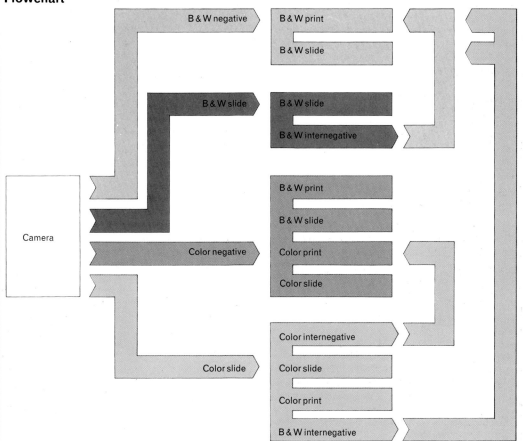

Black and white films

You can use black and white negative camera film to make enlargements on a wide range of papers. You can also print it on film to make transparencies. Reversal film (or reversal-processed negative film, see p. 79) gives excellent direct slides. But when you print from them you must first make internegatives, resulting in loss of quality.

Color negative films

Color negative films offer you the widest choice, with the least cost or loss of quality. As well as negative/positive paper prints, you can make black and white prints and slides by printing the negative on panchromatic paper or film. You can also make color slides or large transparencies by printing on print film, see p. 63.

Color slide films

These films produce the highest quality slides for projection. You can print slides on to positive/positive paper or, via an internegative, on to negative/positive paper. Avoid printing from overexposed or contrasty slides. If you make a black and white internegative you can then print on any black and white material.

Black and white and color chemicals

There are two main chemical solutions for black and white processing—developer and fixer (see p. 52). You will also require an intermediate stop bath, to prevent any carried-over developer contaminating the fixer. You can use stop baths, fixers and also some "universal" developers for both negatives and prints (usually mixed to different dilutions). For advanced work it is best to choose a specific, film-only developer, and use a different developer for prints. Each film developer formula is a compromise, offering a different balance of finest image grain, fastest emulsion speed, and sharpest resolution of detail. You should select a print developer for its effect on image color and contrast; you can choose between a neutral black and a warm result, for example.

There are also two optional processing chemicals. If you use a clearing agent or "hypo eliminator" after fixing your film, you will cut the washing time to approximately one-quarter. And a wetting agent added to the final rinse helps the film to dry evenly, which prevents drying marks.

Manufacturers supply chemicals for processing color films and papers in kit form. You must choose the correct kit for your film or paper. Process E-6, for example, suits Ektachrome, Fujichrome and some other brands of slide film. You will find the process required marked on all film cassettes and paper packs. Color processes sometimes change, so you should use the descriptions given below as a guide, and always read the current leaflet packed with your processing kit.

Chemicals for black and white films

Developers	Stop baths	Fixers
Standard fine grain These normal-contrast, moderately fine-grain developers are suitable for most processing. You can also use a "universal" type for negatives and prints. **High energy** (speed enhancing) These powerful developers increase the emulsion speed 100 per cent or more (see p. 76). But the grain is also accentuated. **Maximum acutance** Diffusion through film emulsion causes loss of detail. These developers form a silver image on or near the film surface; this gives sharp "edge" to detail. **High contrast** Process line or lith films in this type of developer, which will form strong blacks without degrading white areas.	**Rinse** A water rinse for 10-15 sec is adequate to halt development and reduce carry-over into the fixer. **Acid stop** A stop containing acetic acid neutralizes alkaline developer, preserves fixer, prevents stains. Essential for lith work. **Indicator stop bath** These stop baths are yellow when fresh, and turn purple to indicate exhaustion.	**Acid** Acidified "hypo" (sodium thiosulfate) is the cheapest form of fixer. Use this fixer at film strength. **Acid hardener** For most work use acid fixer containing gelatin hardener to protect processed negatives. **Rapid fixers** These contain acidified ammonium thiosulfate, and, usually, hardener. They halve fixing time.

Kits for color films

Reversal	Negative
You can purchase a kit containing all the processing chemicals for your particular slide film. Most slide films of A-type chemistry (see p. 56), Ektachrome, Fuji-chrome and Barfen CR for example, require process E-6. A few B-type-chemistry films, such as Agfachrome, require Agfa process 41. Some slide film must be processed by the manufacturer, see your pack for details. Several chemical manufacturers sell their own kits to suit these processes. Most amateur kits will process either 6 or 10 films of 36 exposures each.	Color negative processing is simpler than slide processing, and therefore it requires fewer stages. Kodak's C-41 is the most universal negative process–Fuji, Sakura and even Agfa make negative films which use it. Some older type-B-chemistry films use processes such as Agfacolor N. Most photographic chemical manufacturers make color negative kits, in general process C-41. Some of these color negative kits reduce the processing time by combining several solutions in one, so that even fewer stages are required.

Kits for papers and films

Universal kits
Both color negative films and negative/positive papers require similar processing stages (see pp. 54-5). This means that you can use a "universal" kit to process both negatives and prints. Most are designed for films that require C-41 processing and negative/positive paper requiring Ektaprint processing. Kits contain color developer and bleach/fix, plus stabilizer. Usually you mix an additive with the developer when you use it for prints. Universal kits contain fewer chemicals.

Chemical handling

You can purchase most processing chemicals as concentrated liquids. These are quick to make up and bring to the correct temperature by adding water. Cheaper, powdered chemicals have a longer shelf life, but you must dissolve them well before use. You should read the instructions carefully–if you add chemicals in the wrong order they may not dissolve. Take care to avoid contamination, work in a well-ventilated area, and wear rubber gloves (see p. 332). Use your developers on a "one-shot" basis (see p. 70), diluting from stock solutions stored in accordion bottles. Do not refrigerate liquid chemicals–some crystalize out below 55°F (12.5°C). The guide, right, relates to stock solutions stored in full, stoppered bottles, at room temperature.

Typical keeping properties for stock solutions

Black and white chemicals

Standard fine-grain developer	6 months
Universal developer	12 months
Standard paper developer	24 months
High-contrast developer (sep. A & B)	6 months
Rapid fixer	2 months

Color chemical kits

Negative/	Most first developers	6-8 weeks
positive	Color developers	8-12 weeks
processes	Bleachers	8-24 weeks
Reversal	Most first developers	2-3 weeks
paper	Color developers	4 weeks
	Bleachers	6 weeks
SDB	Developer	4 weeks
paper	Bleacher	4 months
	Fixer	6 months

Chemicals for black and white papers

Developers	Stop baths	Fixers
Standard fine grain These print developers will give neutral blacks on all bromide papers. Alternatively, you can use a "universal" type developer.	**Rinse** You can use a water rinse only, but be prepared to replace your fixer frequently.	**Acid** Use the same acid as for film, but diluted. Do not exceed 25 prints (8x10ins/ 20 x 25cm) per liter.
Warm tone Special slow-acting developers give extra-warm images on chlorobromide emulsions. Or you can overexpose and use diluted normal developer.	**Acid stop** Acid stop, at film strength, is preferable to water. Use one part glacial acetic acid plus 40 parts water.	**Acid hardener** Acid fixer contains hardener to prevent damage during washing –essential before glazing glossy prints.
High contrast There are no contrasty developers made for papers. Use concentrated standard fine-grain developers to boost contrast.	**Indicator stop bath** These stop solutions change color to show their strength. You can see a yellow-to-purple change under safelights.	**Rapid** Use at half film strength to speed the fixing process. Excessive fixing time may bleach the image.
Rapid processing This type of developer functions best with resin-coated papers. Rapid-processing developers are fast-acting and work well at high temperatures.		

Kits for color papers

Negative/positive	Reversal	Silver dye-bleach paper
Every color paper manufacturer, and practically all makers of processing chemicals, offer 2- or 3-solution kits for negative/ positive color paper. Some kits have a wide choice of working temperatures, others are especially low-cost. (To save money you can even mix up your own chemical solutions.) There are two types of negative/positive paper kits. Most kits are designed to suit type-A-chemistry papers such as Kodak. The other type of kit is designed for Agfa type-B-chemistry paper.	These kits process the chromogenic papers for color printing from slides. All modern papers of this kind, both Agfa and Kodak, work with the same type of kit, normally containing 6 chemical steps. You can use kits by Kodak, Agfa, Unicolor, and Photochrome for example. Reversal chemicals are about twice as expensive as kits for negative/positive papers. Improved reversal kits are gradually reducing the time and number of stages that you require to process chromogenic paper.	Silver dye-bleach materials require reversal processing, but they use entirely different chemical steps to other reversal kits, see left. You require only three chemicals–developer, silver bleach and fixer. Most photographers use kits made by silver dye-bleach paper manufacturers, such as Ilford, but there are a few independent kits. You can use an ordinary black and white developer instead of the kit developer in order to alter contrast (see p. 132). These kits cost about the same as chromogenic reversal kits.

Black and white papers/darkroom films

There is a wide range of papers available for black and white printing. They differ in size, weight, light sensitivity, contrast, type of image (negative or positive), type of base material, and tint. All these features are described below. Decide first between conventional paper-based bromide papers and those with a plastic, resin-coated base—they differ in important practical ways. Next you must choose between contrast graded papers, and papers where you vary contrast by using filters. There are also more specialist papers with unusual characteristics (see below and p. 64). Kodak, Ilford, and Agfa are the major manufacturers of papers and films, and their product names are listed in the Appendix.

To exploit the darkroom completely it is worth becoming familiar with black and white sheet film. This allows you to print black and white slides, convert normal photographs into extremes of black and white, and make negatives and positives to print together, to create a variety of special effects.

Identifying sheet film

Each piece of sheet film is notched. If you hold the film with the notch in the top right-hand corner, the emulsion surface will face you. Each Kodak film has its own identifying notch; Ilford, however, use the same notch each time.

Black and white papers

Emulsion type	Safelight	Base material	Weight
Bromide Papers with a mainly silver bromide emulsion give a neutral black image. Regular bromide papers are blue-sensitive only, and are used for most black and white printing. A wide range is available of surfaces, weights, and contrast.	Orange	**Fiber** Fiber-base papers are slightly cheaper and easier to mount than resin-coated types, but they take longer to process, wash, and dry. For a high-gloss fiinish, prints have to be glazed (see p. 95).	**Double** Doubleweight is the thickest paper base. It is available for all sizes of paper. Doubleweight paper particularly suits large prints, which crease easily if they are printed on thin paper.
Panchromatic bromide This emulsion is sensitive to all colors of light. It gives accurate black and white prints from color originals (see pp. 144-5), where blue-only sensitive papers would distort. Available in a range of surfaces, weights, and contrast.	Preferably none (or dark green)	**Resin coated** Most popular modern printing papers have a plastic resin layer coated on each side of the fiber base. As the paper fibers are sealed in, they cannot soak up chemicals. This allows you to reduce the total processing, washing, and drying time by two-thirds (see pp. 93 and 95). Resin-coated prints dry in the air without curling. Glossy types do not require glazing. Image quality equals that of fiber papers. Resin-coated papers are more difficult to mount, and the plastic finish sometimes forms a crazed pattern in prints displayed for long periods.	**Single** Singleweight is about the thickness of this page. It is cheaper than doubleweight, and suits prints up to about 8x 10 ins (20x25 cm). You can also use single-weight for larger sizes if you mount the print. **Lightweight** A few papers (document and "stabilization" types, see p. 64) have extra thin bases. These suit special applications, such as making paper negatives for later printing, or for quick print production for press work.
Chlorobromide Emulsions with both silver bromide and silver chloride give a warm brown-black image. This is more pronounced with more exposure and less development. Available in a range of surfaces, weights, and contrast.	Orange (some require red)		
Document This neutral black, high-contrast matte bromide paper is designed for copying documents by contact printing. It is useful for printing lettering where you want black and white only. Limited range only.	Orange		**Medium** Resin-coated printing papers are only available in mediumweight. However, the added plastic layers in resin-coated paper make this thickness very similar to doubleweight fiber-based papers.
Direct positive This unique bromide emulsion gives a positive print from a positive image (a slide) using normal bromide processing. It is high contrast, requiring "flashing" to give gray tones (see p. 145). One type only.	Orange	**Base tint** Apart from normal white, some printing papers have off-white or ivory base tints, which may suit your subject.	

Suitable safelighting

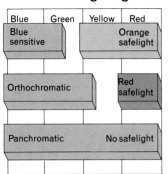

Blue	Green	Yellow	Red
Blue sensitive		Orange safelight	
Orthochromatic		Red safelight	
Panchromatic		No safelight	

Most black and white papers, and some darkroom films, respond only to blue light. (This also means white light, which is a mixture of all light, including blue.) These materials are said to be blue sensitive. You can handle and process them under an orange filtered safelight because orange is a mixture of red and yellow light, which come from the opposite end of the spectrum to blue, see left. Most other darkroom films, and some papers, are ortho-chromatic (sensitive to green light as well as blue). This extended range of sensitivity reduces the length of exposure required under the enlarger, but does mean that you must use deep red safelighting, see left, as these materials will fog if used under orange light. You can use blue-sensitive only materials under red illumination, but your safelight is then dimmer than necessary. Panchromatic black and white materials are sensitive to all colors. You can, however, use a very dim greenish safelight, but it is best to work in complete darkness. Remember to follow the manu-facturers' instructions carefully – even the correct safelight will fog if it is too bright, or too close, or allowed to act on the emulsion for too long a period.

Contrast	Surface
Graded papers Bromide papers for general use are made in a range of contrast grades. Low-contrast papers give a finer variation of gray tones between black and white than high-contrast ones (see p. 96). Normal contrast is grade 2. Grade 1 (soft contrast) will give normal-contrast prints from harsh, contrasty negatives. Grade 3 paper (hard contrast) suits flat, low-contrast negatives (see p. 97). Popular papers are made in six grades ranging from 0 to 5. **Variable contrast** Instead of buying bromide paper in several contrast grades, you can work with one packet of variable-contrast paper. This paper has two emulsions: one high and one low contrast, differing slightly in their blue/blue-green sensi-tivity. By altering the color of your enlarger light, you can vary the paper's contrast. You can use a set of lens filters, ranging from pale yellow to purple, or a color head enlarger (see p. 96).	**Matte** Matte papers dry with a surface totally lacking reflective sheen. Some are smooth with no surface texture, others have roughened tex-tures similar to blotting paper. Matte papers are ideal for retouching and artwork, but only pro-duce a maximum black that is little darker than dark gray. **Glossy** Glossy papers give a smooth, mirror-like surface. Prints have a deep, rich black and make the most of your negative's shadow gradation and detail – but retouching and coloring are difficult as they reduce the reflec-tive surface of the paper. To produce the final sheen on fiber glossy paper you must glaze it – dried naturally it has a semi-matte surface. **Other** Other paper surfaces include rough and fine luster, velvet stipple, and "silk". The more pro-nounced textures help to disguise graininess in pictures (useful in big enlargements), but break up fine detail.

Black and white darkroom films

Normal contrast	High contrast
Normal-contrast "continuous-tone" films produce a full range of tones between black and white. These films are excellent for print-ing black and white slides from negatives (see p. 140), and for various effects such as bas-relief (see pp. 216-7). Some con-tinuous-tone types are blue sensitive only; these can be handled under normal safe-lighting. You should think of them as normal-grade bromide paper when exposing and pro-cessing. If panchro-matic film is essential (when working from color negatives or slides, for example), you should use a slow camera film such as FP4 or Plus X. Remember then to work in total darkness, as no safe-light is completely safe.	These darkroom films, if properly exposed, give images of extreme con-trast, with no inter-mediate shades of gray. You use them for simplifying a normal photograph (see pp. 146-7) or making screens and masks (see pp. 156-62). Most of these films are orthochro-matic (blue/green-sensitive). There are two main types – line or lith. You can process line sheet film in concen-trated print developer. Lith materials produce a much more intense black and slightly finer detail. But you must process them in lith developer, which is more expensive than print developer. For high-contrast results from colored originals, you will have to use panchromatic lith film.

Using darkroom films
Some of the films above are intended for use in large-format cameras, but you will be handling and exposing them like paper under the enlarger. (Only a few darkroom films are made in 35 mm.) 5 x 4 ins (12.5 x 10 cm) sheet film is adequate for most purposes. Always check the recommended safe-lighting on the film packing slip. Most types use either deep red or the normal orange safelight. ASA ratings are seldom given or used, as this varies according to your choice of developer.

Color papers/darkroom films

Papers for color printing fall into two main groups: those that produce a color print from a color negative (negative/positive), and those that produce a color print from a color transparency (positive/positive). You have a choice of two different forms of positive/positive paper (see pp. 54-5), and these are compared below. With all color paper, the appearance of the final image is affected by filtration and exposure, and the suggested values for these factors are printed on every pack (see facing page). Generally, color papers have fewer surface textures and sheens than black and white materials (see pp. 60-1), and are made in one contrast grade only. Also, most color paper is resin coated. Specific product names of color papers and darkroom films are listed in the Appendix.

Several film-based materials are available, which allow you to print slides or prepare color negatives from slides for printing on paper. Color materials will fog under most safelights, so it is best to work in complete darkness.

Safelights for color materials

You can purchase dark amber safelights for use with some negative/positive papers only (see leaflet). Illumination is weak—you must wait 5-10 min for your eyes to adapt.

Color papers

Paper type	Surfaces	Processing chemistry
Negative/positive Paper for printing from color negatives is the cheapest, most popular color print material. It works chromogenically (see p. 56), forming a color negative of the color negative. The effect is that the tones and colors of the original subject appear correctly when the paper is processed. The dyes formed by the paper, and its general contrast, are designed to suit the manufacturer's own brand of film, but it is possible to "cross-print" one manufacturer's film with another's paper. These combinations can add a richness to some colors, while muting others. The only way you can test the effects is by trial and error.	Most negative/positive papers are available in a choice of glossy, luster, or "silk" surface finishes. They are mostly resin coated and dry almost flat. Glossy paper dries with a high-gloss sheen without any glazing.	There are two main types of processing chemistry—type A, for Kodak and similar products, and type B which you require for some Agfa products. Most negative/positive paper manufacturers produce chemical kits for their particular products, but there are many other kits. Processing takes about ten min.
Positive/positive (reversal) This is one of the two types of paper you can use to make color prints directly from color slides (the other type is described below). To form a positive image from a positive original you have to use reversal processing, similar in principle to color slide film processing (see pp. 54-5). Reversal paper is much lower in contrast than negative/positive paper because color slides, which are designed for projection, are brighter and more contrasty than color negatives. You can make a print from any brand of color slide, but avoid images that are overexposed or excessively contrasty: these may be outside the contrast range of the paper.	Choice is quite limited with reversal papers—either glossy or smooth luster surfaces. Most of these positive/positive papers are resin coated.	Use chromogenic reversal processing (see p. 56). Type A reversal chemistry suits Kodak products and type B suits Agfa products. Most of the independent kits only suit type A. With some kits you have to expose the paper to white light part-way through processing. Processing takes about 16-20 min.
Positive/positive (silver dye-bleach) You can also use silver dye-bleach (SDB) paper to make prints from slides. It works on an entirely different principle (see pp. 54-5) from reversal paper, and requires much simpler processing. The colored dyes that make up the final image are already present in the paper's emulsion layers. As a result of this, image colors are richer and more permanent than the dyes that are formed chemically during reversal type processing. The presence of the dyes in the paper helps reduce light scatter during exposure and therefore SDB paper produces slightly sharper image detail than reversal paper does. But as a result silver dye-bleach material is very slow.	Silver dye-bleach materials are again made on resin-coated paper and are available with a pearl surface finish, or a glossy plastic surface, which looks similar to resin-coated glossy paper.	Use dye-bleach chemistry. Kits are supplied by the manufacturers and are not suitable for any other reversal papers or films. Dye-bleach materials are more tolerant of variations in timing or temperatures—giving relatively little shift in image color. Processing time is about 12 min.

Handling darkroom materials

Interpreting packaging
It is impossible to be absolutely consistent in manufacture, so the makers test every batch of paper or film, and print recommended filtration and exposure values on the label. Each maker presents data in a different way, see right. When you change from one pack of a material to another while printing, you may have to alter settings (see pp. 115 and 120).

Storing materials
If you store your materials in hot, humid conditions or near chemical fumes, the color balance of the emulsion layers will quickly deteriorate. Ideally, you should keep your color paper or film in the main compartment of your refrigerator. Always remove the materials you require 2-3 hours before each printing session, or condensation will form, and affect your results.

Kodak Ektacolor (negative/positive)

TRICOLOR FACTORS			WHITE LIGHT DATA		
	Red	80	WHITE	CC	+15Y
	Green	70	LIGHT	CC	00M
	Blue	70	DATA	Ex. Factor	95

Ilford Cibachrome (positive/positive)

	Kodachrome	Ektachrome	Agfachrome	Fujichrome
Y	20	20	20	25
M	00	00	05	00
C	05	00	00	00

Advantages	Disadvantages
Working negative/positive gives good reproduction of the widest range of subject and lighting conditions.	Working from negatives makes assessment of pictures difficult until they are printed.
Cheapest color paper.	Processing temperatures are critical.
Widest range of surfaces.	Prints on type A material show a bluish cast until they are completely dry.
Simple processing.	
Wide choice of kits.	
Working with reversal paper, you choose which image to enlarge from the positive slide rather than from the negative.	More expensive than negative/positive materials.
	Processing is slower.
You always have the option of projecting your original slide, or viewing the print.	Exposure of the paper is critical.
	Reversal materials give poorer prints from contrasty subjects than do negative/positive materials.
You can mount and display prints.	
SDB paper produces a richer, sharper image than either negative/positive or reversal materials.	The most expensive color printing material.
	Less light sensitive than other enlarging papers.
Tolerant of exposure and processing temperature variations.	Glossy prints are very delicate and scratch easily.
Refrigerated storage of paper is not necessary as SDB dyes are very stable.	

Color darkroom films

Slides from negatives	Negatives from slides
Using color darkroom film you can print a color negative to make either a large color transparency for displaying on a light box or a normal size color slide for projection. Ektacolor print film (available in sheet and roll form) is matte surfaced front and back. These surfaces are easy to retouch, and they also reduce reflections— helpful if you want to display a large transparency. To produce a 35mm slide, contact print your negative on to Ektacolor 35 mm slide film. This film stock is contrasty and has a clear film base suited to projection. No matter which method you use, you must make exposure and filtration tests (see pp. 120-2) just the same as for negative/positive paper.	An alternative to printing slides directly on reversal or SDB papers involves making an intermediate color negative. With the negative, you can print color enlargements on negative/positive paper, which is the cheapest enlarging paper. The additional cost of making the negative is quickly made up for if you intend to produce several prints from the same negative. Quality too is often better using a negative to print from, especially with a contrasty slide. To make the negative, you must contact print the slide on to low-contrast internegative color film. Choice of exposure and filtration will help you to obtain the right contrast. Process internegative film in regular color film chemicals.

Handling and using color darkroom film
It is best to use color darkroom film as if it were color paper—in complete darkness. Always handle darkroom film by the edges so as not to mark the image area. If you want to copy an original slide or negative using 35 mm size film, it is handy to use your camera fitted with a 1:1 close-up attachment. You can process your print or internegative sheet film in a daylight print drum (see p. 45), and 35 mm size film in the usual daylight film tank (see pp. 42-3).

Special black and white printing materials

There are several materials, available from specialist photographic suppliers, which are not commonly used. These include emulsion-coated aluminum, linen, or plastic, mural paper, and color-based paper, which you can use to give your pictures an "unphotographic" look. Examples of these appear in later sections of the book.

Stabilization papers (used for fast production press work) are special in that they produce a black and white print within a few seconds – and they allow you to print without any wet bench facilities (see right). The image, however, is not permanent (see below); for normal photographic work you should use resin-coated bromide paper, which takes a few minutes longer to process, wash, and dry, but gives a fully permanent image.

Stabilization paper processor

Rollers accept the exposed sheet of paper, drawing it through troughs of activator and stabilizer. The finished, damp print emerges from the back after 15 sec. You can use the processor to develop resin-coated bromide paper if you use regular developer and fix and wash normally.

Special materials

Type of material	Features	Typical uses
Stabilization processing paper These bromide papers contain developing agents within their emulsion layers. When you treat them with an alkali "activator" solution, the image develops in seconds. You then stabilize the image by passing the print through concentrated fixer solution, and then you dry it without washing.	**Advantages** Produces prints quickly. **Disadvantages** The machine is expensive. Prints fade within months.	Useful for quick portrait proofs and newspaper type work where speed is more important than permanence.
Color-based paper Some bromide papers have colored bases, instead of the more normal white. Colors include gold, silver, fluorescent orange, green, and yellow. Most require deep red safelighting. Give this paper normal processing to form a black image, which you can later bleach to white.	**Advantages** It gives bold, graphic effects. **Disadvantages** The base tint lowers image contrast. Hard negatives print best.	The brighter-colored papers make attractive posters and display or greetings cards. Very effective when combined with line negatives.
Mural paper Mural bromide paper is designed for making very large prints and photomurals. It is only available in roll form – from 20 to 54 ins (51 to 137 cm) wide. The paper is single-weight, which helps to disguise joins and overlays, and its tweed luster surface minimizes graininess inherent in giant enlargements.	**Advantages** It is easy to retouch and color. It is cheaper than an equivalent area of regular paper.	You can use the rolls for decorative wall coverings and giant enlargements, or cut them up into smaller sheets for low-cost printing.
Photo linen Photo linen consists of paper laminated between layers of coarse linen, coated with a silver bromide emulsion. It feels and looks like slightly starched fabric, and it is extremely tough. Exposure and processing are the same as for paper.	**Advantages** Produces a rich image. Easy-to-clean surface. **Disadvantages** Relatively expensive. Has to be mounted.	Can be used for giant enlargements and mounted for display directly on a wall. Spotlighting helps reveal the surface texture.
Opalized plastic This material has a thick, milky white plastic base coated with normal-grade bromide emulsion, which you can process like paper. Lit from the front, it has the appearance of a print, lit from the rear, it is a rich-toned black and white transparency.	**Advantages** No lightbox is required. Completely texture free. **Disadvantages** The surface is easily scratched in processing.	Used for display when rear lit. Its reverse surface allows hand coloring, and the opal plastic diffuses any brush marks.
Emulsion-coated aluminum Metal plates are available from specialist suppliers, coated with a hard-grade bromide emulsion. Exposure and processing are the same as for paper. If you varnish the surface after drying, you can achieve a highly durable finish.	**Advantages** It is free-standing and can be curved or angled. **Disadvantages** It is very expensive.	You can print from line negatives to make name plates, dials, instruction plates or display prints, for indoor or outdoor use.

Processing your own film

Introduction

This section deals with processing film. It concentrates on 35 mm, but at the same time covers essential ground for roll and sheet film, too.

The first pages guide you through basic tank loading. This is the job that requires most practice when you are a beginner, as it is the preliminary step for processing both black and white or color. Black and white film processing is next followed, step by step, to negative assessment, control of grain, and some of the exposure error corrections possible during development. The remainder of the section covers practical aspects of processing and assessing color negatives and slides.

Processing film may be your first step toward photographic self sufficiency. It puts you in control of results in two ways. First, you can ensure consistency—each film is given exactly the same treatment, by tight monitoring of time, temperature, agitation, and solution strength. Second, there are several ways you can give controlled modifications of results to suit the particular subjects and approach of your photography. These include choice of developer, under- or overdevelopment to suit subject and printing conditions, even processing with incorrect chemicals for special effects. Processing is, therefore, a combination of disciplined routine and knowing what rules can be broken or adapted to give a particular kind of result.

Care and attention to detail are essential to all forms of film processing. The key stages are developing, because it affects the density and contrast of the image, and fixing, because errors can give impermanent results. Small errors in timing or temperature are unlikely to ruin films, but they will give you inconsistent results.

When you process film, remember how the chemicals have to reach the silver halides (see pp. 52-3). The gelatin of the emulsion swells like a microscopic sponge, absorbing the liquid, allowing chemicals access to the latent image without disturbing its position. By-products are equally free to diffuse out of the emulsion back into solution. Film agitation is essential to make this two-way flow work evenly.

The presence of gelatin also means that when changing from one solution to another, your films "carry over" some of the first chemical. If this contamination is likely to damage the second solution, an intermediate rinse or neutralizing stop bath has to be included between the two. During washing there must be sufficient time and water flow for all soluble salts to be cleared from the emulsion. The success of the washing process depends on well-organized equipment and careful timing of each stage.

Finally, at the drying stage, bear in mind that the film is essentially a length of plastic, coated with swollen gelatin. It is very vulnerable to scratches from rough handling or dirt. The gelatin must be allowed to re-set evenly by drying at a steady rate.

As you have seen already, basic equipment for film processing is not particularly complex or expensive. The same items can be used for color as for black and white; but chemicals, particularly the kits required for color, can be expensive. Remember that made-up solutions have quite a limited life. For the most consistent results with critical solutions such as developers, work on a one-shot basis—diluting, using, and then discarding after processing each film. Most other solutions can be economically and safely used several times.

Working with black and white

On average, a black and white film or batch of films can be processed in about 45 minutes. This includes washing but not drying. The exact time the developer is allowed to act depends on the type of developer you use, its temperature, and the amount of agitation given. It also varies with the type of film—fast films generally require longer development than slow ones. To start with, choose one of the developers listed as suitable by the manufacturer of your film.

As a beginner, try to keep to one developer as much as possible. Get to know the standard quality of negative it gives, then keep to a regular processing technique so that you can learn to identify any exposure and other camera errors. Later, experiment so that you can extend your processing craft. If your photography is mostly of subjects in poor lighting conditions, decide whether to use ultra-fast film, or fast film processed in speed-enhancing developer. A reel of film exposed in overcast, misty lighting will give more easily printed negatives if development is increased slightly to boost contrast.

Do not neglect fixing just because it makes little visual change beyond clearing the milkiness of the emulsion. Films still require agitating in the fixer and, although the solution itself can be used repeatedly, do not let it become chemically exhausted. Discard fixer when emulsion takes twice as long to clear as it did when the solution was newly made.

A recent trend in black and white film is to manufacture emulsions that are given the same (or similar) processing as color negatives. The dye image formed (usually sepia or brown-black) enlarges with better resolution than a silver negative. Under- or overexposure gives a thin or dense image, but with less loss of shadow and highlight detail and contrast than you would get from silver negatives.

Working with color

There are more changes involved in color negative processing than in black and white. Color developer forms a black and white silver negative in each layer of the film and (by using by-products) forms dye negatives there too. You must then bleach and fix out the silver to leave a final image in dyes alone. Chemically this would take longer to

achieve than regular black and white processing, but because the solutions are used at higher temperatures—usually 100°F (38°C)—the overall time required is only about 25 minutes.

There are even more stages involved in processing color slide film. Here you start with a black and white developer to form silver negatives only. Instead of fixing the remaining halides, these are fogged, color developed, and then the whole film is silver bleached. What remains is a positive image in dyes. Typically the whole process takes about 40 minutes, again at 100°F (38°C).

Unlike in black and white film processing, there are no choices of individual developers for color. Chemicals are bought as complete kits designed for a particular slide or negative process. Different brands of kit vary in price, number of solutions, operating temperatures, and slight variations in color "warmth" or "coldness". In general, all temperatures and times have to be held much more accurately than in black and white processing, to ensure film-to-film color consistency. Do not be put off by the temperature accuracy specified for developers. These are not difficult to achieve–and they only have to be held for the short period that the particular stage requires.

As you become more confident you may want to over- or underdevelop your color film to compensate for having to over- or under-rate its normal ASA speed when shooting under problem lighting conditions. These "pushing" and "pulling" techniques can be done with color slides by adjusting the timing of the first (black and white) developer. They are not advisable for color negatives as the only developer used directly controls color as well as density, so changing timing will also alter the color balance of the whole film.

Slides may be both overexposed and underdeveloped to reduce image contrast, for example when copying other slides. With experience, you can also develop slide films as high-contrast color negatives to give stark, distorted color prints. In all color processing it pays to master consistent control of results first, then experiment with "misuse" for unusual images without loss of this underlying control.

Finally, do not overlook the importance of looking after your processed films. Prints, if mishandled, can be reprinted, but films usually carry original images and any damage is enlarged on every print. Protect them carefully and file each image so that you can easily find it again.

Historical background

Like the wet plates that preceded them, gelatin emulsion camera materials were at first made only on glass (1879). Photographers processed each negative individually, in trays. Since the emulsion was insensitive to red light, the photographer used an oil or candle lantern with a red screen to watch the image appear. Development was "by inspection".

Later (1889) roll films were introduced to enable users of hand-held cameras to take several pictures without carrying plates with them. Photographers still used the inspection technique for the new materials. Processing was slow and awkward, and often damaged emulsions. When panchromatic materials were introduced (1906), plates and films had to be processed in light-tight tanks. Processing was controlled by time and temperature.

Processing solutions at this time were mostly mixed from raw chemicals. Five different chemicals were required for the average black and white developer. Few people attempted color photography before the 1930s. Those who did could choose between making three separate black and white negatives, or using a "screen" transparency process. Separation negatives were exposed through blue, green, and red filters, then printed in yellow, magenta or cyan dye.

The 1930s brought triple-layer color slide films–three emulsions sensitive to blue, green, and red, processed to form images in yellow, magenta, and cyan dyes. The first of these was Kodachrome, in 1936. It was (and still is) too complicated for user-processing, requiring upward of 14 chemical stages. Within the next decade Agfa, then

Early darkroom
A typical nineteenth-century darkroom (right) was stocked with the chemicals used to coat plates with collodion emulsion, and to process them. A clamp on the wall held plates during coating. Red-colored paper over the window provided "safelighting". On the floor (left to right) stood a negative drying rack, printing frames, and a camera plateholder. The large earthenware sink acted as a wash bath.

Kodak, introduced slide and color negative films and paper which could be user processed.

By today's standards processing procedures were long and arduous. For example, Ektachrome films of 1946 (ASA 12) took 1½ hours to process. Nine years later improved Ektachrome (ASA 32) could be processed in 67 minutes, using a kit known as E-2. Today's Ektachrome is processed in 37 minutes in E-6 chemicals.

The pattern of progress in color film processing–both slides and negatives–is toward fewer stages, shorter time and higher temperatures. New color films now tend to conform to existing processes. Today, process E-6 (for color slides) and process C-41 (for color negatives) are standard for a whole range of color film products. Some of the latest dye image black and white films are also designed for C-41 processing. Eventually, all types of negative film may be put through the same processing.

Loading the film tank

Most film is panchromatic (sensitive to light of all colors), so you must load it into the film processing tank in complete darkness. Once it is inside, and the lid in place, you can carry out processing in normal light–hence the common name "daylight tank."

You load the tank by pushing or winding the film on to the grooves of the tank reel, so that it is held in a loose coil. There are two methods of doing this–from the edge or from the center (see facing page). Loading the tank properly is the most skilled stage of processing–quick and easy when you know how, but requiring practice. It is best to learn on a length of outdated or already processed film. Run through the method a few times in normal light and then try it with your eyes shut. Marks are often caused by trying to force the film on to a damp reel so that the film buckles and touches other film surfaces, preventing the free flow of the processing solutions.

The most popular tanks are the plastic type (easier for beginners and adjustable to accept most film sizes) or metal type (easier to keep dry and clean), shown on the facing page. But there is one tank you can load in daylight (see below).

Changing bag

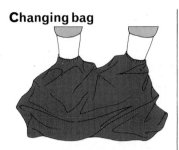

This black bag with light-tight armholes enables you to load your film tank in normal light. Before you open the film container in the bag, make sure you have all your equipment inside and ready.

Opening the film container

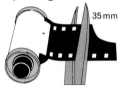 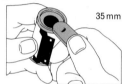

35 mm 35 mm 120 110

Cut off the shaped leader of 35 mm film, taking care to cut between the sprocket holes.

In complete darkness, remove the top of the 35 mm cassette using an ordinary bottle opener.

Separate rollfilm from its backing paper in the dark. Unwind the paper until you reach the film end.

In darkness, break the plastic cartridge, remove the spool and separate the film and backing paper.

Using a daylight loading tank

This special 35 mm plastic tank lets you load your film in normal light. Cut the film leader square, drop the cassette into the hollow reel core, and feed the film end through the slot, into the innermost groove of the reel. Make sure it is held on the plastic hook. Then add the other half of the reel and place it in the tank. Use the external controls to wind in the film (see below).

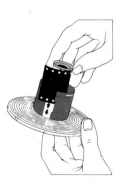 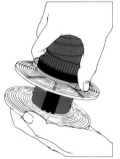

1 *Insert the cassette into the reel core. Leave the film end protruding through the slot and attach it to the hook.*

2 *Fit the other reel half. Next, place the reel and cassette in the tank body. Attach the outer part of the lid.*

3 *Turn the lower control knob to feed the film on to the reel. Turn the upper knob to detach the film from the cassette.*

4 *Invert the tank and the cassette will drop out. Now add the inner lid, and you can start processing (see pp. 70-1).*

Using a plastic tank

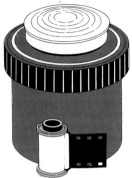

Plastic tank design

Plastic tanks come in different sizes to accommodate one or several rolls of film. You can adjust the central reel to suit different width films. With plastic tanks, you must cut the film leader square. In darkness, push the film end through the guides and on to the outermost groove of the reel. With the film in position, rotate the reel halves back and forth relative to each other. In this way, you will draw the film on to the reel (see below). When the reel is full, place it in the tank and close the lid. You can now pour solutions in through the top, without fogging the film (see insets above). You can insert a rod through the lid to agitate the film during processing. Alternatively, fit a water-proof cap and invert the tank to agitate the solution (see p. 71).

Using a metal tank

Metal tank design

Stainless-steel tank reels are not adjustable and you have to buy them for each size of film you process. You must also load them from the center of the core outward. With some stainless-steel reels, it helps if you shape the film end, as shown above. You have to practice loading metal tank reels more than the plastic types. But it is possible to load metal reels when the film is still wet (useful for some manipulations). The big advantage with these tanks is that they are far easier to dry and clean. When the film is loaded, place the reel inside the tank and add the water-tight cap. During processing, you can invert the tank to agitate the solutions (see p. 71). If you want to process several films at the same time, you can purchase taller tanks.

1 *Set the two reel halves to the correct width for your film, and then lock them in position.*

2 *In darkness, open the cassette using a bottle opener, and push the film on to the outer groove.*

1 *Make sure you correctly position the reel to accept the film before turning the lights off.*

2 *In darkness, open the cassette and clip the film end securely to the core of the reel.*

3 *Rotate the reel halves back and forth until you have cranked the whole film on to the reel.*

4 *Cut the end of the film from the empty cassette and tuck it into the outer reel groove.*

3 *Turn the reel, gently pressing the sides of the film so that it bows slightly as it feeds in.*

4 *When the reel is loaded detach the film from the cassette and tuck the end into the groove.*

Black and white negative film

There are four steps in processing black and white film: 1 development, 2 stop bath, 3 fixing, and 4 washing. The action of the developer converts the film's latent image into a visible image of finely divided black silver (see pp. 52-3). You control development by correct timing and temperature (see below), and by agitating the tank (see facing page). The stop bath halts the action of the developer, and the fixing solution converts all the halides unused in exposure and development into invisible salts, which you must then wash away. If you are careless over developer time and temperature, or solution strength, your negatives will show uneven or inconsistent density. If you neglect to fix or wash the film properly, the negative image will not be permanent.

Equipment checklist
1 Accordion bottle for developer
2 Bottles for stop and fix solutions
3 Funnel
4 Graduated cylinders
5 Mixing rod
6 Thermometer
7 Timer
8 Plastic bowl
9 Gloves
10 Tank and reel
11 Film clips
12 Hose
13 Water filter
14 Scissors
15 Squeegee
16 Drying line

Preparing equipment

Processing solutions
Mix all solutions and measure them out into their graduates.

Timer Pre-set a photographic or kitchen timer for the correct development time. Start the timer when you pour the developer into the tank.

Thermometer Do not use the wider print thermometer as it must be thin enough to fit the pouring hole of your tank.

Developing tank
Before loading your film into the developing tank, make sure the reel is set to the right width, and is clean and dry.

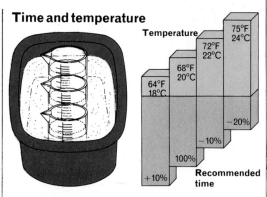

Using developer

Start by choosing the developer suggested on the instructions that accompany your film. Later, you can try other types to achieve a particular effect (see pp. 58-9). There are two main ways of using developer. You can make up a working strength solution and note the number of films processed. Then, increase development time progressively to compensate for its gradual loss of strength (see below). A better, but more expensive, method involves diluting only enough concentrate for each film, before you develop. After developing each film, throw the residue away.

Development time increases
(Using a one-reel-tank of D-76)

1-2 processings	Normal time
3-4 processings	Normal time +6%
5-6 processings	Normal time +12%

You must then discard the developer

Time and temperature

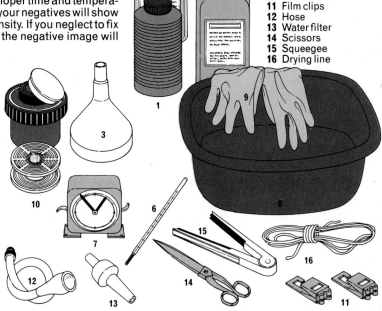

Two of the factors controlling development are time and temperature. It is easy to keep your chemicals at a standard temperature. Stand your containers of diluted chemicals in a large bowl of water at the correct solution temperature – usually 68°F (20°C). The bowl should be large enough to hold your film processing tank (see above left). If the temperature does vary, alter the development time to compensate (see above).

Film processing

Development time varies according to the developer you use, type of film, and solution agitation and temperature – so make sure you read the leaflet that accompanies the developer concentrate. You can save processing time by using a "rapid fixer" instead of the normal type. And if you soak the film in "hypo eliminator" (clearing agent), after fixing, washing time is about 5 min instead of 30 min. When processing any type of film, always start to drain the tank 10 sec before the end of each timed stage. It is important to agitate the film properly during development (see right). Too much agitation gives overdevelopment and surge marks. Too little will form uneven negative density. Always avoid chemical contamination – particularly stop or fixer in the developer.

Agitating the film tank

After you have poured the developer into the tank (see below), fit the cap, and agitate the solution by inverting the tank. Make sure you keep your finger over the cap to avoid solution spillage.

1 Mix a tankful of developer and bring it to the correct temperature. Keep other solutions within 5°F (3°C) of this.

2 Tilt the tank slightly for easy pouring. Add the developer steadily, taking about 10 sec. Start the processing timer.

3 Tap the tank to dislodge any air bubbles clinging to the film. Use a rod to agitate the solution, or agitate as shown above.

4 10 sec before the end of the development period start to drain the tank. Discard or rebottle the developer solution.

5 Quickly pour in a premeasured tankful of stop bath solution. Agitate the tank as before.

6 After the stop period, return the "indicator" stop bath (see p. 58) to its bottle for later use.

7 Pour in the fixer, and agitate initially as for developer, then as recommended by the maker.

8 After half the fixing time you can remove the tank lid and check a few frames for results.

9 Complete fixing and rebottle the solution. Push a hose into the tank reel and wash the film.

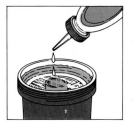

10 At the end of washing, add a few drops of wetting agent. This stops water drops clinging to the film.

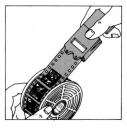

11 To dry the film, attach one film clip, pull it from the reel, and attach the second clip.

12 Wipe the film with squeegee tongs dipped in wetting agent from the tank. Hang film to dry.

Assessing black and white negatives

When your length of film is dry, cut it into convenient, easy-to-view strips of five or six negatives, and examine the results. The negatives on these pages and pp. 74-5 will help you to identify some common, but at first puzzling, faults. All the film shown is 35 mm, but most symptoms and their causes apply equally to rollfilm or sub-35 mm film. First check that your negative is free from the extreme errors shown on the facing page, and the image is sharp where you expect it to be. Then look for the more subtle mistakes below. Important shadow parts of the original subject (pale areas on the negative) should contain discernible detail, and never be as empty and transparent as the clear edge (the "rebate") of the film. Important subject highlights (dark areas on the negative) should not be so dark or "dense" that detail is obscured. As a guide, press a length of film face down on to the page of this book. In good lighting you should just be able to make out the lettering through the darkest parts of the negatives. For printing, you should choose a negative image that looks rather less contrasty than the average print. It is usually easier to increase the contrast of your pictures when printing than to reduce it. Here, choice of paper grade is important (see pp. 96-7), but you should aim at producing a negative with a full tonal range.

Viewing negatives

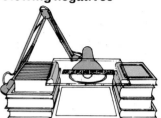

View your negatives against an evenly lit white surface. A light box containing strip tubes is ideal. Make your own using a sheet of glass or plastic supported over white paper lit by a lamp below the glass. Use a magnifying glass to see fine detail on a small negative.

Exposure effects

Underexposure
Underexposure gives a pale (thin) negative. This negative was underexposed by 1½ stops. The girl's dark hair looks empty and transparent, and will print as an area of flat, solid black. Highlight areas, such as the girl's cheeks, still show good detail.

Correct exposure
This negative received the correct exposure–three times more than the one above. The hair now shows far more detail, yet the highlight areas of the image are not excessively dense.

Overexposure
Overexposure gives a dense negative. This negative was over-exposed by 1½ stops. Subtle detail in the girl's cheeks has merged into one dark tone. When printed this will produce a "washed out", featureless white, or an overall gray area.

Development effects

Underdevelopment
Underdevelopment is easily confused with underexposure, because both produce a thin negative. But under-development does not destroy as much shadow detail, as you can see in this negative, which received 25 per cent underdevelopment. Low contrast and weak highlights are typical.

Correct development
This negative was given correct development time. Notice that the image has more "body", particularly in the highlight areas. Like the correctly exposed negative on the far left, this image will probably print well on normal-grade paper.

Overdevelopment
A 50 per cent longer development time has made the image denser and more contrasty. Over-development causes the silver grains that form the image to clump together. When enlarged, they will produce a noticeably grainy pattern. You can use overdevelopment to correct underexposed film (see pp. 76-7).

No image formed

If the film is completely clear, with even the manufacturer's name and edge numbers missing, you have mistakenly put the fixer in the tank first, instead of the developer.

If the film is completely black, with the manufacturer's edge lettering missing, you have probably allowed it to be severely fogged to light. You may have done this either before development or during processing itself.

If the film is completely clear, but edge lettering is present, you have probably processed an unexposed film. Edge lettering is printed on the film by light when it is manufactured. Its appearance here indicates that processing was correct.

Superimposed images

If the film has a black frame at the beginning of a clear strip (except for the edge lettering) the camera has not advanced the film. As a result, all the pictures are taken on top of each other. The tears are caused by the camera mechanism.

If the film has overlapping double images, you have run the same roll of film through the camera twice. It is easy to make this mistake, so always mark your exposed cassettes in some way.

Uneven density

Uneven density can have many causes. The first two film strips on the right have been spoilt at the processing stage—the first is a chemical fault, the second a mechanical one. The third strip shows a combination of faults—light fogging the film while it was in the camera, and scratches probably caused when you dried the already processed film. These scratches also occur if there is grit caught in the light trap of your film cassette, or on the camera's film pressure plate. Check the film carefully: if the scratches do not extend the whole length of the film, you can probably print some of the less-affected frames.

Bands of uneven density indicate that you have used too little developer. Always measure out the correct amount to cover completely the film and reel in the tank.

A clear or opal patch indicates that you have allowed the emulsion surface of the film to come into part contact with another surface, probably another loop of the film.

A black bar is a sign of fogging—perhaps the camera back or cassette leaked light. The parallel scratches were caused by grit, either in the camera or on the film tongs.

Black and white negative errors

Your film may contain negatives that, at first sight, seem successful but reveal problems when you come to enlarge them. Check dry, processed film through a magnifier if there are signs of spots or slight variations in density. Look at any large areas of even tone in your pictures, such as blue sky; these will show up faults more clearly than areas of complex detail. The rebate areas of your film are also important. If a fault extends across these areas, it probably happened when you were loading or processing the film, rather than when you were exposing it.

Processing errors can result from inexperience, attempts at short cuts, or failure to concentrate on what are often boring but important routines. Sometimes the film itself is faulty, particularly if it is outdated stock, or has been badly stored. You can correct, or at least minimize, several of the negative faults shown here to give an acceptable print—so do not throw away a good picture until you are sure improvements are impossible. Sometimes an accidental error, such as exposing the film to light during processing (see below), may produce an effect you can use again, under controlled conditions (see pp. 236-43) to create special visual results either in black and white or color.

Reticulation

If your negative shows a reticulated pattern, like the one above (magnified x2), you probably transferred the film from an alkaline developer to a strong acid fixer, or from very hot to ice-cold water. However, most modern films are very resistant to this defect.

Processing faults

Fogged before processing
If the film has a partial or overall gray veil of fog, you probably loaded the reel in a poorly blacked-out darkroom. If the effect is uniform you may be able to print through it. (Push-processed fast films, see p. 77, always show slight overall fog.) If the fog is bad, try chemical reduction (pp. 170-1).

Fogged during development
If the film has a gray fog as well as edge lines around the sprocket holes, you have exposed it to light part way through development. There is no remedy for this but you can use the negative to print solarized pictures (see pp. 236-43).

Exhausted developer
If the negatives are underdeveloped and have a veil of fog and a yellowish gelatin stain, you have probably processed the film in exhausted or contaminated developer. This happens when you use the same working strength solution over and over again beyond its capacity. Always follow developer instructions.

Surge marks
If your negatives have patches of uneven density adjacent to the sprocket holes, you have agitated the film tank too much. The developer solution has surged through the sprocket holes and created extra development in nearby areas.

Insufficient fixing
If the film has a yellowish or milky opalescence you have probably not fixed it sufficiently. You can correct the fault by resoaking the film in fresh fixer solution, then washing and drying it normally. Sometimes developer contaminating the fixer solution forms a similar-looking fog.

Drying marks
If the film has circular patches with dark rims, sometimes enclosing lighter density, you have dried it unevenly. You may have hung it up with water droplets clinging to it, or splashed it when it was already dry. To reduce marks, soak film for 10-20 min in warm water, or wipe it with cotton balls containing wetting agent.

Incorrect processing

If your processed film has an orange stain, you have probably processed color film in black and white chemicals. You can either print on panchromatic paper (see p. 60), remove the stain and then print as black and white (see below), or convert it to color negative (below right).

Removing the stain from Kodachrome and Ektachrome

1 Soak the film in wetting agent for 1 min, then rinse.
2 Bleach the film for 7-14 min in a solution consisting of film-strength rapid fixer plus 8 grams of citric acid per liter of solution.
3 Wash the film for 10 min.

Salvaging a color negative from Ektachrome

1 Wash the film for 15 min.
2 Treat the film with fresh C-41 bleacher for 4 min.
3 Wash the film for 15 min.
4 Expose the film for 15 sec to a photolamp 12 ins (30.5 cm) away.
5 Give full C-41 processing (see pp. 80-1).

Camera errors

Obstructions
Sometimes errors made when you exposed the film look like processing faults. If part of the image is blacked out, you may have allowed the camera strap or your finger to obscure the lens. This fault most often happens with direct vision viewfinder cameras.

Flash speeds
If the negative shows only part of the image, you may have used a shutter speed that was too fast for electronic flash. You must usually set cameras with focal plane shutters (most SLRs) at 1/60 sec or slower when using electronic flash. A speed of 1/250 sec often records half the image, 1/500 only one-quarter of the picture.

Rollfilm faults

With the exception of surge marks, all the errors on these pages apply equally to 35 mm and larger format rollfilms. However, the faults, right, are more often associated with rollfilm negatives. This is because of their dimensions and because they are packaged on flanged spools instead of in cassettes. The image also extends closer to the film edges, so you must take particular care always to handle the film by the edges to avoid any possible damage to the image area.

How kinks form
Rollfilm is broader than 35 mm film, and so forms kinks more easily. When you load it on the reel, make sure it feeds in straight, and is not too bowed, as above. If you feel it buckle or jam, unwind a turn or two and try again.

Kink marks
If your processed negatives have one or more small crescent-shaped marks, similar in appearance to film that has been exposed to light, you have kinked the film when loading. The kink marks, above, are shown three times actual size.

Edge fog
If both edges of your negatives have black fog marks, you have probably left the film in strong light either before or after it was exposed in the camera, or wound the film too loosely on the rollfilm spool. The fastest films fog most easily.

Pushing/pulling black and white film

Camera film speed and film development time are integrally linked. Chemical manufacturers suggest a development time which assumes that you have followed the film manufacturer's ASA recommendation when taking your pictures. The assumption is also that you have "correctly" exposed an "averagely lit" subject. Sometimes, though, you may have to underexpose ("push") your film by increasing its ASA setting, and then compensate by over-developing; or overexpose ("pull") by decreasing its ASA setting, and then compensate by underdeveloping ("holding back"). This situation may arise if your subject is unusually flat or contrasty.

You cannot use development changes, though, to compensate fully for exposure variations. Altering development may produce awkward side effects if taken too far, and bear in mind that any changes in development will apply to all the negatives on your film.

Clip test

To test how much to alter development time, cut off at least the first 4-5 ins (10-13 cm) of exposed film for trial processing.

"Pushing" film speed

Often when taking photographs under very flat lighting, you will want to increase the contrast of your pictures. Or you may find that the lighting is so poor you cannot use a reasonable aperture and shutter speed combination. Under these conditions you can push your film speed by exposing a 400 ASA film, for example, as if it were 800 ASA. This will effectively double its speed and allow you to use a smaller aperture or faster shutter speed. Afterward, you must increase, or push, development time, to give negatives of normal density. The more you push the film, when exposing and developing, the more contrast it becomes, and the more film grain (see p. 78) becomes apparent. You must expect deep shadow areas to print as featureless gray or black, and in mid-tone areas grain will be noticeable.

ASA x 2/normal development
Underexposing, by doubling the ASA setting, gives a thin negative.

ASA x 8/extreme development
Extreme pushing gives excessive contrast, grain and empty shadows.

ASA x 2/pushed development
30 per cent extra development produces more normal density.

Boosting image contrast

Sometimes you will want to increase the contrast of your negatives to compensate for flat, gray subject conditions. Distant misty landscapes, smoky scenes, and subjects taken with very long focal length lenses all tend to result in disappointingly flat pictures. You may also want to make a contrasty negative of a normal-contrast scene, to produce strong graphic shapes or silhouettes. Start by giving half the "correct" exposure (pushing 1 stop), and then increase development by 30 per cent (see table facing page).

The long focus lens image above is shown correctly exposed on 125 ASA film and normally developed (top left). Overcast lighting has given a flat negative. The version above right, was exposed on the same film, but rated at 250 ASA and development time increased from 10 to 14 min. This technique produces a negative of more normal contrast.

Degree of compensation

The amount by which you can alter development time varies with the type of film and developer (see right), and the subject contrast. If you expect to push your film, it is best to start with a fast type. Slow types respond best to pulling — or holding back the development. These are inherently more contrasty, which counters the loss of contrast you get with underdevelopment.

Camera exposure (using HP5)	Developer	Development time adjustment
−1 stop (x 2 normal ASA)	D–76	Increase by 30%
−2 stops (x 4 normal ASA)	D–76	Increase by 75%
−3 stops (x 8 normal ASA)	Microphen	Increase by 160%
+1 stop (½ normal ASA)	D–76	Decrease by 30%
+1 stop (½ normal ASA)	Perceptol*	Normal time
+2 stops (¼ normal ASA)	Perceptol* (½ strength)	Normal time

*Low-activity, speed-reducing developer

"Pulling" film speed

Pulling film speed is not as common as pushing. You may find yourself taking pictures of a very brightly lit subject and have your camera loaded with fast film. This combination could result in even the fastest shutter speed and smallest aperture overexposing the film. Or you may feel that the subject you are photographing is too contrasty for the film you have available. In these circumstances, you can overexpose your film by using a 400 ASA film, for example, with the meter set for 200 ASA. (You may also do this accidentally, as when you change film and forget to change meter setting.) You must then pull, or hold back, development time (see above). As less development reduces contrast, avoid flatly lit, low-contrast subjects. Avoid a development time less than 5 min, as it may result in uneven development.

ASA x ½/normal development
Overexposing, by halving the ASA setting, gives a dense negative.

Reducing image contrast

With extremely contrasty subjects, you may often have to reduce the contrast of your negatives to retain detail in both shadows and highlights. Interior scenes with brightly lit windows, or sidelit portraits taken on a harsh, sunny day, will probably produce negatives that are difficult to print. To reduce contrast, try giving your film twice the "correct" exposure. Then hold back development by shortening time by 30 per cent, or using a developer designed to reduce film speed at normal development time (see above).

This contrasty interior scene gives a harsh negative when the film is exposed at its stated ASA rating and developed normally (top left). The version above right, was exposed on film rated at half its stated ASA and processed in a low-activity developer. Negative contrast has been reduced, and highlight and shadow details will be easier to print.

ASA x ¼/extreme development
Extreme pulling gives excessive flatness and poor definition.

ASA x ½/pulled development
Underdevelopment produces a negative of more normal density.

Grain in negatives

The "grain" of a negative is the fine pattern of black silver grains (see p. 53), which you can see if you magnify the processed film. The grain characteristics of different films are largely determined by the film manufacturer. Fast films contain larger silver halides, generally in thicker layers than found in slow films. Because of this, an enlarged print from a fast film shows the grain structure of the image more clearly than a similar enlargement from a slow film. Some new films (not shown here) reduce this tendency by replacing silver with dye during processing (see p. 66). Other factors affecting graininess include choice of developer (see p. 58), exposure and development time (see below), paper type and enlargement size.

Degree of enlargement

The detail above, and those below, are enlarged 30 times from 35 mm negatives (the same as a whole negative printed 28 x 42 ins/71 x 107 cm).

Film and developer combinations

Fine-grain developer
The details below were processed to give fine-grain response, normal film speed and contrast.

Extra-fine-grain developer
Grain here is finer, but the details show some loss of speed and contrast.

High-energy developer
The grain in these details is noticeably coarser and the image less distinct.

Slow film
The details on the right are from 32 ASA film. Extra-fine-grain developer gives the finest grain response. The version given high-energy developer shows excessive contrast.

Medium-fast film
These details were all shot on 400 ASA film. The two fine-grain developers reduce the tendency of the silver halides to clump together, but they cannot match the effect of the slower film above.

Ultra-fast film
All these details were taken from negatives shot on very fast 1250 ASA film. The appearance of the image is severely broken up even when developed in extra-fine-grain developer.

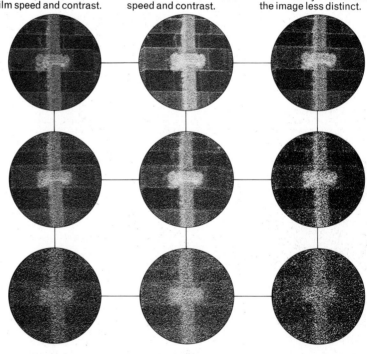

Development effects

These three details were shot on 400 ASA film and developed in fine-grain developer. The effect is clear: the overexposed and underdeveloped detail has the finest grain, but image contrast suffers.

Underexposed/overdeveloped

Normal exposure/normal development

Overexposed/underdeveloped

Black and white reversal film

If you want to produce black and white projection slides you can use Agfa's Dia-Direct film, which is designed to give direct positive images. Or you can reversal process black and white negative film, but rate it at three times its stated speed. Reversal kits are available, or you can use regular solutions or make up your own (see Appendix).

Not all negative films are suitable for reversal processing. You have a better chance of being successful if you use a slow film, such as Ilford Pan F, Kodak Pan-X, Kodak Direct Positive Panchromatic, and most line films. As with color reversal processing (see pp. 84-5), you must chemically fog black and white film or re-expose it to white light (see below), to reverse the image.

Equipment checklist
1 Containers for 5 solutions
2 Graduates
3 Water bath
4 Film tank and reel
5 Thermometer
6 Timer
7 Film clips
8 Gloves
9 Light source
10 Squeegee tongs
11 Funnel
12 Mixing rod

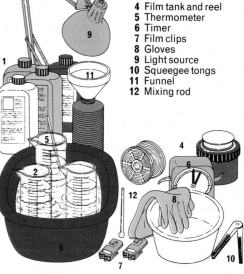

Processing procedure

1 *The temperature of the first developer must be exactly as recommended. Pour in and start timing.*

2 *After development, continue with a 5-min wash, bleacher, washing, and clearing agent.*

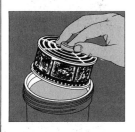

3 *If your kit does not provide for chemical fogging, remove the reel from the tank in darkness.*

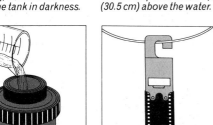

4 *Place the reel in a bowl of water and expose it to a 150-W lamp held about 1 ft (30.5 cm) above the water.*

5 *Place the reel back in the tank. Pour in the second developer, then rinse the film and fix it.*

6 *After a final wash with wetting agent, hang the film up to dry before you cut and mount frames.*

Assessing results

Underexposure
Like color slide film, if you underexpose in the camera the image has a dark appearance. This frame was underexposed by 2 stops, giving dense shadows and veiled highlights. You could try chemical reduction (see pp. 170-4) to improve the result.

Correct exposure
Notice in this image that there is a rich range of tones. There is still plenty of detail even in the darkest shadow areas, and highlight detail has not burned out. The slide has a good, well-balanced appearance.

Overexposure
This example was overexposed by 2 stops. The result is a bleached, weak-looking slide, lacking in highlight detail and gradation. You can do little to improve the image. Intensification (see pp. 168-9) would deepen the shadows, but it cannot restore missing information in the lighter areas.

Accuracy in color processing

Before you start to process color film, or paper, remember that it consists of at least three different emulsion layers (see pp. 54-6), carefully balanced in their sensitivity to light and their contrast. If your processing is, in any way, inaccurate, the resulting images could show a shift in color away from that of the original scene, as well as having the wrong density or contrast. The factors that could cause problems in color processing are solution temperature and strength, agitation, and the timing of each processing stage (see facing page), and you must pay close attention to all these.

Unlike black and white processing, where chemical solutions are chosen and bought separately, color processing chemicals are nearly always supplied as complete kits (see pp. 58-9). You should always follow the accompanying instructions in reference to time and temperature extremely closely. With most color processing, you cannot compensate for a variation in the temperature of the chemicals by altering the development time.

Timing the stages

Tape recorder

Programmable timer

You can use a programmable timer, or a precisely timed tape recording, to take you through each stage of color film processing.

Temperature control

If your budget allows, a tempering box (see p. 45) is the most efficient way of maintaining all your solutions at the correct temperature. Alternatively, you can use a deep bowl filled with water maintained at the correct temperature. You can do this by passing either hot or cold water through a hose directly from a faucet (see far right). An accurate high-temperature thermometer is essential. The easiest one to use (but the most expensive to purchase) is an electronic type with a digital display.

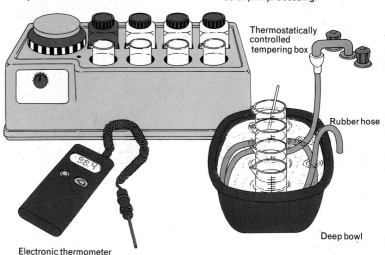

Thermostatically controlled tempering box

Rubber hose

Deep bowl

Electronic thermometer

Solution maintenance

You must dilute each kit solution accurately. If the solution is re-usable, mark the storage bottle with the step, the storage expiry date (see p. 59), and the number of films processed. It is false economy to use solutions after they are exhausted

(see below). The two commonest processes are C-41 (negative) and E-6 (slide).

Solution exhaustion table			
Process	C-41	E-6	C-41/E-6
Solution/500ml	Dev.	Devs	Others
Film size	35mm (36 exp.)	35mm (36 exp.)	35mm (36 exp.)
Increase dev. time after	2 films	2 films	—
% time increase	7%	7%	—
Discard after	6 films	4 films	8 films

Temperature latitude (negative film)

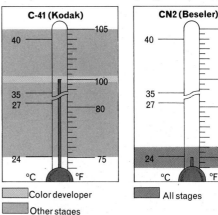

C-41 (Kodak)

CN2 (Beseler)

■ Color developer
■ Other stages

■ All stages

You must maintain developer temperature very accurately. Kits formulated to work at

lower temperatures are easier to use, but processing may take longer (see facing page).

Color negatives

It takes about 25 minutes to process a color negative film (see below). The first step, color development, forms a black silver image plus colored dye negatives in each layer (see pp. 54-6). You must next bleach and fix away the silver image (sometimes combined in a single step, called a "blix" solution). After processing, you have an image with reversed colors and a pale orange mask.

Processing equipment

Most of the equipment is the same as for black and white. You must, though, have extra containers and graduates, and a thermometer marked in 0.5°F (0.3° C) divisions. A metal tank is best for the higher temperatures. Most color negative films use type A chemistry (see p. 58), and require process C-41; but check your film container.

Equipment checklist
1 Correct chemical kit
2 Numbered containers for made-up solutions
3 Dispensing graduates
4 Developing tank
5 Water bath
6 Funnel
7 Film clips
8 Rubber gloves
9 Hose and filter
10 Thermometer
11 Timer
12 Measuring graduate
13 Scissors
14 Mixing rod

Typical processing times

	Type A		Type B
	Kodak C-41	Beseler CN2 (C-41)	Agfa-N
Temperature	100°F 37.8° C	75° F 23.8° C	68° F 20° C
	Min	**Min**	**Min**
Colour developer	3¼	16	8
Intermediate bath and wash	—	—	18
Bleach	6½	—	6
Wash	3¼	—	6
Bleach/fix ("blix")	—	9	—
Fix	6½	—	6
Wash	3¼	4	10
Stabilize	1½	—	—
Total time	24¼	29	54

Processing procedure

1 *Have all chemicals ready in the correct order and at the correct temperature. Fill the loaded film tank with color developer. Start the timer. Agitate solution as recommended.*

2 *10 sec before development is complete (see above), start to drain developer and return it to its container. Pour in the next solution and begin timing and agitating.*

3 *Follow the same procedure for fixing. Use a rubber hose and filter for all wash steps. With most processes, you can remove the tank lid for all stages after bleaching.*

4 *After washing time is complete, you may have to soak the film in stabilizer solution (see kit instructions). After the required period, hang the film up to dry in a dust-free area.*

Assessing color negatives

Wait until your film is completely dry before you try to assess the results. Most color films have resin-bonded couplers (see p. 56), which make the negatives look slightly opalescent while wet. You must also become used to the yellow or orange mask covering the negatives. The presence of this mask makes it difficult for you to judge if there are any slight color casts, which are easily seen on slides. Negatives look more fully exposed than they really are, and all colors appear as their complementaries (for example, yellows look purple and reds look greenish).

Start by comparing any new negatives against a negative you know to give a good print. One of the main faults to look out for is underexposure (see below). Empty shadow areas typically print with a color cast and, because there are no contrast grades in color paper, you cannot avoid the resulting print appearing gray and flat. You can push or pull color negative film by modifying the camera exposure/development time ratio (see facing page). But unlike black and white negative film, altering the development time here affects the color as well as the density. Your modified color negatives may look fine, but they could be very difficult to filter properly when you reach the printing stage (see pp. 114-5 and 121-3).

Viewing color negatives

To reduce the effects of the colored mask, view your negatives through a filter of the same color. This will help you to see how much shadow and highlight detail is present.

Exposure effects

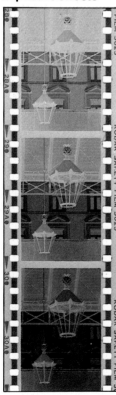

Underexposure
Shadow areas look empty –lacking contrast, detail, and color. Mid-tones and highlights record well, and show good detail. These areas may print well, but the shadow areas will look flat and lifeless. The negative on the left was under-exposed by 2 stops.

Correct exposure
This negative is darker, with stronger tone and color information in the shadows. Details in the highlights are still distinct and you can pick out the colors clearly. Contrast within shadowed parts and brightly lit parts does not greatly differ.

Overexposure
The negative received 2 stops more exposure than the one above. Subject highlights are now beginning to look clogged and solid, and the colors too dark to separate clearly. They will print bleached and featureless. Color and tone values in the shadows are excellent.

Development effects

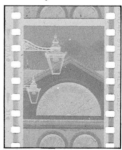

Underdevelopment
This negative was correctly exposed but under-developed. The highlights are weak and they will probably print yellowish. Shadow areas contain slightly more detail than the underexposed version on the left. The negative is too flat for color paper, and your prints will lack sparkle and brilliance.

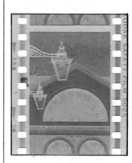

Correct development
This negative has been correctly exposed and developed. Overall contrast is stronger than the one above. The high-lights, particularly, are darker, and details look more contrasty and distinct. The negative is well balanced, and should give a good print if it is given the correct filtration (see pp. 114-5).

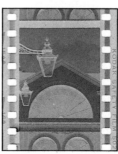

Overdevelopment
Overdevelopment forms a more contrasty, bright negative with dense highlights. Shadows, how-ever, are less detailed than in an overexposed negative (see left). This negative will probably print with harsh, dark shadows as well as bleached highlights, and the grain will also be more noticeable.

Color negative faults

Wrong film
If images are contrasty and have a purple cast, you have processed slide film as color negative film.

Fogged to safelight
If you expose negatives to brown safelight before processing they will have a cyan cast, as above.

Fogged during processing
If you do not seal your tank properly, you may fog your negatives to white light, as above.

Chemical contamination
If you contaminate developer with bleach/fix, you will get overall fog and incorrect color.

Contaminated tank
If your tank is damp with fixer before processing, negatives will show a color cast and cyan staining.

Scratched when drying
Unless you thoroughly clean your sqeegee tongs, you will cause scratches like those above.

Pushing and pulling

If you have underexposed (pushed) your color negative film due to poor light, or overexposed (pulled) it due to very bright light, you can make partial corrections in development (see right). This will not, though, correct color casts caused by the wrong exposure, and it may introduce further distortion. Consider any development corrections beyond one stop as emergency treatment only.

Compensation processing (using C-41)

Camera exposure	Development time adjustment
2 stops (×4 normal ASA)	Increase by 75%
–1 stop (×2 normal ASA)	Increase by 35%
Correct exposure	Normal development
+1 stop (½ normal ASA)	Decrease by 30%
All steps after development are timed as normal	

Normal processing
Normal exposure and processing give good color (right).

Pushed processing
Underexposure and overdevelopment give harsh contrast (left).

Color slides

You can process most slide film yourself, using chemical kits made by the film manufacturer or by independent manufacturers (see pp. 58-9). Slide film processing has far more steps than color negative processing. The first step is black and white development, although with some of the older kits you have to give the film an initial pre-hardening (see table below). You then wash the film and fog all the remaining unblackened silver halides (see pp. 54-6). It is only these halides that are affected by the next solution – color developer. Finally, you must bleach and fix away all the black silver produced by development, leaving only the positive dye images. The critical processing stages are the first development, because it controls the amount of halides left for later color stages, and color development itself.

Processing equipment

Storage containers
Make sure your storage containers are the correct size for your made up solutions. If the containers are too large, the chemicals will quickly oxidize. Label each container with the name of the process and the solution.
Graduates Label graduates as well as storage bottles to avoid chemical contamination.
Timing Use a timer that you can program for the complete sequence, or a timed audio tape recording (see p. 80).

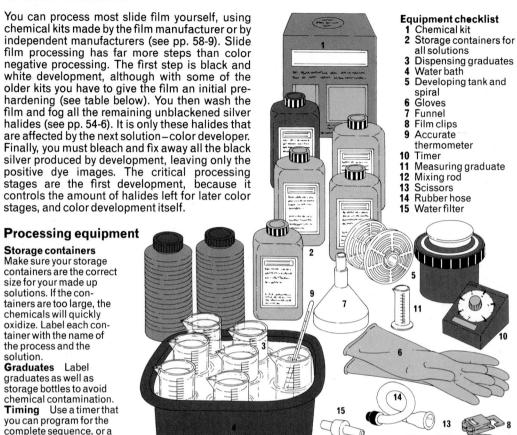

Equipment checklist
1 Chemical kit
2 Storage containers for all solutions
3 Dispensing graduates
4 Water bath
5 Developing tank and spiral
6 Gloves
7 Funnel
8 Film clips
9 Accurate thermometer
10 Timer
11 Measuring graduate
12 Mixing rod
13 Scissors
14 Rubber hose
15 Water filter

Typical processing times

	Kodak E-6	Unicolor E-6	3M Reversal	Agfa 41
Temperature	100°F	100°F	68°F	75°F
	37.8°C	37.8°C	20°C	24°C
	Min	**Min**	**Min**	**Min**
Pre-hardener	—	—	5	—
Wash	—	—	2½	—
First developer	7	6½	16	13½
Wash	2	2½	½	¼
Stop bath	—	—	2	3
Wash	—	—	3	7
Reversal bath/Exp*	2	2	3*	1*
Color developer	6	6	20	11
Wash	—	—	—	14
Stop bath/Conditioner	2	1	—	—
Wash	—	2	—	—
Bleacher	7	3	12**	4
Wash	—	—	—	4
Fixer	4	2	—	4
Wash	6	2½	6	7
Stabilizer	1	¼	1	—
Total time	37	27¾	71	68¾

The table on the left shows some typical kit processing steps and times. You must give most modern films E-6 processing. The older Agfa and 3M kits use lower solution temperatures, but require longer processing times. You also have to remove the reel from the tank and re-expose the film to light to reverse the image. With modern kits, this is usually done chemically with a reversal bath. Times and processes are often updated. Always read the instructions provided with each kit.

* Exposure time to a 500-W photolamp at 3 ft (1 m) from the film.
** Combined bleach/fix solution.

Temperature latitude

The illustration on the right shows the temperature latitude of Kodak E-6 solutions. When the temperature drifts out of these bands, the components in the various solutions change their chemical activity by different amounts. You cannot compensate for incorrect temperature by adjusting timing because of the effect these chemical changes have on color balance.

First developer

Color developer

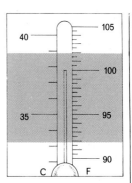

Other solutions

Processing procedure

It is especially important when processing color slide film to follow instructions to the letter, as there is no printing stage where you can correct processing faults. An inexpensive method of maintaining the correct temperature is to fill a bowl with water at a slightly higher temperature than that recommended – for example 107°F (42°C) for E-6 chemistry. Place all your chemical solutions in the bowl except first developer, which should be ready at exactly the correct temperature. Then, start processing. By the time you reach color development, the water will have fallen to the temperature you require. Later solutions will cool further, but the temperature of these is less critical (see above).

The processing kit

Most kits contain bottles of concentrated liquids; but some use powdered chemicals. Both give good results. Usually, the film processing capacity of the first developer and color developer is half that of the other chemicals, so kits often contain double amounts of developers.

1 *Using Kodak E-6, pour the developer into the tank, taking about 10 sec. Start the timer.*

2 *Agitate as recommended for the kit. 10 sec before the end of this stage begin to pour the developer out.*

3 *Wash the film in running water for 2 min, or fill the tank with water, agitate, and drain it twice.*

4 *Pour in the reversal bath. Check the temperature of the color developer. Rebottle the reversal bath.*

5 *Pour in color developer. Take care over temperature. After 6 min pour developer out and stop in.*

6 *Rebottle the stop bath. Then bleach the film for 7 min and fix it for a further 4-min period.*

7 *Next, wash and soak the film in stabilizer before removing the reel from the developing tank.*

8 *Remove the film from the reel and hang it up to dry without washing. Rebottle your stabilizer.*

Assessing color slides

You will find that it is much easier to identify color and tone errors on transparencies than on color negatives. Try to judge all your films against the same light source–ideally a color-matched fluorescent tube. First look for exposure problems: because slide films are reversal processed, overexposed images look too pale, and underexposed ones too dark. Then try to identify any color errors that are due to lighting conditions–perhaps you used the wrong film for the light (daylight film in tungsten light, for example), or you took your photograph in mixed lighting, see right. Heavily overcast weather often gives a blue cast. Color casts show up most clearly in images that contain neutral grays and off-white subjects.

Errors made during the many stages of processing result in a wide range of faults. And these faults will vary according to the brand of film and process chemicals that you are using. Often, film rebates are helpful in identifying errors, see below. If you intend to make prints from your slide (see p. 129) you can make corrections at the printing stage. You can sometimes improve slides that you want to project by using chemical reducers to treat individual color layers (see p. 337) or to lighten the whole image.

Lighting and color balance

A color cast may be due to mixed lighting. On daylight film (bottom right) light from a lamp records as too orange; whereas on tungsten-type film (top left) daylit areas are too blue.

Exposure range

Underexposure
The slide, left, received only one-quarter of the correct exposure. In the shadow areas colors have become heavy, and details difficult to see. Highlight colors and details are good. Give underexposed slides extra development (see facing page).

Correct exposure
This image is not so dark and has more shadow detail. Highlights are lighter, but they still show good color and detail. The more harshly lit your subject is, the more accurate your exposure must be to balance shadow and highlight information.

Overexposure
An overexposed slide has bleached highlights, see left. Only shadow areas show colors strongly. Lighter areas are often important, so your image will look weak when you project it. Prints will be poor, with flat, white or gray areas instead of highlight details.

Processing faults

Overdevelopment
This gives pale results, particularly in highlights (see left). First developer may have been too warm, or timing too long.

Bleach omitted
Bleach removes black silver images formed during development. If it is omitted, the presence of silver gives an almost black result, bottom left.

Fogged at processing
If "white light" reaches film during, or just after, first development, the image will look weak, with gray shadows, top left.

Underdevelopment
Too little first developer produces dark results, which may lack contrast. Temperature may have been too low or timing too short (see pp. 84-5).

Contaminated developer
If you contaminate your color developer with even a few drops of bleach, your film will have degraded images with blue blacks, see top left.

Contaminated developer
If you allow fixer to contaminate color developer, results will have a magenta cast, bottom left.

Pushing/pulling color slide film

When shooting on slide film, you can overexpose ("pull") or underexpose ("push") to help compensate for exposure conditions. To process pushed or pulled film you will have to re-time the first development stage. You must overdevelop pushed film so that it forms a stronger black and white negative, leaving less silver halides to be fogged during development. (Therefore your slides are correct.) When you push process, grain and contrast will increase, and you may get poorer shadow detail and some color shifts. You should underdevelop ("hold back") a pulled film in order to get an acceptable slide. You can use this technique to reduce contrast when copying (see p. 180).

E-6 compensation processing

Camera exposure	Changes in first dev. time
−2 stops (×4 normal ASA)	Increase by 80%
−1 stop (×2 normal ASA)	Increase by 30%
Correct	Use normal time
+1 stop (½ normal ASA)	Decrease by 30%
+2 stops (¼ normal ASA)	Decrease by 50%

Time all steps after first development as normal

Correct exposure and processing
Compare color, contrast and detail in this slide with results right.

Overexposed ×2, held back
Contrast is lessened, and highlights have a slightly warmer tone.

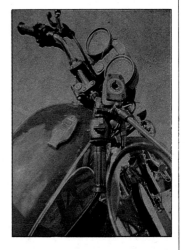

Overexposed ×4, held back
Avoid extreme correction – this flat-looking slide has a cast.

Correct exposure and processing
Compare color, contrast and detail in this slide with results right.

Underexposed ×4, pushed
Shadows begin to lack detail and contrast. Colors are more limited.

Underexposed ×8, pushed
Gives gray shadows, harsh highlights, overall color cast.

Storing and mounting

The more film you take and process the more important it becomes to have some system of protecting and filing your results. Make it a routine to cut up and protect negatives or slides as soon as the film is dry (see p. 43). You should store all your negatives in special acid-free plastic or paper sleeves. You can mount successful slides in either cardboard or plastic and glass mounts, and then store them in a variety of ways (see below).

One of the main problems with any filing system is being able to find a particular image quickly and easily. With negatives, you can give each processed film a sequential number and then identify individual negatives by their edge numbers. But you must write this number on the back of every print. With slides you will have to use a card index.

Filing film

You can file strips of slide film in clear plastic or paper sleeves (see left). Store negatives for printing in sleeved pages held in a binder. These hold an entire roll of film, and you can file the corresponding contact sheet alongside (see below). Give each film a reference number, then use rebate numbers to identify individual negatives.

Projecting slides

Hold your slide with the picture as it should look on the screen. Then invert it, keeping the same face toward you. Place a spot on the mount in the top right-hand corner. In the projector, the spot should face away from the lens.

Hand viewer

You can buy various hand viewers, most of which are battery powered. Insert the slide the right way up. You view the slide through a large magnifying glass. A diffused lamp inside automatically provides illumination for the slide.

Mounting slides

Glassless mounts
The cheapest, simplest slide mounts are those made from self-adhesive cardboard. These are completely safe to send through the mail. But the film does tend to heat up and bow out of focus slightly when projected.

Glass mounts
Glass-faced plastic mounts protect your slides from finger marks and dust, and hold them perfectly flat during projection. You can easily re-open the mount if you want to remove the slide for printing.

Large-format mounts
Larger slide mounts are available for all sizes of rollfilm. These are nearly always made of plastic — and have glass inserts — cardboard is too flimsy for the larger size mounts.

Filing slides

First, you must decide how you want to sort your images — perhaps by date, or by subject. Once sorted out, you can store them in suspension files (see below), which hold 20-25 slides per sheet. Or keep them in boxes (see right). A diagonal line drawn across the mounts tells you instantly if slides in a set are out of order.

Black and white printing

Introduction

This section deals with how to turn your black and white processed negatives (see previous section) into prints. Starting with how to expose and process a set of contact prints, it goes on to explain how the choice of paper contrast grade affects the print's final appearance. Testing and making an enlargement are also explained, and you are introduced to basic controls, such as lightening and darkening selected parts of the picture. It also shows how to finish off and mount your work.

For black and white printing the materials you will be mostly dealing with are insensitive to red or orange light, and are processed in open trays where you can see the gradual appearance of the image as it develops. No matter how many prints you make, there is still a magical quality in seeing the picture take form. Negatives themselves tell you whether the image is correctly exposed, accurately focused, and generally sharp. But it takes a print to tell you if the expression in a portrait, for example, is relaxed or selfconscious, or the lighting in a landscape exactly right.

It is quite possible to start with color printing (see next section) and then move on to black and white. But, exposing and then tray processing black and white material, working in dim safelight, is the most informative way to learn your basic printing craft. Also, the inevitable mistakes you will make at the beginning will be confined to less costly black and white paper and chemicals. With practice, all the disciplines and controls learnt with black and white will become second nature – and then easily applied to color printing.

The main value in doing your own printing is the control you have over the results. Instead of accepting standardized, full-frame prints produced by automatic machine, you decide the cropping, contrast, and density best suited to each individual picture. You do not have to enlarge every picture either. It is generally a mistake to make prints from every frame of a roll of film, and then realize that about half of them were not worth the time or paper in the first place.

This is where a sheet of negative-size contact prints of every picture on a roll is an invaluable guide to selection. Get into the habit of making a good-quality contact sheet of every film you process. Then spend some time over it with a magnifying glass and mark up (with cropping indicated, if necessary) only the best pictures. Being selective in this way is both time and paper saving.

The principles of enlarging

Enlarging is a special form of printing in which the image is projected down on the light-sensitive surface – like a transparency projected on to a screen. Passing the light through a lens magnifies the silver image of the negative (including its grain and any dirt, dust, or blemishes resulting from rough film handling). You can interrupt the light beam by inserting a piece of cardboard or your hand between the lens and paper to shorten exposure over one part of the picture and make the result lighter. The contrast of the whole picture can be increased by changing from soft to normal-grade paper, or from normal to hard grade. This produces a similar effect to shifting the contrast control on a television set.

The paper itself responds in a similar way to film, although it is much slower and insensitive to colors in the spectrum beyond blue. It is also less susceptible to damage than film, and can be handled much like any other tough paper, whether in or out of solution.

Processing the paper

Paper processing is soon mastered, but you will find that this is an aspect of printing where the utmost consistency pays off. "Snatching" prints from the developer tray because they are over-exposed and form too quickly will give grayish, degraded blacks. Extending development time to try and darken an insufficiently exposed print may give stained whites. Get used to viewing prints in safelighting – they should look fairly dark if they are to appear correct in normal lighting.

The best way to organize a printing session is to allow yourself about 1½ hours to enlarge and process a batch of perhaps six to eight negatives (not including washing and drying time). You can accumulate prints in the wash and then dry them all together at the end of the session. With experience you will find that you can save time by developing one print along with the test strip for the next negative. Several prints from the same negative can all be processed together by "stacking" them into the developer at five-second intervals, and then continually removing the bottom sheet and replacing it at the top until the first sheet has received its full development time.

Unfortunately, printing paper is expensive due to its large area of silver halide emulsion (on average, paper constitutes about 75 per cent of the running costs of printing, the rest being chemicals). You must budget for sufficient paper to make mistakes, particularly when you are just starting. However, there are ways of minimizing the cost. One of these is to use variable-contrast paper – one packet and a series of filters offers a similar range of contrast grades to three or four packets of graded papers. Other savings include buying your paper in boxes of at least 100 sheets. Each sheet then costs about 15 per cent less than if you bought it in packets of only 25 sheets. (Black and white papers will last 1-2 years without change if stored away from damp, heat, or chemical fumes.) Another economy is to use only one size, surface, and thickness of paper. If you want an occasional small size print, cut up one of your regular sheets. Always make test strips on an offcut or half-sheet of paper, and resist the temptation to "guess expose" a whole sheet. Chemicals, too, are far cheaper if you avoid the smallest size packs. Do not skimp when making up your processing solutions – the developer tray, for example, should be at least half full for consistent

results. Try to print negatives in batches – it costs almost the same to develop a single sheet as it does to process half a dozen.

Print quality

Good image quality in a print is difficult to define. A common definition is that a print should have a rich scale of tones ranging from the white paper base through to deep black. In many cases this is true, but some prints require other qualities – depending on subject matter. A picture with a stark graphic design will often look stronger if printed with harsh contrast, whereas a totally different hazy, atmospheric scene will work best in a print limited to gently gradated grays. Let the content and the "feel" of the picture itself determine the qualities to aim at — but make sure you have the ability to translate this to paper.

In the first instance, this ability should cover control of image contrast, cropping, and shading. These controls can be used to compensate for deficiencies when shooting – making over-dark shadows print lighter, or improving detail in "burnt out" brilliantly lit areas. More creatively, the same techniques allow you to transform an objective record of a scene into something much more interpretative – perhaps emphasizing one chosen element and subordinating the rest.

Bear in mind, however, that the single most important factor when printing is the quality of your negative. It is usually best to start with a negative that carries detail and a good tone gradation throughout the image. You can then use your printing techniques to discard what is not wanted – darken shadows, lighten highlights, or coarsen tones at will.

Historical background

Black and white printing is 100 years older than color printing. In the 1840s the first negative/positive process, invented by William Fox Talbot, used sensitized writing paper for both negatives and positives. The paper, soaked in a salt solution and brushed over with silver chloride, was used for printing by contact. Later, albumen (white of egg) was considered a possible binding agent for the silver halides, but it would not accept enough halides to give the plate a practical speed. Collodion was used instead. However, albumen was adopted for printing paper because it could be used dry – essential for contact printing. By 1866 production of "albumen paper" was absorbing approximately half a million hens' eggs per month in Britain alone.

During the 1870s more convenient gelatin-coated chlorobromide papers were being sold ready for use by the photographer. The "self-toning" types only required fixing and washing. Mostly they were known as "Gaslight" papers, meaning that they could be handled safely in a normally (gas or oil) lit room.

An enlarger was still an exceptional piece of equipment at this time. The first ones were free-standing units you would set up outdoors. Mostly they were used to make enlarged negatives (via a collodion or albumen intermediate positive on glass) for contact printing. The first indoor enlargers made use of a north-facing window or skylight as a light source. Later, enlarger lamphouses were added using oxy-hydrogen "lime light". Gradually, as electricity became available in towns, vertical electric enlargers were introduced.

Bromide papers themselves changed very little during the first half of this century. Variable-contrast (multigrade) paper first became available in 1940. In the mid-1970s resin-coated paper (originally introduced as a base for color prints to speed up processing) was used for black and white papers too. It allowed substantial time saving, particularly in the washing and drying stages of print production. Most other improvements during the past 10 years have been largely concentrated in equipment and materials for color printing. The range of black and white printing paper types and sizes has grown narrower as color becomes the overwhelmingly preferred form of photography. Also, the increasing popularity of resin-coated paper has made it harder to obtain traditional fiber-based paper, which suits many techniques.

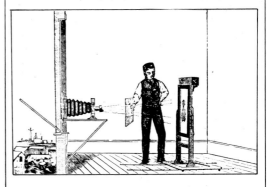

Early enlargers
The illustration above shows an early enlarger, which used a hole in the window black-out as rear illumination. Outside the room a white-painted board was used to reflect even light from the sky.

Making a contact sheet

For every newly processed film, your first task will be to make a set of contact prints. After the film is dry, you cut it into strips of five or six negatives, lay them in contact with bromide paper, and expose them to light. After processing the paper (see facing page) you will have a contact sheet consisting of rows of miniature prints.

These contact sheets are important, and worth doing well. You will probably spend a long time looking at them—deciding on which prints to enlarge (see pp. 98-101), and where they should be cropped (see pp. 102-3). File the contact sheets with your negatives and you have a reference to every photograph you have taken (see p. 88).

The equipment you require for making and processing a contact sheet is illustrated below.

Equipment checklist

1 Enlarger
2 Desk lamp
3 Glass
4 Contact printing frame
5 Bromide paper
6 Orange safelight
7 Enlarger timer
8 Opaque cardboard
9 Containers for processing chemicals
10 Three trays
11 Graduates and thermometer
12 Processing timer
13 Print tongs
14 Print washer
15 Mixing rod
16 Gloves

Exposing equipment

Light source You can use any source of even light—a desk lamp, for example—to make a contact sheet. An enlarger, though, is ideal. Raise the enlarger head sufficiently to give a patch of light broader than the paper, and stop down the lens to about f5.6.

Contact printing frame To hold the negatives flat during exposure, you can use a sheet of clean glass. A purpose-built contact printing frame has channels on the underside of the glass to hold each strip of negatives in place.

Printing paper 8x10 ins (20x25 cm) bromide paper is just the right size to record 36 negatives.

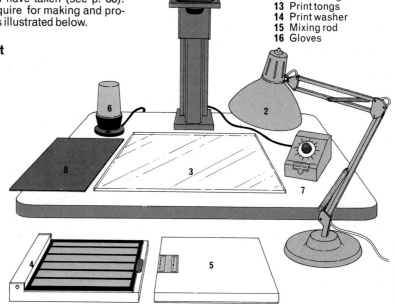

Processing equipment

Processing trays You require three different colored processing trays—one for developer, one for stop bath, and one for fixer. You should always use the same processing tray for a particular solution to avoid the possibility of contamination.

Print tongs You require two pairs of tongs. Use one when the print is in the developer and the other when the print is in the stop and fixer.

Graduates Use two graduates for mixing the solutions—one for the developer and the other for the stop bath and fixer.

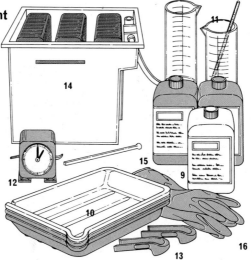

Temperature control

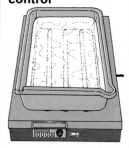

Keep your developer near its recommended temperature. Place the developer tray inside a larger tray of water at the correct temperature, or use a tray heater (see above).

Making a test strip

When you make a contact sheet you are dealing with 20 or 36 separate negatives. It is impossible, of course, to make exposure allowances for each individual negative, but it is a good idea to make a test strip first, using two different exposures (see right). Use soft-grade paper, as this will produce reasonable results from a wide range of light and dark negatives. As a guide, assume an exposure time of 10 sec.

1 *With the safelight on, place half a sheet of paper emulsion (glossy) side up on the baseboard. Cover the lens with the red filter, switch on, and make sure the paper is fully lit.*

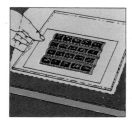

2 *Position the negatives emulsion (dull) side down on top of the paper. Lay a clean piece of glass on top of the negatives and paper. Remove the red filter and expose the paper.*

3 *After 5 sec, cover half the paper with opaque cardboard and continue the exposure for a further 5 sec. Switch off the enlarger, remove the paper, and process it (see below).*

Processing the test strip

The technique described below applies equally to processing the whole contact sheet, or any print (see pp. 94, 98-9). There are four basic steps in print processing: 1 development; 2 stop; 3 fixing; and 4 wash. Make up sufficient working strength developer to half fill one of your trays. You will have to discard this solution at the end of the printing session, but you can rebottle the stop bath and fixer for later use. Before you begin, check that the developer is within a degree or so of the temperature recommended by the paper manufacturer. The table given on the right shows the times required to process fiber-based and resin-coated paper in Dektol or D163, followed by an "acid hardener" fix (diluted for print processing).

Typical processing times at 68°F (20°C)

	Fiber	Resin coated
Dev.	2 min	1½ min
Stop	¼ min	¼ min
Fixer	10 min	2 min
Wash	30 min	3 min
	42¼ min	6¾ min

1 *Tilt the developer tray forward slightly and lay the paper face down in the tray. Start the timer.*

2 *Lay the tray down so that the developer washes back over the print. Turn the print over and gently agitate the tray.*

3 *At the end of the correct development time (see chart above), use the developer tongs to remove the print.*

4 *Allow the print to drain, and drop it face down into the stop bath. Do not allow the developer tongs to enter this solution.*

5 *Use the fixer tongs to agitate the print gently for the complete stop period. Remove the print and allow it to drain for a few seconds.*

6 *Place the print face down in the fixer, and agitate for the first 15-20 sec. After 1 min you can switch on white light and turn the print over.*

7 *You can view the print before fixing is complete. The back of a spare tray makes a handy surface. Return the print to the fixer for its full time.*

8 *After fixing is complete, wash the print for the recommended time in a constantly changing source of water. Then dry the print (see p. 95).*

Assessing the test strip

The test strip now shows two very clearly divided zones. The lighter half received the shorter exposure time of 5 sec. Of course, individual negatives will vary in contrast, some printing better at one exposure and some at the other. But you must decide the best compromise exposure for the whole sheet.

Exposing the whole contact sheet

Using the information gained from the test strip, the contact sheet on the left was given an 8-sec exposure at f5.6. You make the contact sheet in the same way as the test strip, except that you use a full sheet of paper and give it an overall exposure. If the whole sheet is too gray, you might try a different grade of paper (see pp. 96-7). To lighten one strip of negatives that is printing too dark, lay a piece of opaque cardboard over those negatives part way through the exposure. To darken a strip of negatives that is printing too light, see below.

Correcting the contact sheet

Expose the sheet normally and then cover all but the light areas with opaque cardboard (see above). Judging the additional exposure required is largely trial and error.

Washing and drying prints

You must wash prints, like negatives, to free the emulsion of any processing chemicals and unused silver salts. Because you cannot see any changes, proper washing of prints is often neglected. If you do not remove these unwanted by-products, though, they will eventually stain and bleach your image.

You can choose from a wide variety of print washers and driers (see pp. 44-5). These are designed for use with either fiber-based or resin-coated papers. You must wash fiber-based prints for 30-40 minutes because the paper itself retains chemicals, though. Resin-coated prints require about 3 minutes washing in a constantly changing flow of water. If you are washing more than one print, make sure they do not come into prolonged contact.

Testing washer efficiency

Leave a drop of hypo tester on the print border for 3 min. If it reacts, use the tone card to measure the amount of fixer present.

To test the efficiency of your washer, drop a little colored dye in the water when there are no prints present. All color should be gone within 4 min. To test if your prints are properly washed, you can buy "hypo testing solution" and a special tone card. If you place a drop of solution on a dry print, it forms a brownish stain in the presence of sodium thiosulfate (a chemical used in fixers).

Washing prints

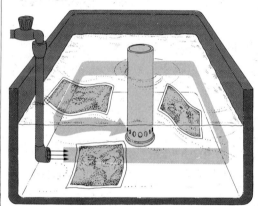

You can adapt your sink for use as a print washer by placing a perforated tube over the outlet (see above). The unit, right, washes resin-coated prints in about 4 min. If you add "hypo clearing agent" (see p. 58), wash time is further reduced.

Drying prints

Resin-coated prints
After washing, stand the prints in a drying rack (see above). Leave the rack at normal room temperature

and the prints will dry in about 30 min. If you prefer, you can use a domestic hair dryer to help speed up the drying process.

Fiber-based prints
After washing, squeegee off excess water. Because they tend to curl, place the damp prints in a roll of

photographic blotting paper (see above). Or dry prints between sheets of blotting paper under books. Leave overnight.

Glazing prints

To glaze a fiber-based print, squeegee it face down on the metal sheet of the glazer (called a "ferrotype plate"). Then insert the plate into the heated glazing unit. If you only want to dry your print, squeegee it face up on the plate. You do not have to glaze a resin-coated print—the glossy type dries with a naturally glazed finish.

1 *Squeegee each wet print face down on the ferrotype plate.*

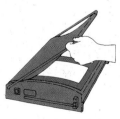

2 *Place the plate in the heated glazer and close the cloth lid.*

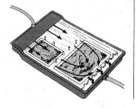

3 *After about 10 min the glazed prints will separate from the plate.*

Understanding paper grades

Black and white paper is available in different contrast grades, from low contrast or "soft" to contrasty or "hard". Hard papers produce a wider tonal range, and give fewer intermediate grays between full black and white than soft paper. Your choice of paper grade determines how the tonal range of your negative will be reproduced. If you have a low-contrast negative (one where the tonal range is limited, and the intermediate shades of gray seem to merge), a hard-grade paper will broaden out the tonal range, eliminating some of the grays. A soft-grade paper, on the other hand, will "tone down" an excessively contrasty negative by reducing the tonal range and reproducing a greater number of intermediate grays than a normal or hard-grade paper would.

Manufacturers number all paper grades – 0 being the softest, and up to 5 being the hardest. In general, grade 2 is considered "normal". Manufacturers have slightly different systems of grading. Kodak grade numbers, for example, give about half a grade higher contrast than the equivalent Ilford numbers. You will also find that you must increase exposure by about 50 per cent when you change from Kodak grade 3 to grade 4 or harder.

As an alternative to buying several individually graded papers, you can use one package of variable-contrast (or "multigrade") paper and a set of enlarging filters (see below). Changing filters alters the paper's contrast in half grades, approximately from normal grade 0 to 4. With a color head enlarger, you can use color printing filters instead.

Graded papers

The sections of prints (see right) show the effects of enlarging a normal-contrast negative on six different paper grades. (The numbers at the top represent the different grades.) Softer grades (lower numbers) produce most gray tones. Harder-grade papers coarsen the tonal differences, giving few grays between black and white.

Variable-contrast paper

The results on the right show the effects of using seven Ilford enlarging filters and variable-contrast paper. The numbers at the top represent filter numbers (not paper grades). The numbers at the bottom represent the color head filter settings you can use instead. If unfiltered, the paper prints as grade 2.

Filtering the light

Filter sets for variable-contrast paper are either optical quality gelatin filters that you position under the lens, or cheaper acetate filters, which you place in the lamphouse filter drawer. You also require a calculator disk for your particular brand of paper. This shows the exposure corrections required when you change filters.

You can buy a clamp-on filter holder or tape the gelatin enlarging filter under the lens.

Place the larger, acetate filters in the lamphouse filter drawer, where optical distortion will not matter.

Matching paper grade to negative

Low-contrast negative
Judge negative contrast by the range of tones between the darkest and lightest important parts of the image. The negative below looks flat, and has a very limited tonal range.

Normal-contrast negative
The negative shown below has a full range of tones, without appearing harsh. Compared with the other two negatives here, its image is of medium or normal contrast.

Contrasty negative
The negative below shows a more extreme difference between its lightest and darkest tones. Intermediate grays are fewer and clearly visible. The negative looks "bright" and is of harsh contrast.

Soft grade (1)

Normal grade (2)

Hard grade (3)

 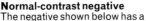

Printed on all three grades of paper, the low-contrast negative gives the best results on hard, grade 3 paper (bottom) – blacks are richer and whites cleaner.

The normal-contrast negative prints well on normal, grade 2 paper (center). You can see a full range of grays, well separated, between black and white.

For the contrasty negative, soft, grade 1 paper (top) produces the best print. The paper's range of gray tones counteracts the harshness of the negative.

Making a test strip

A contact sheet (see pp. 92-3) helps you to select your best pictures, but enlargement really brings them to life. The size increase brings out image detail and the relative sharpness of the different elements within the picture, revealing perspective and giving a three-dimensional effect.

For each printing, the best exposure time depends on the density of the particular negative, the size of enlargement, lens aperture, enlarger bulb wattage, and the paper type and grade. You can determine exposure with an exposure analyzer (see p. 128), or by overprinting a gray scale (see facing page). The best method, though, is to make a test strip (similar to the one described for a contact sheet, see pp. 92-3). Position the strip so that each zone will contain dark and light image areas.

Exposing equipment

Masking frame Use the masking frame to hold the paper flat and in position throughout the exposure. Do not cover it with glass, as this often adds marks.
Paper Choose the size, surface, and grade of paper to suit your particular negative.

Equipment checklist
1 Negatives
2 Enlarger
3 Timer
4 Masking frame
5 Bromide paper
6 Safelight
7 Focus magnifier
8 Canned compressed air
9 Opaque cardboard
10 Magnifying glass
You will also require all the processing equipment used for making a contact sheet (see p. 92).

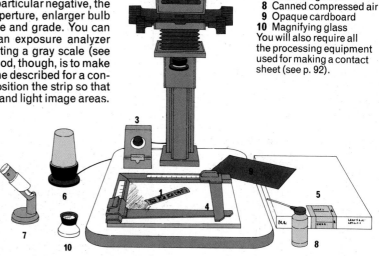

Preparing to expose

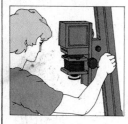

1 Select the pictures you want from your contact sheet and mark them up for cropping. Note negative numbers.

2 Mix and set out your processing solutions in the same way as for contact printing (see p. 93).

3 Adjust the empty masking frame to accommodate your size of paper. Allow for a suitable border all the way round.

4 Pick out the negative you want and blow away any dust on both surfaces. Place it in the carrier, emulsion side down.

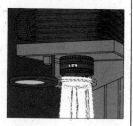

5 Change to darkroom safelighting. Switch on the enlarger at full aperture. Adjust the height until the image size is correct.

6 Focus the image on the frame base. Adjust the frame to compose the best picture. Alter head height if necessary and refocus.

7 Stop down the lens to about f5.6. If the negative is very thin and likely to print dark, stop down the lens to f8 or f11.

8 Swing the red filter over the lens and switch off the enlarger. You are now ready to make a test strip (see facing page).

Exposing the test strip

1 *Choose the paper grade that best suits your negative (see p. 97). Under safelight, fold and tear a sheet of paper in two.*

2 *With the red filter still in place, turn on and position the paper. Swing back the filter and give the paper a 5-sec exposure.*

3 *Cover one-third of the paper and give another 5-sec exposure. Cover two-thirds of the paper and give it 10 sec more.*

4 *Remove your exposed test strip and process it as shown on p. 93. When it is sufficiently fixed, examine it in white light.*

Assessing the test strip

The test strip on the left shows three exposures: 5 sec (bottom), 10 sec (middle), and 20 sec (top). The test exposures should range from under- to overexposure. If your test is too light overall, and does not indicate overexposure, open up the enlarger lens one stop. This will effectively double each of your exposure times. If your test is too dark, close down the lens one stop to halve the exposures.
5 sec bottom zone Highlight detail appears bleached, and even the deepest shadows are only dark gray.
10 sec middle zone This is the nearest correct exposure, but could be a little darker (see p. 100).
20 sec top zone Highlights are gray and dark mid-tones and shadows merge into black.

Projection print scale

The projection print scale (see right) produces 10 exposure segments through 10 different densities of black printed on a piece of film. To use the scale, place it over a piece of paper and expose your negative for 60 sec. After processing the test print (see far right), you can read off the required exposure time (in seconds) for the result you prefer, from the numbers on each segment.

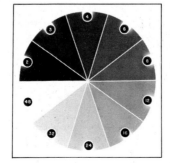 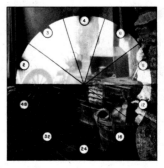

Making an enlargement

Your test strip (see pp. 98-9) will give you a good idea of the correct exposure for making the enlargement, but you will discover far more from the first full print. Unevenness, marks, wrong contrast grade, and poor framing are far more obvious on an enlargement. The print below shows a wide range of defects, and the print corrections at the foot of the page show how you can put them right to produce the version on the facing page. (See pp. 104-5 for further print correction possibilities.) In general, a good print should show a rich range of tones between deep black and clean white. However, much depends on the subject and your interpretation (see pp. 106-9).

Exposing the print

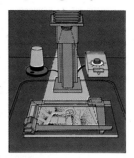

Switch back to safe-lighting and place a full sheet of paper under the masking frame. Give the paper the exposure judged to be the best from your test strip (12 sec in this case – see pp. 98-9). Make sure you develop the exposed print for exactly the same time and at the same temperature as your test. Any variation in processing will merely confuse your exposure time decisions.

Picture faults

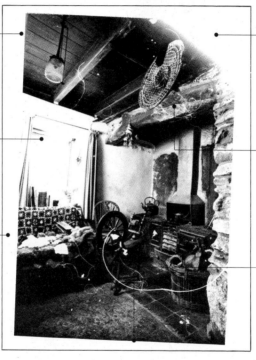

Unwanted edge detail
This element in the picture is distracting and best removed. You can crop it off by increasing the degree of enlargement or by shifting the edges of the masking frame inward slightly.

Uneven density
Although exposure time was correct for most of the print, you could improve these areas with slightly more exposure, and the darker areas with slightly less.

Unequal white border
The width of the border here is unequal, and the picture is slightly crooked on the paper.

Obstruction
This vignetted corner does not appear on the negative, so something has obstructed the light path. The soft edges suggest that the obstruction was some distance from the paper–it was probably the red lens filter.

Hairs and debris
White shapes with sharp outlines are generally caused by dirt on the negative or on the glass surfaces of the negative carrier (if you use that type). Occasionally, hairs may fall on the paper surface itself.

Flare from rebate
This darkened area has been caused by light passing through the clear film rebate. It indicates that you did not place the negative correctly in the carrier–it was not masked off on all four edges.

Correcting the first print

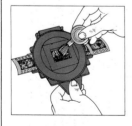 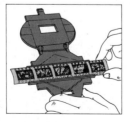 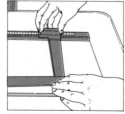

Hairs and debris
Remove the negative carrier. Hold it under the light beam and dust off both film surfaces.

Flare from rebate
Re-align the negative accurately in the carrier so that all four negative rebates are masked off.

Borders and edge detail
Alter the paper stops to equalize the print borders. Move the frame edges to crop out the detail.

Density and obstruction
Now reprint, making sure the red filter is out of the way. Shade the print from 10-14 sec (see pp. 104-5).

Cropping the image

One of the main advantages of printing your own pictures is that you can decide which part of the negative to use. It might be that you made a mistake when shooting the picture, or you might simply decide to alter the relationship of elements within the composition, or the proportions of the image itself (see below and facing page).

To preview the effect of different croppings, you can make two pieces of L-shaped cardboard. Place them over an image on your contact sheet and then overlap and shift them to form frames of different proportions. When you come to make your enlargement, adjust your masking frame in the same way.

Many sizes of paper (8 x 10 ins/20 x 25 cm, for example) are squarer than 35 mm negatives, but more rectangular than 2¼ x 2¼ ins (6 x 6 cm) negatives (right). Either leave a wide border at the bottom of the print (and include all the negative), or crop out part of the negative (and fill the paper).

5 x 4 ins/12.5 x 10 cm (also 8 x 10 ins/20 x 25 cm)

2¼ ins sq/6 cm sq

35 mm

Draw a diagonal line across a print to find how to crop negatives in order to fill the paper.

Strengthening composition

Enlarging only part of the image (below) repositions the figure at the classical "intersection of thirds" (right).

Implying the action

By repositioning the masking frame, you can often place the image of a moving subject near one side of the frame or the other. The dog (left) seems to be running into the picture, starting the action. In the print below he appears to be leaving, implying the action is over.

Relating elements

Use cropping to relate certain picture elements more strongly to others. The full image (below) was cropped (right) to relate boat to shore. In the crop below, the boat is dominated by the falls.

Changing the horizon

In most landscape pictures the position of the horizon determines the proportion of sky to land. Avoid a central horizon–it tends to have a static effect. If you can, crop your image so that the horizon is higher or lower than the center. A high horizon emphasizes the foreground –distant objects seem firmly set within their environment. A low horizon emphasizes sky and space and gives a more open feeling.

A print from the bottom half of the negative will make the land the dominant feature, and lead the eye up to the main element.

Moving the horizon to the lower part of the picture changes the emphasis completely–sky now dominates and the effect is more open.

Local density and contrast control

You can improve most pictures during enlargement by lightening or darkening selected areas. The basic principle is common to black and white and color negative/positive printing: to lighten an area, you shield it from light during part of the exposure (shading, or "dodging"); to darken it, you give extra exposure after the main exposure (printing in, or "burning in"). Shading is a general term: it refers to shielding part of an image, whereas "dodging" refers to covering a small area in a negative. Tools you can use include opaque cardboard shapes, your hands, or even a flashlight to "fog" in certain areas. If you have an area too small or complicated to control by shading or dodging, you can use a fixed mask (see p. 157), or chemically reduce the print (see pp. 172-4).

Dodger shapes

You can buy kits of print dodgers in a variety of shapes and sizes, or make them yourself for very little expense. Use opaque cardboard taped to stiff, thin wire (see above).

Basic shading methods

You can shade in various ways when exposing the print to hold light away from areas that are printing too dark. From a test strip you can calculate the degree of shading time required. Practice shading without any paper at first. In this way you can judge which shape will fill the area best.

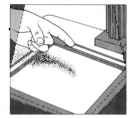

Fingers *If the area to be shaded is near one edge, you can cast a shadow with your fingers.*

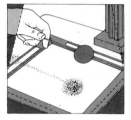

Dodger *Use a dodger for an isolated area. Keep the wire continually moving to avoid a line shadow.*

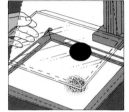

Shape on glass *Using opaque dye, you can paint any shape you require on a piece of clean, thin glass.*

Shading an accurate shape

The window in the print, right, is a precise shape, so you must tailor the cardboard to the outline (see below). When printing in this area, hold the cardboard still to avoid darkening areas around the window. The print, far right, shows the result of doubling window area exposure.

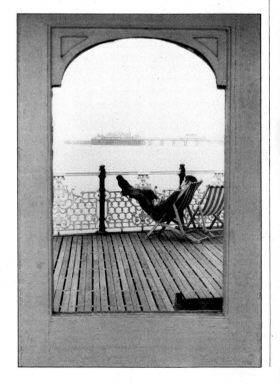

1 *Hold opaque cardboard a few inches above the masking frame. Turn the enlarger on and trace the outline of the window.*

2 *Cut the window area out. Expose the main print, then print in window detail, holding the card at its original height.*

Using your hands

For shading some areas and printing in others, there is nothing quite so versatile as your own hands. This does require practice, as shown on the right. Use some form of audio timer, or learn to count regularly, so you can concentrate on hand and eye co-ordination. For best results, hold your hands 2-3 ins (6-7 cm) below the lens.

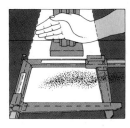

1 *Hold one hand edge-ways to form a narrow shading shape. Curve your palm for a squarer shape.*

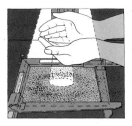

2 *To print in a small area, cup both your hands to-gether, leaving a small gap at the bottom.*

3 *After printing in, raise one hand to obscure the light, and switch off the enlarger with the other.*

Using a flashlight

You cannot always re-move or tone down ex-cessively contrasty areas (right) by using the burning-in techniques described above. The modified version (far right) shows how you can use a flashlight (see below) to fog in a distracting high-light area in the back-ground.

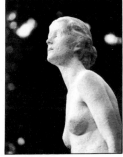

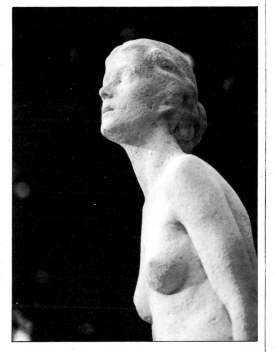

1 *Make a tapering cone of stiff black cardboard, and tape it over the head of a small flashlight.*

2 *During printing, use the modified flashlight close to the paper to restrict the light beam.*

Using variable-contrast paper

With variable-contrast paper you can change the contrast grade of different parts of the same print (see p. 96). This type of paper is very useful when, for example, the majority of a print requires normal-grade paper, except for a small area of under-exposed shadow, which requires a hard-grade printing paper.

1 *Filter your enlarger to the grade of contrast required for the majority of the image (see p. 96). During exposure, shade out the shadow area.*

2 *Switch off the enlarger. Change filters, or dial in the correct color filters for the hard-grade response. Do not move the enlarger or frame.*

3 *Now print in the area you shaded in 1. You may have to adjust the ex-posure time – check the paper manufacturer's filter calculator.*

Objective printing

If you photograph your subject in very contrasty lighting, you will have to shade or print in local areas of the negative afterward. Careful camera exposure may give you a negative which retains just enough information in both highlights and shadows, but this is impossible to put on paper at any one printing exposure. Very soft-grade paper usually has a gray, flattening effect on shadow details, because these are quite low contrast. Often normal or hard paper will give you a better result, as long as you shade shadows and burn in highlight areas. The pictures on these pages are worked examples of this procedure, which you can use to help re-create the scene that you saw when you took your photograph.

Equipment checklist
1 Negatives
2 Enlarger
3 Timer
4 Masking frame
5 Bromide paper
6 Safelight
7 Focus magnifier
8 Canned compressed air
9 Opaque cardboard
10 Scissors
11 Scalpel
12 Pencil

Printing procedure

For any excessively contrasty image you will have to make two test prints–one for shadow detail only, the other for highlight only. Now plan your exposures, far right. Decide where you must shade, and which areas you must print in afterward. For the final print, facing page, the photographer decided on 15 sec general exposure, 4-5 sec shading for shadows, and 20 sec extra exposure for highlights.

10-sec exposure *The photographer printed to show the silhouetted figures, above. Building detail is flared by light.*

25-sec exposure *This exposure, above right, recorded detail on the buildings only.*

Printing shading plan *Make a rough sketch of the areas that you plan to shade or dodge. Keep this near your masking frame for quick reference.*

Exposing the final print

Once you decide the areas for shading or printing in, using your printing plan, you must work out the most convenient way to expose them. If several areas require lightening separately, your total shading time cannot be longer than the overall exposure you give. Count seconds, or use an audio timer to time periods of shading during the main exposure. You may have to prepare special, shaped dodgers or cut holes in cardboard (see p. 104). You should practice all shading and printing in before exposing on your empty masking frame. Leave your test prints face up in the fixer, to remind you of the areas requiring special attention. Use the step-by-step routine, right, as a guide to producing your own prints.

1 *Make sure that you can form the correct shapes—practice the whole sequence first without paper in the frame.*

2 *Set your enlarger timer for the overall exposure (15 sec). Under safelights, position the paper under the masking frame.*

3 *Begin the exposure—start dodging the first area that requires shading immediately, timing this for 4 sec.*

4 *Move your dodger to the second and then the third area (time each area for 4 sec).*

5 *When the timer switches off the enlarger, mask off correctly exposed areas. Switch enlarger on.*

6 *Burn in areas where you want extra density. Cover the lens and switch off the enlarger.*

Subjective printing

You can use control of local density when printing not only to produce a picture that is an accurate record of the original scene (see pp. 106-7), but also to make a print which is a strictly subjective interpretation. By the use of careful shading and printing in you can emphasize one particular aspect of a picture and subdue others (see the worked example below and facing page). As you become more familiar with these types of printing controls, you may find that you rarely make an absolutely straight print from any negative.

Straight print

The examples on these pages illustrate some of the techniques you can use when printing—even a favorite negative may benefit from a different approach. The straight print on the right (20-sec overall exposure) shows the background competing with the horse and cart. To counter this, the photographer decided to subdue the background, so that the horse and cart stand out (see far right).

Shading plan

Before drawing up a shading plan, study your first print carefully to see where you can make changes. In this case, the photographer decided to print the horse and cart lighter (16 sec instead of 20 sec), and give the surroundings a relatively brief exposure (8 sec). To improve small areas of detail, he also decided to shade the front of the horse and increase exposure for the milk cans.

Printing procedure

To obtain the type of result, above right, you can either give a short exposure and burn in, or give a long exposure and shade. In this example, the photographer gave the horse and cart a 16-sec exposure, but shaded the surrounding areas for half that time (see right). He would have achieved the same result by giving an overall 8 sec exposure and then burning in for 8 sec.

Use your hands to shade large areas. The background is subdued and detail in the horse improved by a 2 sec shade, right, but the cans are weak.

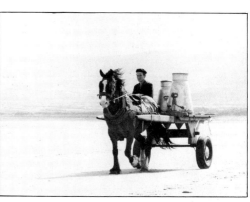

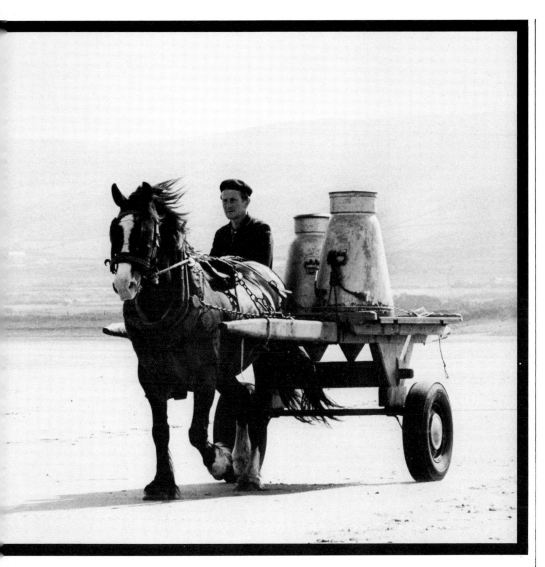

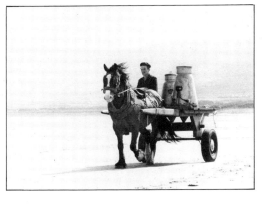

To burn in a precise area, make a hole in a piece of opaque cardboard. Here, the photographer gave the cans 4 sec extra exposure (see right).

To improve your composition, you can print a black border round your print (see above). This often helps a light-toned print.

Print finishing

No matter how careful you are during printing and processing, some of your prints may have small defects, such as dust specks or hair marks (see the corrected and uncorrected versions below). Provided these marks are small, you can easily retouch them as shown below. (More elaborate techniques are shown on pp. 280 and 284.) Any print you want to display will be improved by mounting on thick board. The neatest method is to use a special tissue and a dry-mounting press (see right). Make sure the press is suitable for resin-coated papers; at high temperatures the plastic surface may melt. You can also use a self-adhesive sheet between the print and mount. Spray glues, mounting cement, and rubber cement are all suitable alternatives. But avoid household adhesives.

Dry mounting

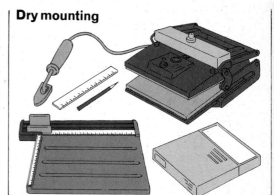

Simple retouching

To remove white spots, use a sable brush (size 0 or 1), a tube of black water color or retouching dye, and a plastic palette or saucer (see left). You can spot most matte-surface papers using a soft lead pencil. Use white pigment or the point of a scalpel blade to remove black specks (see below).

To dry mount a print using heat-sensitive tissue, you will require most of the items illustrated above. The press itself provides even pressure and, more importantly, an accurately controlled temperature. For resin-coated prints, set the heat control between 180°F and 210°F (82°C and 99°C). (You can mount small prints using a domestic iron at its lowest setting.) To fix the tissue firmly to the back of the print you must use an electric tacking iron. You will also require a print trimmer, dry-mounting tissues, a ruler (to help you position the print squarely on the mounting board), and a large piece of thin cardboard (to cover print during heating).

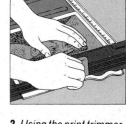

1 Cover the back of your untrimmed print with an oversized sheet of tissue. Fix the tissue in place by touching its center with the tacking iron.

2 Using the print trimmer, carefully cut through the print borders and tissue on all four sides. Leave only the picture area that you want to mount.

White spots Stipple in the spots with the tip of an almost dry brush until they disappear.

Black specks Use white pigment or scratch them from the surface of fiber-based paper.

3 Place the trimmed print and tissue on the mounting board, image upward. Lift each corner of the print and tack the tissue directly to the board.

4 Place pre-warmed protective cardboard over the print, place it in the press, and apply pressure for 30 sec. With a domestic iron, work from center to edges.

Color printing

Introduction

This section deals with all the basic aspects of color printing, whether you intend to work from color negatives or color slides. It starts by looking at the very basics of color printing – the principles of mixing and filtering colored light. These are important points to remember when you are checking the results of test strips or deciding from the results of one print how to improve the next. How to make a color contact sheet from a set of color negatives is next shown, together with the associated processing steps. This leads on to making an enlargement and the various controls you can exercise over color balance using combinations of filters of different hues and strengths.

The next major aspect dealt with in this section concerns contact printing and enlarging directly from color transparencies. This positive/positive printing (making a positive print from a positive original), like negative/positive printing (making a positive print from a negative original), is best carried out with a color head enlarger using the "subtractive" principle of filtering – but you can also work "additively" using three differently filtered exposures on the same piece of printing paper. This section also explains some of the electronic and other aids available to help you predict the correct filtration and density for a particular negative or positive. These aids are of particular value to the small percentage of the population suffering from some form of color vision deficiency. About 10 per cent of the male population, and 0.5 per cent of the female population, have an uneven response to colors – usually this deficiency is in the red/green area of the spectrum.

Why print in color

One obvious but important reason for printing in color instead of in black and white is the added realism it gives your pictures. It also gives you a major extra dimension to your work. By having control over color you can change the mood and emphasis. A scene can be "warmed" or "cooled" to suit its content or your particular interpretation. You can also render a straight scene totally impossible by using outlandish colors. None of these variations is normally possible using a commercial processing and printing laboratory, which has machines geared to produce objective results from "average" subjects.

From a practical point of view, color printing differs from black and white in three main ways. First, materials, especially chemicals, are more expensive. Second, paper processing takes place at higher solution temperatures and in light-tight drums and, therefore, you can use normal room lighting. Third, assessment of results takes longer at each stage of testing because you must make decisions concerning the accuracy of image color as well as density.

It is quite possible to process color prints in open trays. This way you require no more processing equipment than for black and white. But the problem is that more chemicals must be made up to give sufficient depth of solution in a tray as compared to a rotating drum. The first stages of color processing must be carried out in complete darkness – and moving the paper from tray to tray with no light may well lead to contamination of the exposed chemicals. The larger surface area of solution in trays also makes accurate maintenance of high temperatures practically impossible. A final point against open tray processing of color paper is that some chemicals quickly oxidize in contact with air. It is therefore best to buy even the simplest daylight processing drum for paper.

You must expect to allow a longer session for color printing than you would for black and white. Until you are very experienced, it will probably take almost one hour to print and process one unfamiliar negative – making at least two test strips before the final enlargement. Do not overlook the importance of keeping detailed and complete notes every time you print. Record both exposures and filtration settings for every contact sheet, test strip, and final print, both as a reminder at each stage and for future reference when reprinting the same or similar negatives. These notes will save you time and paper by cutting down on guess work concerning the filtration to be used.

There is no real necessity to have tried black and white printing before tackling color work. You can learn your contact printing and enlarging skills on color paper, and later adapt this to black and white.

Whether you start to work from negatives or slides is mostly a personal decision. Negative/positive printing still tends to offer finer control, but working from a positive slide makes it easier for you to preview results before you start – and you have the added advantage of being able to compare your print against the true colors of the original, not the complementary colors of a negative. With both forms of original, it is quickest and easiest to print by subtractive filtration – inserting yellow, magenta, and cyan filters into the light beam – instead of the older, triple-exposure additive system. (The only exception to this is on some modern programmed enlargers, which automatically give the sequence of exposures, changing filters and measuring the times required for each.)

Materials and equipment

If you can possibly afford it, buy an enlarger type that uses some form of dial-in filtration color head. This gives the greatest degree of flexibility and is much quicker to adjust – especially in the dark. Most color heads allow dial intensity adjustments of all three complementary colors. The types that only have a provision for adjusting yellow and magenta are adequate for negative/positive printing, but you may then have to use separate cyan filters when printing slides on positive/positive paper. The actual filters you require for "average negatives" vary a great deal, according to the brand of film you use, the enlarger lamp, paper batch,

and, of course, your personal assessment of the results. You will find filtration values quoted alongside most of the pictures in this section merely as a comparative guide to the changes you can expect when the same image is given different exposure or filtration settings. In fact, as color materials are improved each time, the papers become more closely "keyed" to color film characteristics. The result is that less and less filtration is required. Paper manufacture is becoming more consistent too, requiring few filter adjustments when changing from one batch of paper to another.

Another important aid to the color worker is the introduction of very compact electronic analyzers. These units "memorize" the exposure time and filtration found to be correct for readings made from one negative and then relate these to readings made from the next negative.

As with black and white printing, you can keep costs down to a minimum by economizing in directions that will not lead to poor results. Paper is cheaper if bought 100 sheets at a time. But, unlike black and white printing paper, you must keep color paper sealed and refrigerated when not in use. Chemical kits, which can make up over 50 per cent of the running costs of a home darkroom, are now available from a wide range of manufacturers, and in a wide range of prices. All of them are, however, cheaper if bought in the larger volume form, provided you can use all the component chemicals within their recommended life span.

You can also save money by making tests for print density and color in the most efficient way. Some form of flap system, which accurately covers and uncovers small areas of paper in the dark, will make the maximum use of every square inch of emulsion. A paper safe is a sensible investment also, both in terms of convenience and economy. If you keep your color paper in the packaging in which it is supplied, there is always the possibility that you may not seal it properly before turning on white light, and fog all the sheets. The paper safe will only deliver one sheet at a time, storing the rest in a light-tight compartment.

From the manipulations sections later in the book, you will see how the ability to print in color extends almost every technique into new and potentially interesting areas. If you want to exploit fully your photography and also use the newest advances in equipment and materials now coming on to the market, it is no longer enough to work in black and white alone.

Historical background

Before the 1940s "natural" color prints (as opposed to hand colored black and white prints) called for an elaborate system of separation negatives. James Clerk Maxwell had demonstrated in 1861 that three negatives of the same subject, taken through blue, green, and red filters and made into black and white lantern slides, formed a full color image when projected by three similarly filtered lanterns arranged so that the images overlapped on a screen. To make color prints, the three separation negatives had to be turned into positive images in yellow, magenta, and cyan, and then stacked in register on sensitized paper.

It was one thing to know the theory, however, and another to make it work in practice. For an acceptable color print, even in the 1930s, you had to take your separations one at a time of a still life subject, or use an expensive camera (see below) capable of exposing all three pictures at the same time. Plates were essential because each

One-shot camera
The 1930 camera (above) exposed three black and white separation negatives simultaneously. It used semi-silvered mirrors behind the lens and a different filter in front of each plate holder.

filtered negative required a slightly different development time. Sheet film could not be used because the images tended to stretch slightly.

The next stage of print production was the most skilled and complicated, and usually involved making three identical-size enlargements. The image part of each print was then made to absorb dye of the appropriate color – usually by adapting one of the old monochrome processes (see pp. 316-17). Each dye image had then to be transferred by pressing it in turn, and in register, on a sheet of paper, building up a full color image. One print took several days of skilled work. Color prints were, therefore, expensive rarities, made mostly for advertising, fashion, and portraiture.

All this changed when triple emulsion film and color development able to form a different dye image in each layer were introduced in the late 1930s, initially for slides. During World War II both Agfa and Kodak introduced negative/positive color materials, at first for laboratory processing only, then, during the 1950s, for user processing too. It was not until the 1970s that improved quality, simplified shortened processing, and lower-cost equipment systems made color printing a practical proposition for amateurs. Similarly, silver dye-bleach materials for printing from slides were improved in performance. What had been a five-solution, 47-minute professional print-processing routine in 1963 had shrunk to a convenient three solutions, taking 12 minutes to process at home by 1975 (Ciba).

The invention of daylight print processing drums, low-cost temperature-control units, and variable filtration systems are all products of the 1970s. At the same time, highly sophisticated electronic printers installed by laboratories have lowered the cost and improved the quality of color developing and printing. Increasing demand has greatly reduced the price gap between black and white and color papers. As the do-it-yourself color movement gains in momentum, improved equipment and improved materials are appearing every year.

Basic principles of light

The visible spectrum comprises three broad bands of radiation–blue, green, and red, the primary colors of light. Remove one primary, and you are left with its complementary (a mixture of the other two primary colors). This primary/complementary relationship (see p.54) is fundamental to color printing, and you should be familiar with it: blue/yellow; green/magenta; red/cyan. You must also understand how color filters affect light passing through them–each absorbs ("subtracts") light of all colors except its own. A primary colored filter passes one primary only, stopping the other two.

A complementary colored filter (yellow, for example) subtracts light of its primary color (blue), but allows the other two (red+green=yellow) to pass.

The three silver halide layers present in all color materials (see pp. 54-5) each respond to one primary color of light only. For a good print, you must balance the responses of each layer. With primary filters you make three exposures, one with each primary color of light–*adding* the colors. But with complementary filters, you can make one exposure–because each filter affects the response of one layer, leaving the other two unaffected.

The spectrum of white light

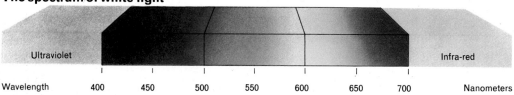

Wavelength	400	450	500	550	600	650	700	Nanometers

"White" light in fact comprises a mixture of wavelengths, measured in "nanometers". When droplets of water (as in a rainbow) refract white light, these wavelengths are separated out, and revealed as the colors of the spectrum. Because of the limitations of our eyes, we can only see colors with wavelengths of between 400 and 700 nanometers.

Ultraviolet (UV), with a wavelength below 400 nanometers, and infra-red (IR), with a wavelength above 700 nanometers, are invisible to the naked eye.

Additive colors

You can form white light by adding together the three primary colors. If you project red, green, and blue light on a screen, where they all overlap you will get white, as shown above. Where blue is missing, you will get its complementary (yellow). Similarly, where red is absent you will get cyan, and where green is absent you will get magenta. The symbolic star diagram, above, shows each complementary opposite its primary.

Subtractive filtration

The filters that you will use most often in color printing are the three complementaries. A yellow filter will control blue–it subtracts blue from the white enlarger light, but allows red and green (= yellow) to pass unaffected. Cyan will subtract red only, and magenta will subtract green. Wherever two complementary-colored filters overlap, a primary color appears, as shown above. If you use yellow and cyan filters together, they will subtract both blue and red, so only green will pass through. Where all three filters overlap, you will remove equal amounts of primary colors, so the area will look gray or black (depending on filter strength).

Basic principles of filtering

The essence of color printing is the use of light filters to control the overall balance of color, and of exposure time to determine the lightness or darkness of your print. Most filtering methods work on the subtractive principle of light (see facing page): you give one exposure, using combinations of different strength yellow, magenta, and cyan filters to control color balance. Or, you can work additively giving three separate exposures, each through different filters (see below). As some of your paper's emulsion layers are sensitive to ultraviolet and infra-red radiation, there are two colorless filters that you should use at all times to counter any resulting color distortion. One selectively absorbs UV, and the other IR radiation.

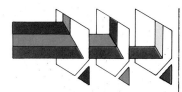

All the diagrams on this page refer to negative/positive paper, which records blue, green, and red light in yellow, magenta, and cyan dyes.

Using subtractive filters

It is unlikely that you can ever print a color negative without using some form of filtration. Subject conditions, film type, enlarger lamp, and paper batch all vary so much that adjustment of color balance is essential. You control print color in two ways. Firstly, your choice of filter color determines which paper layer is affected (right). Secondly, its strength controls the degree of adjustment made (see below).

Unfiltered light
This affects all paper layers equally, and produces a brownish-gray result.

Magenta filter
Add this to subtract green light. The green-sensitive layer forms less magenta, so the print looks greener.

Cyan filter
Add this as well to subtract red. Less cyan forms in the red-sensitive layer, making the print yellower.

Filter strength

10Y 20Y 40Y

Whichever filter color you use, its strength determines whether your changes to color balance are small or large (see above). Density numbers indicate filter strength – 20Y filters, for example, subtract twice as much blue light as 10Y.

Additive filtration

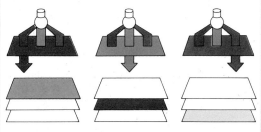

To use this method you must make separate exposures through red, green, and blue primary filters. This will expose the red-sensitive layer to produce cyan, the green-sensitive layer to produce magenta, and the blue-sensitive layer to produce yellow dye, respectively (see above).

Adjusting filtration

To adjust the colors of your prints, you must either stack filters in a drawer in the enlarger lamphouse, or dial up filter values on a color head (see pp. 38-9). If your image looks too yellow when it is filtered 40Y, for example, add 05Y to make it slightly bluer (or 20Y for a larger change). If your result is too red, add equal amounts of yellow and magenta or remove cyan from your filters. If, when adjusting filtration, you find you are using all three filters, you are, to a degree, subtracting all the colors and producing a "neutral density" effect. It is much better if you subtract the lowest density value from all three filter settings (thereby zeroing one, see right). In this way you will achieve the same color balance, with brighter illumination, and shorter exposure time.

Filtering 10Y 20M 05C on a color head or in a filter drawer introduces five units of unnecessary "neutral density."

If you subtract the lowest value present (05) from all filters, you will simplify settings to 05Y 15M.

Making a neg/pos contact sheet

It is important to make contact prints from every color film you process. File each sheet with its negatives for reference–used with your notebook it will give you a guide to filtration and exposure when you make enlarged prints. As you will be working in total darkness, use a contact frame to position the negatives and paper (emulsion to emulsion) under the enlarger. Make two tests: first to determine the best exposure time, then to find the best color filtration. Process the print in a light-tight drum, in normal lighting, see facing page. Processing normally takes about 10 minutes. You must dry the print before you can judge color and density. Once you have obtained the correct filtration you may have to make further tests to adjust exposure.

Equipment checklist
1 Color enlarger
2 Contact printing frame
3 Shading card
4 Negative/positive color paper in safe
5 Notebook and pencil
6 Enlarger timer
7 Voltage stabilizer
8 Pre-soak calculator disk
9 Processing kit
10 Processing timer
11 Print processing drum
12 Measuring graduates
13 Storage bottles
14 Tempering unit/bowl
15 Thermometer
16 Gloves
17 Mixing rod
18 Print washing tray

Exposing equipment

You will require the items right to expose prints by subtractive filtration.
Enlarger This must have a color head or a filter drawer (see p. 38).
Contact frame This is essential when working in total darkness, and it must have grooves to position the negatives.
Exposure timer Use this to preset times.
Paper Keep in a safe with automatic closure.

Processing equipment

Daylight processing drum Use one with some means of controlling temperature.
Containers and graduates You require these for each solution in your kit. You also require a washing tray, a thermometer, timer, and gloves.

Print drum

The daylight drum holds one or more sheets of exposed paper, with the sensitive surface curved inward. Most lids are designed so that, when the drum is vertical, they retain the small quantity of chemical that you pour in. The chemical only reaches the paper surface when you tip the drum horizontally and rotate it, see right.

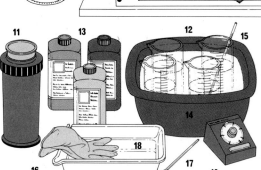

Vertical position Horizontal position

Choosing a kit

Your kit must match your negative/positive paper. You should process type-B-chemistry papers in the correct Agfa kit. You can process type-A-chemistry papers in a range of kits (see p. 59). These vary in the number of solutions they use, their working temperature, convenience, and cost.

Temperature control

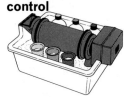

Use a tempering bath, above, or a pre-soaking routine, see facing page, to standardize temperature.

Exposing a test strip

Make sure that your enlarger illuminates the whole contact frame evenly. Check your paper packet as a guide to filtration. Your notebook is important – enter filter and exposure data for each test, and write a reference number on a back corner of your test strip, after processing. This will be a guide when printing future contacts from the same brand of negatives.

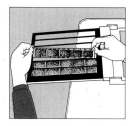

1 Clean the contact frame glass. Place the negatives in the grooves, shiny side to the glass. Position the frame under the enlarger for even illumination.

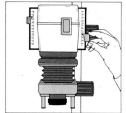

2 Select aperture, time and filter settings. Set the lens at f11, the timer 5 sec, and try a 70Y 50M filtration, or as directed on paper packet.

3 In darkness, place paper in the frame, under negatives. Use cardboard to expose steps of 5, 10, and 20 sec. Remove the paper and load it into your drum.

Processing the print

Put your exposed paper in the drum, emulsion inward, and attach the lid; now all processing steps can take place in normal light. Put on gloves and dilute into graduates the correct quantity of each solution for one use, in your drum size. Amounts are small as the drum will constantly rotate to keep the solution flowing over the paper surface, see right. Start draining the drum a few sec (see kit) before the end of each stage, and discard each solution after one use. Consistency is vital in changes in temperature, timing or agitation may give print-to-print differences of color density.

Agitation

You must use consistent drum agitation for all processing stages. You can roll a simple drum by hand to and fro over a bench top, see right, or you can leave it on a motor-driven cradle. More expensive motor-driven drums sit in a tempering water bath, see facing page.

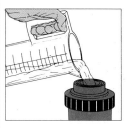

1 Fill the loaded drum with water to bring it to working temperature. A pre-soak disk will show you which temperature you should use.

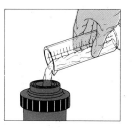

2 After 1 min pour pre-soak water into a pitcher. Hold the drum upright and pour in developer, which must be ready at the correct temperature.

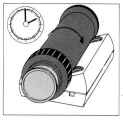

3 Start your timer. Place drum horizontally, and keep it rolling steadily – either by hand (see above right) or on a motor-driven cradle, as above.

4 A few sec (see kit) before the end of develop-ment, drain developer. If the kit has stop-bath, add this, roll for required time, and discard.

5 Pour in bleach/fix. Time and roll the drum, then discard the solution. Refill with pre-soak rinse from the pitcher.

6 Open the drum, care-fully remove the print and wash it in an open tray. Thoroughly wash and dry drum and graduates.

7 Take your processed print out of the tray, hold it in a dry pair of print tongs, and gently sponge off any surplus water.

8 A domestic hair dryer will speed up print drying. When your print is dry you can judge density and color, see p. 118.

Assessing exposure

Wait until your test strip is completely dry before you try to assess exposure. If you cannot examine it in natural daylight, use a 5000K light source. Your first test strip is important, as it will tell you which exposure time produces the best print density. The test strip below illustrates this clearly.

The underexposed zone (5-sec exposure) shows pale shadows and bleached highlights. The overexposed zone (20-sec exposure) indicates heavy, dense shadow areas and veiled highlights. The best compromise exposure for the majority of images falls within the middle zone (10-sec exposure).

Assessing filtration

Use your first test strip as a guide to filtration as well as exposure. You cannot correct color balance for each individual image on one sheet of paper, but you can give the best overall filtration. In this case, the appearance of the first test (70Y 50M) is too green. For the test strip below, the filtration was changed to 70Y 40M,

judged from the ring-around (see facing page) and the exposure zones to 7, 9, and 11 sec. Overall density now appears best at 7 sec, but the result is slightly too yellow.

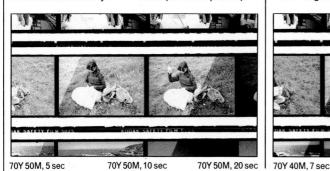

70Y 50M, 5 sec 70Y 50M, 10 sec 70Y 50M, 20 sec

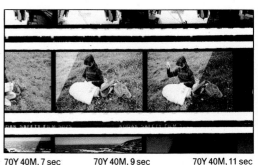

70Y 40M, 7 sec 70Y 40M, 9 sec 70Y 40M, 11 sec

The final contact sheet

Use the information gained from your second test strip to set filtration and exposure for the final contact sheet. To counter the yellow cast produced by 70Y 40M, the contact sheet above was filtered 80Y 40M and given an overall exposure of 7 sec. If your negatives contain a mixture of images shot under tungsten light and daylight, you will not be able to give them all the same filtration.

Making a neg/pos ring-around

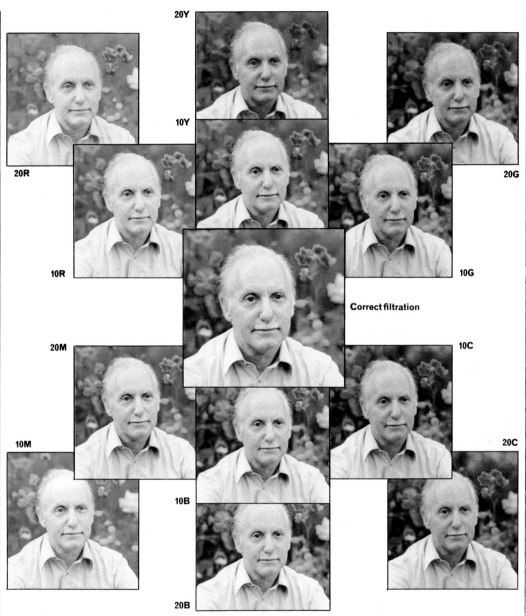

20Y

10Y

20R

20G

10R

10G

Correct filtration

20M

10C

10M

20C

10B

20B

A series of pictures, like the one above, is an invaluable visual aid for identifying filtration errors. It consists of a series of prints from one color negative, which show varying degrees of incorrect color. You compare this sequence with a test print from another negative to help judge the direction and amount of filter correction you require. In the ring-around above, the colors are correct in the center print; the others are biased toward yellow, magenta, cyan, blue, green, and red by increasing amounts. Each print in the ring-around is shown with a filter number. This represents the amount of filtration you must subtract from your filter head settings to correct that amount of error. (If you cannot subtract any further, you will have to add complementary-colored filters of equivalent strength.) If you want to subtract a primary-colored cast (10R, for example), you must remove its two complementary filters (10Y and 10M). You can detect color cast most easily in near-neutral areas, and in mid-tones or skin tones. To make a ring-around, choose an accurately exposed negative that is not excessively contrasty. Mount your ring-around prints on a board, and display them in your darkroom in a convenient position.

Simple filtration and exposure aids

You can obtain several simple aids to assist you to work out correct filtration and exposure for subtractive negative/positive color printing. Viewing filters (see below) help you to judge filter changes when you assess your test strip. They are a handy alternative to a ring-around print set (see p. 119). Filter alterations may affect the exposure time that you require—a simple calculator disk or table (see below) will show you any corrections you should make. When you change from one package of paper to another of a different batch, you may have to change exposure and filtration substantially (see below). Your notebook is an excellent printing aid because it records information about your own equipment and negatives. (See also test print equipment, pp. 116-7.)

Color correction

The table below summarizes the color correction steps that you should take when printing with subtractive filters (see p. 114). Always try to reduce your filtration if this is possible, rather than increase it (see p. 115). Viewing filters (see right) help you to identify correction color and strength.

Filtration guide

Print appearance	Filter changes Take out	Or add
Too blue	Yellow	Magenta & cyan
Too green	Magenta	Yellow & cyan
Too red	Cyan	Yellow & magenta
Too yellow	Magenta & cyan	Yellow
Too magenta	Yellow & cyan	Magenta
Too cyan	Yellow & magenta	Cyan

Making notes

Record the essential exposure and filtration data for each negative in your notebook. This will help to save paper when you make reprints from existing negatives, and give you a guide for printing new negatives on similar film. Provide columns in your notebook for the following: subject description, brand of film negative, type and batch of paper, processing kit, size of enlargement, lens aperture, filtration setting, and exposure time. Make an entry for every test you do (with an assessment of results) as well as for your final print.

Filter factors

Color filters of any type stop the passage of light to some degree. Therefore you will have to adjust printing exposure whenever you make filtration changes. Even the more efficient dichroic filters may require filter factor corrections, though, because these filters shorten exposure, corrections will generally be small. The easiest way to correct is to read figures from a disk calculator, see above right. Or look at the table below (which covers Kodak filters). For example, if your test print shows correct density at 10-sec exposure, but appears too magenta, you could decide to add 30M to the filtration. You must

then multiply exposure by 1.7, and give 17 sec. If you reduce filtration, you must divide the exposure time by the factor for the filter that you remove. When you add or take away two filters, you must first multiply their factors, and then use this figure to multiply or divide the exposure.

Filter factor table

Filter strength	Yellow	Magenta	Cyan
05	x 1.1	x 1.2	x 1.1
10	1.1	1.3	1.2
20	1.1	1.5	1.3
30	1.1	1.7	1.4
40	1.1	1.9	1.5
50	1.1	2.1	1.6

Changing paper batch

Color and speed characteristics will vary slightly from batch to batch. Information appears on the package label, see p. 63. (You will often find data for subtractive negative/positive printing headed "white light data".) If you change to a new package of a different batch in the middle of printing, you should first subtract the filter values on the old package from the enlarger filtration you are using. Then add the values on the new package to your filtration. For example, if the old label reads + 20Y 00M, and your current filtration is 40Y 20M, and you change to paper labeled + 10Y 10M, you must alter filtration to 30Y 30M. If the new paper label also shows a different exposure (speed) factor, divide this number by the factor of the old paper, and multiply your original exposure time by the result.

Making a neg/pos enlargement

You should choose an accurately-exposed and evenly-lit color negative from which to print your first color enlargement. Your contact sheet (see p. 118) will help you to choose an appropriate negative, as well as giving you a guide to the filtration you should set on your enlarger. For your negative, first make an exposure test (see below). Next you will have to make a filtration test. Use the information gained from your contact sheet to set the initial filtration. Then, using the best exposure from the first test strip, make three exposures varying the filter settings only (see p. 122). As the change in filtration will probably affect exposure (see facing page), you may have to make a third test. Select the best filtration from your second test and vary the exposure (and filtration, if necessary – see p. 122).

Equipment checklist
1 Color enlarger
2 Negative/positive color paper in safe
3 Color contact prints
4 Masking frame
5 Focus magnifier
6 Notebook and pencil
7 Enlarger timer
8 Voltage stabilizer
9 Filter change exposure calculator disk
10 Test print shading cards
Also, all processing equipment illustrated on p. 116.

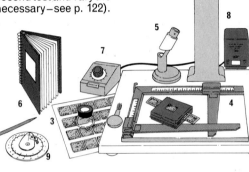

Exposing equipment

You will require the items shown right to enlarge prints by subtractive filtration.

Filters If you have a two-filter head buy supplementary 05 and 10 cyan filters. Use these in the filter drawer when you can no longer subtract yellow or magenta.

Exposing procedure

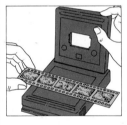

1 Clean your negative and place it in the negative carrier, emulsion side downward. Insert carrier into enlarger.

2 Adjust frame for paper size. Switch on enlarger, open lens aperture, and set zero filtration. Compose and focus on frame.

3 Examine your notes and the paper manufacturer's recommended filtration and exposure times for your brand of negative.

4 Reset chosen (shortest) test exposure on enlarger timer. Dial-in or select filters for probable color filtration.

5 Reset your frame for a half-sheet of paper. Angle the frame in order to test a typical section of your chosen image.

6 In darkness, place a half-sheet of paper under the frame masks, emulsion upward.

7 Expose the entire half-sheet. Cover one-third with cardboard and re-expose, cover two-thirds and expose again.

8 Remove the exposed half-sheet of paper. Put it in the processing drum, close the lid, and then process in normal light.

Exposure test

| 10 sec | 15 sec | 20 sec |

Wait until your first test print is dry before you try to assess results. The whole image above is too orange/red at 50Y 25M, but print density appears correct in the central band (15 sec). The test on the right shows the effects of changing filtration. (Yellow and magenta filtration were increased, in order to obtain a cooler result.)

Filtration test

| 50Y 30M | 55Y 30M | 65Y 40M |

Mask off each area and expose it separately. The strip, top left, was filtered 50Y 30M (reducing magenta). The center strip received 55Y 30M (reducing yellow). The strip, bottom right, received 65Y 40M (reducing red). All strips were exposed for 15 sec. The central one has the most acceptable color, but weak density.

Exposure adjustment

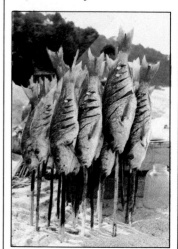

| 18 sec | 20 sec | 22 sec |

As a final check, make a third test (this time for density) using the best filtration settings from your filtration test (see left). The example above was filtered 55Y 30M each time, but exposed for 18 sec (top left), 20 sec (center), and 22 sec (bottom right). The enlargement on the facing page received 20 sec, 55Y 30M.

Identifying faults

| 1 | 2 | 3 | 4 | 5 |

The sections of prints above show some of the most common faults you are likely to come across when learning to print in color.
1 If you put your paper in the masking frame emulsion side down, your print will look like this. It will have left-to-right reversal and a pale cyan cast. Practice with a waste piece of

paper until you can detect the emulsion surface in the dark.
2 Your image will look like this if you totally omit the printing filters during exposure. This can happen if you use the "white light" lever to check the image and then forget to restore filtration before printing.
3 The "flatness" and areas of

uneven development probably mean that you put the paper in the drum back to front.
4 If the developer temperature is too low, image density will be weak, contrast low, and colors distorted.
5 If all your print has an intense magenta fog you probably contaminated the developer with bleach/fix.

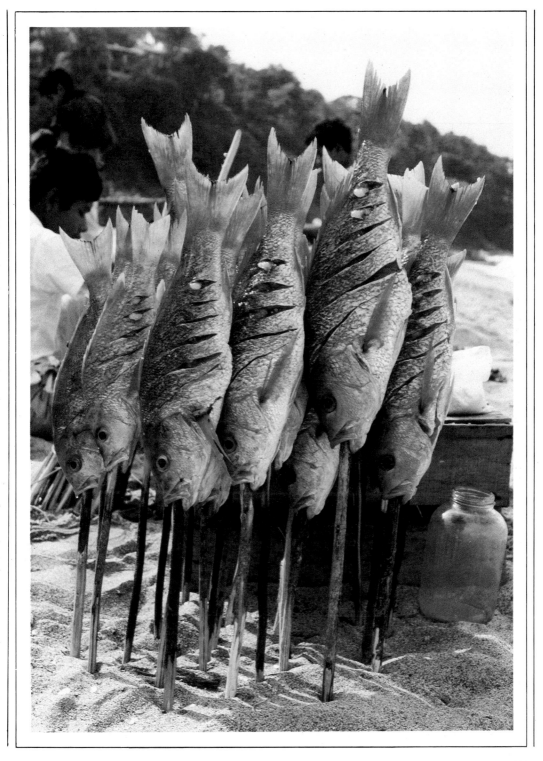

Making a pos/pos contact sheet

Printing from a transparency is simpler than printing from a color negative, as you can compare the colors of the print with those of the original. Also, the papers that you use to produce a positive from a positive are very tolerant of inaccuracies in color filtration. In general, you should make a print from a transparency that is slightly dense and flatly lit, rather than contrasty. If you make a contact sheet of a few transparencies (see below), you will have a guide to filtration and exposure differences, which will be useful for making enlargements.

There are two different types of positive/positive paper available—chromogenic reversal and silver dye-bleach paper (see pp. 62-3). Exposure for both is similar, but they require different chemicals and processing (see below and facing page).

Exposing equipment

Enlarger You can use the same filter system that you used for negative/positive printing (as shown on pp. 38 and 116).
Paper safe Store color printing paper in a light-tight safe.

Processing equipment

Storage bottles You will require one storage bottle for each stage of the processing sequence.
Graduates Use a different graduate for each chemical solution.
Bucket For SDB paper processing you will have to have a large-capacity plastic bucket in which to neutralize solutions before discarding them. All other equipment is the same as for negative/positive paper processing (see pp. 116-7).

Reversal paper kit

Kits for processing reversal paper contain up to five chemical stages. Store working-strength first developers and color developers in airtight accordion bottles.

SDB Paper kit

The processing kit for silver dye-bleach paper processing contains chemicals for three solutions, and a powder for neutralizing used chemicals.

Making a test strip

You can keep transparencies in their mounts for contact printing, but tape them together so that you can position them easily in the dark. With positive/positive paper, very long or very short exposure times may cause color distortion. To avoid this, use a different aperture setting for each strip of the test, but the same exposure time.

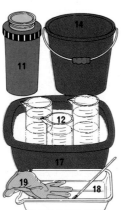

1 *Adjust the enlarger so that its light covers your size of paper. Stop the lens down to f5.6.*

2 *Set filtration as recommended on the paper pack. In darkness, place your slides on the paper.*

3 *Use opaque cardboard to make three exposure strips. Start with f5.6, then use f8, and f11.*

Reversal processing

You must give reversal paper chromogenic reversal processing (see below). This process has about eight stages and takes about 15 min, depending on the kit you use. The changes that take place are similar in principle to those which occur when you process color reversal film (see pp. 84-5). The working temperatures of the first developer and color developer are critical, and you should use a pre-soak to bring the paper and drum up to the correct temperature. Always read instructions–procedures change from time to time.

SDB processing

Silver dye-bleach printing paper does not have as many processing steps as reversal paper (see left). Also, the processing temperature is lower. The chemicals supplied are very corrosive, so you must pour them into a bucket containing neutralizing powder after they have been used in processing. Take particular care when handling SDB paper; even a slight knock may lift off the yellow and magenta dye layers, leaving the cyan layer exposed. To minimize the possibility of damage, wash prints in a tray washer (below).

1 Load your test strip in to the print drum in complete darkness. Fill the drum with pre-soak water at the correct working temperature.

2 After 1 min return the pre-soak water to its graduate. Pour in first developer, heated to slightly above the recommended temperature.

1 Place neutralizing powder in a bucket. Bring developer solution up to the correct temperature, and pour it into your loaded print drum.

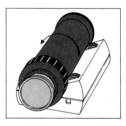

2 Agitate the drum as recommended. At the end of the development time (see chart below) drain all developer solution into the neutralizer.

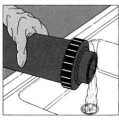

3 Start the timer and begin to roll the drum to agitate the solution. Continue agitation for the full development period.

4 After 3 min discard the developer. Then wash the print 3 times, changing the water each time. Use the pre-soak water for the first wash.

3 Pour in the bleacher and agitate for the required time. Discard the bleach into the neutralizer. Repeat this procedure with the fixer solution.

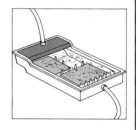

4 Carefully remove your print from the drum. Wash it for 3 min in running water. You can now dry your print. The red cast will disappear when dry.

Typical processing times

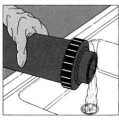

5 Pour in color developer and agitate the solution as before. After full development period (see table right), discard developer and wash.

6 After washing, pour in bleach/fix and agitate for full period. Then remove print from processing drum and wash in running water.

Reversal processing 86°F (30°C)		SDB processing 75°F (24°C)	
First dev.	3 min	Dev.	2 min
Wash	½ min	Bleach	4 min
Wash	½ min	Fix	3 min
Wash	2 min	Wash	3 min
Color dev.*	3½ min		
Wash	2 min		
Bleach/fix	3 min		
Wash	3 min		
Total	**17½ min**	**Total**	**12 min**

*Usually incorporates reversal bath

Assessing exposure

Wait until your test print is dry before you assess the results. The half sheet of prints below, was filtered 10Y 15C. It was exposed for 30 sec in three strips at f11, f8, and f5.6. Colors look generally too cold, but first judge the images for their density. In this example, the center strip (f8) appears to give the best compromise exposure for the four images.

f11, 10Y 15C f8, 10Y 15C f5.6, 10Y 15C

Assessing filtration

Use the results of your first (exposure) test to make filtration changes for your second test. In the example below, filtration was changed to 30Y 15C to try and counter the cold appearance of the first test. Because of the color latitude of positive/ positive paper, it is not necessary to alter exposure time for the increased yellow filtration. The middle strip still appears to give the best result, so the full contact print (below left) was exposed for 30 sec at f8, and filtered 30Y 15C.

f11, 30Y 15C f8, 30Y 15C f5.6, 30Y 15C

Final contact print

Control of density and color

With positive/positive paper, your density and color control methods are the opposite of negative/ positive paper (see table below). With both paper types, though, it is best to alter color by removing filters, not adding them. Large changes of dyed filters will probably affect image density. Use your filter disk to calculate this, or refer to the table on p. 120. Keep all contact print information – it will help you when printing more slides of the same brand of film.

Comparative exposure and filtration corrections

Print	Pos/pos paper	Neg/pos paper
Too light	Reduce exposure	Increase exposure
Too dark	Increase exposure	Reduce exposure
Small area dark	Burn in	Shade
Small area light	Shade	Burn in
Too yellow	Reduce yellow filters	Add yellow filters
Too magenta	Reduce magenta filters	Add magenta filters
Too cyan	Reduce cyan filters	Add cyan filters
Too blue	Reduce magenta +cyan filters	Reduce yellow filters
Too green	Reduce yellow +cyan filters	Reduce magenta filters
Too red	Reduce yellow +magenta filters	Reduce cyan filters

Making a pos/pos ring-around

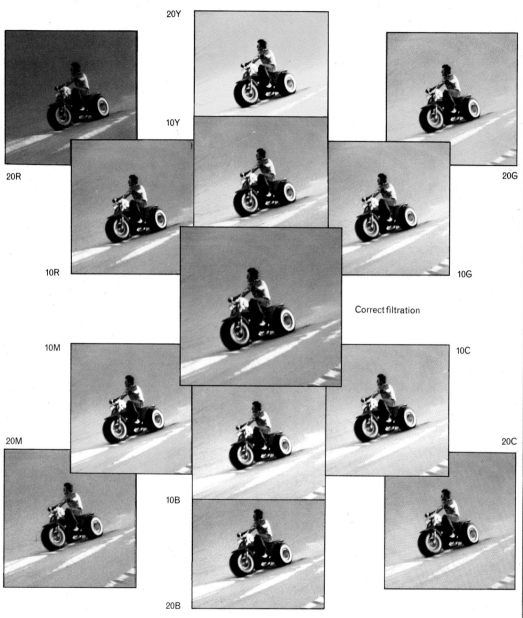

20Y

10Y

20R

20G

10R

10G

Correct filtration

10M

10C

20M

20C

10B

20B

A print sequence like the one above is an invaluable visual aid for identifying filtration errors. The prints, all from one color slide, show varying degrees of incorrect color. Compare this sequence with a test print from another slide to help judge the direction and amount of filter correction you require. An image that contains some neutral and pale colors will show any casts most clearly. In the ring-around above,

made on SDB paper, the center print is accurately exposed and filtered. The other prints show casts of yellow, magenta, cyan, blue, green, and red by varying amounts. Each print in the ring-around has a filter code caption. This represents the amount of filtration you must subtract from your color head to correct that degree of error. Unlike the negative/positive ring-around (see p. 119), filtration follows the

(see p. 119)

same tint as the cast. If you want to subtract primary colors (for example 20R), you must remove equal amounts of two adjacent complementaries (20Y + 20M). Alternatively, add an equivalent amount of the third color (20C). If your enlarger head has only yellow and magenta filtration, you should buy some 10 and 20 cyan filter drawer acetates to use for positive/positive printing.

Using color analyzers

When you make a color print you will have to assess visually several test prints in order to find the correct filtration and exposure settings. You can, though, lessen the number of tests by using a color analyzer, which, once set up (see below), electronically measures the intensity of the blue, green, and red light in your image as projected by the enlarger. It then compares this information with a "standard" image known to give a good result. Another type of "analyzer" consists of a mosaic of colored patches (see below). When you print your image through it, you obtain a different colored result in each patch.

You can use both these types of device to help you print from color transparencies or negatives, and most can be used for either additive or subtractive printing. For black and white work, you can use most analyzers for exposure only.

Electronic analyzer

An electronic analyzer measures the quantities of blue, green, and red light emitted from your projected image. It then compares these readings with a memorized program from a previous, correctly printed image, and reads out the exposure and filter values you should set. The unit, right, has a measuring probe, which you can use to sample a small area of the image (a "spot" reading), or to make an overall "integrated" reading (see below).

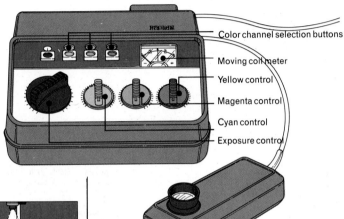

Color channel selection buttons
Moving coil meter
Yellow control
Magenta control
Cyan control
Exposure control

Color-measuring probe

Using an analyzer

Integrated readings
Most probes have a diffuser that you hold close to the lens to scramble light from the whole image. Results may be inaccurate if your main subject is surrounded by areas of strong color.

Spot readings
Remove the diffuser, leaving the probe with a small measuring aperture only. Position the probe on your masking frame so that it reads the light from a key area of your picture, such as flesh tones.

Mosaic analyzer

Mosaic analyzers consist of a pattern of about 100 filter patches in varied tints, a diffuser to scramble light, and a gray tone scale on cardboard with holes to help you assess your print. Place your negative in the enlarger, and set lens aperture and filters according to the instructions supplied. Next, hold the diffuser just below the lens, and contact print your mosaic in the four quarters of one 8 x 10 ins (20 x 25 cm) sheet of paper, giving four different exposure times. After processing the paper, use the perforated cardboard to decide which patch printed neutral gray. The mosaic reference chart identifies this patch position and shows which filter changes you require to print your negative.

Programming an electronic analyzer

You must program your electronic analyzer to suit your enlarger, film type, and paper batch. Pick a typical image (your ring-around negative, for example), and then make a perfect print. Next, place the probe under your set-up enlarger and make an integrated or spot reading (see above). Now turn the programming controls to the exposure time and filtration that produced the print, and your analyzer is ready to use. To make a print from a new frame of film, place the probe as before, and make yellow, magenta, and cyan exposure readings in turn. In each case, alter your enlarger's filter dials (or change the color head filters) until the meter on the analyzer shows a central, zero reading.

Making a pos/pos enlargement

To make your first color enlargement from a color transparency, you should choose an evenly lit image, which is not particularly contrasty or overexposed. A weak transparency will tend to give a print with washed-out highlights. But a denser, marginally underexposed transparency will give richer colors, and you can often lighten the print by adjusting the exposure.

Using positive/positive paper (see pp. 62-3), first make a test print to determine correct exposure and filtration (see below). Use larger steps than you would with negative/positive paper – small steps will not be obvious. Try to avoid very long or very short exposure times as this tends to alter color balance – it is best to adjust exposure using the lens aperture.

Equipment checklist
1 Color enlarger
2 Voltage stabilizer
3 Blower brush/ canned air
4 Masking frame
5 Focus magnifier
6 Piece of cardboard
7 Positive/positive paper in paper safe
8 Test strip
9 Enlarger timer
10 Magnifying glass
11 Filter change exposure disk
12 Notebook and pencil
Processing equipment and kit as shown on p. 124

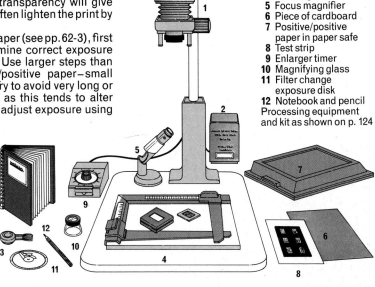

Exposing equipment

Enlarger You must have an enlarger with a color filter drawer or color head (see pp. 38-9).
Test mask Use black opaque cardboard.
Cleaner Have an efficient cleaner, such as a blower brush or canned air to remove all dust from your transparencies.

Printing procedure

1 *Remove the transparency from its mount and place it in the negative carrier, emulsion (dull) side down.*

2 *Clean the transparency. Dust appears as black specks on a positive/positive print, and is difficult to remove later.*

3 *Insert the negative carrier into the enlarger. Switch off the room lights, focus and compose image on the masking frame.*

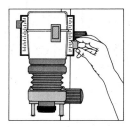

4 *Set the filtration suggested on the paper pack (or refer to your notes if you made contact prints – see pp. 124-6).*

5 *Set the enlarger timer for the exposure time recommended for your paper, or refer to your contact printing notes.*

6 *Place a sheet of paper in the masking frame. Cover a quarter of it with the cardboard and expose for the set time at f5.6.*

7 *Expose the three remaining strips of the paper in turn by re-aligning the mask. Expose the strips at f8, f11, and f16.*

8 *Remove the paper and load it into the print drum. Close the drum and process in normal lighting (see pp. 124-5).*

Exposure test

| f16 | f11 | f8 | f5.6 |

Wait until your test is dry before you assess the results. In the example above, all strips received 15 sec exposure, filtered 40Y 15C. The strip exposed at f16 has the darkest density, and f5.6 the lightest. The results are slightly blue, but at f11 density looks correct. The test on the right shows the effects of changing filtration, in yellow.

Filtration test

| 70Y 15C | 60Y15C | 50Y 15C | 40Y 15C |

All the strips above received 15 sec at f11. Strip 70Y 15C shows a shift toward green, and the other strips differ in their yellow content. The strip filtered 60Y 15C has the best color and density, but could still be a little "warmer". For the enlargement on the facing page, filtration was adjusted to 70Y 15C with 16 sec exposure at f11.

Identifying faults

| 1 | 2 | 3 | 4 | 5 |

All the faults above are on SDB paper, but you will get generally similar results if you print on reversal chromogenic paper (see pp. 62-3).
1 If you slightly fog your paper to light before processing, your print will have a bleached and purple appearance, with most of the top (yellow) image destroyed. This happens if light enters a partly open paper package.
2 You will get a blotchy, uneven effect if you load your paper back to front in the drum. You will get similar results from using too little of each processing solution.
3 If you print without any filtration (perhaps using the "white light" lever), you will get this result.
4 You will get this type of result from insufficient or exhausted bleach solution.
5 If you scratch the wet print surface, you may tear through the yellow and magenta layers, exposing the cyan layer.

Pos/pos printing controls

The introduction of positive/positive materials and processes is fairly recent, and each of the two systems presently available has advantages over the other (see right). A disadvantage of both systems is that the masking frame, which prevents light reaching the picture edges, produces a black instead of a white border. If you want white borders you must fog them in, as shown below.

Another problem you are likely to find with these materials is that your resulting print is excessively harsh if your original transparency is even slightly contrasty. With SDB paper you can reduce contrast by using a fine-grain black and white developer instead of the one supplied with the kit. Also, the two contrast-reducing techniques below apply to both reversal and SDB papers.

Positive/positive papers compared

Reversal	Silver dye-bleach
Lower cost paper	Fewer processing
More light sensitive	steps
Wider choice of	Lower temperature
processing kits	process
Less toxic chemicals	Wider temperature
Finished prints are	tolerances
easier to retouch	Colors are richer
and mount	and more permanent
	Prints have slightly
	higher resolution of
	detail

Making white borders

To produce white borders on positive/positive paper you must fog the paper edges to light, after exposing the image. When fogging the paper, use an opaque cardboard mask to protect the picture area (see right). You can make colored borders by simply setting the filtration controls to your chosen color.

1 Place thin black cardboard in the frame, trace your picture format, and cut out the image area.

2 Expose your print. Switch off and place the mask over the image. Hold it down with coins.

3 Lift frame arms, remove negative carrier, and give twice the exposure used for the image.

Contrast masking

To make a less contrasty print, first make an under-exposed contact print on slow, panchromatic black and white sheet film. Then underdevelop the film to produce a negative that just records subject highlights. Position the slide emulsion upward on the film, so that the slide base separates the two emulsion surfaces (see right). This will soften the image.

1 Contact the slide, emulsion up, on slow panchromatic film. Reduce development 50%.

2 Cut out the negative and register it with the slide. As before, have the slide base separating emulsions.

3 Tape the two together along one edge. Place them in the negative carrier and enlarge.

Contrast "flashing"

Another method of reducing contrast is by "flashing" your paper to white light after you have exposed the image. This will decrease shadow density without affecting the highlights. The only equipment you require is an ND2 (neutral density) filter (see right). This method is quicker and cheaper than masking, but produces flat, gray shadows if overdone.

1 Expose the paper to the slide normally, but judge exposure time for image highlights and mid-tones, not shadows.

2 In darkness, carefully remove the color slide. Replace the negative carrier, taking care not to knock the enlarger.

3 Place an ND 2 (dark gray) gelatin filter under the enlarger lens. Give the paper the same exposure time again.

Additive printing

With additive printing you give the paper separate exposures through the three primary-colored filters. You use the blue filter to produce a yellow dye response in the paper, the green filter for a magenta dye response, and the red filter for a cyan dye response. To adjust print density, either increase or decrease all three exposures to the same degree. To adjust a complementary color cast (magenta, for example), you must change the exposure time through its corresponding primary-colored filter (green, in this example). To correct a primary color cast (red, for example), you must change the exposure times through the blue filter, which produces yellow dye, and the green filter, which produces magenta dye, by the same amount (yellow+magenta=red).

Equipment checklist
1 Black and white or color enlarger
2 Tri-color gelatin filters
3 Lens filter holder
4 Masking frame
5 Focus magnifier
6 Enlarger timer
7 Notebook and pencil
8 Blower brush
9 Color print paper in safe
10 Shading cardboard
You will also require the correct kit for your paper and all processing equipment

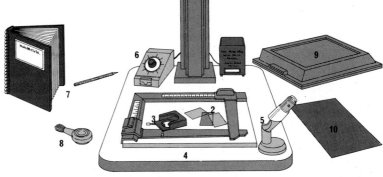

Exposing equipment

Filter holder For quick filter changing in the dark, use a filter holder you can attach to the enlarger lens (see p. 96).
Filters You must use gelatin filters—acetate printing filters will spoil image definition.

Making a patch-chart

The best way to make a test print when additively exposing is to work through two stages. First make a test strip giving different exposure times through the blue filter only. Process this and you will have a yellow image (on negative/positive paper), which you can then assess for print density. As the yellow image is pale, view it through the blue filter. Next, make a color test exposing your whole image through the blue filter, plus strips at different exposure times through the green filter, and further strips (at right-angles to the first) through the red filter (see right). Always hold these filters by their edges and keep them clean and dust-free. And consider making an identifying notch on each filter to help you work in the dark.

1 *Clean your color negative; compose and focus on the masking frame. Stop the lens down by about 2 stops.*

2 *Insert the blue filter and set your timer. In darkness, expose half a sheet of paper in strips of 5, 10, and 20 sec.*

3 *Process your test. Decide correct exposure, assessing highlight and shadow detail in neutral parts of the image.*

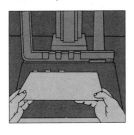

4 *In darkness, place a sheet of paper in the frame and give the blue filter exposure time you judged to be correct.*

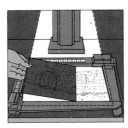

5 *Still in darkness, change to the green filter. Re-set timer and give three exposures of 10, 20, and 40 sec.*

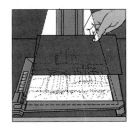

6 *Change to the red filter. Give the same exposure steps as in **5**, but at right-angles. Process your test (see p. 134).*

Assessing your result

10B 40G 40R	10B 40G 20R	10B 40G 10R
10B 20G 40R	10B 20G 20R	10B 20G 10R
10B 10G 40R	10B 10G 20R	10B 10G 10R

Assuming that your first test
showed 10 sec blue exposure to be
correct, the diagram above maps
the combination of exposure times
you should give your second test.
As shown right, the processed
image has a different color balance
and density in each patch. The one
given 10B 20G 20R looks correct,
and a full print from these settings is
shown below. For some prints you
may have to make a further
patch-chart to find a square that
gives the correct color and density.

Final print

Controlling density and color

When you expose additively you
make your print lighter or darker by
changing all three exposures by
exactly the same proportion. For
example, using negative/positive
paper, you must change 10 sec (B),
20 sec (G), and 40 sec (R) to 15 sec
(B), 30 sec (G), and 60 sec (R) to
give a result the same color but
darker in density. To change image
color you must alter filter exposures
individually. In negative/positive
printing, if you give a longer blue
exposure your result is yellower.
Green exposure increases magenta

and red exposure increases cyan.
With positive/positive printing all
these controls are the opposite.
Because of the three exposures, it is
difficult to make local changes in
density (see facing page). However,
tri-color filters do allow you to
separate the yellow, magenta, and
cyan elements of any color image
(see below), by exposing through
only one filter each time. These
resulting "color separations" are
useful for darkroom manipulations
such as highlight masking (see pp.
218-20).

Yellow

Magenta

Cyan

Local color control

When you make a color print, you can lighten or darken selected areas, and adjust local areas of color to rectify a cast or introduce more color than was originally there. If you are printing from a color negative, you can use all the shading and printing in techniques described for black and white printing (see pp. 104-5). If you are printing from a slide, though, shading will darken the image and printing in will lighten it (see table on p. 126). You can make an area of any one color richer as well as darker by giving it extra filtration. To boost color on negative/positive paper, give extra filtration through a filter complementary to the color you want to increase. On positive/positive paper give extra filtration through the filter the same color as the one you want to boost. If you decide to use filters held below the lens, then they should be optically suitable, color compensating (CC) gelatin types. You cannot use acetate color printing (CP) filters as they will spoil image definition.

Boosting color

Correcting color

Often, bright skies in landscape pictures reproduce as bleached areas on prints, completely lacking detail (above left). To bring out the detail you can see in the version above right (on negative/positive paper), increase sky exposure by 50 per cent and print in through a 30Y filter. On positive/positive paper, shade the sky throughout the exposure using a 40B (or 40M 40C) filter.

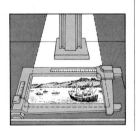

1 *On negative/positive paper, expose the whole sheet to give the best overall color and density.*

Sometimes, prominent shadow areas take on an excessive cast when printed. In the example above left, the blue from the sky has picked up in the foreground snow. To correct this (on negative/positive paper), shade the foreground with a blue CC filter (or extra magenta and cyan filters). Then give the area extra exposure to maintain density. On positive/positive paper use a yellow filter.

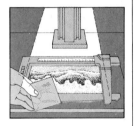

1 *On negative/positive paper, shade the blue cast with a blue filter throughout the exposure.*

2 *Hold a yellow CC gelatin filter below the lens, or dial in extra yellow in the filter head.*

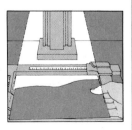

3 *Now, burn in the sky area for the extra period. Shade the rest of the print with opaque cardboard.*

2 *Reset the enlarger timer to give extra exposure (to correct any local change in density).*

3 *Mask off all but the shadow area of the print. Burn in for the extra time, again using the blue filter.*

Print finishing

You will probably have room to display only a small percentage of your color prints. To show them at their best, you should remove any blemishes–scratches and dust spots, for example–before displaying them (see below and right). If you have a dry-mounting press (see p. 110) you can use it for most color, resin-coated papers, but cover the print with a silicon release paper (see below) and hold the press temperature to 210°F (99°C) or less. Silver dye-bleach prints are particularly easy to damage, and you should only cold mount them, using double-sided adhesive tape.

Choose the color of your print surround with care. Generally, a neutral-toned cardboard mount looks best. Use a laquer spray to protect the print surface, and to disguise any retouching marks.

Making an overlay mount

Cold mount SDB color prints on thick board with a cardboard overlay. You will require a sharp knife, baseboard, cardboard, acid-free adhesive tape, a ruler, and a pencil. Use a set square to make sure corners are at right angles (see below left).

Spotting and correcting color

To treat color prints you will require fine brushes, cotton balls, and wet and dry retouching dyes (see above). If your print has any small white specks, use a brush and diluted water color (see p. 110). For large light-colored areas, such as skies, you can use either water color or dye designed for your type of paper. Apply the color in light coats, building up to the right strength. Treat any black specks with a chemical reducer (see pp. 172-4). To suppress a localized color cast, see below.

1 *Mark out an area on the cardboard overlay that is slightly smaller than the image area of the picture.*

2 *Use a metal rule and a sharp knife to cut out the cardboard along the marked lines.*

3 *Position the print on the baseboard and secure it with adhesive tape.*

4 *Stick the cardboard mount to the baseboard using double-sided tape.*

1 *Breathe on a cake of dry color. Use cotton balls to apply the color with circular movements.*

2 *To make the retouching permanent and remove surface marks, hold print over steam for 10 sec.*

Texturing prints

Texture sheet

Release sheet
Heat seal film
Color print
Dry-mounting tissue
Mounting board

Correcting a local color cast	
Color cast	**Neutralizing dye**
Red	Cyan
Green	Magenta
Blue	Orange
Blue + Magenta	Yellow

You can use a texturing kit with a dry-mounting press. This gives you a choice of surface finishes for your prints, and you can combine dry mounting with texturing.

You place the texture sheet of your choice in the press, along with the release paper, print and mounting board. Follow kit instructions for time and temperature.

Basic
manipulations

Introduction

Once you feel that you have mastered the straight or "official" uses of the materials, equipment, and processes in the first four sections of this book, you can begin to discover some of the "unofficial" alternatives. But do not try this too soon – the ability to make first-class black and white or color prints is your first priority. You must be familiar with all the controls and have a good idea of exactly what is happening at the different stages of processing. This also means that all the basic disciplines–such as keeping dry from wet, avoiding contamination, and checking time and temperature – should now be fairly automatic. On the other hand, do not become so bogged down in routine that you lose the incentive to experiment.

No routine is inflexible. No one material has to be used in a particular way. To take just one example: there is no reason why a paper print should always carry a positive image. There are also some interesting special materials – neither expensive nor complicated – which allow you to convert one type of image into another.

Of course it can always be argued that manipulations are no more than "gimmicks". This is often true if they are not used with imagination and in conjunction with the right sort of image. But, having established a darkroom and all the equipment for routine processing and printing, you owe it to yourself to explore the other possibilities they offer. This section, therefore, starts you off by "breaking the rules" and introduces processes and materials to be exploited further later in the book. An example of this is the use of half-tone screens, which convert a normal continuous-tone image into a series of finely graded areas of black and white – an essential first step for a process such as photo silkscreening.

To begin with you will find a number of conversion techniques explained. Black and white slides for projection can be printed from either black and white or color negatives. Black and white negatives can be made from color slides, or slides enlarged on black and white paper to give negative or positive prints. Some of these conversions may seem a little eccentric at first, but used with the right image they can give pictures an interesting new identity. Equally, a technique may form just one of several steps towards a total transformation.

There are several unfamiliar light-sensitive materials that figure heavily in many more advanced manipulations and are worth learning to use. One of the most important of these materials is high-contrast sheet film. You can handle films of this type in a similar way to paper, but since most are sensitive to green light (to improve their otherwise slow speed), you will require a deep red safelight. In fact, you should rate a red screen for your safelight as essential for most darkroom manipulative work. Conversion to a harsh-contrast line image is interesting in its own right, and of great importance later in dozens of processes, such as posterization and solarization, which can only work with images that have been changed into this tone-simplified form.

The pages ahead also introduce you to an extremely useful technique for printing manipulations – registration. It allows foolproof alignment of one image after another on one piece of printing paper, even working in color in complete darkness. Some examples of its use appear in this section, and you will notice its regular appearance in many advanced techniques later. For nearly all serious darkroom work, a registration punch and pin bar is strongly recommended.

Copying is another fundamental skill you should master. In this section you are shown how an enlarger or camera can be used to copy prints or slides. Copying and enlarging are optically very similar, except that light travels in the opposite direction. If your enlarger lens will not focus close enough to produce same-sized or reduced-sized images you can use your camera instead, fitted with extension rings, set up over the original film image on a light box.

Abusing the processes

Among what may be called "abuses of processes" you should try mastering the technique of enlarging black and white negatives on negative/positive color paper. Printing in color from black and white can produce some outstanding results, similar to toning but with subtle, gradated colors introduced purely by the use of filtration. This procedure is also a challenge to your basic color printing skill. A further mismatch is to process color slide film in color negative chemicals, and vice versa. It is a way to make color film produce startling results from familiar subject matter.

Another way to distort normal photographic results is by exploiting grain. A coarse or gritty pattern destroys fine detail. It gives a semi-abstract image that is particularly strong and graphic if converted to high contrast too. Already you will see how one manipulation can be added to another to give an enormous range of final results. Other techniques shown here include the use of liquid emulsion to make virtually any surface light sensitive – say, a piece of wood or a plate. You can then project an image on the treated surface to form a black and white photographic image. If you apply the emulsion unevenly, leaving numerous brush strokes, the effect is very unlike a photograph in the accepted sense. "Patches" of image can also be formed on conventional photographic materials by applying developer unevenly, using either a brush or a water spray.

Going in yet another new direction – gradated shading to lighten areas during enlarging can be used to shade off the edges of pictures into vignettes. If you can shade off an image into white paper, it is also possible to print another negative back into this space – a technique that opens up a vast range of surreal pictures, and is elaborated on further in the advanced manipulation section.

Methods of working

Looking over this section and the next, which both concentrate on the practical detail of *how* image manipulation is done, raises the question of *why* do it? In some cases – such as intensifying thin negatives – the technique is remedial, to counter-act earlier mistakes. In others, like making slides, you are simply changing the final physical form of your image. With most of the manipulative techniques, though, the image is altered radically, like an artist's work is altered when he etches a lithographic plate instead of painting a water color.

To begin with you will probably pick an image on which to try out a particular technique. This is useful experience and interesting to do, but not the most constructive way to work. It is better to look over the various image controls and changes – trying some of them out but remembering them all as a kind of visual dictionary. Later, when you have an image that could make a stronger, more direct statement through an unconventional treatment, you can recall just the right technique.

Make the picture (and your visual ideas behind it) the determining factor. For example, a subject with an interesting outline can have this one aspect emphasized if the image is finally presented as stark black and white. In converting it to line you can also dispose of unimportant mid-tone detail, by arranging it so that it is absorbed into either solid white or black areas.

In another case, colors may conflict with the tonal mood and structure of another wise accept-able scene. Photographing it in black and white and then introducing wanted hues during color printing may be one way round this problem. For other pictures you may want to make comparisons and `draw parallels between diferent situations. Combination printing may be the answer.

The best approach is to teach yourself each technique, but avoid using them for their novelty value or to bolster weak images. Use a strong picture (or picture components), and manipulate only in ways that allow image and darkroom technique to work together naturally.

How to use the "Reference box"

The types of techniques in this and the next, more advanced section, have been carefully structured so that the main information builds up logically throughout. Because of this, the majority of the topics carry a *Reference box*, which tells you where to find information in the book relevant to the technique you are looking at. Sometimes the reference is very specific and is therefore essential reading. In other cases, the reference is simply there to present you with the chance of reading background information.

Historical background

Basic manipulations or "dodges" were an essential part of nineteenth-century photography. Most of them were required to improve the performance of the elementary materials available. Intensification and other chemical aftertreatment of negatives were a regular routine to compensate for exposure guess-work errors. Often, too, when printing an uneven or contrasty plate, the contact frame was covered over with tissue paper, with holes cut corresponding to the densest part of the image.

Until 1906 plates were insensitive to green. This meant that in landscape photography when the land part had sufficient exposure, skies were hopelessly overexposed. Experts would often take a second negative, exposed for sky detail only. The same sheet of paper was then contact printed behind the land negative followed by the sky negative (shading the lower half of the paper).

Shading off the edges of the pictures to form a vignette (see below) was also fashionable for portraits. It helped them look less photographic, more like a miniature or a sketch. The backs of these negatives were often dyed yellow over the palest parts of the image to make these areas print lighter. Nearly every portrait studio employed a retoucher, whose job it was to disguise sitters' spots and wrinkles by dyeing or penciling over the image on the emulsion surface.

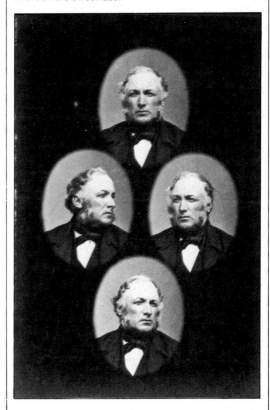

Early vignettes
A portrait like this would be taken on a shifting-plate camera or printed *from four negatives, then fogged behind opaque oval shapes on glass.*

Black and white slides and negs from color

One of the main advantages of doing your own darkroom work is the flexibility of end result you have–despite the original image medium. For example, you can make black and white slides from either black and white or color negatives. By choice of film and aftertreatment, such as toning (see pp. 268-75), you can produce startlingly original images for projection. Working the other way round, you can make black and white prints from color slides. You can use a direct reversal

paper (see pp. 144-5), but for the best results use an intermediate black and white film negative. To control the tonal reproduction of color you can use various color filters, and careful exposure and development will fully preserve the detail and contrast of the color original (see facing page). With all techniques, you must print on film–either by direct contact or by same-size projection. Working through the enlarger (below) is the better method–there are no glass surfaces to attract dust.

Black and white slides from negatives

To project a same-size image with your enlarger, the lens must be half-way between the negative and masking frame. If your lens will not focus this close you can buy an extension tube. As a precaution, check that negative illumination is still even (see p. 37).

1 *Use a slide mount to size and compose image. Fine focus by shifting the whole enlarger head.*

2 *Expose on to film backed by black paper. Work in darkness or the correct lighting for film.*

3 *Tray process the film in print developer. When it is dry, trim and mount your black and white positive.*

Black and white negatives from slides

You can make black and white negatives from color slides using the technique shown above. For continuous-tone results without excessive contrast, process in a

half-strength negative developer. Use panchromatic film (top left) for correct tonal rendering. Using 100Y 100M filtration (above left) will darken blue skies and lighten reds.

The result, top, was produced on orthochromatic lith film, processed in lith developer. Panchromatic lith film filtered deep red produced the result shown above.

Correct exposure/underdeveloped

Correct exposure/development

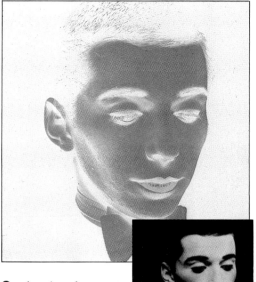

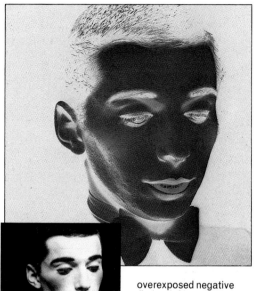

Contrast and density

These negatives are all from the same color slide. Each was printed on the same paper and given the same exposure (center). The correctly exposed negative (top right) processed in diluted developer gives the best mid-tone response. The

overexposed negative (below left) merges paler mid-tones with highlights when printed, but gives more shadow detail. The overdeveloped negative (below) gives so much distortion that the effect is almost a line image. The underdeveloped negative (top left) produces a low-contrast print. But it would print well on harder paper.

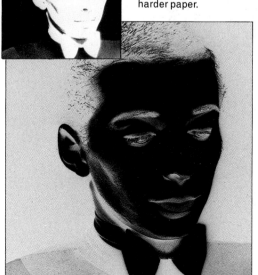

Overexposed/correct development

Correct exposure/overdeveloped

Color prints from black and white

The technique of enlarging black and white negatives on negative/positive color paper produces a range of subtle image colors (see below). Results resemble color toning (see pp. 268-75), but you can achieve a wider range of hues and saturation. First determine the filtration and exposure that produce a neutral, correct-density black and white print (by forming dye in each of the paper's three emulsion layers). Then decide the color and intensity of tint you require for your image, and change filtration accordingly (see below). If possible, sandwich your black and white negative with a piece of unexposed but fully processed color negative film. The yellow or orange mask (depending on the brand you use) means you will require less filtration for a neutral result, and this will give you a wider choice of filter options. You can produce images that are all one color, or that gradate from neutral to color, or that combine different colored areas.

Testing for density and neutral color

125Y 50M

75Y 50M

100Y 75M

Set up your negative in the normal way. If you are not using film as a mask, set a relatively high filtration. Make an exposure test strip (see pp. 98-9). Exposure times for these test strips ranged from 5 sec to 30 sec, using 5-sec intervals. If your first print is too blue (as above left), shift yellow filtration by 50 to achieve a more neutral result. If your second test is too red, shift the yellow and magenta filters by approximately 25 units to correct to neutral (as in the test strip series above).

Testing for colors

Yellow shift

Magenta shift

Red shift

Having found neutrality (100Y 75M here), make another test varying yellow filtration only. Results change toward blue or yellow.

Vary the magenta settings to achieve colors of increasing strength toward green or magenta, see above.

This test used variations in red (Y + M) filtration. It shows how you can turn the image either cyan or red.

Making final prints

For reference, make a print like the one above to provide a working "palette" of possible colors. Note filtration and exposure details so that you can repeat colors easily. You can introduce several colors into one print by shading, changing filtration, then burning-in again. Alternatively, use one or more over-lay masks for shading (see pp. 156-7). The print right was shaded with cardboard. Settings were 40 sec at 125Y 60M for the roof, 46 sec at 98Y 72M for the wall, and 40 sec at 90Y 100M for the ground. Devise a reliable method of resetting your filtration in the dark — if necessary cover the paper, then switch on the enlarger in order to illuminate the dials.

For this print the roof was filtered 45Y 60M and the wall 85Y 20M, both for 28 sec. The ground was filtered 97Y 72M for 40 sec.

Here the roof was given 40 sec at 65Y 40M, the wall 46 sec at 97Y 72M (neutral filtration), and the ground 6 sec at 22Y 72M.

For the version above the roof was filtered 97Y 72M for 40 sec. Wall (filtered 65Y 40M) and ground (65Y 60M) were exposed for 28 sec.

Black and white prints from color slides

If you want to make black and white prints from color slides–without using an internegative–there are two quick and convenient methods available. You can enlarge your slide on regular or panchromatic bromide paper to form a paper negative (see below). You must then contact print this on another sheet of bromide paper to produce a final positive result. Alternatively, you can enlarge your slide on a black and white reversal paper, which will give a black and white positive image from a color slide (see facing page). With either method, your results will not have the same image quality as a print made from an intermediate continuous-tone negative (see pp. 57 and 140-1), but you will find them useful for making quick proofs. Also, both methods result in a considerable increase in contrast, so your prints may require contrast reducing by "flashing" (see p. 132). For the best results, select low-contrast slides of flatly lit subjects. Or, you can turn the contrast enhancing aspect to good advantage by using harshly lit subjects or silhouettes.

Paper negatives

Enlarge your color slide on to paper in exactly the same way as you would a black and white negative. Use the softest grade of bromide paper possible, and one that has an untextured surface. Because you will have to print through the back of the paper, you should use a thin, lightweight type (see pp. 60-1). For correct tonal reproduction of colors, expose on to a panchromatic bromide paper and process in total darkness. Most subjects, however, will reproduce acceptably on regular bromide paper (see left).

Make sure that your paper negative has an absolutely flat, even surface. Place it face down in contact with a sheet of soft-grade bromide paper. To make sure both sheets stay in contact, cover them with a sheet of clean glass that is slightly larger than the paper. Expose this "sandwich" to light from the enlarger –have the lens fully open and expect to give at least 20 or 30 sec exposure. Results from contrasty slides tend to be harsh (see left). Red-colored objects (the curtains in this example) reproduce as dark tones.

Direct reversal paper

All the images on the right were printed from color slides using Kodagraph Transtar. This material gives a positive image with ordinary black and white print processing chemicals. It has a high-contrast emulsion, which is fogged evenly during manufacture. When you expose it to the image this fog is destroyed (the "Herschel effect"), so that light areas of the image record as light parts of the print. Final results are better than those from paper negatives (see facing page), but large mid-tone areas tend to show uneven mottle. Also, you must work under deep red safe-lighting, and because the paper has a narrow exposure latitude use smaller steps than usual when making test strips. Like positive/positive color paper, with Kodagraph Transtar the longer the exposure the lighter the print. If you find your results are too contrasty, try giving the paper a flash exposure about one-tenth as long as the image exposure time.

The print, top right, received an overall exposure of 60 sec with no contrast control. For the central print, some contrast control was exercised by shading the lighter parts and burning in the darker parts (the opposite to negative/positive printing). The lower print received an overall exposure of only 40 sec, followed by a 4-sec flash exposure with the slide removed from the negative carrier.

Conversion to line

You can convert normal "continuous tone" images to stark black and white using line or lith film (see p. 61). These high-contrast films record all half tones as either clear film or dense black. Because of their slow speed and very limited exposure latitude, it is better not to use them for straight photography. Instead, you should work from existing normal-contrast negatives or slides. Choose sharp images without conflicting shadows. Pictures full of detail show dramatic change (below), silhouettes (right) become sharper edged.

Working from a slide

If you decide to use a slide as your starting point, you can make a line negative in one step instead of two. When shooting the slide, arrange the lighting, if possible, so that your subject appears mostly as a silhouette (this will help you to forecast the result). The black and white slide below was printed on lith film (center), and then printed on hard-grade paper to produce the result, bottom.

Using a continuous-tone negative

Original slide

The top half of the picture above is an ordinary print from a continuous-tone negative. The lower half is printed on the same paper, but from a line conversion negative. You make a line conversion negative either by contact printing (see diagrams) or by copying (see p. 180). In the print, light grays become white and dark grays become black. The exact tone at which this "split" occurs depends on the exposure you give.

1 *Contact print your negative on line or lith sheet film. Make several test exposures. Then tray process.*

Line negative

2 *Select the result that gives the best split of tones into black and white. Paint out any spots with opaque dye.*

3 *Contact print this line positive on line or lith film. Paint out any spots, and enlarge the negative on bromide paper.*

Resulting bromide print

Multi-image printing

You can combine several
line images in one print
very simply. Extreme-
contrast negatives have
such dense blacks that
the white parts of pic-
tures fail to affect the
printing paper at all.
Therefore you can expose
a single sheet to a series
of negatives (or different
sections of the same
negative). After exposing
the first image, put the red
filter over the lens, and
re-arrange the paper for
the second image. For
accurate results make a
master sketch first (see p.
225).

Using grain

If you use grain intentionally, it can be an effective way of simplifying an image. It allows you to produce an impressionistic result, losing fine detail yet still retaining a bold, contrasty print (unlike diffusion, see pp. 208-11). For maximum graininess, use a high-speed silver negative film and photograph a softly lit subject. Make your image quite small and extremely sharp. Then slightly overdevelop the film in either speed-enhancing or acutance developer (see facing page). For more extreme effects, chemically reduce the print (see pp. 172-4). For best results, use a condenser enlarger (see pp. 36-7) and hard-grade paper. Its grain will be too fine to affect results, but its contrast will emphasize a grainy negative. Grain is most noticeable in midtone areas.

Increasing grain in an existing image

You can convert an existing fine-grain negative or slide by copying it on coarse-grain, high-speed film. The left-hand side of the picture below is an ordinary enlargement from a fine-grain negative. For the right-hand side an enlargement was copied 1 mm high on 1250 ASA film, and enlarged again on hard-grade paper (see pp. 96-7).

Film and developer

The prints opposite (enlarged × 14) show how film and developer control grain (see also p. 78).

Ultra-fine-grain developers

These low-contrast developers give best results with slow or medium-fast films, which have slightly higher inherent contrast. They give flat negatives on fastest films.

Fine-grain developers

These developers are designed for general use, but are not recommended for very fast films—which fail to reach full emulsion speed and sometimes show dichroic fog stains.

Speed-enhancing developers

These are designed for very fast films, but also useful for general-purpose work. They produce maximum emulsion speed and contrast—moderately fine grain and good definition.

Acutance developers

These developers form an image with high definition, but are not particularly fine grain. They are best for slow or medium films—with very fast films they give a low-contrast image and "gritty" grain. Grain is also emphasized by the contrasty paper used to print negatives.

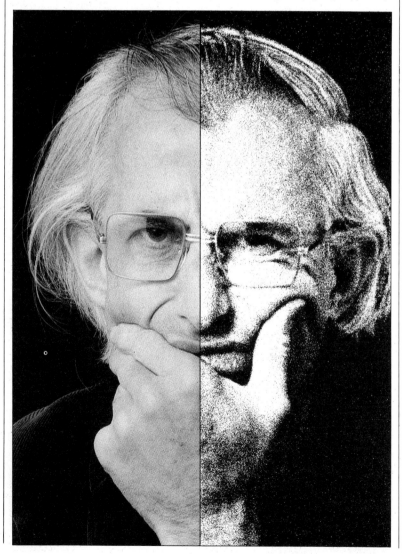

32 ASA film

Extremely fine-grain, high resolution emulsion film. Responds best to slow, low-contrast developers.

125 ASA film

Slow/medium speed film. Gives fine grain in all except speed-enhancing developers.

400 ASA film

Medium speed film. Gives just noticeable grain in all types of developer.

1250 ASA film

Very fast, coarsest grain. Designed for HC 110 processing. Others may give poor contrast and stains.

Abstraction through the use of grain

At extremes of magnification the image begins to lose its identity. From a normal reading distance the picture above is largely an abstract design. It was produced from one of the coarse-grain results on p. 149, copied as a small image on very fast 1250 ASA film, and then finally enlarged on extra-hard-grade paper.

The creative use of grain

The picture above, by Bill Brandt, shows the crossed knees and elbow of a human figure. The use of image grain, plus the extremely close use of a wide-angle lens, turns the limbs into stone-like abstract forms. The result looks like an austere modern sculpture, softly lit and tightly composed.

Vignetting and combination printing

Vignetting is a printing technique you can use to shade off the edges of your print gradually to white (or black), as shown below. The lack of defined edges helps give your pictures an unphotographic look. It also solves problems when surroundings are either too prominent or form awkward shapes with the picture edges. Traditionally, vignettes are oval in shape and fade out into white paper. For a white vignette, you must shade the picture surround throughout the entire exposure (see below). For a black vignette, you first expose the image as for a white vignette, and then fog the surround until you get a solid black while shading the image area. If you are in doubt about the suitability of this technique for a particular image, you can pre-visualize the effect by looking through an appropriately shaped white or black piece of cardboard. Vignetting is also the first step to combination printing – the merging together of two separate images on the same piece of paper. This allows you to create the type of dream-like image on the facing page, and pp. 154-5.

Reference box

Technique	Page
Local density and contrast control	104-5
Multiple printing	224-31

Making vignettes

To make a white vignette you must print your picture through a piece of opaque cardboard with a hole cut in the center. Make sure the shader is large enough to mask off all the paper edges. For the opposite effect, print as for a white vignette, remove the negative, cover the area of image you want to retain, and then fog the picture edges to white light. Keep the shader or dodger moving.

Size and shape
Focus the image on the masking frame. Hold cardboard between the lens and frame and sketch the shape to suit your picture.

White vignette
Insert paper in the frame. Using the red filter, position cut-out surround. Remove the filter and expose (see below left).

Black vignette
Vignette as left. Use the red filter and remove the negative. Hold dodger over image, remove filter and fog edges (see below).

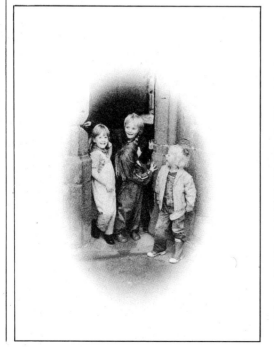

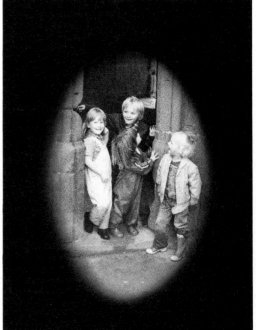

Vignetting to combine images

If you dodge out part of one image during printing, you form a space into which you can vignette another image. Take care over your choice of picture elements. Technically, they should match closely in lighting, perspective, and image contrast. Visually, they should relate in some way. Check the combination before printing by tracing outlines of both images on opaque white cardboard on the masking frame. This forms a registration system of the type used in multiple printing (see *Reference box*). Use it to cover the printing paper between exposures, and as a guide to the position and size of each element. You can fully overlap your combined images (as shown below), or merge them along convenient lines (see pp. 154-5).

1 *Set up and focus your first negative. Place a sheet of cardboard in the frame. Trace the main outlines in pencil.*

2 *Change negatives. Alter head height and frame position until the new image fits the first. Trace it on top.*

3 *Test each negative alone for correct exposure. Use your tracing in the frame when setting up each new negative.*

4 *Expose the first negative on bromide paper. For the image below, the central area was dodged for half the exposure time.*

5 *Place the paper in a paper safe. Carefully locate the tracing in the masking frame. Set up your second image.*

6 *Replace tracing with your part-exposed paper. Vignette in the second image for half its correct exposure time (see below).*

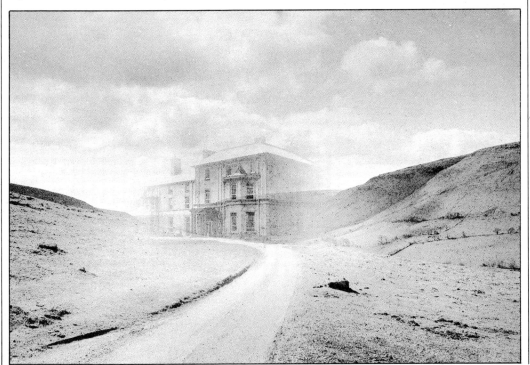

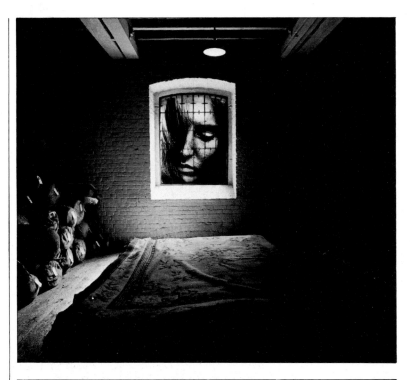

Combination printing

When you are combination printing into a distinct shape, you can use a tightly shaped contact mask. For the print on the left, a complete print was made first from the interior negative (on double-weight paper). The window shape was then cut from the paper using a sharp knife. To make the final print, bromide paper was taped to the open masking frame, and exposed to the interior negative, except for the window area which was dodged for part of the exposure. Then, the print with the cut-out section was placed on top of the part-exposed paper, and positioned with the aid of the red filter. The negatives were then changed and the second image printed into the hole.

Joining at a straight line

If you have two images that simply butt up against each other along one straight line, you can expose using two halves of a cardboard mask in contact with the paper (see result left). Or you can overlap the images so that details merge realistically (see facing page). For this effect, shade half the paper with the side of your hand held several inches above the paper during the first exposure. Then, using the same hand profile, print in the second negative.

Registration

Darkroom manipulation techniques often call for the precise shielding of parts of the image during exposure. You will find that processes such as high-light masking (218-20), multiple printing (224-31), and posterization (244-51) all depend on you being able to contact print several images in sequence on one piece of paper or film in exact register—working under dim safelighting or even in total darkness. A punch system is the best method of registration. This makes two or more holes near the edge of each sheet of film or paper corresponding to pins which you locate firmly on the enlarger baseboard. You can punch the material before exposure, then locate it on the pins knowing that the projected image will fall in exactly the same place each time. After processing, you can contact

print a sequence of these sheets on punched photographic paper—the pins ensuring automatic registration. If you are using existing negatives this way, you can tape a width of scrap film along one edge and punch the holes in this.

The simplest registration system is an ordinary office punch and a two-pin board you can make yourself (see below left). Alternatively, you can buy a precision Kodak register punch and a tape-down pin bar. These are more robust and accurate for very precise work, but much more expensive to buy. The illustrations on the facing page show a practical use of a register pin bar and punch system of the Kodak type. Several film variations (and intermediates) from an original negative were contact printed in sequence to form one image.

Office punch system

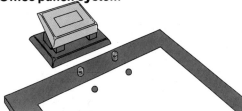

Buy a good-quality office punch, strong enough to punch holes through plastic sheet film without making it tear and buckle. For working in the dark set the punch into a board (see right) so that the whole film remains level during punching. Make your pins from wooden doweling, or cut the heads from stubby nails and file the ends down smooth. Fit the pins into a piece of non-warp board larger than the biggest material you are likely to use.

1 *Set the punch into a thick board platform. The lower edge of the punch throat must be level with board top surface. Fit film stops if you require.*

2 *Punch holes in a scrap sheet of film. Use this as a template and mark the exact position of the pins required on your exposing board.*

3 *Drill out and glue in place wooden or metal pins ½ in (1½ cm) high. Smooth pins until films fit firmly but lie flat. Paint board matte black.*

Kodak punch system

A photographic punch is more precisely made than an ordinary office type (see left). It also cuts holes wider apart for greater accuracy when using larger films or papers. By making three holes of two different shapes, it prevents you locating the punched materials on the pins the wrong way up in the dark. Sets of precision-made pins mounted in thin metal bars come with the unit. You attach them to the baseboard with tape.

1 *Mount the punch on a baseboard. Leave holes below each punch pin for punchings to fall clear. Fit the film platform at punch throat level.*

2 *Temporarily attach the pin bar to one side of your enlarger baseboard. You should use strong double-sided adhesive tape.*

3 *Fit another pin bar along one edge of a light box. This allows you to register images for viewing before printing, or for copying (see p. 180).*

Making register pin masks

Sheet 1 *Set up the enlarger. In safelighting punch a sheet of ortho-chromatic continuous-tone film, and place over pins. Expose and process.*

Sheet 2 *Punch a sheet of acetate. Place this over processed film on light box, both on pins. Paint out areas to be masked using liquid opaque.*

Sheet 3 *Remove negative from enlarger. In safe-lighting, punch a sheet of lith film. Place film, then acetate, over the pins. Contact print (see below).*

Sheet 4 *Process and dry* **Sheet 3.** *Contact print it on punched lith film, to pro-duce a high-contrast version of* **Sheet 2.**

 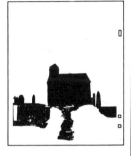

Sheet 1

Sheet 2

Sheet 3

Sheet 4

Using register pin masks

Using a register pin system allows you to choose any or all of the masks above, and print them in sequence (with or without the projected image). To produce the result on the right, it was necessary to return the original negative to the negative carrier. **Sheet 4** was located over the pins with a sheet of white paper underneath. Then the negative was shifted until the projected and film images exactly aligned. **Sheet 4** and paper were then removed. The print was finally exposed using two masks and two nega-tives (as shown below).

1 *Register punch a sheet of photographic paper. Place it on pins with* **Sheet 3** *on top. Expose to projected negative image. Remove paper to safe.*

2 *Change to a suitable sky negative. Replace paper over the registration pins with* **Sheet 4** *on top of it. Expose paper to the pro-jected negative; process.*

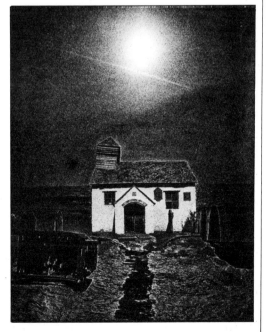

Final result

Half-tone screens

Using a half-tone screen you can reproduce a full range of gray tones with materials and processes which normally only give solid black or clear white. These screens consist of continuous-tone film carrying a pattern of equal-width light and dark lines rendered slightly unsharp. When you print a normal photographic image through such a screen on lith film, bright parts of the image record as large sharp dots or lines, and dim parts of the image record as smaller dots or lines. From a normal viewing distance, the eye sees these size variations of line or dot as differences in tone.

Screen and image formation

The screen forms gradated "pools" of light on lith film (lower layer). Bright image light "burns through" as big spots, and dim light records as small spots.

Screen patterns

There are a large number of commercially made half-tone "contact" screens, varying in design and size of pattern. Some of the more popular are shown here. The cross-line screen (see p. 163) is the most commonly used because it is the least obtrusive. You can also draw your own screens (see right). The finer the screen rulings you draw, the greater the number of gray tones you will obtain in the final reproduction.

Mezzotint

Concentric circle

Parallel line

Wavy line

Brick

Making and using screens

To make your own screens, prepare a large area of pattern of equal black and white zones. This might be hand-ruled lines, dot tint transfer, or an obliquely lit textured surface. Photograph this on high-contrast film, and then enlarge it, slightly out of focus, on continuous-tone sheet film (see below). Use a magnifying glass and check that throughout the final pattern each line reproduces as a dark "core" graduating to clear film. To make the final half-tone image, press the screen down on lith film and expose your picture image—either by projecting through it or by contact printing on top of the screen. You have more flexibility when enlarging as you can vary the coarseness of your result by making the image small or large (see p. 163).

1 Enlarge the line image photograph of a fine pattern (shown here oversize) to give the area of screen required. Illumination and density must be even.

2 Shift image slightly out of focus. Use a magnifier to check that lines are soft edged. Expose on continuous-tone sheet film. Process normally.

3 Set up your picture image in the enlarger. In correct safelighting, position the lith film with your screen on top. Cover with a piece of clean glass.

4 Expose and process the lith. Examine the result with a magnifier. Varying-size dots or lines should be present from the shadows through to the highlights.

Mezzotint pattern half-tone negatives

It is a characteristic of half-tone images that grays are reproduced by thickening or thinning of the black line part of the screened pattern. Areas that appear as dark gray have the black part of the pattern wider than the white parts. This relationship is reversed in areas that appear as light gray (see below). Both half-tone negatives here were made by projecting a color slide through a mezzotint pattern contact screen on to lith film. The image, right, is from a slide of a back-lit landscape, printed through coarse mezzotint. A slide of a lower-contrast scene, screened by fine-patterned mezzotint, gives the result below.

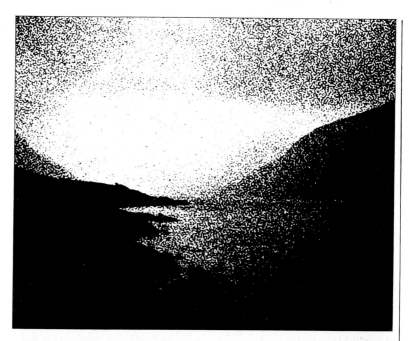

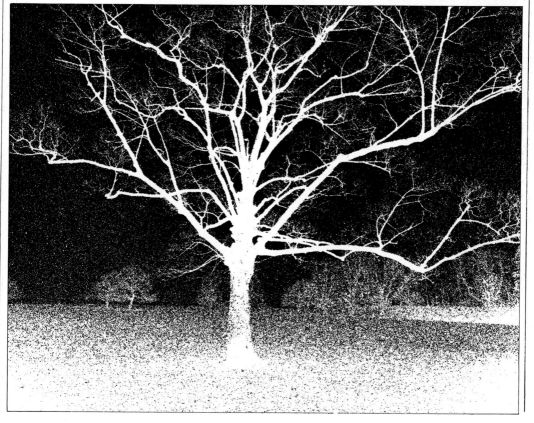

Using linear effect screens

These negatives and positive prints were made from images converted to half tone with linear screens, as shown on p. 158. They all have obvious patterns, which were chosen to blend with the particular images. In this way, the "bulls eye" of a concentric circle screen above coincides with the point of convergence in the landscape. Vertical wavy lines suit the image right, and straight parallel lines relate well to the horizon below. In all cases, you can enlarge small areas of an image to produce a semi-abstract effect (see facing page).

Mixed screen patterns

You can use a mixture of "assertive" half-tone screen patterns to suit different areas of the same image. For the landscape on the right, a vertical brick pattern screen (see p. 158) was butted up against a mezzotint pattern screen. The image was then carefully positioned so that the join corresponded with the straight-line horizon. Another, more flexible, way of working is to make two or more half-tone paper prints, each fully screened in a different pattern. Then cut out the chosen parts from each print and use them to reassemble a complete picture. Finally, copy the montage (see pp. 288-92) on line film. You can also mix negative images (see below) with parts of positive images. If you print on color paper you can filter the patterns into different colors (see pp. 142-3). Then carefully cut out parts of these color prints and assemble a mixed negative and positive color montage.

Prescreened film

A cross-line pattern screen produces the least obvious effect when you convert a continuous-tone image to half tone (for example, prior to reproduction by silkscreen, Color Key, or some of the old processes – see pp. 260-4, 313-14, and 318-31). You can make or buy cross-line contact screens, or use Kodalith Autoscreen sheet film, which is fogged in manufacture behind a cross-line screen. You expose and process Autoscreen in the same way as all other lith materials, but it automatically reproduces continuous-tone images in dots as if they were exposed through a screen. Enlarge or contact print images on this film, or cut it to fit your camera for copying slides or bromide prints.

Controlling the coarseness of the screen

For final screen ruling of	16	66	133	lines per inch
Expose image on Autoscreen at	x⅛	x½	x1	final size

The screen pattern built into Autoscreen film is only made 133 lines to the inch. You can, however, vary this by carefully printing (or exposing your image in the camera) on film smaller or larger than you finally require (see table above). You can then enlarge the dot image (or reduce it by copying) to its final size for your image.

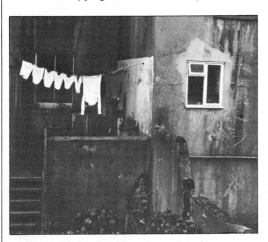

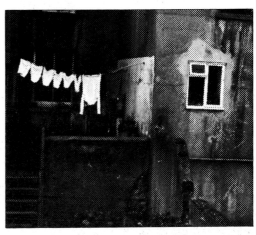

For the image above left a continuous-tone negative was enlarged on Autoscreen film, then contact printed on bromide paper. The resulting half-tone pattern has 133 lines per inch, which, from a normal viewing distance, gives a good range of tones. Processes such as photo lithography (see pp. 297-8) can make use of even finer screens. If you intend to silkscreen your image, however, very fine rulings may result in the ink clogging. It is much safer to prepare a coarser 66-line screen, as in the image above. To produce this, the original image was exposed half size on Autoscreen, and the film then enlarged to double this size. For the coarse result, left, the original 35 mm negative was contact printed on Auto-screen, then enlarged by 13 times its original size.

Tone-line

The tone-line process converts a continuous-tone photograph into a white or black contour image that resembles a pen and ink drawing. Results are similar to solarization (see p. 236) or equidensity film images (see p. 212). Choose a strong, linear design and make one negative and one positive film image from it. (These must be exactly the same size, density, and contrast.) Next, place the two films in contact back-to-back, or space them apart using a sheet of clear film to make the line thicker. Contact print this sandwich on lith film using oblique lighting. Light will spill through the images along their outlines (see below), recording detail as a black contour on processed film. For a complete record, you must keep the direction of illumination changing by rotating the light or the printing frame during the exposure (light must remain oblique to the film). If you want a slightly different effect, you can make one of the sandwiched films denser or more contrasty than the other. This will give you some tone in your final result.

Preparing and exposing the image

Select a sharp, simple image that will not become too cluttered. Enlarge your image on print-size line or lith film, then contact print the result on another sheet of the same film. Sandwich the two results, back to back and contact print on lith film. Either place your printing frame flat on a record turntable, with a light bulb or flash lamp several feet away, at a 45° angle, and rotate it, or use a swinging light system (below right). Always give an exposure time of at least 10 sec for an even result.

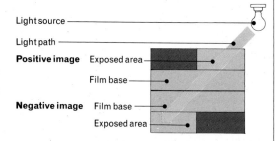

Light source
Light path
Positive image — Exposed area
Film base
Negative image — Film base
Exposed area

1 *Enlarge your continuous-tone negative to final print size. Expose it on register punched high-contrast film. Process and dry result (below center).*

2 *Contact print positive on register-punched high-contrast film, emulsion to emulsion. The positive and negative should be of equal density.*

3 *Place a new sheet of lith film on the register pins. Place the film sandwich (negative and positive), back to back, on top of the lith film.*

4 *Set a small ceiling-hung lamp swinging so that it circles the frame throughout required exposure time. Process film; contact print on paper.*

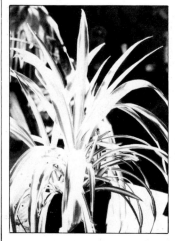
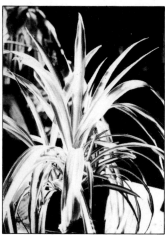

Original

Positive

Negative

Uneven development

You can abstract ordinary images into various patterns by dabbing or dribbling developer over the exposed paper, instead of evenly developing it in a tray. You can apply the developer, either in concentrated form or diluted as recommended, using simple tools such as brushes, a bottle spray, or a sponge (see right). When the patches of emulsion affected by the developer reach full density (this will be quicker if you use concentrated developer), fix the print immediately, and wash your result to make it permanent. The more irregular and coarse the application of developer the more your image becomes abstracted (see below and facing page), and the more interpretive the final result.

You can obtain similar results if you splatter iodine bleacher (see p.172) on a fully processed print, and then fix and wash it. Another possibility is to make your enlargement from a transparency. You can then develop it unevenly, fix, and wash it, and contact print it on to another sheet of paper (see p. 144).

Applying developer unevenly

Tools for applying developer include various coarse brushes, a bottle spray, paper towel, and a paint roller – use them singly or in combination.

Controlling results

You can unevenly develop papers of all types and surfaces. First test to find the exposure time that produces a good print when you develop the paper normally in a tray. For your uneven processing, use a flat non-absorbent surface, which you can tilt if required. Work near a safelight obliquely positioned to show up the distribution of developer droplets. Even with concentrated developer you must allow sufficient time for affected parts of the image to reach full tone. Often, you can treat extra areas with developer after the first ones have begun to appear.

The image shown above is a fully and evenly developed print from the negative used for four of the manipulations below and on the facing page.

The type of uneven development above, usually occurs accidentally. If you dip the paper into the developer in stages, and do not agitate sufficiently, you are likely to get bands of light and dark density.

Using a paint brush

The result above was produced with concentrated developer painted on exposed 8 x 10ins (20 x 25cm) paper using a 1in (2.5cm) brush. For this effect, load your brush with developer and apply it in one continuous movement (right). Leave paper flat to develop fully.

Using a scrubbing brush

Use a scrubbing brush dipped in developer moved backward and forward across the paper once to produce the effect above. Take care not to scratch the emulsion or you will get black abrasion marks as well.

Using a spray

The crazed pattern version above, was made by applying concentrated developer with a spray. For the type of result below, spray the paper lightly and then squirt on extra developer in a rough criss-cross pattern. If you pour developer from about 2 ft (60 cm) on to the exposed print, you will get the type of result shown far right.

First practice your spray distance and angle on scrap paper to find the best pattern of droplets.

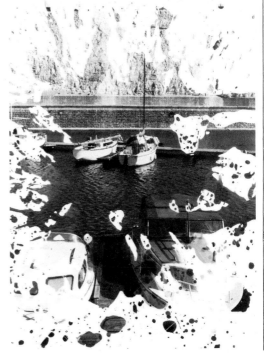

Intensification

A thin, low-contrast negative will generally print flat and gray, even on a hard grade of paper (see pp. 96-7). It is possible to improve results, though, by intensifying (strengthening) the negative either chemically or non-chemically. A thin original negative may be either underexposed or underdeveloped. Underdevelopment is much easier to correct because some weak shadow detail is still likely to exist (see p. 72). Chemical intensification (see below) converts the silver image into darker chemical compounds, or colors them so that they are effectively more dense. It does, though, increase grain, and there is some risk of damage or staining when you are treating the negatives. As a precaution, you should make the best possible

prints from all your negatives before you start giving them any chemical intensification.

A non-chemical method (suitable for silver or dye image film) involves combining a negative with an image-strengthening mask (see facing page). With this method, you must first make a duplicate negative and then sandwich it with the original. A side-effect of this type of treatment is an overall increase in contrast. To avoid excessive contrast, make sure that the sandwich negative contains more shadow than highlight information.

You should only regard intensification techniques as emergency treatments. Your results will never match the quality of prints made from correctly exposed and developed negatives.

Chemical intensification

Use a fully fixed and washed film. Load complete films on reels and place them in tanks. Treat single negatives or strips in trays. For moderate intensification, bleach and sepia tone the film like a print (see p. 268). For a stronger effect (below), use a chromium intensifier (available from photographic suppliers).

1 *Soak negatives in clean water for 10 min. Wearing gloves, prepare chromium bleach solution according to instructions.*

2 *Gently agitate the film until blacks turn pale yellow. Wash away stain. Re-blacken in concentrated print developer.*

3 *Wash your negatives thoroughly in running water for at least 10 min. Hang the film up to dry in a dust-free area.*

Print from original negative

Print from intensified negative

Non-chemical intensification

To intensify very thin negatives, press them against white paper and copy them (see p. 180). If a thin negative has very low contrast as well, you can make a duplicate negative and print this in combination with the original. To make the duplicate you must first contact print the original on continuous-tone film (to produce a positive), then print the positive on continuous-tone film (to produce a negative). For underexposed negatives with low-contrast shadows but normal-contrast highlights, make a positive film mask (see **Mask 1** right). Use this weak film image in combination with the original and make another positive (**Mask 2**). Remove **Mask 1**, combine the original with **Mask 2** and print on hard-grade paper.

Mask 1 **Mask 2**

1 *Contact print original negative on continuous-tone film. Underexpose so that only shadows record, remainder is clear film.*

2 *Process and dry first mask, then tape it in register with the original negative. Shadows will flatten out.*

3 *Contact print combination on continuous-tone film to produce a second mask. Underexpose and underdevelop.*

4 *Remove* **Mask 1** *from the original negative and replace it with* **Mask 2**. *Enlarge combination on hard-grade paper (below).*

Print from original negative **Print from negative and mask 2**

Negative reduction

Chemical reduction or masking will improve a dense black and white silver negative which would otherwise be impossible to print. If subject highlights are heavy and flat, but contrast is normal in the shadows, you probably overexposed your negative. An overdeveloped negative will have increased contrast overall, with very dense highlight detail. You can minimize both these faults by using chemicals that dissolve away some of the silver image to make the whole image less dense (see below). Some solutions, such as Farmer's reducer, will increase negative contrast; others maintain it at about the original level. They all, however, exaggerate image grain. If you are not careful, it is possible to over bleach film—so

test solution strength on an unwanted negative first. Reduction by masking (see facing page) is a slower technique than chemical reduction, but it has the advantage of not exposing your negative to possible damage. You first make a weak positive mask on film, which you use to add density to shadow parts of the negative. Although this combination appears to be even darker than the original negative, masking gives the image lower, more equalized contrast. Your masked negative should print well if you give it a long exposure on a hard-grade paper. With both these methods of reduction, you cannot expect results to match the quality of a print made from an accurately exposed and processed negative.

Chemical reduction

Use normally fixed and washed negatives and ordinary room lighting. Farmer's reducer will make negatives lighter and more contrasty (see right). If you have to reduce contrast as well, bleach the negative completely in sepia toner bleacher (see p. 268), then darken it in quarter-strength developer until the density looks correct.

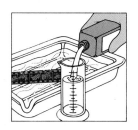

1 *Pre-soak negatives for 10 min. Prepare Farmer's reducer. Test strength; dilute if necessary.*

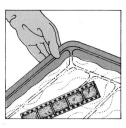

2 *Immerse your negatives in the reducer for a few secs, gently agitating the film.*

3 *Rinse, then check image density. Repeat until reduction is sufficient. Wash for 10-20 min.*

Print from original negative

Print from reduced negative

Masking

Masking is often the best way to improve a negative which is excessively contrasty as a result of overdevelopment or harsh subject lighting. This type of negative will generally print with chalky, "washed-out" light tones (see below left). If you try to correct this by using a longer exposure, the transparent shadow areas of the negative will scatter light into the highlights,

turning them a muddy gray. However, if you add a weak positive mask to the negative, it will give the shadows enough density to allow you to expose your image for longer without creating flare. Make your mask slightly unsharp (see below). If you make too strong a mask, the shadow detail will begin to print with predominantly negative tones.

Original negative

Positive mask

1 *Contact print negative on continuous-tone film. Underexpose so that only shadows will record.*

2 *Process in diluted developer for pale gray shadows (above far right). Leave film to dry.*

3 *Cut out this positive mask and register it with negative, back to back. Tape them together.*

4 *Enlarge combined sandwich, doubling the exposure you gave when you printed negative alone.*

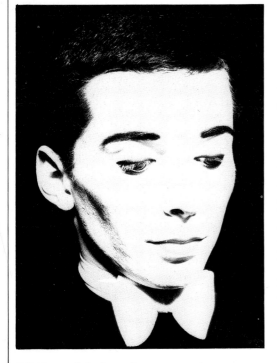

Print from original negative

Print from negative and mask

Print reduction

The chemicals you use to improve dense negatives (see pp. 170-1), will also reduce black and white print density. Farmer's reducer (available from photographic suppliers) applied to a processed print will lighten areas too small or too awkward to shade during printing. You can also totally change the atmosphere of a picture by making a very dark print and then chemically treating one element so that it stands out from somber surroundings. You can make overexposed, flat prints lighter and, because Farmer's reducer affects pale tones faster than dark ones, it is excellent for "clearing" veiled highlights so that they appear more brilliant.

A home-made reducer containing iodine (15 g potassium iodide with 5 g iodine per liter of water)

is ideal for bleaching parts of the print down to white paper, without permanently staining the base material. You can also use it to turn black spots white for later retouching (see p. 110). Unlike Farmer's reducer, iodine reducer keeps well as a working-strength solution. During bleaching it forms a brown patch on the print, but this clears completely if you refix and wash it.

You can apply both types of reducer in normal room lighting. It is best to handle selective reduction of small areas using a brush or cotton ball, as shown below. To treat a large area, apply protective rubber solution to the areas you wish to retain and then place the whole print in a tray of chemical reducer (see facing page).

Reducing small areas

To lighten a small, hard-edged area, such as the figures below, apply Farmer's reducer with a brush. Wet the print first, and then remove all excess water with a sponge or print squeegee – this will stop the chemical running into other areas. Reduce in stages. Apply water frequently to stop the action of the reducer.

1 *Pre-soak a dry print for 5-10 min while you prepare the chemical. Test your solution strength on a waste print.*

2 *Place your print on a smooth, flat surface. Remove excess water, then carefully apply reducer with a brush.*

3 *Rinse in running water and then repeat* **2** *until the density of the treated area is correct. Re-fix and wash the print.*

Original print

After reduction

Reducing large areas

If you want to lighten the whole image, submerge the print in a tray of dilute Farmer's reducer. In the example below, highlights are brighter and the grain is exaggerated. To bleach a sky completely white, paint rubber solution over all other areas and then immerse the print in a tray of iodine reducer (below right).

1 *Working on the dry print, paint protective rubber solution over areas you want to retain. Allow rubber solution to dry.*

2 *Immerse print in iodine reducer for 1-2 min. Then rinse and fix until all trace of stain disappears. Wash for 10-20 min.*

3 *Dry the print. Carefully peel off the rubber coating. For a selection of results, see below right and also p. 174.*

Original print

After Farmer's reduction

After further iodine reduction

The ability to apply chemicals to tightly limited areas of a print is useful for further print manipulations such as toning (see pp. 268-75). The print above had all parts of the image except the buildings coated with rubber solution. It was then bleached and color toned. When the coating of rubber was peeled away all the protected areas retained their original black and white appearance.

Using liquid emulsion

You can form photographic images on various unusual surfaces by sensitizing them to light with a coating of liquid emulsion. When the emulsion has dried, you expose the treated material under the enlarger, and then process it using ordinary printing chemicals to produce a black and white image. You can make up a mixture of silver halides and gelatin, but the preparation is time consuming and it is very difficult to obtain consistent results. Instead, you can use a ready-made preparation called Liquid Light (see pp. 176-7).

Practically any surface is suitable for this type of treatment – wood, plaster, wallpaper, glass, ceramics, and most plastics, for example. You can also apply liquid emulsion to paper, giving it a pattern of brush marks. Liquid emulsion is easy to apply to three-dimensional objects as well, such as eggs, sea shells, or various man-made forms. Try using materials that relate to your photographic image – perhaps through association of texture or shape.

Printing on stone

The piece of stone above was coated on both its front and side surfaces, then exposed under the enlarger, and processed as shown on p. 176. Next, the back surface was coated and printed with the same negative in the enlarger (see left). As the coating of emulsion is very thin and transparent, it takes on the texture and color of the base material used. If you side light your results you can make the photographic image seem deeply impregnated into the stone. With most surfaces you must apply some form of foundation ("subbing") layer first. This helps the emulsion adhere evenly to the surface (see p. 176).

Base preparation, emulsion testing

Liquid Light is supplied with a tough, two-part gelatin subbing solution, which you must use for preparing non-porous materials such as glass or glazed ceramics. You may have to give highly porous materials, such as plaster and some plastics, a thin coating of a clear phenol varnish diluted 1:1 with naptha. If you are using primed canvas, give it a coat of dilute, flat wall paint. With most papers, cloth, and unprimed canvas you can coat on the emulsion direct. Always test the emulsion for condition, as shown below. Shelf life (chilled) is about 6 months, but as it ages the fog level increases. An anti-fog developer additive supplied with Liquid Light helps keep this in check.

Applying and printing emulsion

Usually when applying emulsion your aim is to form a thin, even surface layer. If you warm the surface first, spreading will be much easier. For a flat, smooth surface, pour on the emulsion and tip any excess back into the container. Spread the coating with your finger or use a flat brush. On coarse, stretched canvas apply the liquid with a wallpaper brush. You can dip small 3D objects in a bowl of emulsion. Do not allow the emulsion to build up excessively because it will reduce image definition. When applying the emulsion, also coat a small piece of the same material (or similar material). You can then use it to make an exposure test strip (as shown below).

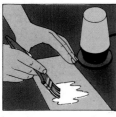
1 Clean base material. Apply subbing (or similar foundation). Allow 1 hour drying for subbing and 12 hours for varnish.

2 To turn the emulsion into liquid, invert the stoppered container in water at 95°-104°F (35°-40°C) for about 5 min.

1 Under safelighting, pour sufficient emulsion into a warmed graduate. Coat a sample piece of the material to be used.

2 Hold the prepared surface horizontally. Pour on the emulsion, tilting to spread it over the surface. Tip surplus into bottle.

3 Under orange safelighting, open the container. The emulsion should have a creamy consistency – spread a little on paper.

4 When dry, process the paper in print developer, stop, and hardener fixer (without giving the paper any exposure).

3 Remove any bubbles with a soft brush. Then dry the emulsion for at least 20 min in a cool stream of air.

4 Make a test strip on the sample material. Process, and assess the correct exposure time you will require for the full image.

5 Carefully reseal the emulsion container. Switch on the white light and check your paper for signs of gray fog.

6 If necessary, use the anti-fog chemical supplied. Add to developer as recommended in the instructions.

5 Expose the complete surface. Develop, stop, and fix. Wash non-porous surfaces for 15 min, others for 30 min. Then air dry.

6 Give a protective varnish, or recoat with emulsion for multiple images. Scrub failures in hot water to remove the emulsion.

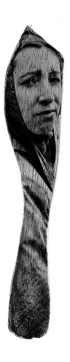

Printing on glazed ceramics

The photographs printed on the glazed white plate and wooden spatula were made by separate exposures to the same negative. Both objects were coated with liquid emulsion as shown on the facing page. The color of the underlying wood gives the spatula image its yellow-brown appearance. Broken emulsion round the perimeter of the plate image was caused by "frilling" during development. Make sure that solution temperatures do not exceed 68°F (20°C). With care, you can cut and peel away any rough edges prior to drying and varnishing. Try to choose an image that fits well within the shape you are sensitizing. High-contrast line or lith negatives often produce striking results. Before sealing the image you can hand color it (see pp. 280-3).

Processing distortions

You can deliberately process film incorrectly for a range of colorful effects—examples on these pages show what happens when you make color prints from such film. You can form a color negative on most types of color slide film by giving regular color negative processing, as shown on pp. 81 and 83. Equally, color negative film will give slides, of a sort, if you process it in chemicals designed for color slide film.

The mime artist in these pictures was photographed through a prism lens, using Ektachrome and Kodak color negative film. Each film was cut in half, and two half-films (shown on this page) given C-41 processing. The other two half-films (facing page) were processed in E-6. You should always use "one-shot" chemistry when you are processing film incorrectly, as the by-products will contaminate your solutions.

C-41 processing

Both film images shown below were processed normally in C-41 color negative chemistry. When you enlarge C-41-processed color negative film on to negative/positive paper, the result is a normal image, right. If you keep the same filtration, but print from a negative formed on Ektachrome film, the result will be strongly yellow, see lower left. Ektachrome will give normal colors if you adjust filtration, but with an increase in contrast, lower right.

Film image 1
Ektachrome incorrectly processed in C-41.

Film image 2
Color negative film correctly processed in C-41.

This enlargement from **film image 2** *was made on negative/positive paper* *and filtered 65Y 30M. It shows normal color and contrast.*

This enlargement was made from **film image 1** *on negative/positive paper,* *filtered 65Y 30M. Absence of the usual mask causes this cast.*

This print was also made from **film image 1**, *but with filtration changed to* *95Y 30M. Compare contrast with the correctly processed image.*

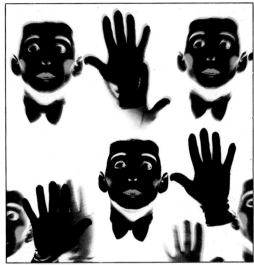

E-6 processing

Both the film images right were given E-6 processing. The color negative film (near right) has a warm cast due to its mask. It was enlarged on to negative/positive paper and filtered 75Y 45M to give a white background (above).

The E-6-processed film image, left, is on Ektachrome film, for which E-6 is the correct chemistry. Enlargement on to negative/positive paper gives an extremely hard result with simplified color (above). To keep the neutral white background a filtration of 85Y 55M was given.

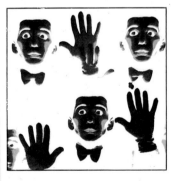

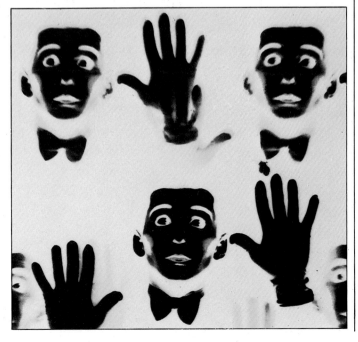

Images above and right were enlarged on to negative/positive paper from E-6-processed color negative film. The version right was given no filtration, and the smaller print (above) was filtered 90Y 40M. Experiment with filtration until you get the colors that you want. Use the variations on these pages as starting points for your own manipulations. You can also mount the incorrectly processed negative film itself, and then project it as a final slide image.

Copying

Your enlarger can do more than just print nega-tives or positives. You can, for example, use it like a camera and copy-photograph drawings, stamps, coins, publications, and prints (for montage) placed on the baseboard. Most of these basic techniques are shown below. It is important to il-luminate the baseboard evenly—for black and white work you can use two desk lamps, but for color copying you must use light of the correct color balance to suit your film. To minimize glare, keep your lights at a low angle to the baseboard. Make each exposure on a length of film short enough to tray process, and if you are using blue-sensitive or orthochromatic materials you can use safelighting. With some enlarger types (see pp. 38-9) you can rotate the lamphouse mirror and use it to look down through the negative carrier. If you then replace the carrier with a special ground-glass focusing screen unit, and slip a sheet film holder into position before making the exposure, you will have a very versatile copy camera. You do not, though, require a sophisticated enlarger for copying. Any enlarger will act as a light source for contact copying material directly from books (see below). Or, replace the head with a reflex camera, and use the set up as a vertical copying bench.

Using the enlarger as a camera

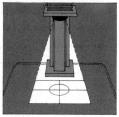

1 *Draw cross lines on clear film. Place it in the negative carrier and focus to the size of your original. Lock focus and turn the enlarger off.*

2 *Tape down the original within the area of the pro-jected image. Set up your lighting and test for expos-ure with the lens stopped down using a light meter.*

3 *In complete darkness, replace the clear film with a short length of un-exposed camera film (or cut-down sheet film), emulsion side down.*

4 *Control the length of ex-posure by turning on the lamps for the required period. Remove and process the exposed length of film.*

Copying from a light box | Reflex copying | Copying on instant film

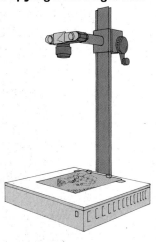 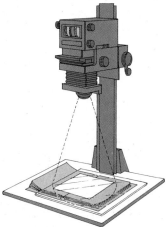 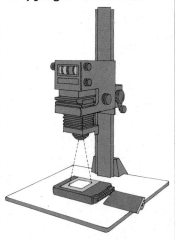

It is easy to copy prints (with lamps) or slides (using a light box) if you substitute a camera for the enlarger head. For posterization-type results (see pp. 244-51) tape register pins (see pp. 156-7) on the light box and copy images in sequence through color filters, on a single frame of color film.

You can make copies of books and documents by direct contact using reflected rather than transmitted light. Cover the page with single-weight, hard-grade paper, emulsion down. Press under heavy glass, then expose to light from the enlarger. Process, and use the sheet as a paper negative (see p. 144).

To make quick copies of color slides, you can use a 5×4 ins (12.5×10 cm) instant film pack back. Glue white paper to the top of the darkslide and focus the image. Stop down the lens fully and try filtration of 40M 30C. In darkness, withdraw darkslide and expose for about 4 sec. Pull tabs to process.

Advanced manipulations

Introduction

This is the most comprehensive darkroom section of this handbook. There is no practical reason for working through it sequentially, as most of the techniques have *Reference boxes* that tell you where to find additional information in other parts of the book. The sixteen subject areas in this section build on the printing skills taught at the beginning of this book, as well as some of the basic manipulations in the previous section. Once again, bear in mind that your choice of original image is fundamental to the final result.

The label "advanced" does not necessarily mean complicated, so much as extending and, in many cases, combining your existing knowledge. Some topics may seem out of place as advanced work, but they span a number of procedures; for example, photogram techniques range from basic black and white printing to polarized light color printing. Rather than split the same technique between two sections, it is presented here as one broad group. At the other extreme, this section also teaches techniques such as dye transfer and materials like equidensity film, which take very considerable time and care to master properly.

When looking through this section you will notice how often procedures overlap and interweave. Sometimes it is difficult to say where one area (shadow masking, for example) ends and another (say, bas-relief) begins. They are all presented here as methods you can continue to mix and blend to make your pictures something out of the ordinary.

The first pages deal with photograms in black and white and color, on paper or film. Photograms are a truly cameraless darkroom method of creating pictures, and also form a first-class source of patterns for making texture screens or images for later manipulation, using techniques like highlight masking or Color Key. Next, there is a group of manipulations based on the use of high-contrast black and white films. They stem from the conversion of images to line introduced in the previous section. Now, however, this use of line or lith materials extends into making distorted color prints, and the addition of stark black highlight or shadow areas to slides. Some of these materials are demanding to use, but with experience they offer you a short cut method to other techniques, such as solarization. All these manipulations give very bold "graphic" results.

A number of specialized optical effects are also explained here. They cover distorting the shape of your image and diffusing or patterning it to destroy fine detail. Techniques like this apply to black and white and color images. Here is also an instance where the additive method of exposing color prints offers extra possibilities – optical devices can be altered, and screens shifted, between each of the three separate exposures.

Sometimes a manipulation may involve only an extremely simple technique, yet has the potential of giving striking results when used imaginatively, and with the right images. A classic example of this is the sandwiching of two color slides to give a composite picture result. They can then simply be printed on positive/positive paper. Another way of forming strange, dream-like images is to print from several negatives, one at a time, on a single sheet of paper. Multiple printing gives a great range of interesting results because of its flexibility – you can control relative size, contrast, and color of each component part of the picture. Results look very convincing even though the situation shown is clearly totally impossible. The techniques involved in multiple printing graduate in complexity from simply exposing two halves of the picture from separate negatives across a straight horizon, to lengthy and complex printing sequences involving shaped cardboard masks, film masks, and a half a dozen negatives.

The "classical" manipulations

For nearly all photographers the term "darkroom manipulations" immediately conjures up certain time-honored techniques, such as posterization, bas-relief, and solarization (the Sabattier effect). These particular devices mostly date back to the 1920s, where they formed part of the revolutionary art movement of the time. Today, of course, they can embrace color as well. Results have their own characteristic qualities – solid areas of tone or bright color, lined-in shapes, flattening of forms and perspective. They are all worth trying, and you will quickly realize how most of these are close relatives of techniques used elsewhere. Solarization is, after all, a form of masking, and posterization is based on tone-separated negatives. One or more working methods for each are given here. But, having grasped the principle, you will soon devise variations of your own.

The final manipulations in this section use processes that are carried out partly in the darkroom and partly in a normally lit workroom. Dye transfer, for example, is a throw-back to assembly color printing of the 1930s, when people had to work from tri-color separation negatives. As a method of printing color objectively it is extremely skilled and time consuming; but it offers a relatively simple means of making manipulated prints in one or two colors. Once your gelatin "printing plates" have been made photographically, colored results are made by dyeing and then rolling them in contact with a piece of receiving paper. Choices and changes of color can be decided physically, on the spot.

Photo silkscreen printing is another assembly process, which is part photographic and part mechanical. It brings together both line and half-tone conversion techniques and separation negatives (found in the previous section), and bridges this darkroom section with the *Workroom techniques* section following. Silkscreening offers a wide range of broad poster-type results, and is best used with large areas of color. It is easy to combine images and alter colors, even at the final stages. At the printing stage of this technique you apply

printer's inks to paper, working in a normally lit room. Here the process is explained in a form using lowest-cost materials and equipment, but mechanized silkscreen printing is an important commercial printing process too. In the fine arts it is much used as a creative medium.

Experimentation

Regard the techniques presented in this section as starting points for your own experiments. By understanding the main principles, as well as practical handling procedures, you can plan permutations of processes that can lead to very unusual results. For example, black and white photographs can be tonally separated and then silkscreen printed in color. You should also try extending the detail of each process. Image shape changes are demonstrated here by bowing and angling the paper – but what happens if you stand mirrors vertically on color paper and turn the image into a kaleidoscope pattern? Try it and see.

Even at the end of a manipulation technique, when you are processing your color print, remember what the various chemical stages do (fourth section). A negative/positive print could have the bleach and subsequent processing stages omitted, and just be fixed instead. You might then try brushing on ferricyanide reducer (fifth section) to bleach the silver and reveal color only in chosen parts of the print. Again, just because the result of a technique is shown printed on silver dye-bleach paper, does not mean that it might not look as good or even better printed on negative/positive paper, or exposed additively instead of subtractively. If you buy color-based black and white bromide paper, this could be used for printing any of the manipulations that finally produce a black and white result. (Line images of all varieties can give impressive results if you enlarge them on a silver-colored paper, for example.)

With such a rich choice of multiple treatments do not get carried away with technique for its own sake. Remember also the simpler procedures here that can be used alone to produce a range of interesting images – for example, drawings made on paper can be contact printed on black and white or color paper, with great success.

Historical background

Multiple printing from several negatives was the most skilful of many manipulations used by "serious" photographers from the late 1850s onward. This method of picture building overcame technical limitations of slow collodion plates, and followed the painters' method of building up the canvas. It was ideal for the themes considered suitably lofty for "High Art" photography – allegoric, highly poetic, and impossible to find naturally in real life.

The production stages for this type of working were as follows: firstly the whole composition was designed on paper, then negatives were produced of each figure or group of figures, exactly posed and sized to follow the sketch, and contact printed. Next, unwanted areas of the figure negatives were covered with lamp black or opaque paper and contact printed, one at a time, in correct position on a sheet of albumen paper. (This self-darkening paper allowed density and positioning to be checked after each part exposure.) Then the contact prints of the figures made previously were cut out and placed over the figure images on the paper to act as masks while the whole sheet was exposed again behind a negative of background detail. Finally, any errors resulting from this lengthy procedure were retouched on the toned print.

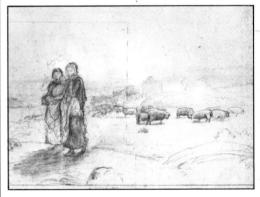

Planning a multiple print
Compositions were first sketched (see example top), and then each convenient element was photographed separately. The final com- *bination print (see above) looks as it was intended – romantic, "tasteful", and highly realistic – an example of High Art photography.*

Photograms

Making photograms is a simple form of "writing with light". You can think of it like placing a stencil over a surface and spraying it with paint. But to make most photograms, you lay actual objects on (or above) light-sensitive paper or sheet film, and then expose the material to light. Shadows cast by the objects create shapes and patterns, which appear as permanent images when you process the paper or film. By changing the angle of the light, or varying its distance, or shifting some of the objects during the exposure, you can create a surprising and very diverse range of results (see facing page and pp. 186-95).

You can also place opaque or transparent objects in your enlarger's negative carrier, to magnify their detail. Even the most mundane household item can form the basis of a striking image. And what begins as a simple photogram you can then print, tint, solarize, and manipulate like most photographs described in this book. The only limiting factors are time and imagination, and you must allow for a high materials' wastage rate as you experiment.

You require only the simplest items to make photograms (see right). For black and white images, as shown here, you can use any light source. For color photograms, shown on following pages, you can control results best with an enlarger. If you use negative/positive paper (see pp. 62–3), you can produce colors complementary to those of the objects you use. But if you use positive/positive paper, you can create direct positive color images.

Objects to use

To make photograms, collect small objects with interesting shapes, such as the ones shown above. Some could be opaque, like small cogs or pins, some translucent, like pasta or ferns, and some transparent, like glass or plastic. Your main challenge when making photograms is the design, whatever objects you decide to use.

Preparing to print

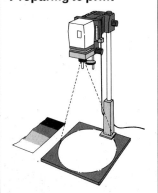

You can use any convenient lamp for black and white photograms, but small or distant sources form the sharpest shadows. If you use your enlarger, raise its head to the top of the column. Adjust the focus (and the lamp, if necessary), to produce an even patch of light large enough for your photogram. Make a test strip (see pp. 98-9) and find the f stop that produces a rich black with a 10-sec exposure. Use this test strip also to find the exposure times required to form dark, medium, and light grays. Your enlarger must have a red filter. It allows you to preview shadows without exposing the paper.

Hard outlines

The photogram below was made using a set of pencils. Lay them out in direct contact with a sheet of hard-grade bromide paper, see right. Take great care to position them evenly, forming interesting straight or ragged shapes. Give just enough exposure for a rich black; overexposure tends to spread light and gives a smudged outline to the objects.

Hard and soft outlines

If you raise it a few inches above the paper, you can give any object a sharp or diffused outline. You can do this by accurately positioning your subjects on a clean, raised glass shelf (see right), and then adapting the light source. For a sharp outline, you should raise the enlarger head to the top of the column, and stop the lens well down. For a soft outline, open up at least two stops and hold a sheet of tracing paper 1 in (2.5 cm) below the lens. Increase this distance for greater diffusion. The outline of object you place in contact with the paper is unaffected by these changes in the light.

Controlling results
For all three versions of the photogram on the right, the shapes were arranged as in the diagram above–some in contact with the paper and some suspended above it. For the version with sharp outlines, the lens was left unobscured. The softer, diffused versions were created by holding a sheet of tracing paper at different levels below the enlarger lens.

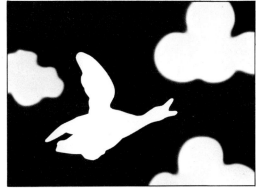

Multiplying shapes

You can multiply shapes and create a range of tones by moving objects part way through the exposure. The photogram on the right was made this way, on normal-grade paper, using a piece of shaped, black cardboard. Use the test strip described on the facing page to calculate the exposure times for the different grays. During the exposure, shift the cardboard up the paper as explained below. Offsetting the cardboard left or right between shifts will give your "skyline" photogram variety.

1 *Make equally spaced, erasable marks on the baseboard, either side of the printing paper.*

2 *Align the shaped cardboard with the first marks. Give half the exposure required for a rich black.*

3 *Switch off, and re-align the shape with the second marks. Re-expose, giving half the previous time.*

4 *Switch off, and re-align the shape with the third marks. Turn on, and give the same exposure as **3**.*

Simple color photograms

When you make photograms on color paper, the principles of hard and soft outline used in black and white work (see pp. 184-5) still apply. You can use negative/positive paper or positive/positive paper. Thin transparent materials will print their own coloring (positive/positive) or complementary coloring (negative/positive). But translucent items in contact with the paper usually require color strengthening by extra filtration. Start by testing for the filter settings and exposures required to give a range of neutral grays. (With negative/positive paper this may mean heavy filtration. You can place a developed piece of unexposed color negative film in the carrier and use its color mask as a filter.) Then generate extra color by shifting filters away from their neutral settings. Avoid overexposing or underexposing objects, as both will destroy the richness of the colors. For the photogram on the right, a slice of apple was enlarged on negative/positive paper filtered 60Y 60M. Changing filter settings to 80Y 40M produced the version bottom right. The spectacles below rested on silver dye-bleach (SDB) paper (see pp. 62-3) filtered at 50Y 25C. Settings of 50Y 20C and a longer exposure produced the lighter picture, bottom.

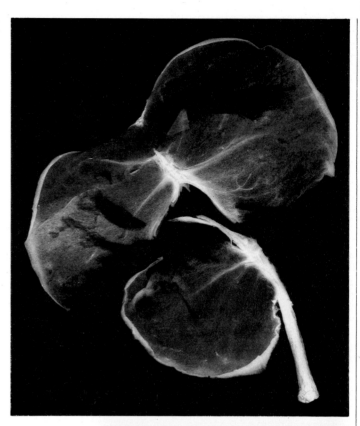

Objects inside the enlarger

Both the images on this page were made by arranging three-dimensional objects inside the enlarger itself. The SDB print, right, was made directly from a tiny model airplane, hung just below the negative carrier (which you can see in the background). For the result below, pins and pushpins were placed on a glass negative carrier and enlarged on negative/positive paper. Scattered light reflections from the inside surfaces of the enlarger will help to fill in detail and color, provided you give enough exposure. You can intensify this reflection by fitting a white paper disk to surround the upper surface of the lens mount. Filtration settings were 55Y 15C for the airplane, and 60Y 30M for the pins.

Using 3D objects

If you stand a transparent 3D object directly on your paper surface, you can form various flat patterns. The three photograms on this page were made using a cut-glass bowl. In the version on the right, the bowl was exposed for 18 sec on normal-grade bromide paper (see diagram below). For the version above, the bowl was given three exposures of 6 sec, and was rotated about its axis between each. A contact print (see p. 144) from this photogram on soft-grade paper gave the result above right.

Setting up
Center the bowl below the lens for symmetrical shadows. Set the lens to its smallest aperture.

Using a flashlight

You can expose your paper using a flashlight instead of the enlarger. If you use the flashlight from an oblique angle, you will form elongated shadows, as shown in the photogram of a comb (far right). The light was about 5 ft (1.5m) to one side, taped to a tripod, and exposure was 60 sec. When the flashlight is fitted with a cowl, you can use it like a spraygun, giving 1-sec bursts of light above individual objects to create the type of photogram below.

Restricting the beam
For close work, cowl your flashlight (see p. 105). To create a halo effect, hold the light near to the objects and expose them from above.

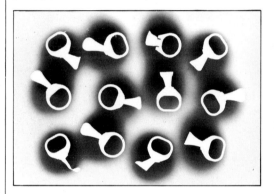

Abstract patterns

You can create abstract patterns by printing a simple shape several times on one sheet of paper. The photogram on the right was made with the rectangular aperture cardboard below. Five short exposures were given, shifting and turning the cardboard between each. If you align the shape with one edge of the paper, the design will consist entirely of vertical and horizontal lines. You can vary the tonal range by your choice of paper grade (see pp. 96–7).

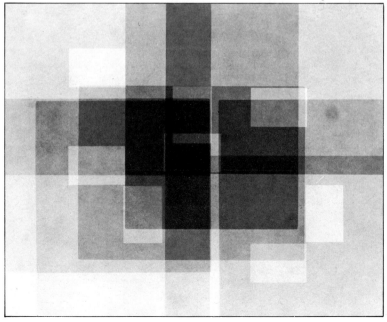

Using local filtration

When you make photograms on color paper, using filtration, you can choose colors for the various objects, irrespective of their true colors. Give enough exposure for some light to reflect under objects not in tight contact with the paper, to "color in" the shapes. The picture, left, received three separate exposures and filtrations on negative/positive paper. From top to bottom, these were 20 sec 30Y 40M, 17 sec 80Y 80M, and 40 sec 100Y 50M, all at f16. Use your hand to shade different areas of the picture (see pp. 104-5).

This detail shows the effect of changing settings to 30 sec 100Y 50M, graduating to 45 sec 90Y 70M.

For detail of the central area, filtration was altered to 40Y 40M, and a 40-sec exposure. The background remains too overexposed to show color change.

Here, the top had 25 sec 80Y 80M, graduating downward to 20 sec 60Y 80M. Keep your hand moving to avoid abrupt changes (see pp. 104-5).

Creating backgrounds

Photograms with backgrounds of flat tone or color can become monotonous. You can achieve more interesting results by varying filtration and shading, or overlaying patterns. The lower part of the print, left, was shaded, then printed back in with extra magenta filtration to turn it green. For the larger photogram, the colored pattern, below, was first drawn on clear film using felt-tipped pens. The film was then placed in the negative carrier of the enlarger, filtered, and finally enlarged.

The photogram above was filtered 100Y 30M. The shaded lower part was then printed back at 100Y 100M.

The version below was first filtered 100Y 50M. The shaded lower part received 80Y 30M.

Natural patterns

All the examples on this page began as soot patterns on glass plates. Passing a plate through a stream of smoke from a spirit lamp gave the pattern above. For the large image, right, a plate was sooted, a drop of methylated spirit added, and the plate rotated. For the photogram above right, a pool of methylated spirit was allowed to dry slowly on a sooted plate. Then a further drop of methylated spirit was added. For the explosive image below, a drop of methylated spirit was poured from high above a sooted plate. In each case, the prepared plate was placed in the negative carrier and enlarged on singleweight normal-grade paper. These were then contact printed on soft-grade paper to produce the "positive" results.

Working from drawings

You can make photograms from your own drawings and tracings, or from shapes cut from paper and cardboard. The white-on-black image, left, was made by contact printing an ink drawing on tracing paper on hard-grade bromide paper. Arrange the tracing, ink side up, flattened under glass. Stop the lens well down to give a point source light (see p. 37). You can also combine drawings with patterned materials, or camera negatives (see below). Once you have the printed image, you can try color toning it (see pp. 268–75), silkscreening (see pp. 260–4), or most of the manipulations in the *Workroom techniques* section of this book.

The result above is simply contact printed from a tracing overlaid with thin paper towel.

The shape above was cut from thin, opaque cardboard, and contact printed to form a reversed-tone image.

A cardboard shape on the paper, and a negative in the carrier gave the combined effect above.

Mixing your methods

When you have mastered most basic photogram techniques, try mixing several together. For the film club poster, right, photographic and drawn images were combined, together with liquid and 3D objects. The portrait, clipped from another poster, was laid face down on normal-grade bromide paper. It was covered by clear acetate stenciled with black lettering and bullet tracks. A sheet of glass was placed over the acetate, its top surface covered with splashes of black water color. The areas of glass above the portrait and lettering were wiped clean. Finally, two halves of a toy gun were placed on top of the glass for 10 sec of the 15-sec exposure the paper received.

Polarized light

A "colorless" transparent piece of crinkly plastic looks featureless if you hold it up to the light. But colors appear if you add a polarizing filter behind the plastic, and hold another in front. This effect is called bi-refringence, and you can use it to make photograms. Place one large filter so it covers the negative carrier above the material to be enlarged (see below). Hold another, camera-quality, polarizer below the lens. Then rotate the lens filter until the background darkens and the strongest colors appear in the image. For the result below, the carrier contained adhesive transparent tape. For the photogram on the right, torn transparent wrapping was suspended from the negative carrier. Both photograms were filtered 90Y 60M on negative/positive paper.

 Polarizing filter

 Object in carrier

 Lens

 Polarizing filter

You must place polarizing filters above and below the object being enlarged.

Colored drawings

With color paper you can make photograms from colored drawings. The result on the left was contact printed on negative/positive paper from a child's wax crayon drawing (see above left).

The result from another drawing is shown above. Expect to adjust your filtration to counter the yellowish tint of some sketch papers. Settings for these photograms were 19Y 15M.

Using chemicals

You can further abstract any color photogram by chemically bleaching certain parts. Most household bleach will attack color print dyes. You must wear chemical-proof gloves for this work. When working on a black or neutral area the bleach tends to remove the cyan top layer first, leaving red. Yellow in the lowest layer is bleached last. The photogram on the right began as an overexposed version of the photograms on p. 186. Apple parts of the image were painted over with rubber mounting gum to form a protection for the surface. Bleach was then swabbed on the unprotected areas. Finally, the rubber coating was peeled off to reveal the finished picture.

Using lith emulsions

Lith emulsions have special features that make three forms of image manipulation possible. You can make extreme black and white images with finer detail sharpness than is possible with line emulsions or, by controlling exposure and development, you can achieve a yellowish-brown plus black image. Finally, you can make prints in color (by combining the first two results) with tinted midtones and tonally distorted shadows (see pp. 198-9). You must process lith material in special developer. Development is initially slow, but accelerates rapidly in the last 30 seconds, or so. For controlled results when using this material, you must be particularly accurate with the timing of development.

Handling lith

Handle lith material under deep red safelighting. If working from a color original, use panchromatic lith. Developers come as A and B solutions, which deteriorate quickly when mixed together. For maximum contrast effects always mix up fresh solutions. For brown tones (bottom right), process your paper or film in diluted, used developer.

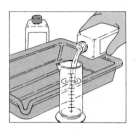

1 *Mix equal parts of A and B solutions just before use. Working-strength developer lasts 60 mins.*

2 *Contact print or enlarge your continuous-tone negative on sheet or 35 mm lith film (or paper).*

3 *Agitate developer until the image starts to blacken. Then leave it still. Stop, fix, and wash.*

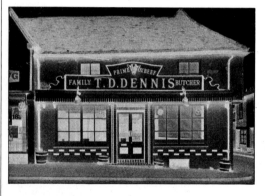

Original negative

Bromide paper print

Lith film print (correct exposure/development)

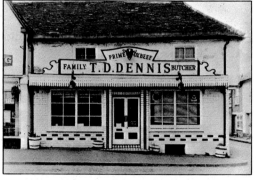

Lith paper print (underexposed/developed)

Density and color

For dense, neutral blacks, process lith material in fresh developer. For a warmer result, process film and paper in well-used, diluted developer. The length of exposure also affects image color (see right)—with the briefest exposure giving the warmest result. Here, the images received (left to right) 18 sec, 6 sec, and 4 sec exposure. Over exposure spreads the image and destroys resolution.

Continuous-tone masks

To make mixed warm- and neutral-toned images, you must first make continuous-tone masks from each of the lith positives above right. Contact the positives on normal-contrast film and process normally. The films right, all had the identical exposure time. When the films are dry, register punch them.

Liths and overlays

The three film images, above and right, were made from combinations of the films at the top of the page. The image above shows the lightest continuous-tone negative overlayed with the 6-sec lith positive. Brightest highlights are now dark gray. For the image right the same combination was printed on lith paper.

For the result above, the 4-sec lith positive was registered with the darkest continuous-tone negative. Only the darkest detail appears (in brown) against a flat, gray-toned background. If you are working on 35 mm lith film, you can project your finished results as slides. You can, also, use any format of lith film to print on negative/positive paper (see pp. 198-9).

197

Lith in color

All the prints on these two pages, printed on negative/positive paper, were made using the film images on pp. 196-7. For a color result, first enlarge your original negative (to print size) on lith film to give a pale brown positive. Change to color paper and test for the filtration you require to give a neutral color print from the projected negative (90Y 45M, in this case). Then, using a fresh piece of color paper, expose it to the negative with the lith positive in register on top of the paper. The result below was filtered 90Y 45M. The versions on the facing page received (bottom) 50Y 45M, and (top) 70Y 30M. The print left, also received 70Y 30M but only half the exposure time.

Line separations color printed

Line separations can be the source of an enormous number of stark and varied color prints. Basically, the technique consists of converting a continuous-tone black and white negative into several different forms of line image. Once you have prepared these, you can sequence print them on color paper in unusual ways. Start by making as many variations of one image as possible–by printing and reprinting–on line film. Include line positives and negatives and sandwiches of the two (as shown below). Give different levels of exposure, as for posterization. You can make some separations through half-tone screens (see *Reference box*)–these and other processes will suggest themselves from different parts of this book. When printing, expose each separation on color paper at a different filter setting. You can expose them one after the other in register or offset, or with selected films out of focus or diffused. Some of the printing methods possible are explained on the facing page, with the results on pp. 202-3.

Reference box

Technique	Page
Color prints from black and white	142-3
Conversion to line	146-7
Half-tone screens	158-62
Tone-line	164-5
Diffusers and texture screens	208-11
Multiple printing	224-31
Posterization	244-51

Preparing line separations

When making line separations it is cheapest and easiest to work entirely by contact. This means that every image will be exactly the same size (essential for sandwiching films together in different permutations), or printing in sequence. Following the steps below, you will produce four very different looking separations, but many others are possible. You can use either line or lith film, but take special care to avoid dust and dirt on all glass surfaces. Paint out any pinholes in the images using liquid opaque before the next stage.

1 *Contact print your original continuous-tone negative on high-contrast sheet film. Expose by light from the enlarger. Process and dry.*

2 *Recontact print the positive line image on another piece of line film. Process and dry to produce a line negative.*

3 *Carefully register the line negative and line positive images back to back over a light box. Tape the two film images together along one rebate.*

4 *Expose on line film using a moving light source. Process the film to produce a black outline image. Contact print on another sheet of line film.*

The resulting images

The methods left will give you four line separation images from a continuous-tone negative (see right). Each of these films has been given a code number which will be used later at the color printing stage (see facing page). The tone-line image (**F3**) is the direct result of exposing the negative/positive sandwich (**F1** and **F2**) to a moving light.

Print from negative

Line positive (F1)

Line negative (F2)

Line print from negative and positive (F3)

Line negative made by contact from F3 (F4)

Color printing offset images

One way of printing your line separations is to make a number of slightly offset images in different colors. For this, it is best if you use the most simplified, outline-only, separation (such as **F4** on the facing page). After each differently filtered exposure, move the paper to a new position relative to the image (see below). For other variations try printing the outline film offset with different outline images (provided that they do not become too confused). Use either contrasting colors, or black (results are shown on pp. 202-3).

Printing in flat color

By exposing several of your line separations at different filtrations you can print an image that is a combination of both outlines and filled-in areas of flat color. Results are similar to posterization (see *Reference box*) but more wide ranging. You can make individual exposures with the images in or out of focus, registered or offset, as well as contrasting in density and color. A typical sequence is shown below. So many permutations are possible, you should keep notes of chosen steps to compare against results.

1 *Enlarge film* **F4** *to the image size you require. Trace over the projected image on white paper located in the masking frame.*

2 *Make test strips on negative/positive paper for exposure and neutral filtration (see* Reference *box). Set filtration for color of line required.*

1 *Enlarge* **F4** *to final print size. Trace image on drawing paper in the frame. Test for neutral color and correct density on negative/positive paper.*

2 *Process and assess your test. Choose settings for neutrality and correct exposure. Expose a full sheet of paper and then place it in the paper safe.*

3 *Position a sheet of fresh paper in the frame. Expose, then remove paper to a paper safe. Clip bottom corner to remind you which way up is correct.*

4 *Replace tracing in masking frame. Shift frame until the projected image is offset by the required amount. Reset filters to produce a different color.*

3 *Replace film image* **F4** *with* **F2.** *Return tracing to the frame and align old and new images. Test for filtration to give a yellow print.*

4 *Expose the* **F2** *image on the previously exposed piece of paper, and then return it again to the paper safe. Reposition the tracing in masking frame.*

5 *Remove the tracing and replace it with the previously exposed sheet of paper from the safe. Expose the image and return the paper to the safe.*

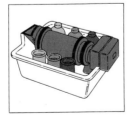

6 *Repeat steps* **4** *and* **5** *to give other offset image variations, making major filtration changes each time. Finally, process and dry your print.*

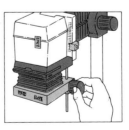

5 *Carefully shift the image out of focus, comparing the effect against the sketch. Next, change the filter settings to give a magenta print and retest.*

6 *Finally, take the twice previously exposed paper from the safe and expose it to this out of focus image. Then process and dry (see result on p. 202, top left).*

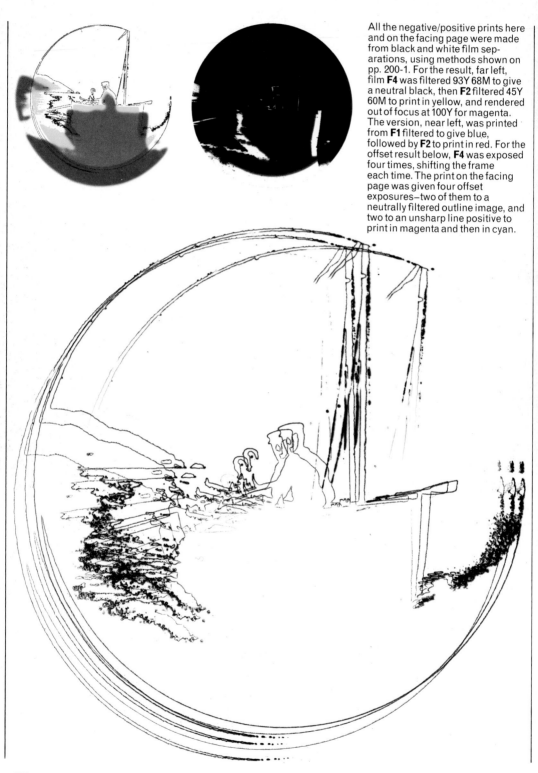

All the negative/positive prints here and on the facing page were made from black and white film separations, using methods shown on pp. 200-1. For the result, far left, film **F4** was filtered 93Y 68M to give a neutral black, then **F2** filtered 45Y 60M to print in yellow, and rendered out of focus at 100Y for magenta. The version, near left, was printed from **F1** filtered to give blue, followed by **F2** to print in red. For the offset result below, **F4** was exposed four times, shifting the frame each time. The print on the facing page was given four offset exposures—two of them to a neutrally filtered outline image, and two to an unsharp line positive to print in magenta and then in cyan.

Shape changes and image distortion

When you make a normal enlargement, your negative, lens surfaces, and printing paper are all parallel to each other. If you change this relationship, by inclining the paper at an angle, or forming it into a bowed or crumpled shape, your print will show a distorted image. The parts that are closest to the lens will be magnified less, and appear smaller in size than parts furthest away. You can exploit these optical changes to elongate or compress an image for effect, giving ordinary objects strange shapes. And you can use this technique to correct negatives which have converging perspective in a horizontal or vertical plane–such as buildings photographed with the camera tilted upward (see p. 206). With both forms of shape change, you must solve the technical problems of maintaining sharp focus overall, and keeping print density even. You can also distort the colors of an image by using Infrared Ektachrome film and then varying filtration to produce false color prints.

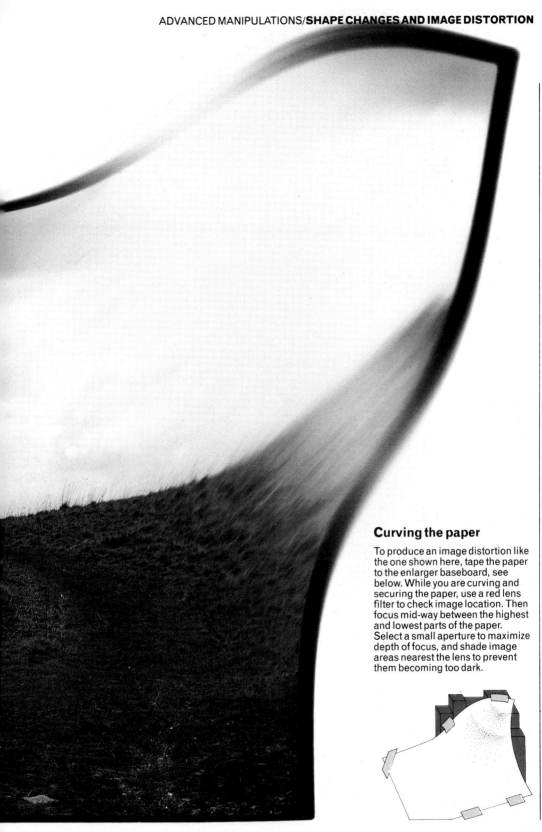

Curving the paper

To produce an image distortion like the one shown here, tape the paper to the enlarger baseboard, see below. While you are curving and securing the paper, use a red lens filter to check image location. Then focus mid-way between the highest and lowest parts of the paper. Select a small aperture to maximize depth of focus, and shade image areas nearest the lens to prevent them becoming too dark.

Tilting the masking frame

To correct a negative which, when enlarged normally, shows a building with converging vertical lines (right) you should tilt the masking frame. For the print far right, the base of the building was brought much closer to the lens (see diagram below right). Full correction of verticals has given the building a stretched and unnatural look—tilting is most successful if you use it to compensate for slight convergence of vertical or horizontal lines only. You can also use this technique to make square-on views of objects converge in either direction.

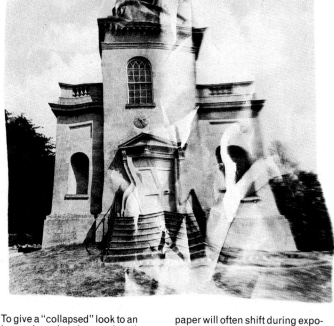

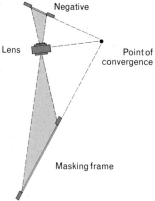

Negative

Lens

Point of convergence

Masking frame

To give a "collapsed" look to an image (see above) crumple a sheet of singleweight paper and then spread it out on the frame for exposure to the projected image. Do not use doubleweight paper—it tends to crease rather than crumple. Next, soak the paper in water to flatten it prior to development. You will find that parts of the springy paper will often shift during exposure, blurring and adding to the "earthquake" effect. You should use a matte-surfaced paper in order to minimize printing reflections.

Angling the masking frame

This enlarging set-up was used for the print directly above. If your enlarger allows (see p. 39), make the planes of negative, lens panel, and paper converge on one point—this gives maximum depth of focus. Focus halfway down paper, then stop lens well down.

Color distorting parts of a scene

You can make a color print which has dramatically distorted colors and tones (except for those of growing vegetation) if you print from Infrared Ektachrome film. This special slide film records the infrared-reflecting chlorophyll in living plants as magenta. Blacks, whites, and blue sky will remain normal, see right. When you print one of these slides on regular negative/positive color paper you can filter to restore foliage to green (see below right), leaving all other colors and tones wildly incorrect. Filtration for this, and for the larger print at the bottom of the page (also from an infrared slide), was 110M 30Y. Similar filtration was used for the image below, which was printed from an Infrared Ektachrome slide of tufts of grass, and water.

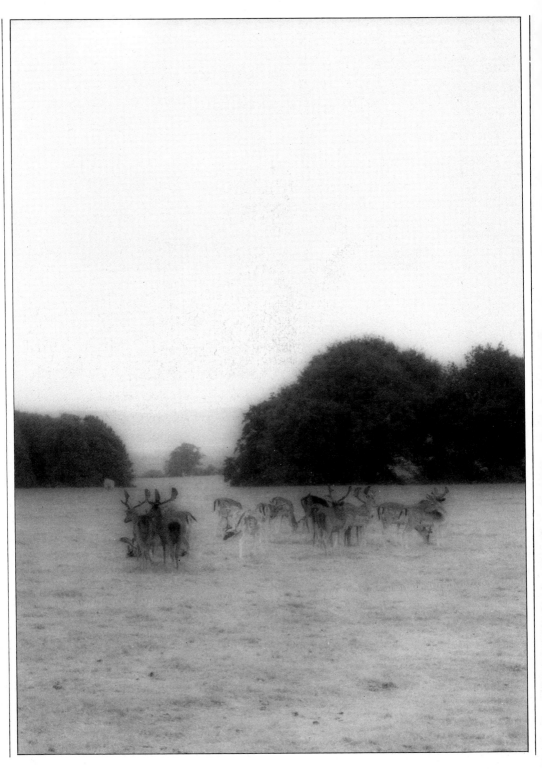

Diffusers and texture screens

You can soften or break up fine image detail by printing through either a diffuser or textured screen. Diffusing means scattering the light slightly—perhaps using grease on a piece of glass, or thin tissue paper or stretched nylon placed just below or above the lens. Light always scatters from the brightest into the darkest areas of the projected image. This means that if you are printing negatives, the shadow parts of the original scene will appear spread or "smudged". When printing on positive/positive paper (see p. 210), diffusion spreads highlights into the shadows, giving the print a high-key, romantic effect.

A texture screen is usually made of plastic or glass, or it may be film printed with an overall pattern. You position it either against the negative or the paper to superimpose a sharp pattern over the image. This can give the image a grainy or textured-surface appearance. Do not confuse texture screens with half-tone screens (see *Reference box*), which have a very different function.

Reference box

Technique	Page
Additive printing	133-4
Half-tone screens	158-62
Pointillism effects	257-9
Color Key film	313-14

Using a diffuser

The degree of diffusion you can produce depends on your choice of diffusing material, the percentage of the exposure it is in use, and how close to the lens you position it. For the result on the facing page, thin paper tissue was positioned just above the lens throughout the exposure (see right). An undiffused print from the same negative is shown below.

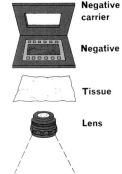

Negative carrier

Negative

Tissue

Lens

Using texture screens

You can make screens by photographing an evenly patterned or textured surface. If you intend to sandwich the screen with the film in the negative carrier, make it thin and low contrast. Use high-contrast screens spaced apart from the negative (this allows you a choice of sharpness by stopping down), or in paper contact (allows you to shift the screen during exposure).

Screen above carrier

Screen in contact with negative

Lens

Screen in contact with paper

1 *To print in color with a screen in paper contact, first test for image exposure without the screen.*

2 *Press your print-size negative or positive screen against paper, under glass. Expose to image.*

3 *For color patterns, use a black and white screen, expose additively, and shift screen at each filter change.*

4 *Or use a color patterned screen and move it several times during the same exposure (see p. 211).*

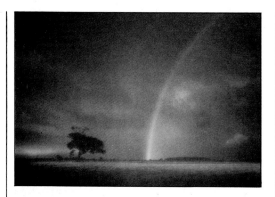

Color printing with a diffuser/screen

It is best to use slides and positive/positive paper when color printing with a diffuser or patterned screen. Slides allow you to forecast exactly results on the masking frame. The image above was printed from a slide through thin gauze held just below the lens. Diffusion has spread the highlights, enhancing luminosity, just as it would if you had diffused the camera lens (compare this with the diffused image on p. 208). The image right, was printed from a slide with rice paper stretched just out of contact with the film. The thin paper adds pattern and provides some degree of diffusion. The lens was well stopped down. For the result below, a slide of a motor cycle was enlarged on paper covered by molded patterned glass.

"Step and repeat"

You can create further patterns and forms of diffusion by using movement during the exposure. You can do this by "step and repeat"–giving part of the exposure required, moving either the image, paper, or texture screen, then giving another equal part of exposure, and so on. All the prints on this page were made from a color slide of a kite. The print right, was exposed using the additive method, shifting the paper in diagonal steps between exposures of 130 sec (blue), 40 sec (green), and 20 sec (red). For the result below, a multicolor dot screen was first made by enlarging an irregular pattern on film. This was contact printed on Color Keys of various hues (see *Reference box*), and then stacked out of register. The screen was kept in contact with the paper while the image was part-exposed. The frame was then slowly moved (while still exposing) to a new static position. In the version below right, the image and paper remained static but the color dot screen was rotated slightly between different parts of the exposure.

Using equidensity film

Equidensity film (available as Agfacontour) has two black and white high-contrast emulsions. One forms a negative image, the other (slightly slower in speed) is prefogged and gives a direct positive result. When you expose the film to a continuous-tone image (giving it regular black and white processing), both the highlights and the shadows record as black. But at one particular mid-tone value the film records a clear, pale density. You determine the exact tone to "trigger" in this way by the exposure you give the film–but every part of the original image that has that density of tone will stand out as white against black. This is known as a "first order" image. If you print this first equidensity image on another sheet of the same film, you will create a "second order" image in which the previous trigger area is defined by two narrow outlines (see facing page). As well as giving solarization-type results, you can use equidensity film to form interesting line separations, which you can then print additively in color (see pp. 214-5).

Testing and assessing exposure

It is very difficult to find correct exposure on equidensity film. Both over- and underexposure give dark or black results, and, because the film is high contrast, there is little exposure latitude. Tape a film gray scale alongside your negative, and give various exposures until a "triggered" zone appears as white about the middle of the scale (see right). Then make a test strip across the image giving times that are close to this exposure (below right). Slight underexposure gives a mainly negative image in blue-black silver. Slight overexposure gives a mainly positive, brownish-black image. The width of the equidensity zone varies according to the color of light–expose your first image filtered 120Y.

1 *Attach a gray scale to the negative. In deep red safelighting make a range of exposures on sheets of equidensity film.*

2 *Process normally. Select sheet that records scale with a white gap. Test at settings near this exposure (below).*

Original image

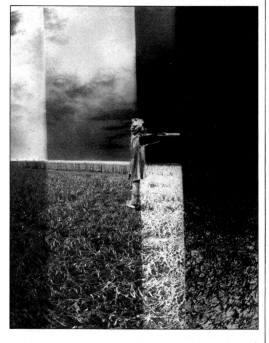

First order test

First order result

Once you have made your exposure tests (see facing page), expose a full sheet of equidensity film (10 sec here). The result below shows the gray scale reproduced black at both ends, and an image with mixed negative and positive character-istics. Only at one point in the original range of densities will the film reproduce as clear (seen in the corn and "rifle", and in the rim of the figure).

Second order result

Expose your first order result on another sheet of equidensity film so that your previously triggered density turns into darker film out-lined in white. The negative-working emulsion fills in its previous light tone, the positive fills in dark tones, but between the two a clear line remains. To widen this line, expose with magenta filtration; to narrow it use yellow.

Third order result

If you print the second order result again on equidensity film you will double each white line (as shown below). The image has now broken down into a pattern of extremely delicate lines. You can make further orders of reproduction, but the results will become increasingly less effective as the lines begin to fill in. To make prints from this order of film, see below (you can also print on black and white paper).

pos. silver neg. silver
 Clear film

pos. silver neg. silver pos. silver

pos. silver neg. silver pos. silver

Preparing to color print

To make color prints (see pp. 214-5) first prepare several print-sized films by enlarging your third order result on lith film. This will give you black lines on a clear back-ground. Use this to make four identical contact prints on lith film. Register punch each. You will now have white lines on a black background. On each sheet, choose and fill in different lines with liquid opaque. Use each sheet to print a different color.

1 *Enlarge your third order result on register-punched lith film to give an image with black lines on a clear background.*

2 *After processing, contact print it on four sheets of register-punched lith film to give white lines on black. Process.*

3 *Using liquid opaque, fill in different lines on each sheet of film. Clear lines allow different filtered light through (see p. 214).*

213

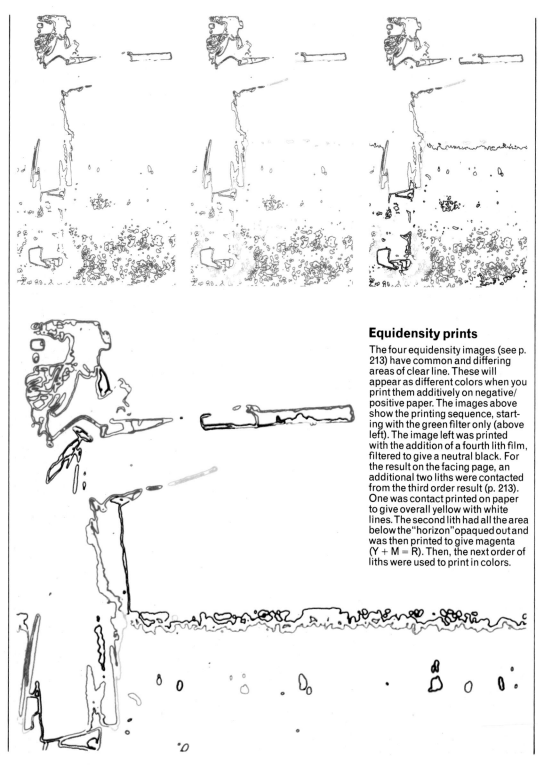

Equidensity prints

The four equidensity images (see p. 213) have common and differing areas of clear line. These will appear as different colors when you print them additively on negative/positive paper. The images above show the printing sequence, starting with the green filter only (above left). The image left was printed with the addition of a fourth lith film, filtered to give a neutral black. For the result on the facing page, an additional two liths were contacted from the third order result (p. 213). One was contact printed on paper to give overall yellow with white lines. The second lith had all the area below the "horizon" opaqued out and was then printed to give magenta $(Y + M = R)$. Then, the next order of liths were used to print in colors.

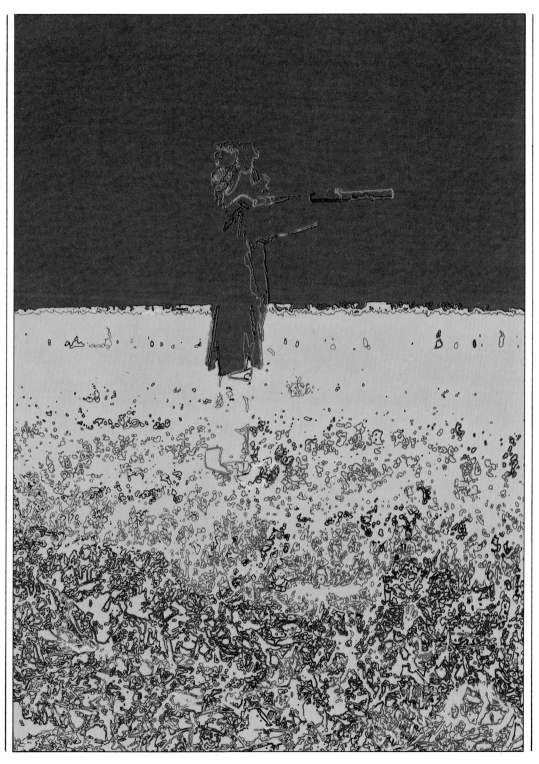

Bas-relief

Bas-relief is a form of sculpture, in which the figures project slightly from their background. You can make photographs look like side-lit, low-relief images by combining negative and positive films of the same image, slightly out of register. The best type of image for you to use is one that is sharply focused, evenly lit, and has plenty of strong, simple shapes. First you must contact print your chosen negative on to a sheet of continuous-tone film, aiming for a positive with similar contrast to the original. After processing, sandwich the positive with the negative, but offset it slightly to one side (see below). When you print, you will find that a dark "shadow" appears on one side of all detail and a clear "highlight" down the other. You can also, if you wish, mount the positive and negative sandwich in the same slide mount ready for projection. Other bas-relief combinations you can use include positive and negative lith films, a black and white negative and a color positive, and a color negative and a black and white positive.

Reference box	
Technique	**Page**
Processing dis-tortions	178-9
Using lith emulsions	196-9
Sandwich printing	232-5

Preparing images

Avoid originals that have spots or scratches (these will appear in bas-relief as well). For the strongest bas-relief effects, print a film positive that has maximum and minimum densities equal but opposite to those on the negative. If the positive is too heavy, the print will appear dominantly nega-tive. If the opposite is true, the print will be dominantly positive.

1 *Contact print on several sheets of continuous-tone film. Use dilute print developer for a low-contrast result.*

2 *Pick the positive that most nearly matches the negative in density. Cut it out of the sheet.*

3 *Tape the two films to-gether slightly out of register. Place them be-tween glass in the carrier and use hard-grade paper.*

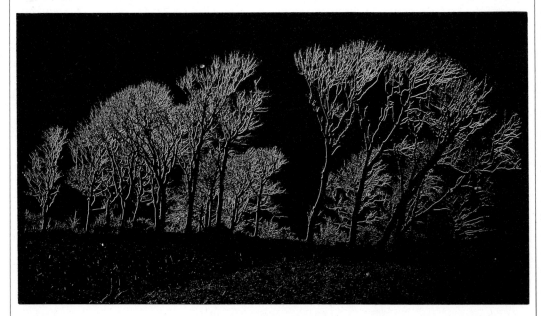

For the image above, the original negative was contact printed on lith film. This was, in turn, printed to give a lith negative. The lith images were then sandwiched, out of register, and mounted as a slide for projection. The bas-relief picture shown on the facing page is the result of combining positive and negative continuous-tone images in one print, as described above.

Highlight masking

You can use a high-contrast film mask to manipulate all parts of an image which have the same tonal value. For example, if you contact print a color slide on line film, then combine the color original and monochrome copy in register, all highlights (or tones lighter than light gray) will appear black. This effect will turn clouds and white flowers in a landscape dense black, without changing the darker tones and colors. (This is because the mask film is so contrasty that these areas only record as totally underexposed and

transparent.) Taking this technique another step further, you can tint highlights strange colors by using a mask with a colored dye image instead of a silver image. Prints on SDB paper from masked slides have a mixture of real-looking shadows and mid-tones, with all the lighter areas falsified in tone and color. Results are often similar to equidensity film images (see pp. 212-15) or solarizations (see pp. 236-43), but they lack the "edge-line" effect. And highlight masking is an easier technique to control.

Prints from masked slides

The prints on these pages were made on SDB paper from color slides sandwiched with highlight masks. A pink/magenta mask– made by dye-toning a lith negative (see p. 220) –was used for the boat-house, right. Since such a mask only carries color in highlight areas, darker colors are unaffected. For the images below and facing page, a cyan mask covered white parts, and a pink mask extended over both whites and pale tones. Where both masks combined, dark gray-blue was formed.

Materials and equipment

You will require all the materials and equipment you used to make lith images (see *Reference box*). To convert these images into dye, use a kit of color-coupled toners. Alternatively, you can use the Color Key process (see *Reference box*). You should have appropriate safe-lighting, tape, scissors, and other darkroom equipment, such as trays and graduates (see right).

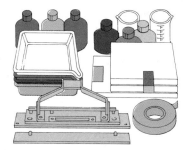

Preparing masks

To make an accurate mask, you must give your lith negative the correct exposure when you contact print it. Under-exposure will mask only the very lightest high-lights, while over-exposure will extend too far into mid-tone areas. Since this technique does not require much film, make a range of masks. Then tone these in different colors, and choose the mask that looks best.

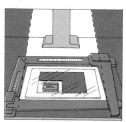

1 *Contact print your color slide on lith film (preferably panchromatic). Make an extensive series of test exposures. Process these in lith developer.*

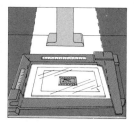

2 *Select exposure that records required range of highlight tones as dense black. Print at this exposure. Make lighter and darker versions.*

3 *Process the films. Fix and wash carefully. (At this stage you can examine dry film with the slide and reject unsuitable exposures.)*

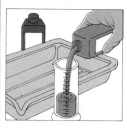

4 *Treat film in bleacher solution from the color-coupler toning kit, then rinse well. Prepare color developer for one or more chosen hues.*

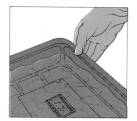

5 *Redarken the image in color developer. If you have made a range of duplicate masks, tone each one in a different color.*

6 *Rinse your film carefully. Next, bleach out the silver image, leaving a mask that consists of color dye only.*

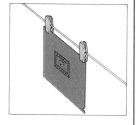

7 *Wash and dry mask carefully. The emulsion is now extremely fragile, so you should wash each film sheet with care in a separate tray.*

8 *When your sheet film is fully dry, cut out the 35 mm images. Your highlight masks are now ready to combine with the original color slide.*

9 *Select the most interesting combination. Tape films together along one side, and enlarge sandwich on SDB or reversal color paper.*

Special points

- Examine your mask carefully for pinholes. If necessary, use line instead of lith film to avoid these defects.
- You can try sepia or metal toners instead of a coupler kit. If you prefer to use the color acetate designed for photocopiers, or Color Key film, print by this method after drying the film at stage 3 above.
- You can manipulate highlight masked results still further during color printing. For example, if you filter the masked highlights back to their original image color, you will give all other tones in the image a complementary hue.

Shadow masking

Just as you can distort the highlight end of your image tone scale by masking with a high-contrast negative, you can obtain unusual shadow effects by using another type of mask. In order to color shadows you must first make large-scale negative and positive lith masks, which you use in direct contact with color printing paper. Use the negative version to block shadow areas from light during the normal printing exposure, then change to the positive mask and fog in shadow with colored light. Changing shadows (or shadows and mid-tones) to flat areas of a chosen color (see pp. 222-3) can have a strange influence on perspective, flattening dark forms into bright, highly-colored "cardboard cut-out" shapes. Shadow masked results look like a composite of posterization (see pp. 244-51) or photo silk-screen (see pp. 260-4), and normal color photography. For a range of manipulated prints made by shadow masking see pages 222-3.

Preparing masks

Because you are working with large-scale masks (to allow easy changes during printing) you should use a pin register system (see *Reference box*). As in highlight masking, the exposure you give to your first mask is critical. It determines the extent of the image tone range that discolors. If possible, make several slightly different versions and choose the best one.

1 *Set up your color slide, enlarging it to the print size you require. Attach register pin bar to one side of baseboard.*

2 *Position a punched, print-size sheet of panchromatic lith film over pins, emulsion upward. Make test exposures.*

3 *Process film. Select exposure that gives black film in all areas except for deep shadows and dark tones.*

4 *Register-punch and expose a whole sheet of lith film at chosen exposure. Process and dry to form negative mask A.*

5 *Contact print mask A on another sheet of punched lith film, then process this sheet. This forms positive mask B.*

Color printing

Opaque out any pinholes in your lith masks. Use masks consecutively, pressing them tightly in contact with SDB paper surface during printing. Use the negative mask during exposure to the slide image and the positive one when fogging to filtered light. Vary results by setting slide slightly out of focus during printing (see pp. 222-3).

1 *Position register-punched sheet of SDB paper. Test for correct exposure and filtration for image.*

2 *Punch a second sheet of paper. Overlay with lith mask B and cover with glass. Expose to the projected slide image.*

3 *Return paper to safe. Remove slide and re-dial filtration to tint shadows. Test fog on a half-sheet of paper.*

4 *Replace paper exposed at step 2 on register pins. Overlay paper with mask A and press under glass.*

5 *Expose to fogging light from enlarger. Process paper. Try variations of fogging color and exposure.*

Manipulated shadows

Because the eye is normally drawn
first to color and detail in the lightest
parts of a picture, colored shadows
have a disquieting effect. The prints
right were made from a color slide on
SDB paper, using shadow masks.
For the print far right, shadows were
fogged to light filtered 140M. The
version near right used the same
filtration, but fogging exposure was
halved. For a "hard/soft" effect
(as shown in the print above) you
should expose color paper in contin-
uous contact with a lith positive
mask, but with the projected slide
image set out of focus. Here, yellow
and magenta filtration was increased
and the image was overexposed in
order to exaggerate effectively the
difference between stark shadows
and softened detail.

The masking technique explained on p. 221 was used to make the two shadow manipulated prints above and right. In order to print the landscape above, the slide image was exposed at a filtration of 15C, with a positive lith mask covering the paper. Filtration was then altered to 50Y, and the mask changed to a negative version. The negative mask was slightly offset for fogging. In the table picture (right) an image filtration of 4M 10C was used with the positive lith mask. Filtration was changed to 140Y 140C when the second (negative) mask was substituted for the fogging stage.

Multiple printing

The term "multiple printing" covers a number of different styles and techniques (see pp. 226-31). Your originals can be black and white or color, negative or positive. The surreal imagery of the multiple print on the facing page relies for its success on the careful matching of print densities and the very accurate positioning of the different elements (see individual images below). To match print densities you must make a test strip for each original. For positioning you have to make a master sketch (as shown below). Although this image is more complicated than the example used in *Combination printing*, the skills that you will require are basically the same. Check the *Reference box*, right, for relevant techniques and page numbers.

Reference box

Technique	Page
Making a test strip	98-9
Local density and contrast control	104-5
Vignetting and combination printing	152-5
Registration	156-7
Using lith emulsions	196-9

Master sketch

To combine a number of different negatives, you will have to use a master sketch. This is essential to give you an exact guide to the position and degree of enlargement of each element. Put each negative in the enlarger in turn; size up and trace each on to the same piece of opaque cardboard. Secure sketch to baseboard along one edge, or use a registration punch system.

Image 1 *An elm tree, suitable because of the large expanse of plain sky.*

Image 2 *A view of city streets, taken from a high-rise block.*

Image 3 *Picture of clouds, taken with the final composition in mind.*

Masks and dodgers

To make a multiple print of this type, you will have to produce a series of masks and dodgers. Project each negative down in turn on to opaque cardboard to the size indicated by the master (see **1**, right). For the picture on the facing page, the photographer made a tree mask (**2**) to print the trees and large shadow only. Next he made a dodger (**3**) to shield the trees and

buildings while printing the sky. To print the buildings, he made a dodger (**4**) to shield the sky and tree. Then, as a finishing touch, he made another two dodgers (**5** and **6**) so that he could remove an ugly building from the foreground and replace it with a bureau (see printing technique below). For the clouds covering the trees, he made a print-sized positive on line film (see *Reference box*), painted

opaque dye over the unwanted areas, and contact printed this back on line film to produce a negative mask (**7**).

Tree negative *Size up the tree negative against the master sketch. Swing back the master and cover printing paper with mask (**2**) and mask (**7**). Expose according to test strip.*

Sky negative *Size up the sky negative against the master. Swing it back and expose with dodger (**3**) in position. Half way through, peel back tree part and print clouds in.*

City negative *Align and size up the city negative. Print the buildings using dodger (**4**). At the same time, use dodger (**5**) to shade foreground where the bureau will be printed.*

Bureau negative *Follow the same procedure, but use dodger (**6**) to print the bureau. Add extra elements to any light areas (like the eye in the branches) using other dodgers.*

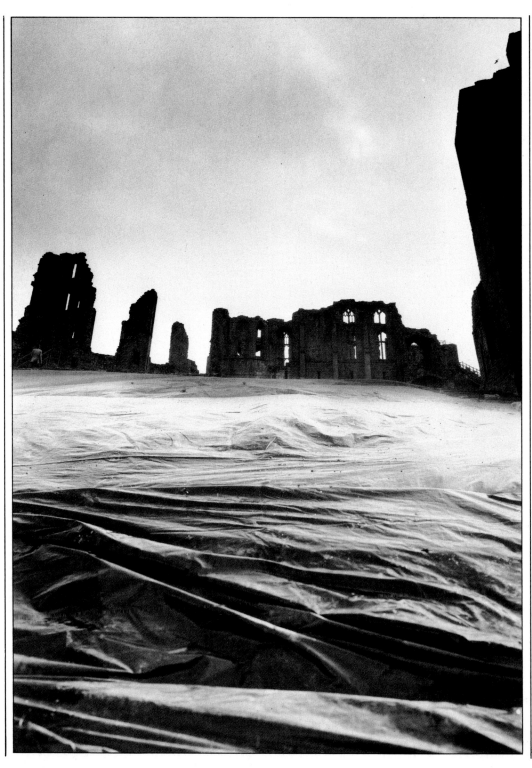

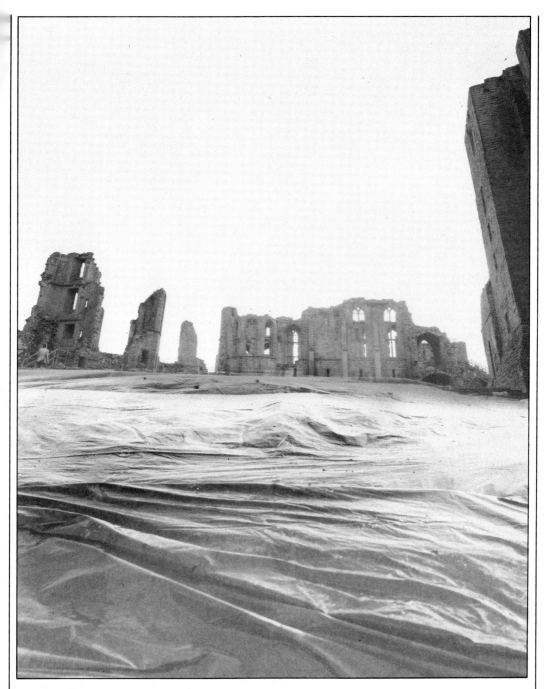

Printing on color paper

The images above and on the facing page were printed on negative/positive paper using two black and white negatives. For this type of work, you must make a master sketch (see p. 225) and a test strip for each negative, to decide filtration and exposure. As you will be working in darkness, mark a shading line on your masking frame in tape. In the picture above the negative of the ruin was filtered 90Y 42M, and the foreground negative 95Y 80M. In the version on the facing page, the sky received 110Y 42M, the ruin 95Y 42M, and the foreground 90Y 42M.

Experimental approach

Multiple printing is a form of experimental art. Practitioners such as Jerry Uelsmann (examples of his work are shown below and facing page) build up a picture from fragments of many existing negatives, carefully combining them on a single sheet of printing paper to make a coherent composition. When printing yourself, you can invert images, reverse them left to right, or use them in negative or positive form. Use your file of contact sheets to select images, and sketch the chosen elements on to paper to help plan your final composition.

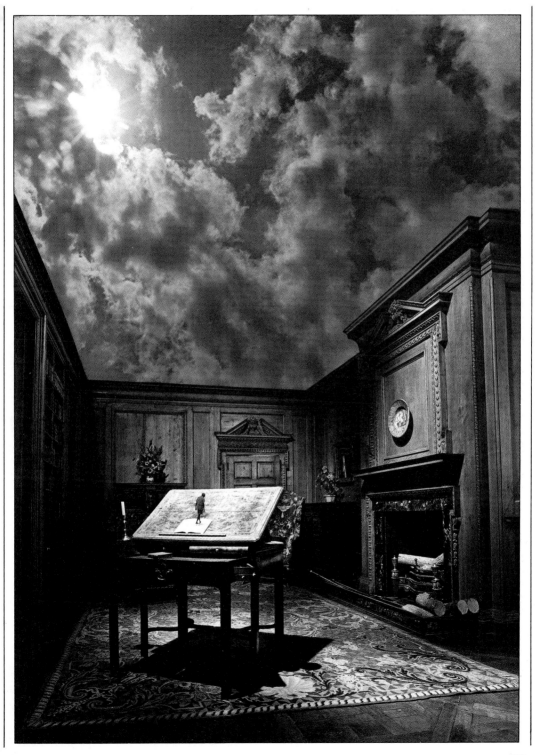

Printing from color negatives

Multiple printing on color paper is difficult because you must work in complete darkness. Without the assistance of the red filter (which allows you to preview your results in black and white printing) the master sketch becomes even more important (see p. 225). If the master is completely opaque to light, you can attach it to one side of your masking frame. Then, whenever you change negatives, flap the master down over your printing paper before turning on the lights. This method is easier than returning the paper to a light-tight paper safe each time. In the pictures left and facing page, there are overlapping elements. For such areas, make a test strip to determine exposure and, when you print, shade them back so that density is consistent throughout. Errors here can easily create a third color, or a band of lighter or darker density.

For the result on the left, the color negative of the castle was printed at the top of the paper, filtered 37Y 19M. The color negative of the cliff was then placed in the enlarger and exposed, filtered the same as above. The picture on the facing page is a combination of a color negative (top half—filtered 57Y 28M) and a black and white negative (bottom half—filtered 90Y 43M).

Sandwich printing

This print was made by enlarging two black and white negatives sandwiched together in the enlarger's negative carrier. One element was a simple photograph of a figure with outstretched arms; the other, a negative of a dancing figure. When you sandwich negatives in this way, details of one image will only print through where the other negative is clear (as in the black leotard of the larger figure).

Sandwich printing differs from other multiple printing techniques in that you print two film images simultaneously on paper. This creates a different effect to printing successive images (see *Reference box*), as the detail of one shows through in the light parts of the other (see facing page). You can use pairs of color slides and print on positive/positive paper (see p. 234), or pairs of color or black and white negatives, or mixtures of each. Pictures can combine dramatic changes of scale, or impossible blends of form and texture. Sandwiching also allows you to use underexposed negatives or overexposed slides to good effect.

You must, however, make sure that the two elements you choose will both print at the "correct" density for your composition when given the same exposure. To do this, you may have to make a test print for each one. If you wish, you can carefully combine two slide images in one slide mount and project them together as a final result. Make sure your projector has a high-output bulb.

Images in contact

You make most sandwich prints by enlarging two films in direct contact. Arrange them emulsion to emulsion, or face to back if the images relate best that way. Use your light box to try out different combinations. Often, you will find that a simple, open shape works well with an overall texture or pattern. You may have to copy some images (see *Reference box*) to change their size. Color slides are easiest to sandwich because you can see the effect at once. Then simply print on positive/positive paper. If possible, use images that are individually low in contrast and density (except lith) because of the density build up.

Images spaced apart

You can achieve some interesting results by separating your two images by the thickness of a piece of glass. This allows you to focus the enlarger sharply on only one image, and render the other soft edged and devoid of fine detail. Alternatively, varying the position of focus and stopping down the lens to different apertures makes possible a whole range of intermediate results. You may still have to use glass top and bottom to hold the films flat and in position. Make sure all surfaces are clean and free of dust. For a different effect, make a high-contrast lith negative from a slide, sandwich both together (separated by glass), and print (p. 235).

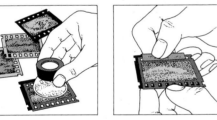

1 *Try different combinations of images on a light box. Overlap and offset them until you find an interesting result.*

2 *Clean both images carefully to remove finger marks and dust. Then, tape them together along the rebate areas only.*

1 *From your chosen color slide make a high-contrast negative by contact printing on to a sheet of lith film.*

2 *Process and dry the lith film. Opaque out any spots on the surface and cut the sheet film down to a convenient size.*

3 *Use a glass negative carrier (or make one from sheets of thin, clean glass) to keep the images flat and sharply focused.*

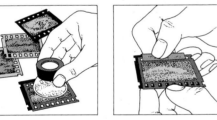

4 *Expose with the lens stopped down to maximize depth of field. You may have to dodge and burn in (see Reference box).*

3 *Space the two films apart with the thickness of a piece of glass between them. Align the images with the lith underneath.*

4 *With the films in place in the enlarger, focus for either image, or between the two. Try printing with the films out of register.*

Sandwiching color negatives

The print above was made on negative/positive paper from two color negatives. One showed a snow landscape and trees, and the other showed a nude against a black background. Filtration was 57Y 65M. Because of the presence of double masking (one mask from each negative), you can seldom produce a true color result from both images.

Sandwiching color slides

The picture on the left is the result of sandwiching a slide of the American flag with one of an eagle against a black background. The sandwich was printed on positive/positive paper, filtered 40Y 20C. The second image appears in the highlights of the first—the opposite to prints from sandwiched negatives.

Sandwiching with lith film

To produce the type of effect in the picture above, first print a color negative on lith film to make an underexposed, high-contrast positive. Sandwich the lith and the negative and expose on negative/positive paper. Color will appear only in image shadow areas. Unless you adjust filtration, the lith film's slight brownish image will give a cyan cast. Filtration in this example was 25Y 05C.

Spaced images

The two prints on the right were enlarged on positive/positive paper from a color slide sandwiched with a contact printed lith negative. In the top version the films were in contact. In the bottom version they were separated by a ¼ in (0.7 cm) thick piece of glass. In this case, the lith was placed on top to create the flaring.

Solarization

Black and white solarization

You can make the type of image above by contact printing a black and white or color image on line film, then solarizing during development (see facing page). You can then either print it on reversal or SDB paper, giving overall color filtration, or just combine it with a filter and project it as a slide.

Solarization (or, more accurately, the "Sabattier effect") involves fogging an image to light part way through development. This has the effect of darkening undeveloped areas, and reversing some of the tones. It also forms a fine, clear "Mackie line" along the borders of originally light and dark areas (see facing page). For the simplest solarization, make an enlargement on very hard-grade paper and switch on white light briefly in the middle of development. Fogging the paper only gives minimal edge-line effect, though, and a generally flat result. For better results, work on black and white film – preferably a line emulsion because contrast is reduced by fogging. As shown below, you can contact print your original negative on line film, solarize the result, and enlarge this on paper. For solarization in color, first solarize your black and white line image (made from a color original). Then enlarge this in sequence with the original color slide or negative on color paper (see pp. 238-9). This method has the advantage of leaving your original image unaffected for "straight" printing.

Black and white results

Choose a sharp image with strong lines and shapes. You can solarize several negatives at once on one sheet of 4 × 5 ins (10 × 12 cm) line film. Your enlarger is a convenient light source for fogging. You alter results by changing the ratio of fogging to image exposure (see p. 241).

1 *Contact print an exposure test strip of your negative on film. Process normally and assess.*

Color results

Color materials are difficult to solarize because of their lower contrast. It is best to make and solarize a black and white film image from the color original first. Then enlarge one after the other in register on color paper. Use panchromatic line film if you want to control which colors will be most solarized in the final print.

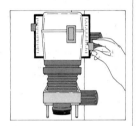

1 *Decide if you want to solarize one color more than the others. If so, filter in this color.*

2 *Decide the correct exposure time, and contact print your negative on another sheet of film.*

3 *Give half the previous development time. Place absorbent paper on the enlarger baseboard.*

2 *Make a black and white solarized film image, see left. (Work in darkness with panchromatic film.)*

3 *Set up solarized film in the enlarger. Make a full sheet test on color paper. Process, assess results.*

4 *Position developer tray under the enlarger. Fog the film (emulsion side up) for the same period as step **2**.*

5 *Complete full development and remaining processing. When it is dry, cut out the film image. Enlarge on bromide paper.*

4 *Expose another sheet of color paper. Remove it to a paper safe. Change to original color negative or color slide.*

5 *Use the first test print to position new image in exact register. Test, then print on the pre-exposed paper from the paper safe.*

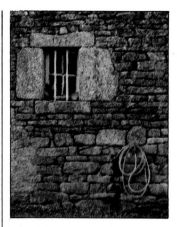 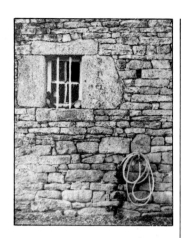

Using neg/pos color paper

The picture top left was printed normally from a color negative, filtered 68Y 34M. A line film contact print was made and solarized (see p. 237), and then printed at 70Y 30M (above center). The result directly above was printed from the original color negative followed by the solarized line film. For the other versions on these pages, a print-sized lith mask was also made from the original negative, processed normally, then registered with the image projected on the baseboard. For the result left, the paper was exposed as above, but covered by the positive lith mask for 10 per cent of the exposure. The version below had the mask in place for 50 per cent of the time. For the picture on the facing page (37Y 26M) the mask was in place for 30 per cent of the time.

Emphasizing edge lines

If your subject is full of complicated patterns and shapes, you may decide to aim for an edge-line effect only. The first requirement for this is that you work from an image which is as small as possible (the Mackie effect gives a constant line width, so the more you enlarge a solarized image, the bolder its lines will become). Second, you must make the fogging exposure form a density closely matching that given by image exposure. For the print, left, the original 35mm negative was contact printed on line film, giving 4 sec image exposure and 16 sec fogging exposure. This produced a solarized film with a slight negative bias. The final print, therefore, has a slight positive bias, "filling in" the main shape with gray. For the version above, film exposures were changed to 6 sec (image) and 8 sec (fog). The structure now has more equal negative/positive characteristics, although this no longer suits the lighter-toned clouds, which print positive.

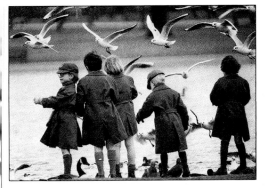

Changing the tonal bias

Most scenes contain a wide tonal range. Complete, equal-bias solarization is only possible for a few tones at a time, as in the crane on the facing page. The prints on this page were all made from the original shown printed normally above. The other versions are from various solarized film intermediates. For the result, top right, the film received 14 sec image exposure and 8 sec fogging. This produced a positive bias in all but the lightest tones, giving a mostly negative print. In the print, right, exposures were changed to 8 sec (image) and 12 sec (fog), reversing most of the darker tones. The print below is from film given equal image and fogging exposure times.

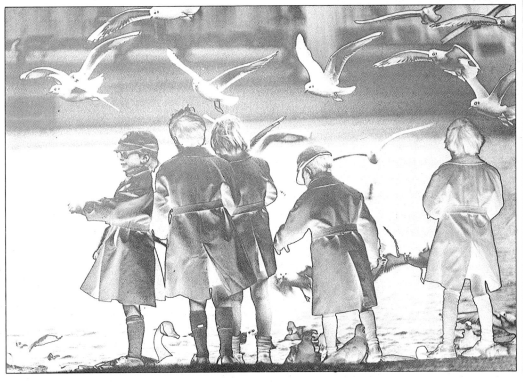

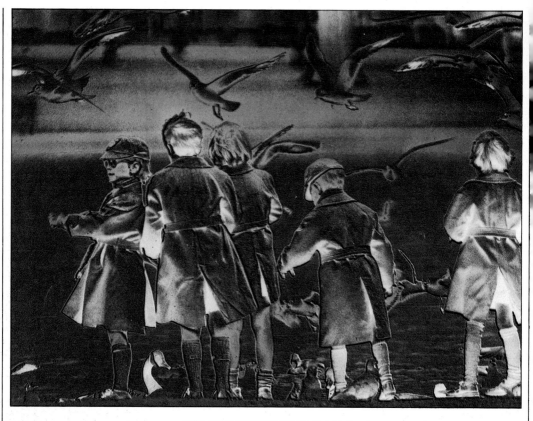

Printing on color paper

You can print the type of black and white solarized films discussed on pp. 240-1 on color paper. Using either one, two, or more versions of the image enlarged on sheet film, you can then print additively through different filters to produce a single, colored print. You can also print negative and positive versions of the same solarized image through complementary filters; or merge two images, one into the other, by shading and printing in. This will give changes of both tone and color across the paper. The result above was printed from positive-biased and negative-biased solarized black and white films. The two images, sandwiched together, were printed on negative/positive paper without any filtration. For the detail shown right, the sandwiched films were printed at 85Y 50M, then a lith separation from the negative-biased film was printed in register, exposed through a deep green filter.

Solarizing color slides

For dramatic solarizations work from color slides. First contact your slide on solarized lith film, then register the two and contact print them on another sheet of lith. Finally, tape original and second lith together. You can then print this sandwich on negative/positive or positive/positive paper. For a result like that below, expose negative/positive paper to an accurately registered sequence of **1** a color slide, then **2** the second lith film. The result right is made from a black and white negative original, a print-sized solarized lith film, and a second lith film made by contact with the first. Expose the negative on negative/positive color paper with the first lith covering the paper. Then change to the second lith and re-expose using very different filtration.

Posterization

Posterization is a process you can use to convert a normal-looking photograph into one that consists entirely of distinct but flat areas of tone or color. A poster usually relies on simple, opaque pigments to produce a bold, striking effect. A posterized photograph has much the same appearance–all shading and gradation being replaced by abrupt changes from one area of tone or color to another.

To make a posterized print from a black and white original, you must first make density separations (see below). You then register (see *Reference box)* and print them on the same piece of paper to produce the types of images on the facing page; or you can print them in color using filtration (see pp. 246-7). If you want to posterize a color original, you have the choice of making separations by density (as described for black and white below), or separations by color, using exposures through blue, green, and red tri-color filters (see pp. 249-51). You can then make your final posterized print in black and white or color.

Making density separations

You can convert a continuous-tone image (right) into a posterized one by making three density separations on high-contrast film using different exposures. Enlarge the original negative on three 8 x 10 ins (20 x 25 cm) register-punched sheets of lith or line film (see below). Underexpose one sheet, normally-expose another, and overexpose the final

one. After processing, each piece of film will show a tonally different positive. One will record only the deepest shadow areas as black, another will record mid-tones and shadows as black, and the third will have all tones black except for the brightest highlights. You then contact print these on high-contrast film to make negatives ready for printing (see facing page).

1 *Project down the original negative on the baseboard. Leave a wide margin for registration holes. Position a register pin bar close to the image and tape it in position.*

2 *Turn on the red safelight and position a sheet of line or lith film. Make an exposure test. Process, and decide which times produce the most distinct differences (see below.)*

3 *Punch register holes in a sheet of film and position it over the pins. Press the film down flat and expose it for one of your chosen times.*

4 *Follow this routine for the next two sheets, but use different exposures. Process, then contact print these (all at equal exposure) on three register punched sheets.*

Positive 1

Positive 2

Positive 3

Printing the separations

To make a black and white posterized image, contact print the separation negatives one after the other on normal-grade bromide paper (see right). Give each negative only enough exposure to produce a mid-gray image. The picture below shows the paper after one separation only has been printed.

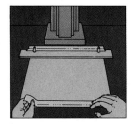

1 *With the safelight on, tape a piece of bromide paper to the baseboard (emulsion side up) next to the pin bar.*

2 *Place the first negative over the pins, emulsion side down. Test expose to find the correct time for mid gray. Process paper.*

3 *Tape down another sheet of paper. Expose the first negative. Exchange this for the second, then the third (same exposure).*

Try exposing various combinations of negatives and positives. For the result right, positive 1 was exposed followed by negatives 2 and 3 combined. The version below is from negatives 1, then 3, then positive 2 with negative 3.

Printing density separations in color

All the pictures on these pages were contact printed from the three line negatives and positives on p. 244. When printing in color you must register punch the printing paper as well, so that you can return it to the paper safe while you alter film separations and filters. The prints left, were exposed (top) from positive 2 with negative 3, filtered

40Y 100M; (center) the same combination followed by negative 2, filtered 85Y 95M; and (bottom) the same sequence plus exposure to negative 1, filtered 80Y 50C. The larger print above was given an additional exposure to negative 3, filtered 150Y 40M. The picture below had the same elements, but filtration for negative 3 was 160Y 35M.

Using posterization techniques, you can easily produce strident, multicolored results. Often, though, you will find that your results are more effective if you make some areas neutral or muted in color. For the result above, positive 2 with negative 3 were exposed and filtered 70Y 30M, then positive 1 was exposed filtered 60Y 60M, and finally positive 3 filtered 95Y 50M. The version right, had the same sequence of separations, but with the filtration changed to 70Y 30M, 50Y 43M, and 95Y 50M, respectively. The two pictures below again had the same sequence of separations but filtered (left) 87Y 80M, 50Y 43M, and 90Y 30M; (right) 70Y 30M, 50Y 43M, and 110Y 43C.

Pseudo-posterization

You can obtain results very similar
to posterization (see above) using
just one sheet of high-contrast film.
Set enlarger head to give the size of
enlargement you require and make
a test print on bromide paper so that
shadow detail fills in (see right).
Next, underexpose the image on
line or lith film to give a thin positive
(see far right). Finally, place the
processed film over bromide paper
in the masking frame, and expose
them to light from the enlarger with
the original continuous-tone
negative in the carrier.

Separations from color images

If you are working with a color original, you can make your separations through color filters. Make exposures on panchromatic lith film using red, green, and blue filters. Your aim is to produce a set of negatives matching in density in neutral-toned areas, but different in colored areas. If you have a negative original, first make enlarged line positives (see below). Then contact print these to make negatives. (If you have a slide original, you make negatives first and use them to produce positives.) You should finally have six line images–being red, green, and blue records in negative and positive form (see below). You can use these in varying combinations for different effects (see pp. 250-1).

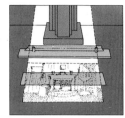

1 *Enlarge your color negative to the final print size. Tape register pins close to one side of the image.*

2 *Remove printing filters. In darkness, make exposure tests on strips of lith film through tri-color red, green, and blue filters.*

3 *Process and assess the test strips. Decide the correct exposure time through each filter that gives equal density in neutral-colored areas.*

4 *In darkness, punch register holes in a full sheet of lith film. Position it over the pins and expose through the red filter for the time determined in 3.*

5 *Expose the other two sheets through the green and blue filters, respectively. Cut a different number of corners off each film to code colors.*

6 *Finally, contact print each separation positive on to register punched lith film. If you are using a slide, print your negatives to produce positives.*

Blue positive

Green positive

Red positive

Blue negative

Green negative

Red negative

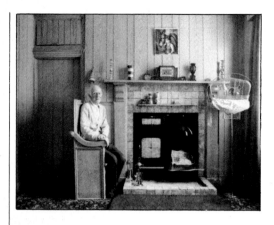

Printing color separations

Separations contact printed (see p. 249) on negative/positive paper are strikingly different from a straight print (above). The print below was exposed to the color negative, then to the combined blue negative and positive, at 75Y 50M. The image right had the blue negative printed 85Y 42M and blue positive 45Y 35M. The print, facing page, used blue and green negatives and positives.

Dye transfer

Dye transfer is a traditional process, useful for both straight and manipulative printing. To make a dye transfer print you apply dyes to a suitably prepared piece of plain paper, using gelatin printing "plates"–one for each color. This system allows you to use pure dyes more brilliant than the usual chromogenic colors.

There are four basic steps to making a dye transfer print. First, if you are using a black and white original, you should make tone separations (giving different exposures for each of your yellow, magenta, and cyan printing colors) on lith film (see *Reference box*). With a color original, you make separations through tri-color filters. Next, enlarge the separations on "matrix" film (see below and facing page), which develops a relief image in gelatin. Then you soak the matrices in whichever color dyes you want, and press them one after another on a white paper base, so that the dyes transfer to the paper and build up a full color image (a range of different color results is shown on pp. 254-6).

Materials and equipment

Apart from the normal black and white darkroom items, you will require: matrix sheet film and developer, a set of dyes, paper conditioner and receiving paper, 2 per cent acetic acid solution, roller squeegee and board, a registration punch and pins, and at least 6 print-sized trays to hold the dye solutions.

Making matrices

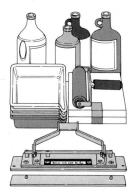

You can make matrices from separations of any continuous-tone original, like the one above right. To make a positive matrix, use a negative separation. For a negative matrix, use a positive separation. When printing, you can use any combination of positive and negative matrices. Place each separation in the enlarger and form an

image 1 in (2.5 cm) smaller all round than your matrix film. Lock the enlarger controls so that each matrix in a series is precisely the same size. Expose the matrix film emulsion side downward, or the image will wash off completely at stage **4** (below). Prepare the tanning developer (which hardens emulsion gelatin wherever silver forms).

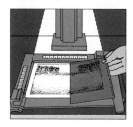

1 *With a red safelight on, place one of your separations in the enlarger and make a test strip.*

2 *Develop your matrix for 2 min in gelatin tanning solution. Agitate continuously. Wear gloves.*

3 *Rinse and then fix the matrix in a non-hardening fixer. All further steps take place in white light.*

4 *Wash away all untanned gelatin in 120°F (49°C) water. Then chill the matrix in 68°F (20°C) water.*

5 *Judge test exposures. Highlights should be just clear of tone and gelatin. Expose your full matrix set.*

6 *Superimpose matrices in turn on a light box and punch registration holes (see Reference box).*

Planning your colors

The matrix images below and right, were all produced from the picture on the facing page via lith negative or positive intermediates. Now choose which color to dye each matrix for your first print. The color will only transfer to the paper from the dark image areas. Mark each matrix with its printing color. If your first test is disappointing, you can re-dye any matrix another color (see below). You should be able to make 30 prints from each set of matrices.

Matrix 1 (negative)

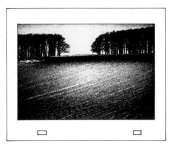

Matrix 2 (negative)

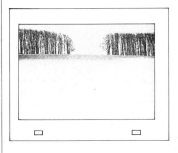

Matrix 3 (positive)

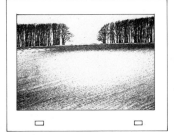

Matrix 4 (positive)

Matrix 5 (positive)

Dyeing and transferring color

1 *Rinse one or more sheets of receiving paper in water. Then soak them in conditioner solution for at least 10 min before you begin printing.*

2 *Lay out your trays – one for each color dye, two with 2% acetic acid rinse. You will also require a tray for each matrix containing water at 100°F (38°C).*

3 *Pre-soak each matrix in its warm water tray, emulsion up. Transfer it to its dye bath and allow it to soak for 5 min at least. Agitate frequently.*

4 *Drain the first matrix. Place it in the first acid rinse for 1 min, then transfer it to the second. Discard first rinse and make fresh solution each time.*

5 *Drain the receiving paper. Tape it face up in position on your printing board against the register pins. Squeegee off water.*

6 *Remove the first matrix from the second rinse. Drain the matrix and locate it on the register pins. Hold it away from the paper.*

7 *Roller squeegee the matrix down on to the paper. Roll away from the pins. Leave for 4 min, then remove the matrix.*

8 *Rinse the matrix in running water and it is ready for re-dyeing. Print down the other matrices in register (see pp. 254-5).*

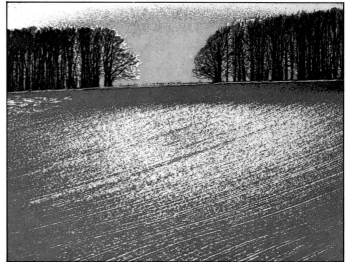

All these prints were made from the matrices on p. 253. The pictures on the left show three stages of color build up. The top one results from transferring cyan dye from **matrix 3**; the center one from adding magenta dye from **matrix 4**; and the bottom one from adding yellow dye from **matrix 5**. The version above, was made by printing magenta and then yellow from **matrix 5**, then cyan from **matrix 3**, and finally cyan from **matrix 1**. The print below has six layers, printed from **matrices 2, 3, 4,** and **5**. Some were dyed evenly, and others just partly dipped into different colors.

Color original

To make dye transfer prints from a color transparency, you must prepare separation negatives using tri-color filters (see *Reference box*). You then enlarge the negatives on matrix film (see pp. 252-3) and print them in the correct dyes (yellow for the blue filter image, magenta for green, and cyan for red). Another approach is to exaggerate contrast and manipulate subject colors using lith separation negatives (see p. 256). Working from the original (above), correctly dyed matrices from lith negatives were used to produce the distorted print (above right). For the version right, the yellow-printing matrix was dyed cyan. The version below, uses a cyan printer dyed magenta and a magenta printer dyed cyan.

Tri-color matrices

To make matrices from a color slide, you must first make separations of consistent density and contrast through deep blue, green, and red filters (see below). To do this, contact print the slide on black and white panchromatic sheet film, placing a gray scale alongside each time. Judge exposure not from the images but from the gray scales. Use panchromatic lith for high-contrast effects (p. 255).

1 *Contact print slide and gray scale on panchromatic lith sheet film, using tri-color filters. Density and contrast of each gray scale should match.*

2 *Cut each processed separation from its sheet. Mark the rebate clearly with the filter color you used to make the exposure.*

3 *Set up your first negative, enlarged to the print size you require. Then expose each on matrix film (see p. 252).*

Blue filter (yellow printer)　　**Green filter (magenta printer)**　　**Red filter (cyan printer)**

Hand control of color

If you wish you can hand color matrices instead of dyeing them overall. You can treat matrices locally to remove or add dye before transfer. Equally, you can work entirely on one matrix, hand coloring areas with a range of dyes, and then transfer the image to the paper. You can make prints in black dye as well, and you can offset several images to create a variety of interesting patterns.

Brushing on color
To add color to chosen parts of the image, paint dye on to a dry matrix using a soft brush. Use normal acid rinses.

Dipping color
For a graduated color effect, you can dip a chosen matrix partially into dye. This works best with large areas of color.

Offsetting
Cover your paper with clear acetate after one transfer. Lay the next matrix on top, decide its position, and remove the acetate.

General advice and instructions

● Instead of using receiving paper, you can use any smooth surface bromide paper, as long as you first fix it in a non-hardening fixer. This means that you can add color to any suitable black and white print.

● You can make photograms (see pp. 184-95) directly on matrix film, and produce rich-toned color prints.

● To reduce the color carried in any matrix you can agitate it in water between the dyeing and first acid rinse stages.

● To remove dye after you have transferred it to the paper, swab the print with 0.5% solution of potassium permanganate (to remove cyan), concentrated wetting agent (to remove magenta), or 5% solution of household bleach (to remove yellow).

● If you do not want color to transfer to a particular area, paint it with rubber solution (on dry matrix film) before you place the film in the dye.

● Although dye sets contain a limited range of colors, you can mix dyes to form a wider range of shades.

Pointillism effects

Pointillism is a nineteenth-century technique employed by painters who applied color in tiny dots or isolated strokes. From a distance, the eye blends the spots to reconstruct the subject. You can give color photographs a pseudo-pointillistic effect by converting the whole image into irregular color spots. Choose a negative or transparency that is accurately focused, has simple shapes, and a good range of colors. The image should be slightly contrasty because screens tend to soften contrast. You can form dots by overlaying your negative or slide with a colored screen. This method produces a coarse result (your screen is enlarged along with the image), but it allows you to make a series of identical prints. Or you can place a sequence of black and white screens in contact with color printing paper, and make exposures additively.

Reference box	
Technique	**Page**
Basic principles of light	114
Basic principles of filtering	115
Additive printing	133-4
Half-tone screens	158-62
Prescreened film	163
Photograms	184-95
Using lith emulsions	196-9

Screens in contact with film

To make a screen by hand, cover a piece of line film with irregular black dots. Contact print on another piece of film to give white dots on a black background. Color in dots with inks – avoid creating clumps of any one color, as this will destroy the final effect. Next, copy the colored screen on color negative film, place screen and negative in the carrier, and enlarge on color paper. If your image is a transparency, copy the screen on slide film first, sandwich the positives and enlarge them on positive/positive color paper.

Screens in contact with paper

For this type of screen, scatter tiny objects (in this example chocolate strands used for decorating cakes) on a piece of lith or line film. Expose and process your screen, then place it in contact with negative/positive color paper. Working additively (see *Reference box*), make three separate exposures. Use different filtration each time, off-setting the screen after each one. The larger your print size, the finer the effect will be. You can also use ready-made screens, including non-glare glass enlarged on line film, and designer's self-adhesive grain pattern attached to glass.

Hand-drawn screen
Use transparent inks or fine felt pen on large film to make a screen. Photograph the screen on to color negative film to reduce image size.

1 Use a draftman's pen to make an irregular pattern of black dots on a sheet of line film at least four times the size of your chosen negative. Apply dots evenly.

Photographed screen
You can use any tiny objects to make this type of screen. Seeds, cake decorations, beads and sequins will all give interesting results.

1 Place a piece of line film in your masking frame and scatter strands on it. Expose the strands and then process your line film to form a paper-sized screen.

2 Contact print the screen on another sheet of line film. The dots now appear white. When the film is dry, carefully color in the dots with transparent color inks.

3 Copy the colored screen on color negative film in the same format as your chosen image. Sandwich the screen and negative in the negative carrier, and then enlarge.

2 Place your negative in the carrier and focus it. Then, in darkness, place the screen directly in contact with the paper, and place this sandwich in the masking frame.

3 Give three additive exposures (30 sec red, 30 sec green, and 2 min blue, with lens at f5.6, in this example). Move the screen slightly sideways between each exposure.

Effects with screens

For a striking pointillist effect you should choose a bold, simple subject, as in the photographs on these pages. The image shown left was printed additively, using a hand-made black and white screen (see p. 257) in contact with the paper. This produced the result below. The pointillist picture is softer and more interpretive than the straight print. The screen used for the photograph on the facing page consisted of hand-drawn colored dots on line film (see p. 257).

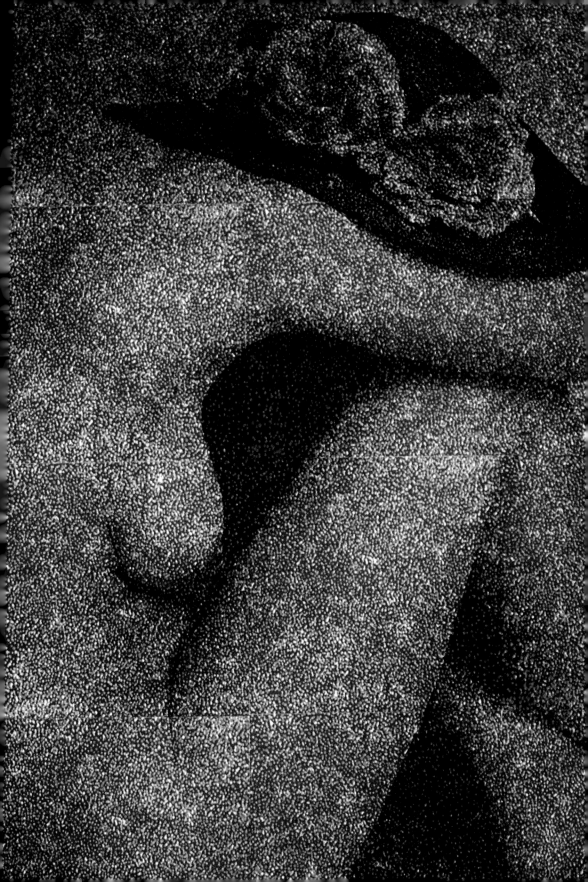

Photo silkscreening

Silkscreening is a system of applying printing ink to paper, or any similar surface, using a stencil. It produces an image with blocks of solid color, which look as if they were painted on in poster color paints. Basically, you use a fine-mesh nylon screen tightly stretched on a frame. For the technique to work, you must block out parts of the nylon mesh by applying liquid opaque, paper, or some form of stencil design to stop the ink reaching the paper underneath. You next place the screen in contact with the paper, pour and then spread thick printing ink on top using a broad-bladed rubber squeegee. The ink passes freely through the mesh only where the holes are unblocked, and in this way the design is transferred to the paper. You can also use a second screen (suitably stenciled) to print parts of the paper in another color, and so on for an unlimited number of colors.

In photo silkscreening, you make the stencil photographically. Use an image that is either line (see pp. 146-7) or has continuous tone broken down by a coarse half-tone screen. You must prepare the image as a final-size positive on high-contrast film and contact print it on a special intermediate "resist" film "processed" so that the highlight parts of the image prevent the passage of ink (see facing page). You then transfer this resist image to the screen. Alternatively, you can coat the screen itself with liquid emulsion (see pp. 175-7), and print on it directly from the photographic film image. You then process this to form your stenciled silkscreen (see p. 264).

Essential equipment

You will require as many screens as the colors you intend to print. Either buy or make them about 3 ins (8 cm) larger all round than your final print size. Use 1 x 2 ins (2.5 x 5 cm) wooden frames with 14-17 mesh nylon stretched and stapled all round. Silk-screening inks are available from artist's supply stores. Turpentine, thinners, screen cleaning liquid, cloth pads, and a scrubbing brush to remove the stencil from the screen are also essential. Have a flat rubber squeegee about 1 in (2.5 cm) shorter than your frame to spread the ink. You will also require brown paper tape or black-out liquid to mask the screen around the edges. For photographic stencils you can use your normal darkroom equipment plus large sheets of line or lith film, resist film, glass, and a UV lamp or strip tube. Wear coveralls and rubber gloves.

Making image separations

If you are starting with a continuous-tone image, you must first decide whether to convert it to a half-tone image by screening (see pp. 163 and 264) or enlarge it directly on high-contrast film. Your film enlargement forms the source of a range of negative and positive intermediates, which you next contact print (see below). When these are processed and dry, paint out different areas and use each one to screen and print a different color on a single sheet of paper to form a multi-colored result (see p. 263).

1 Enlarge your continuous-tone or screened negative to the final print size. Expose on line or lith film and then process.

2 Contact print this first positive on line or lith film to give a master negative (see top of facing page).

3 Working on a light box, or similar well-illuminated surface, opaque image areas not required to print in one particular color.

4 Contact print this on line or lith to form a film intermediate. Wash off the opaque. Repeat steps **3** and **4** for the other areas.

Film intermediates

For the six-color result on p. 263, film separations **A-F** were prepared as shown on the facing page. **A, B, C,** and **D** were all printed from the master lith negative with different parts of the picture opaqued out. **E** was printed from the positive used to make the master, with the figure opaqued out. **F** was printed from **E** with whites of eyes opaqued.

Master negative

Image A

Image B

Image C

Image D

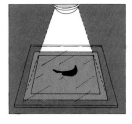

Image E

Image F

Transferring the image to a screen

Your next step is to make each of the images (**A** to **F** in this case) form an ink-resistant mask on separate silkscreens. The easiest method is to contact print them on an intermediate transfer film (available from artist's supply stores). These materials have a UV-sensitive layer on a plastic backing, and you can handle them in normal room lighting. As shown right, after you have exposed them to UV light, development hardens the exposed areas. Then use running water to remove the still soft unexposed emulsion. Next, position the film to adhere to the flat, outer surface of the screen. When it is dry, peel away the plastic backing, leaving only the ink-resistant image areas. You now have a stencil ready for printing.

1 *Position the transfer film (emulsion down) with the lith image (emulsion down) on top. Expose to UV light from above.*

2 *Develop the film (emulsion up). Transfer to an inclined surface and hose with warm water. Then rinse with cold water.*

3 *Position the still wet film (emulsion up) on a flat surface. Bring the clean, de-greased silkscreen into contact with it. Blot and allow it to dry.*

4 *When it is completely dry, lift and tilt the screen and peel off the plastic backing. Gently clean the face of the screen with turpentine.*

5 *Paint out any pinholes and unwanted areas surrounding the image, using a commercial "block-out" solution. Stick brown tape along the inside edges.*

6 *Repeat steps **1-5** for each of the remaining lith separations making up your final image. For the example on p. 263, 6 silkscreens are required.*

1st printing

4th printing

Printing the screens

Use your prepared screens to transfer the stenciled design to the receiving paper using thick printing inks (see printing technique on p. 264). Register each image by eye, and test print each new screen on a scrap print first. For the final image on the facing page the screen made from **image F** (p. 261) was first printed in a pink ink (far left). When dry it was overprinted with **image A** in orange. The third printing was made in green from **image B**. This color also superimposes on the melon skin part of the previous image. Next, **image E** was printed in blue, filling in the background. The fifth printing was in dark brown from **image C**, and the sixth printing used **image D** to add magenta.

2nd printing

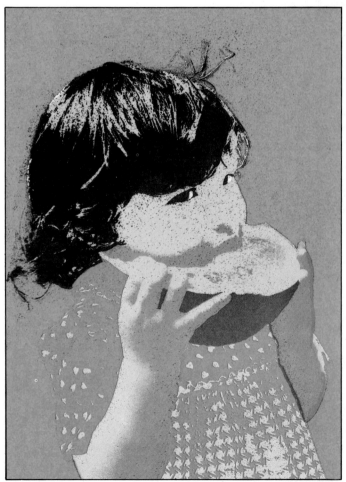

3rd printing

5th printing

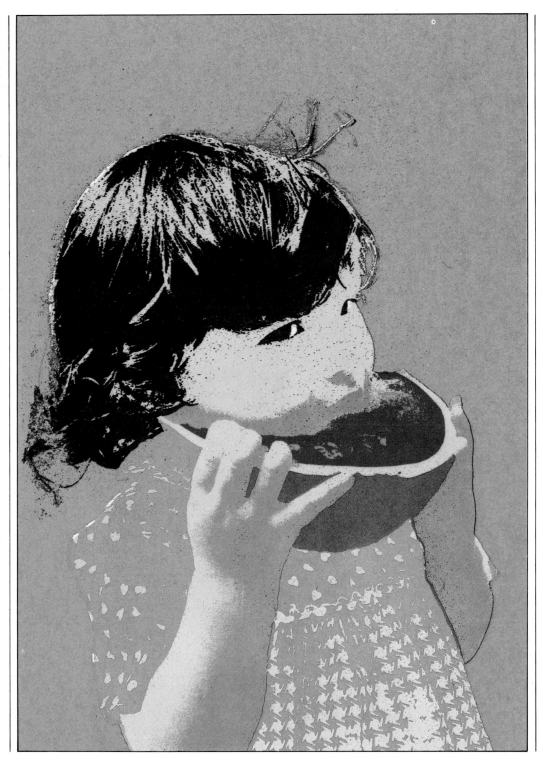

Printing the screens

To squeeze the ink through the screens (prepared on p. 261), position each one in turn over a rigid flat surface (see below). Place movable cardboard guides along two sides of surface so that you can align paper. When changing screens, place a dry first-screen print under the new stencil, register the two images visually, and reset the guides (if necessary). You can print copies until the ink gradually thickens and clogs the fine mesh holes. You must then clean the screen with ink solvent before any further printing.

1 *Position the screen (stencil surface downward) and attach the frame to your work surface using hinges with removable center pins.*

2 *Place the receiving paper under the screen. Attach cardboard guides to work surface. Choose ink color and mix enough for the run of prints.*

3 *Lower the screen over the paper. Pour ink along one edge (on the brown tape or black-out—not over the image area of the screen). Do not over-ink.*

4 *Make one pass of the squeegee across the back of the screen, spreading the ink evenly. Use both hands and pull the squeegee toward you.*

5 *Remove the paper to dry and replace it with another. Pull the squeegee in the opposite direction to print. Repeat for the number of first printings required.*

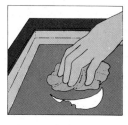

6 *Remove the screen and clean both sides with turpentine. Leave it to dry. Change to the next screen, register image, and begin the next color (p. 262).*

Printing with a half-tone screen

To preserve fine gradations of tone and color when silkscreening from a continuous-tone image, you must first break it down into half tones. Most of the screens on pp. 158-63 will do, but fine patterns will cause the ink to clog quickly. Start by enlarging your original negative on lith film covered by a coarse, unsharp screen. Assess exposure. Image highlights should have tiny black dots or narrow lines. Image shadow areas should have tiny white dots or narrow lines. Then proceed to make as many separations as you have colors to print (see pp. 260-1). Where you want to superimpose two or more half tones (printed in different colors, for example), you must set the unsharp screen at a different angle for each separation during enlarging.

Light-sensitized silkscreens

As a cheaper alternative to buying special intermediate resist film (see pp. 260-1), use an ultra-violet-sensitive liquid resist (available from the makers of liquid emulsion). Following manufacturer's instructions carefully, coat liquid directly on the nylon screen (as shown right). When it is dry, contact print your line positive and process to form the resist. This form of resist gives poorer resolution of fine detail than the film resist, but it wears less rapidly.

1 *In normal room lighting, apply the sensitized emulsion to a perfectly clean screen. Spread it evenly over the back surface using a piece of cardboard. Leave it to dry.*

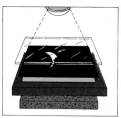

2 *Back up the screen with a thick foam rubber block. Place the lith film intermediate on top of screen (emulsion side down). Cover it with clean glass and expose it to UV light.*

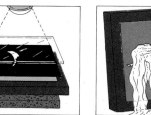

3 *Carefully process and wash your exposed screen, following instructions. When it is dry you will have a stencil ready for printing. Repeat steps **1–3** for each color you want to use.*

Safety when silkscreening

Silkscreen printing involves the use of highly volatile solvents. These are present in the inks, thinners, and cleaning agents, and they can cause headaches and/or giddiness. Always work in a well-ventilated room and never have a naked flame burning nearby. Since the fumes are heavier than air, locate your exhaust fan close to, but no higher than, your printing surface.

Workroom
techniques

Introduction

This part of the book deals with a varied range of image manipulation techniques, separately grouped here because each can safely be attempted outside the darkroom. In fact, for the majority of the procedures a well-lit room is a positive asset. The techniques you will find here serve two broad functions. Some follow on from completed work started in the darkroom. Toning, hand coloring, and montage fall into this category, as well as some more unusual skills, such as metal etching and embroidery of pictures. Others are self-contained workroom processes. Color Key and photocopy derivations are examples of this second type, as well as instant picture manipulation and black and white drawing.

For many of these manipulative processes only the simplest facilities and equipment are required – a water supply, trays, some form of working surface with a plastic finish (preferably white), a light box, and cutting and retouching tools. Some of the others, however, will involve you in having access to expensive printing machinery – printing from inked relief plates, for example.

For most of the results in this section, a great deal can be done with very little, provided you have the time and patience to learn the necessary skills.

Adding color
There is a wide range of ways of turning a finished black and white print into color – by toning the silver image into a colored substance. You can turn the whole image one color (to produce a sepia-toned print, for example), or work it up, stage by stage, changing different areas or tones into varying hues. This is mostly done by "rehalogenizing" the black silver image (returning it to silver halides) using a bleacher, and then darkening these into a color with another solution. A normally lit room cannot fog the picture because white areas of the print contain no halides – they were removed by the fixer during the original printing.

There are several sophisticated kits for toning available now. They contain easy-to-use chemical solutions, which, although colorless themselves, convert silver compounds into wide-ranging hues. Some can give special effects that look similar to color solarization. By selective masking (using waterproof rubber resist), and repeated treatment in different toners, you can build up very unusual multicolored prints.

This section also shows the even greater color control possible by applying dyes and pigments to prints by hand. You can use either water color or oils, working them by brush or with a spray gun (airbrush). Hand coloring tints the white paper and the image parts of the print whereas toning can only affect the image areas. Both tinting and toning were used to re-create subject colors in photographs long before color photography (see facing page). Today, they are mostly used for the opposite function – to give stylized color, or mixtures of black and white and color detail. They allow you to pick

out any chosen part of your picture and subordinate the rest. A particular feature can be dramatically emphasized by giving it a color complementary to its surroundings, or by leaving everything else in the picture black and white.

Another way of adding color subjectively is to work on film. Black and white negatives or slides with silver images can be toned into interesting color slides. They can also be enlarged on negative/positive or positive/positive color paper. You can even dye tint areas of black and white negatives (preferably large format) for color printing.

Constructions
Montage, like multiple printing, is an extremely flexible and creative medium. In this section you will find practical advice on cutting and sticking prints together – either to give "invisible" joins, as may perhaps be required for surreal pictures, or for a rough "assemblage" look. The latter is a useful way of destroying the usual perspective structure and general realism of a photographic image.

Another device for achieving this effect, and for asserting the presence of the flat, two-dimensional picture plane, is to manipulate the actual emulsion surface. Regular prints can be scratched or scored. Instant pictures can be painted over from either the front or the back, frilled in hot water, or have the emulsion pushed around during processing. Some of this may sound eccentric, but if you are concerned with the different relationships between hand and photographically made marks on the print, it is a relevant avenue to explore.

Embroidery is one of several ways of mixing your media. This section shows how prints made on commercial sensitized canvas can be partly or wholly embroidered over, using different types of stitches and threads. The results have a distinct relief appearance, and you can introduce your own textures by using various stitches.

Special processes
Relief images can be etched into metal directly from line or half-tone photographs if you have access to a printing workshop. The result can be left as a decorative metal fretwork, or inked up on a proofing press and used to run off images on paper. Color photocopying machines are a rich source of derivations too. Making copies of color and black and white prints and slides, and then recopying these (with or without hand coloring) radically changes the character of the images. You will also find here examples of tone-separated and montaged prints used to build up bizarre color prints when fed in fast sequence through a color copying machine. Movement of the original bromide during the exposure, and other simple mis-uses of the machine's functions are also worth trying.

Diazo-coated materials can be used for contact printing in a normally lit workroom. You only require an ultraviolet lamp or sunlit window for exposing the emulsion, and a swab to rub on rapid-drying

processing chemical. Color Key foils are probably the most interesting diazo materials to try. Working in white light, they allow you to form prints on film in brilliant monochromatic colors. If several prints are prepared and sandwiched together as a single transparency, your results will be vibrantly multi-colored. By contact printing negatives or slides, you can form miniature Color Key images, which can then be sandwiched and enlarged on color paper. Color Key is in fact a modern commercial version of the old diazotype process. There are many other old printing processes that can be handled in normal (or near-normal) lighting, and all require an ultraviolet rich light source for exposure (see next section).

Combining the techniques

For the most extreme changes in image character and texture, you can try the sequential use of two or more techniques. Painted over or distorted instant pictures, for example, can then be reproduced via a color copying machine. A normal camera image, or parts of an image, can also be reproduced by processes as diverse as line, hand colored con-tinuous tone or reversed color, and then montaged together and copied.

Some workroom processes, such as Color Key, are also useful as a quick way of previewing final results when you are preparing posterized color prints or silkscreen printing in various colors, from separation images. Each separation is exposed on Color Key film matching the color you intend it to print on paper, and the results are superimposed to see the total effect.

Use all of these processes to exploit your own particular skills too. If you are a competant free-hand drawer, then an airbrush will open up an enormous range of results. Skill with embroidery or painting with oils can be harnessed to your printing. Conversely, lack of drawing ability need not prevent you producing excellent pen and ink sketches by exploiting trace-over and bleach-out workroom techniques.

Looking to the future, as new processes and methods of visual communication become avail-able they should all be assessed for their potential combined use with photography. Domestic color video, for example, offers another channel for manipulation. A slide or print can be set up in front of a video camera and fed to your television screen. By mis-tuning the color controls, you can instantly manipulate hue, intensity, and contrast, and then photograph the result directly from the screen on to color film. It may even be possible to set up a miniaturized color monitor inside your enlarger, replacing negative and lamphouse, and so allow direct color printing.

Historical background

Of all the photographic workroom processes, the one with the longest history is the hand coloring of images. For the first 100 years photographers could only repro-duce color by using paint and relying on memory of how the original looked. Coloring was used on the very earliest photographic processes – the daguerreotype, for example – but with mixed success. Finely powdered color mixed with adhesive was prepared and sprinkled on the image surface, the excess blown away, and the remainder attached by breathing on it. But the daguerreotype was difficult to work on as the delicate image on its polished silver surface was easily damaged, even with the most careful handling.

Paper prints, which could absorb colored dye, were much better suited to this toning technique. Professional portrait photographers offered albumen prints initially and then bromide prints "painted in oils by artists", at about four times the price of the same uncolored print. It was essential that colored prints be commissioned at the time of the sitting, as copious notes had to be taken of the sitter's eye coloring, clothing, accessories, and so on. Until World War II every large portrait studio employed at least one staff colorist, while smaller studios made use of freelance artists.

Early hand colored print
This ambrotype was skil-fully hand colored in about 1860. Arranged still life pictures like this were popular subjects for the *major photographic exhibitions. They reflected the nineteenth century love of rich detail and elborate decoration.*

For mass markets, such as photographic viewcards, work was handled on a production-line basis. Specially cut-out stencils were placed over the black and white prints for each color so that paint could be applied using semi-skilled labor. Lantern slides could also be colored, using transparent dyes – although much greater care was required owing to their magnification when projected. Some of the best-quality, nineteenth-century colored pictures appeared as "crystoleums". These were large albumen prints which were totally face-adhered to the back of a curved sheet of glass. The paper base was then mostly sandpapered off and the remainder oiled to make it transparent. Colors could then be applied to the back surface of the picture, without leaving tell-tale surface textures. The finished crystoleum was then backed with a piece of white cardboard.

Toning

Toning is the conversion of black metallic silver into a colored chemical dye. You can start with a black and white photograph, either on paper or film, and in positive or negative form. There are four main toning techniques: single-solution toning, which gradually replaces the silver (see iron toner, right); two-bath toning, where you bleach the silver, then redarken it in toner (see sepia, below); three-bath toning, where you bleach, color develop, then remove the silver (see p. 271); and multi-stage patented toning kits, such as the "Colorvir" kit (see p. 273).

With all toning techniques you can work in normal room lighting. You should fully fix and wash black and white prints first. And soak dry prints for at least five minutes in water before starting the toning process—this will remove any surface grease. Take special care when you are mixing acid (see p. 000), and always wear gloves for toning.

Sepia toner

For sepia work, choose a fully developed print with a rich range of tones (see **1**, right). Bleach the print to a straw color **2**, using a ferricyanide solution (see below). This converts all the black silver into silver bromide, which you can then tone. After a rinse, redarken the silver bro-

mide in sepia **3** using the solution below. Toner only affects bleached parts, so you can selectively tone any area (see *Reference box*). For a partially toned print **4**, dilute bleacher 1:20, and remove the print while the shadows are still black. Then tone normally.

Solutions table

Bleacher
Potassium ferricyanide	50g
Potassium bromide	50g
Dissolve in water to make 500ml. Dilute 1:9 for use	

Toner (re-usable)
either Sodium sulfide	25g
or Thiourea*	0.1g
+Sodium carbonate	50g
Dissolve in water to make 500ml	

* Thiourea solution gives off less odor

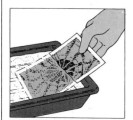

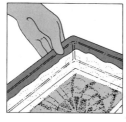

Bleaching
If you want a fully toned result, bleach the print for 2-3 min, until all image blacks become yellow-brown. Rinse for 1 min. The print is now ready for the toning solution.

Toning
Transfer the print to the toner solution and agitate. Leave it until the image stops darkening (1-2 min). Wash the print thoroughly. Sepia-toned results are completely permanent.

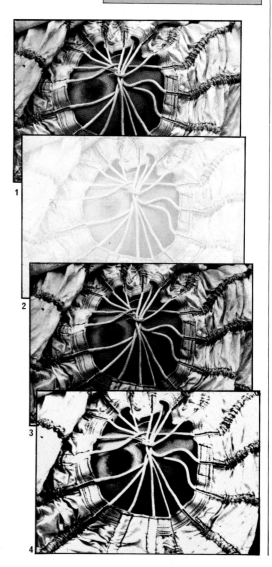

1

2

3

4

Iron toner

Iron toner gives you a strong blue image (see p. 270). It is one of the simplest toning processes to use. You must start with a print that is slightly lighter in density than normal (the toner has an intensifying effect). Make up the combined working solution from the formula below, or buy a ready-to-mix pack. Blue toner slowly converts the black silver image to a ferric (iron) salt. Your results will generally have more "body" if you remove the print before it fully tones to a bright Prussian blue. Then you must wash the print. Blue-toned prints, however, are not as permanent as ordinary black and white images.

Solutions table

Solution A

Potassium ferricyanide	1 g
Sulfuric acid (concentrated)	2ml
Dissolve in water to make 500ml	

Solution B

Ferric ammonium citrate	1 g
Sulfuric acid (concentrated)	2ml
Dissolve in water to make 500ml	

Mix equal parts of **A** and **B** solutions before use

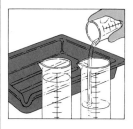

1 *Mix the two halves of your toner solution together. It is best to keep a separate plastic dish for iron toning.*

2 *Pre-soak your print and then place it in the toner face up. Agitate the solution and watch the image gradually change color.*

3 *When the image reaches the color you want, remove the print and wash it until the pale yellow stain disappears (10 min).*

4 *If the image has blue veiled highlights, you can clear them by soaking the print in 10% salt solution. Rinse in running water.*

Nickel toner

This toner produces a bright pink or magenta image (see p. 270) when you use the formula below. You must work with separate bleaching and toning solutions, so it is possible to achieve a range of partial toning effects (see facing page). Your original black and white print should be more contrasty than normal, because the process has a slight contrast-reducing effect. After bleaching, fix the image in a 5% solution of hypo (sodium thiosulfate) crystals for 5 min. Then tone and wash your print (see diagrams below). If you nickel tone a black and white negative, and then print on negative/positive paper, you will get a green result.

Solutions table

Bleacher

A	Nickel nitrate	25 g
	Potassium citrate	75 g
	Dissolve in water to make 500ml	
B	Potassium ferricyanide	20 g
	Dissolve in water to make 500ml	

Mix equal parts of **A** and **B** solutions (acidified with a few drops of citric acid)

Toner

Dimethyl-glyoxime (saturated, in alcohol)	50ml
Sodium hydroxide (0.4% solution)	50ml
Add water to make 500ml	

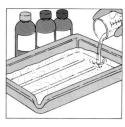

1 *Wearing rubber gloves, prepare your working solutions. Carefully add the citric acid to the bleacher solution.*

2 *For a fully toned result, bleach the print until no trace of the black silver image remains.*

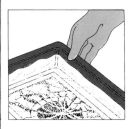

3 *Next, fix the print in a plain hypo solution for 5-6 min. Rinse it thoroughly before toning.*

4 *Place your print in the toner. Agitate it until the image will not darken any further. Then wash the print for 10 min.*

Metal toner results

Both prints on this page were toned in metal toners (see p. 269). If you want a result similar to the image on the left, remove your print from iron toner solution before the silver is completely converted into blue ferric salts. For the type of effect below, you must paint out selected areas of your image with a liquid rubber solution (see *Reference box*). After you have removed your print from the nickel toner solution, and completely dried it, peel off the protective rubber.

Color coupler toning

Unlike metal toners, color couplers allow you to form a range of colors on the same print. The images on this page were identical black and white prints. They were then bleached and redeveloped in color developer along with a coupler of the chosen color (see p. 272). You can choose to keep the black silver image (formed as part of color development), or bleach it away (leaving only the dye image). Blue coupler produced the effect right. Only the bottom half of the print was silver bleached. The print below, was coupled in red and the one below right, in yellow. The large print (bottom) was selectively toned using three different couplers (see p. 272).

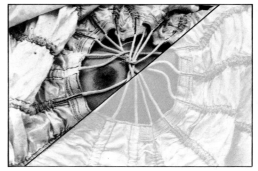

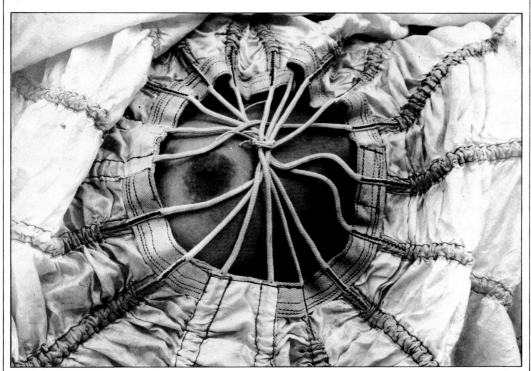

Selectively toned in green, purple, and pink

Using color couplers

If you want a range of different colored toners, you can buy a kit of color couplers. The kit contains a bleach, color developer, liquid couplers, and a silver bleach solution (see right). Alternatively, you can use the bleach formula on p. 268 for your first bleacher, and Farmers reducer (see p. 170) for the final silver bleacher. You can use most color negative developers to color develop, but you must add the color toning kit couplers in the ratio 1 part coupler to 10 parts developer. The process uses the same coupling principle as film processing (see p. 56), except that the couplers are present in the developer, rather than in the emulsion. The coupler liquids for toning are made for basic tints only, but by careful measurement you can mix them to produce a range of intermediate hues.

1 *Carefully measure out couplers to give the required color. Add these to the color developer.*

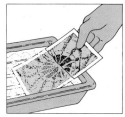

2 *Pre-soak your print and place it in first bleacher. Agitate it until all the black silver disappears.*

3 *Wash the print in running water for 15 min. Make sure your washer is uncontaminated.*

4 *Place the print, face up, in the color developer solution. Agitate it gently for 5-10 min.*

5 *If you prefer to leave the image dye plus silver, wash the print normally and then dry it.*

6 *If you want brighter colors, wash the print for 5 min, silver bleach for 5-6 min, rewash, and dry.*

Selective toning

You can tone various elements of your print different colors by using several couplers. Bleach your whole print in the first bleacher solution. Then use small quantities of color developer, each containing different couplers (see right). Since you are using chromogenic dyes, results may closely resemble a color photograph.

1 *Prepare a small graduate of color developer for each color you want. Add the appropriate coupler.*

2 *Immerse the print in the first bleach. Then wash it for 15 min and remove all surplus water.*

3 *Using a cotton ball, apply the first color solution to the areas you want to tone.*

4 *Blot any excess and change to the next color. Continue until you have treated each area.*

5 *Use print developer to return any untoned areas to black. Now wash the print normally.*

"Colorvir" dye/toner kit

Colorvir is a complete kit, containing dyes, toners, and pseudo-solarization chemicals. It is best to work on resin-coated paper, but you can use film negatives or positives (see p. 275). A typical kit (right) includes concentrated blue and yellow toners, solarization and mid-tone color inhibiting additives, and three or more dyes. (Salt solution is a vital agent. You use it after every toning stage to remove yellow fog

by-products.) Single or multi-colored results produced by toning vary according to the density of grays in your original image, and the sequence and duration of the different baths. Dyeing mostly affects the lightest areas of your prints. You must always precede dyeing by toning, which "mordants" the image (chemically prepares it to accept dye).

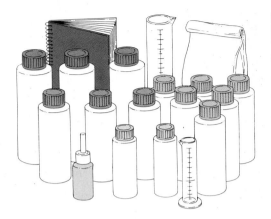

Using Colorvir

Read the kit instructions carefully for the sequence of solutions required to produce different colored effects. Deciding how long to leave your print in each bath is largely trial and error—so note times and effects carefully. Use at least four trays and give yourself plenty of room. Use images with a rich tonal range (avoid line images).

1 *Dilute the kit chemicals for the effect you want. Mix up a salt solution as recommended.*

2 *Lay out trays in sequence. Mix up a solution of dilute acetic acid to clear image highlights.*

3 *Check that print has no scratches (they create uneven action). Process as recommended.*

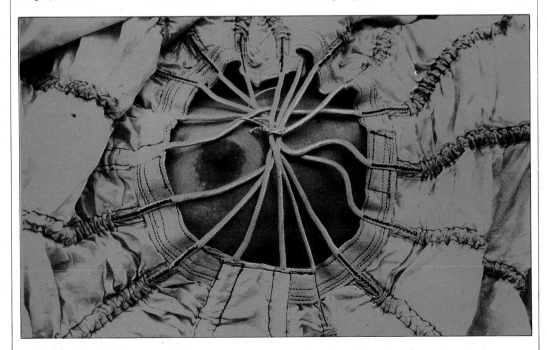

This print was given yellow toning, plus solarizer, and brown dyeing

Toned prints

The two pictures right, were separately toned in blue and yellow Colorvir chemicals. (For a blue toned result it is best to start with a light print.) The large image below was given a long yellow toning, then a shorter blue toning, which gives a solarized effect. The green color forms in the lighter gray areas where the two toners overlap.

This version was treated in yellow toner with a solarizing agent added, then blue dyed. To treat areas locally, use a brush or rubber solution.

This example was placed in yellow toner with a solarizer additive. Next it was treated with dye density restrictor, and finally placed in red dye.

Toned film

You can use some Colorvir chemicals on black and white film negatives (as well as positives). For film, make the solutions four times normal strength. The negative below was given a sequence of blue toner, solarized in yellow toner, and then dyed in magenta. To make the print from it on the right, the negative was combined with un-exposed processed color negative film (necessary because of the mask), and filtered 80Y 30M on negative/positive paper.

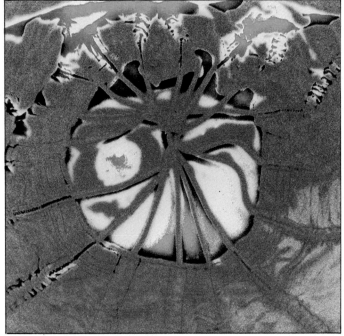

The negative, top, was given yellow toning combined with a solarizing agent, and then dyed blue. Next it was contact printed on negative/positive paper (above).

Here the negative was yellow toned with a solarizer added, followed by magenta dyeing. It was then contact printed on negative/positive paper for the result above.

In this example, the negative was lightly yellow toned, with solarizer, and then blue toned. The resulting contact print above was printed on negative/positive paper.

Black and white drawings

Before the invention of light-sensitive photographic emulsions, artists used a large camera-like device called a "camera obscura" to make accurate tracings of static scenes. Today you can use your enlarger in much the same way. With a slide or negative in the carrier, simply move the head to obtain the degree of enlargement you want, and trace the image on a piece of ordinary paper. Alternatively, you can ink over a photographic print and then bleach away the silver image (see below right).

Silver bleach formulae

Remove the black silver image by soaking the print for 5 mins in *either* iodine bleach *or:*

Copper sulfate (crystals)	50g
Table salt	50g

Dissolve in water to make 500ml
Add to the above 12 ml of sulfuric acid
Finally remove any stain by fixing in normal print fixer for 10 min, then wash thoroughly

Tracing the image

Select a sharp, softly lit image. The advantage this technique has over tone-line (see pp. 164-5) is that you can select the part you want to retain and ignore the rest (see right). Trace the image on drawing paper. Then use this to make a further tracing (in ink) on a sheet of acetate. Finally, contact print the acetate tracing on line film (below) to make a negative. You can use the negative to make black and white contact prints, which you can tone (see pp. 268-75) or give other photographic after-treatments.

Inking and bleaching the image

First produce a bromide print that is light and flat– preferably under-developed. When your print is dry, carefully outline the chosen detail on the print surface using waterproof ink (see below). You can use black or any deep-colored ink. After the ink has dried, bleach away the under-lying photographic image in one of the solutions detailed above. Your result will be a unique line drawing (see facing page). Later you can add shading or tinting.

Hand coloring negatives

If you hand color a black and white negative and then print, you can make any part of your final image a particular color. However, you must learn to work on a film image that has reversed (negative) tones, using tints that are complementary to those of the final colors you require (see *Reference box*). If possible, work on a large negative – 4 x 5 ins (10 x 12.5 cm), for example – as your handiwork will be less obvious if you do not have to enlarge the negative greatly. For this technique, avoid dense negatives, and bear in mind that you can color shadow parts of the image more easily than highlights. When printing, add an orange mask to your negative by sandwiching it with a piece of unexposed but processed color film of the same format (see facing page). Once you have colored your negative you can make a variety of prints from it by altering the filtration, see facing page. You can also work on a black and white positive if you enlarge your negative on sheet film. After you have colored the film positive, either enlarge or contact print the film on positive/positive paper.

Complementary dyes

When you are coloring your negative, you can work on both the front and back surfaces, as in the example on the right. Then combine the colored negative with its mask, select filtration, and print on negative/positive paper. The image below, was filtered 110Y 50M. Keep your test negatives and prints for future reference – they show how various colors will print.

Use water-based inks or dyes and apply them with size 0 or 1 brushes. Hand color on a well-illuminated light box, and use a magnifier to follow the outlines.

Using filtration

The filtration you use when printing a hand-colored negative makes a fundamental difference to the final result. If you combine a colored negative with an orange mask (top segment below) and print without filters, you will get a print with a strong pink cast (as in the lower segment). When the same negative is filtered 90Y 65M, uncolored areas print near neutral, giving a totally different result (see right).

Overall coloring

If you color the entire negative (see below), the lack of neutral tones will permit a wider range of filter change effects. The middle print below was filtered 90Y 60M. The version, far right, was filtered 40Y 40M (and the orange mask removed for 10 per cent of the time).

Hand coloring prints

In the nineteenth century hand coloring or "tinting" was the only way to obtain a colored photograph. Today you can use this technique to gain complete control over the color of each element in your picture–isolating detail, or creating realistic or bizarre effects. You can work with water-based colors (see facing page), oil colors (see p. 283), felt pens or colored pencils. Water colors give fine pastel effects; you use them on a damp print. But apply oil paints to dry paper. Choose a small print size (8 x 10 ins/20 x 25 cm or less) for your first attempts at hand coloring. Your print must be light and full of detail, on a matte or semi-matte paper. If you intend to color with oils, avoid resin-coated papers. You should always sepia-tone a black and white print before you start to tint, as shown below. You do not have to hand color your entire print–you will achieve a very effective image if you use selective bleaching and toning techniques, see facing page.

Materials and techniques

If you try to tint over a black and white print you will mute your colors. Therefore, you should make a light, warm-colored print from your chosen image–either print on warm-toned paper (see *Reference box*) or sepia tone a black and white print (see *Reference box*). If you tone you can also bleach selectively–any parts you choose, such as the dog shown facing page, can remain black and white. You will require the usual bleacher and toner solutions, a small sable brush, artist's sponges, a photographic tray, and a non-absorbent work surface that is larger than your print. If you are working with water-based dyes you will require containers of each color, as well as size 0, 1, 4, and 6 brushes, containers for diluting colors, and plenty of blotting paper. First you must bleach all the image areas which you intend to color: carefully introduce bleacher to the damp print with a brush, sponging the larger areas. Then treat the whole print with toner to turn bleached parts sepia, see facing page. You must always apply colors to your print while it is still damp. Start to color by treating the large areas with diluted color and finish with the smallest areas of strong color.

Original black and white print

Selective bleaching and toning

1 *Soak the print in water, then lay it on a work surface and blot it.*

2 *Apply bleach around outlines with a clean, uncontaminated brush.*

3 *Sponge larger areas with bleach. Tilt print to stop solution running.*

4 *Rinse the bleached print, insert it in toner. Now wash it.*

Bleached and partly toned print

Applying water-based colors

1 *Soak your print in water, then place it face up on the working surface. Carefully sponge and blot off any excess water.*

2 *Add small quantities of concentrated colors to the water, in order to form the weak tints that you will work with.*

3 *Apply thinned-down color to broad areas, such as the sky, using a large brush.*

4 *Build up correct depth of color gradually, to avoid ridges. Sponge off excess color.*

5 *Change to a small brush and, using less color, begin to work on the smaller areas.*

6 *After every application of color, blot your work to remove any excess solution.*

7 *When you have colored all but the finest details, dry your print and mount it (see Reference box).*

8 *Use your smallest brush to add final details in strong dye or diluted oil color, see p. 282.*

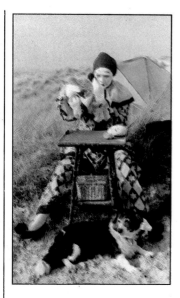

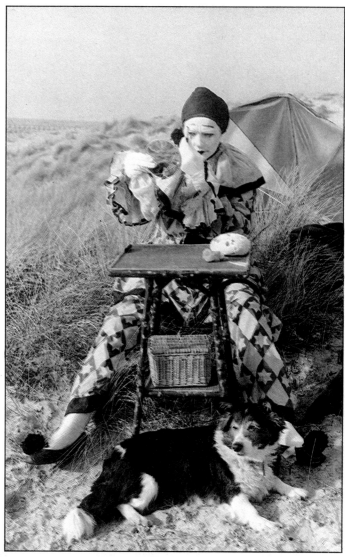

Stages of tinting

When you work with water-based colors you must gradually build up the depth of color over large areas. Take a full brush and, using broad strokes, apply several washes of weak color (see the partly-completed print above). Results will change slightly when the print dries—if in doubt, dry your print, then re-wet it and continue if it requires more color. When you have finished tinting the large areas, work over details in stronger color. After you have dried and mounted your print, you can use opaque color (diluted oil paint) to strengthen a specific area or add areas of highlight, as in the comparative details below. In the final result, shown on the right, every color and point of emphasis has been carefully chosen to create an original image.

Coloring with artist's oils

To create the kind of images on the facing page, work on a dry, mounted, sepia-toned print. Oil is slow drying, and therefore it is easy to spread and blends well with other colors that you add later. Squeeze small quantities of paint on to a palette and, using fine brushes moistened in turpentine, pick up small amounts of color. Color larger areas first, and allow them to dry for 24 hours before you fill in details. Use a cotton bud dipped in turpentine to remove any area of color you want to change.

Airbrushing

An airbrush is a miniature spray gun about the size of a large fountain pen. It uses compressed air to project a fine spray of spirit-based or water-based dye or pigment. You can use an airbrush on prints to color them, spray out backgrounds or add shadows or highlights. You can also use it to hide joins in multiple prints or montages, or to disguise blemishes which were present in your original subject. By adding false highlights or shadows and convincing gradations of tone or color, you can transform one original photograph into a range of results, part photographic and part artwork (see pp. 285-6).

An airbrush is essential for many commercial designers, artists, and photographers – particularly for those involved in making posters, record sleeves, and book jackets. Airbrushing is a skilled job, but one you can teach yourself. It is important to understand the basic techniques, and to be prepared to spoil a lot of prints while learning.

Essential equipment

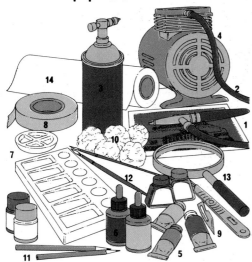

The airbrush itself (**1**), above, has a hollow, pointed nozzle, filled by a tapering needle. A small reservoir on top holds about 1 fl ounce (28 ml) of fluid paint. A long hose (**2**) connects the brush to a supply of compressed air. You control the brush by means of a button– pressing it down allows the air to flow; pushing it back retracts the needle and allows the paint to flow (with a controllable width of spray). You can use either canned compressed air (**3**), or a larger

scale pump and compressor unit (**4**). You will also require a range of other items, such as water colors and gouache (**5**) (or oil colors and turpentine), inks (**6**), paint pallets (**7**), masking tape (**8**), scalpels and blades (**9**), cotton balls (**10**), pencils (**11**), brushes (**12**), and a magnifying glass (**13**) to see fine detail. Use a large sable brush to fill the airbrush with paint. To shade different areas while spraying, you should also have self-adhesive mask film (**14**).

Removing a background

Work on a large-size, matte-surface print, taped firmly to a rigid board. Make sure any pigment you use is perfectly clean and diluted sufficiently so as not to block the paint outlet. Hold the brush at a 45° angle and, for large background areas, about 5 ins (12.5 cm) from the

surface. You should be able to remove a large background area quickly using a wide spray and overlapping "strokes". For a sharply outlined area, use thin mask material in tight contact with the rest of the paper. For a softer effect, hold cardboard above the surface.

1 *Thoroughly practice your technique on a waste print. Try covering broad areas evenly, and making thin lines with a narrow spray.*

2 *Dry mount and tape down your work print. Cover the entire surface with self-adhesive mask film. Make sure you do not trap air bubbles.*

3 *Use a new scalpel blade and carefully follow the outlines of your main subject. Use just enough pressure to cut the film without marking the print.*

4 *Peel off masking film from the background area, leaving the main subject protected. Prepare process white, diluted to a thin cream consistency.*

5 *Fill the airbrush. Begin spraying the background using steady strokes and a broad spray setting. Allow pigment to build up steadily. Do not overspray.*

6 *Wash airbrush. Refill with gray pigment and spray the gradated lower area of background. When dry, remove the mask film. Clean the brush thoroughly.*

The version above shows the original print before any airbrushing or other retouching. You can see that reflections darken the hood and hide interior detail. As with hand coloring (see p. 280), it is best to bleach the print before starting work on it.

All the background areas surrounding the car (including parts seen through the windshield) have been airbrushed in flat white, then gradated downward to dark gray. Car parts of the image protected by the mask during spraying remain unaltered. The car now appears "cut-out".

Dark reflections in the bodywork have been smoothed out with process white. The chrome has been highlighted, with flared highspots added. The windshield has been spray tinted and gray reflections added (see right). The wheel shapes were sprayed in using hand-drawn masks.

Adding tones

Be careful not to destroy the form of the subject when airbrushing reflections and unwanted shadows. First identify the main lighting direction, then airbrush highlights and shadows so that they appear realistic. Mask most of the image, then build up tone by alternately spraying, removing more mask, and spraying again. Unmask areas that require least pigment last.

1 Mask over the background, then protect all other parts of the subject except for those areas that require most lightening.

2 Spray the whole print lightly with white pigment. Cut away the mask from areas requiring slightly less pigment. Spray again.

3 Continue until masking only remains over areas not requiring treatment. Repeat **1-3** for parts to be darkened in gray pigment.

Finishing touches

Add finishing touches to your print partly by airbrush and partly by using small brushes and pens. Usually, this means adding intense local highlights, disguising rough mask edges or building up small areas requiring extra pigment or dye. Avoid using the airbrush too close or with too little pressure as this produces coarse patterns.

1 Add local tone freehand or with a cardboard mask. Use a fine jet of paint to line-in or flare highlights.

2 Put in final points of detail using a clean sable brush. Using other brushes, spot any defects and clean up the surface.

3 Protect the finished print with tracing paper. Copy it (see p. 180) and, for the finest result, make a reduced-size print.

Airbrushing in color

Working from the same original black and white print shown on p. 285, both car pictures on this page have been "constructed" by the skilful use of airbrushing. For the top version a showroom environment has been created by spraying with gray and black pigment. Shadows added under the car suggest frontal spot lighting. After first airbrushing out reflections and generally cleaning up the car body, transparent green dye was sprayed all over the paintwork areas. This was then lightly "splattered" with green and then black dye by using a special spray adaptor. For the version on the left, depth and distance were added by introducing blue sky graduated with a soft masking technique. Bodywork areas were sprayed with purple water color. In the picture on the facing page, delicate tints of transparent water color were airbrushed over a blue-toned black and white print.

Montage

Photographic montage is the combination of portions of various prints in one picture and has, traditionally, been used for descriptive, surreal, and political imagery (see p. 23). As with sandwiching and combination printing (see *Reference box*), you can produce startling results but, using montage techniques, you have much greater freedom. You can join, overlap or blend picture elements, controlling their relative size, density, color, and juxtaposition in order to achieve your intended effect. And you can combine "straight" prints with others that you have already manipulated. Either construct a montage that resembles a single image, or choose a cut and "stuck-on" look (see p. 290).

Try to plan the entire composition first, then go out and photograph each element. Alternatively, compile a library of useful images—landscape and sky backgrounds, structures, figures or parts of figures, for example. Rough print these, then lay them out to select and evolve your composition.

Reference box

Technique	Page
Print finishing (black and white)	110
Print finishing (color)	136
Copying	180
Multiple printing	224-31
Sandwich printing	232-5
Airbrushing	284-7

Essential equipment

For mounting the background print have a good quality mounting board that is larger than your planned print, a dry mounting press, tacking iron and tissue. Use sharp scissors to cut out montage elements and a suitable adhesive to stick them down. Take plenty of time and care when you cut and stick images.

A scalpel knife with a new blade is best for cutting intricate shapes. To disguise joins use felt-tip pens, pencil, spotting brushes, and water color or dye. You will also require equipment for copying the final montage (see *Reference box*).

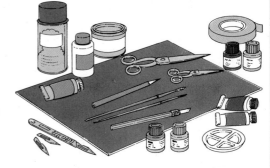

Planning prints

For best results construct the montage at about twice the size of your intended final print. This enables you to reduce any visible joins by making a smaller copy print. Quality and detail will be better too. Plan and make your component prints (as shown below) so that each element has a similar balance of contrast, density, and also color.

1 Pre-sketch, then photograph montage elements, or pick from existing pictures. Use rough prints to help you choose.

2 Enlarge your background image and trace it on paper. Plan the relative image sizes of the other elements.

3 Make a doubleweight matte background print, then singleweight prints of other elements. Match sizes to your traced plan.

Rough cutting

Rough-cut your component prints to within about ½ in (1.2cm) of their final shape (see below). Then compare density, color, and contrast with the background. If you want your montage to look torn or cut out, simply reduce your component prints to their final size and then attach them to the background print with double-sided tape.

1 Dry mount your large background print on its board. You should leave an ample margin on all four sides.

2 Use your scissors to cut away the majority of the unwanted areas of each component print of your montage.

3 For a rough-cut look, cut around image outline using scissors or a knife. Attach elements to background with tape.

Invisible joining

If you are aiming for a realistic montage, try to make image joins invisible. When you mount one shaped print on another, the thickness of the paper will reveal the cut edge (usually as a white line). You will have to reduce this thickness as much as possible, preferably down to the print emulsion itself. To thin the paper, first cut it to shape, then carefully sandpaper the back. With some papers it is helpful to score the emulsion around the image outline, then peel away the paper base from under the emulsion before you sandpaper (see below). This technique works well with resin-coated paper, but extra-thin document-type papers are too delicate for such treatment.

1 *Lightly score around image outline, using a new scalpel blade. Cut through emulsion but not through the paper support.*

2 *Gently bend print so that it splits along the score line. If necessary, make cuts at right-angles through unwanted areas.*

3 *Pull all the unwanted print areas away from parts that you want to keep. The paper support should now peel away from emulsion edge.*

4 *Place the print face down on a flat, smooth surface. Gently rub the cut edges with a very fine-grade emery paper until they are wafer-thin.*

5 *Clean all the print surfaces with a degreasing solution, such as denatured alcohol. Check the position of the cut-out print on the background.*

6 *Evenly coat the back of print with adhesive. Position the print carefully and apply pressure from the center. Wipe any seepage from the edges.*

Montage elements

The two prints (left and below) reproduced in black and white here, are the back- and foreground elements for the color montage on p. 290. In combination, they are a surreal mixture of man-made and natural forms. Shading was used to control tone values and prevent ornaments merging with the background. The foreground element was prepared as above (see p. 290).

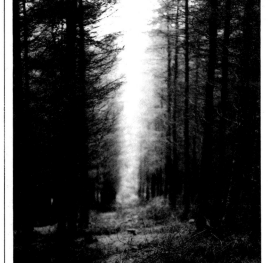

Background image

Foreground image

Montage appearance

You can make montages that are obviously abstract, or ones that imitate a "straight" print. If you are particularly careful when assembling the montage, it may also give the appearance of being a multiple print (see *Reference box*). Use rough-torn edges and hand-drawn patterns and coloring to give a two-dimensional, unrealistic appearance (see pictures above). In these examples, the most realistic photographic elements (the building and the flowers) have their cut-out,

pasted-on origins emphasized, so that they appear as flat surfaces. Make a small-sized montage, then copy it (see *Reference box*) using a hard light source to give highlights and shadows around rough-torn edges. In contrast, you can retain photographic quality for a striking surreal effect (see above). Thin and retouch cut edges where necessary to disguise all joins. Then make a reduced-size copy of your original, using soft shadowless lighting to illuminate it. The smaller you make

this copy print, the less obvious will be the joins as they will be reduced along with the image.

Scale and perspective

Because of the freedom of composition it gives, montage is an important medium for applications such as poster or cover design (see also p. 23). The two pictures right use false scale for dramatic effect. For the image below, a color print was montaged on a black and white background, using double perspective. Sky was colored using an airbrush (see *Reference Box*).

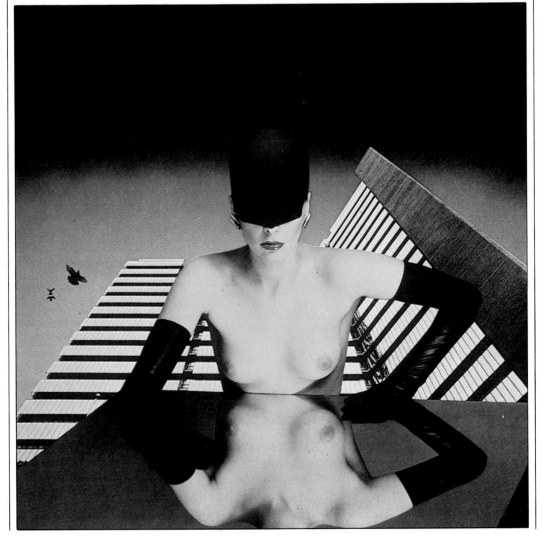

Mixing different techniques

The complex and startling
montages made for such purposes
as magazine covers, album covers,
and advertisements seldom employ
a single technique. The picture
above by Bob Carlos Clarke
combines multiple printing,
montage, and airbrushing (see
Reference box). First the face was
printed with the nose and mouth
shaded, then a negative of dried
mud was vignetted back into this
area. Parts of various prints of

electronic components were used
to compile the montaged headset,
which was then stuck to the back-
ground print. The entire head unit
was heavily airbrushed to give false
highlights (and then lined-in for
emphasis). Shadows under the
head were sprayed in, again using
an airbrush, and zigzag flashes and
other details drawn in with white
poster paint.

Hand embroidery

You can hand embroider a photographic enlargement using colored silks, cottons or wool, provided you print your picture on a suitably tough base, such as linen. You can embroider over the whole image area, which will hide completely its photographic origin, or you can use the technique sparingly just to pick out one or two chosen elements (see examples on p. 294).

Choose a negative to work from that is sharp throughout, evenly lit, and contains simple shapes and textures which will blend with the embroidery stitches. You can buy ordinary linen or canvas and then treat it with a light-sensitive coating (see pp. 175-7), but it is easier to buy ready-made photo linen (see p. 64), which is available in large sheets or rolls. When you enlarge on this material, leave a wide border on all four sides—this will give you enough spare material to stretch the processed print over a wooden frame (see right) before you start to embroider.

Materials and equipment

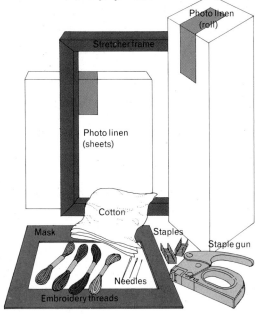

Decide the size of your final enlargement and buy photo linen at least 4 ins (10 cm) wider all round. You will also require a cardboard or black paper mask to produce this size border when printing. You can buy wooden stretcher frames in different sizes from most artists' suppliers, or you can make one up yourself. Have some thick white cotton the same size as your linen print to fit over the frame first. This will back up the image, give it a whiter base, and prevent the wood showing through. You can then use an upholsterers' staple gun to fix the cotton and the linen firmly to the frame. Finally, buy different colored embroidery threads and a selection of fine needles.

Printing on photo linen

Photo linen has a black and white emulsion similar in contrast to grade 1 or 0 bromide paper. You should, therefore, choose a fairly contrasty negative from which to print. You must handle the photo linen under deep red instead of orange safelighting, but in other respects you can process it exactly as you would a paper print. After processing, keep your linen print wet until you have stretched it evenly over the cotton-covered frame and stapled it all round. It will then dry as a flat surface, ideal for embroidery.

1 *Use the mask to compose your image on the enlarger baseboard. Make a photo linen test strip to determine the correct exposure.*

2 *Turn on the red safelight and place a sheet of photo linen under the cardboard mask. Make sure the threads of the linen align with edges of your mask.*

3 *Expose, develop, and fix the linen normally. Wash it for at least one hour—then keep it soaking until you can attach it to your prepared stretcher frame.*

4 *Stretch the cotton under-fabric tightly and evenly over the front of the frame. Secure it with staples driven into the back of the wood.*

5 *Position your wet linen over the frame. Make sure it is stretched tight and even. Then staple it in exactly the same way as you did the cotton fabric.*

6 *When your print is completely dry, make sure it is flat, and has not twisted in any way. Now you can start to embroider (see results on p. 294).*

All three pictures on this page were printed on photo linen and then hand embroidered to pick out small areas of interest (as explained on p. 293). For this technique you can use different thicknesses of thread, but always use a fine needle. Otherwise, bits of the emulsion may flake off. The picture right, has been hand embroidered in satin-stitch, which suits the formal background pattern. The examples above and below have less formal stitching. Try to display your results where oblique lighting will show up the various textures.

Photo etching

In this process you use a photographic image to control the degree of etching of a metal plate—thus forming a relief image (see right). You then ink the plate and bring it into contact with a piece of paper in a press to produce a print. It is unlikely that you will have a suitable press at home, so it is best to use the type of workshop facilities offered by an art college.

Start with an image on lith film. Then contact print it on a pre-sensitized zinc plate and process this to convert the exposed areas into a tough "resist" (similar, in principle, to the resist film used in photo silkscreening—see pp. 260-4). Next you treat the plate with acid to dissolve unprotected areas of metal (see p. 296), leaving a raised surface for inking. Either produce a run of identical prints or vary each print individually (see below).

This zinc metal plate, deeply etched to leave a relief image, was used to make the prints below. It is shown here ready inked for printing.

Printed impressions

The result, right, is an ink print from the photo-etched zinc plate (prepared as shown on p. 296). Various colored inks were applied to different parts of the metal surface—first by rolling on deep red ink, then dabbing on blue, yellow, and red with scrim (cloth). The plate was then pressed in contact with the receiving paper using a small proofing press.

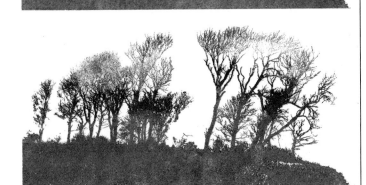

For this next print, the plate was returned to the press without any additional inking and a fresh sheet of paper used. The plate has lost most of the colors applied by the scrim, and the resulting print is lighter overall.

A third print, pulled from the same plate without additional inking, produces a much more patchy result (see right). Notice that fine edge detail is emphasized by ink still clinging around hollows in the plate.

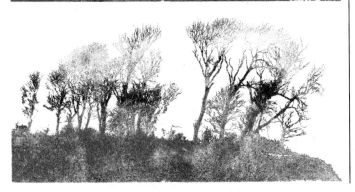

Preparing and etching

Your photographic image must be a line or coarse-screen negative, on film, and made final print size. Contact print the image on a zinc plate with a coating that hardens under UV light. After you have removed unhardened areas (see stage B below), etch the plate in acid (usually nitric). As this is corrosive, you must wear gloves.

1 *Prepare a final size negative image on lith film. When you view it from the emulsion side, the image should appear as it will be when printed.*

2 *Position the film, emulsion side down, on the sensitized surface of the zinc plate. Place glass on top to ensure contact.*

3 *Expose the plate and film to a light source rich in ultraviolet light–a sun ray lamp, for example.*

4 *Following instructions, spray or rub the exposed plate surface with cold water to produce the resist for acid etching.*

5 *Use "powderless etch" solution. This contains a substance which stops the acid undermining raised areas.*

How the plate is etched

A	**Exposed to light**	UV light Negative Resist Plate	
B	**Processed resist**	Resist Plate	
C	**Etched**	Plate	
D	**Inked for printing**	Ink Plate	

Applying ink to paper

Before printing you must inspect the etched plate for any wafer-thin pieces of metal around image areas, and carefully file them off. Then mount the plate on a flat base. You next coat the raised parts of the plate (unetched areas) with thick printer's ink. To do this, place the mounted plate on the bed of the proofing press and pour the ink on an inking table. Then spread the ink over the plate evenly using an inking roller (see below). Finally, place a piece of receiving paper on top of the inked surface and run the pressure roller over it.

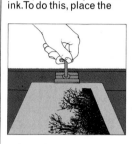

1 *Fasten the plate firmly in position on the bed of press, printing surface upward. Prepare the ink to the recommended thickness.*

2 *Using the inking roller, spread the ink over the raised metal surface. You can apply other ink colors on swabs to produce "one-off" results.*

3 *Lay a piece of receiving paper carefully over the inked surface of the plate. Cover with backing material if this is required by the press you are using.*

4 *Crank the pressure roller once over the plate and paper. Then remove the backing material, peel off the paper, and allow the impression to dry.*

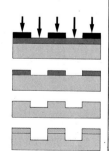

5 *Repeat stages **3** and **4**– either renewing the ink, or continuing with existing inking to produce a series of progressively paler images (see p. 295).*

6 *At the end of the run clean the plate and roller. You can now re-ink in another color, or change to a plate from a different separation.*

Photo lithography

Lithography is a printing process which is based on the principle that oil and water will not mix. Unlike photo etching (see pp. 295-6), which uses a plate with a raised printing surface (similar to the type "face" on a typewriter), a lithographic plate is flat. It is, however, mechanically textured (or "grained") on one side to absorb moisture when damped. For photo lithography, this surface is also coated with an ultraviolet-sensitive layer.

You must first make a final-size negative image on lith film. After contact printing the film image on the plate's UV-sensitive layer, you scrub it with a developer/lacquer to form a greasy image in exposed areas. Next treat the plate with an etching solution to desensitize all bare areas of the metal to ink. To run off the prints, first damp the plate and then lightly cover it with greasy ink. The ink is repelled by moisture on the metal but adheres to the greasy image. Finally, place receiving paper over the inked plate and run it through a press. This form of printing plate reproduces half tones with a finer screen than etching or silkscreening.

Preparing the plate

You can buy, from artist's suppliers, a wide range of sensitized lithographic plates, both negative and positive acting. Each brand has its own pro-cessing chemistry. You can also buy uncoated plates and prepare them yourself with a negative-acting sensitizer (see below). For half-tone reproduction, make 133 line film intermediates on Autoscreen (see p. 163). Wear gloves for all steps.

1 Prepare a final-size negative of your image on lith film. Use Autoscreen lith if you want to re-produce continuous tones as half tones.

2 Clamp the lithographic plate to the table. Pour on sensitizing emulsion and rub it well in. Work under tungsten light only—not fluorescent.

3 When the plate is dry, place the film negative on top (emulsion down). Mask off the surrounds. Expose under glass to bright ultraviolet light.

4 Return the exposed plate to the work surface. Gently but thoroughly rub it with developer/lacquer. Sponge the surface with fresh water until it is clean.

5 Pour on the gum etch solution. Wipe it evenly over the surface of the plate and then wipe it dry. The plate is now ready for inking and printing.

Inking and printing

You can print a litho-graphic plate by damping and inking and then trans-ferring the ink to paper in a flat-bed lithographic press. (You require less pressure than for a relief plate.) If you want your final image to contain several colors (see result on p. 298) you must make a separate plate for each one and then print them in register on one piece of paper using a different ink for each plate.

1 Attach the prepared lithographic plate to the flat bed of the press. The plate must be positioned with the printing surface upward.

2 Spread the lithographic ink on a flat, hard rolling surface of the press. Make sure the ink is evenly distributed. Damp plate surface with wet sponge.

3 Use a large inking roller to transfer the ink to the plate surface. Roll several times with ink, at different angles. Redampen the plate each time.

4 Cover the plate with a piece of receiving paper. Back it up with paper padding and a smooth fiber board greased so that it will pass under the press.

5 Pass this sandwich through the press. Remove the print and backing. Repeat steps 2-4 for further prints, or change plates for the next color.

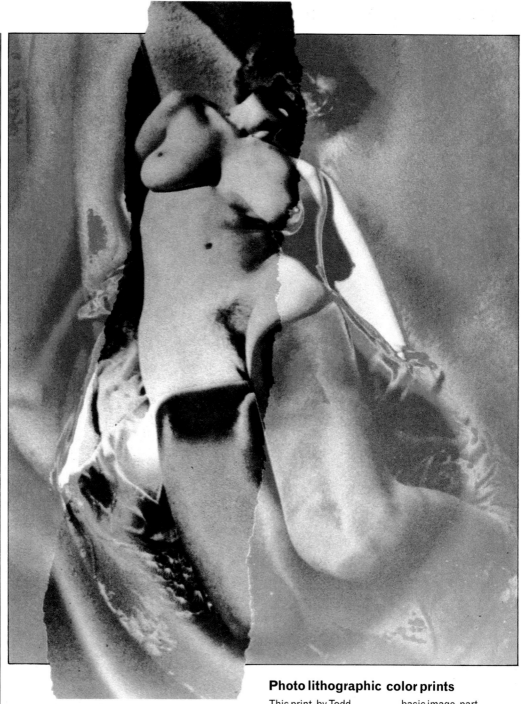

Photo lithographic color prints

This print, by Todd Walker, was made from three half-tone lithographic plates inked in cyan, orange, and black. The photographic films were prepared from one basic image, part solarized and tone separated to print in contrasting colors. A torn strip of paper provided the basic shape for masking the separations.

Manipulating print emulsion

This form of print manipulation involves scratching away part of the emulsion in order to reveal the white paper base beneath. The effect is similar to artists' scratch or scraper board. You can then color these areas using paint or wax pencils. A fully fixed and washed photographic print (black and white or color) is your starting point, and you must decide the relative importance of the hand-worked and photographic content of your picture to begin with. For removing the emulsion you will require a scalpel blade or needle (see p. 300), and it is best to work on a matte-surface, resin-coated paper. You can either make broad sharp-edged lines, or attempt a shaded effect by running fine lines close together in the manner of a drawn engraving (see right).

Although scalpeling the emulsion is basically a simple process, you must plan your results with great care if you are to achieve a pleasing effect. As you are tearing through one or more gelatin emulsions with color prints (see left), you should be aware of the order of the dye layers. For example, if you scratch away the top layer of negative/positive paper in a shadow area (where all dyes are present), you will first remove cyan dye—leaving magenta or yellow. With SDB paper, yellow is on top, followed by magenta and cyan. If you want a "transparent" look, as in the print below, scratch fine lines using a needle. Some photographic detail remains under the scratched-in garment. For the final result, the clothing was then hand colored.

Tools and equipment

You should have a range of pen nibs, scratch knives or scalpel blades, and coarse and medium-size darning needles for manipulating prints. Push needles into corks for easier handling. Use a plastic clipboard to grip your print firmly while you work on it. Use cotton balls and brushes to apply water color or dye. And you will require soft pencils and felt pens if you want to color a dry print.

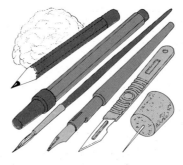

Working method

Take a resin-coated print and dampen it to soften the emulsion before scratching. Experiment on different types of paper to find the emulsion that is the most controllable. Since it involves a lot of work, you should use this technique on relatively small prints. Also, you will find that small images are best suited to this type of result.

1 *Soften the emulsion with a 5-10 min pre-soak in water. Squeegee and blot away surface liquid.*

2 *Clip print to flat surface. Scratch desired areas with a brushing action, using needle or blade.*

3 *Add liquid color to damp print with cotton balls or brush. Or use pencils on a dry image.*

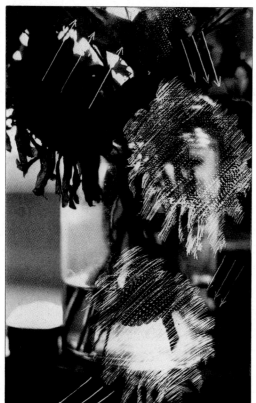

The manipulated images shown here and on the facing page, were all printed on a matte-surfaced resin-coated bromide paper. On each one, part of the emulsion was scratched and scraped down to the white plastic base. The marks that you make will vary according to the type and width of tool that you use, its angle, direction, and the amount of pressure that you apply. The sunflower shapes left were traced with pencil on a dark print of flowers, then scratched in using short and long needle strokes. And hundreds of small nicks were made with a scalpel point. (Sharp-toothed cogs from a clock will give a similar result.) The image above started as a black and white print of a mound of paper. The graffiti-type additions in the version on the facing page were scratched in with the broad tip of a pen nib, followed by gentle brush-like strokes from a needle.

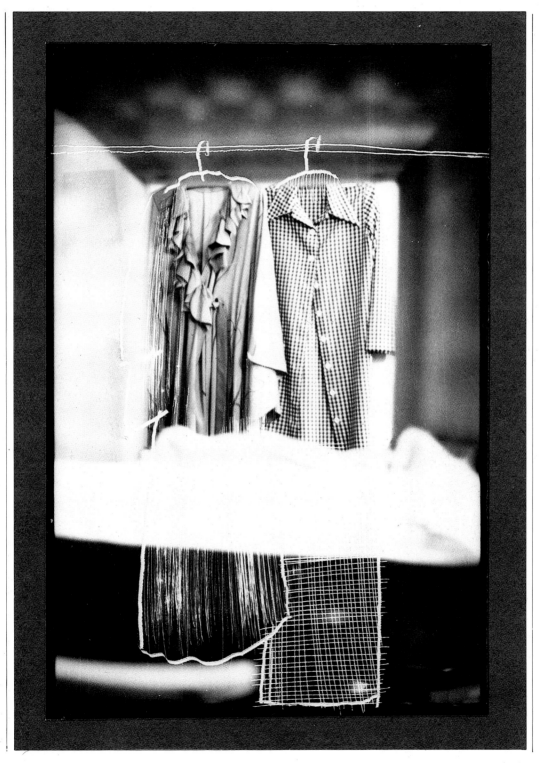

Manipulating instant pictures

Instant picture material is much more versatile than its popular "point and shoot" image suggests. It is possible to hand manipulate an instant photograph, either during processing or by working on the completed print, in order to produce a surreal or semi-abstract result. And you can copy and enlarge the finished manipulation if you desire. Use an instant picture camera to photograph your basic image, or place the film pack under your enlarger and print on an image from an existing slide or negative. Techniques you can use will vary with the material.

Integral SX70 prints contain chemical and dye layers sealed between plastic. When this film passes through rollers on its way out of the camera, pressure releases processing chemicals, which activate the dye layers. These layers become semi-liquid for about a minute, making them easy to distort by pressing on the front. You can also cut open SX70 prints, scrape away areas and substitute hand-applied pigments.

Peel-apart material consists of a sandwich of negative and receiving paper (together with processing chemicals which rollers release). You pull the sandwich apart after a timed processing period. With this material you can alter results before and during processing, as well as on the final print. Procedures for most techniques are shown on p. 304. When you cut open an instant picture, you will expose alkaline chemicals – wear gloves and keep materials away from children.

Montaging

To create a montage, photograph a basic image (Paris rooftops are the subject in the example above). Peel open the finished print (see p. 304), and scratch and paint over any areas you want to color. Scrape away the image completely (see p. 304) where you want to add extra elements (the face and notice in this example).

Manipulating the emulsion

In the first 60 seconds after an SX70 print appears from the camera, its emulsion is still fluid. Place your print on a hard, smooth surface. Take a small, blunt-ended implement and press on the front of the picture to move the dyes around (see p. 304). You can break up plain areas (backgrounds, for example) or "remove" unwanted details. The basic subjects for these images were a domestic interior (above) and a plum resting on a drawn shape (left).

Adding color

The pictures on this page are all SX70 prints, which have been cut open and colored inside with gouache, crayon or ink (see p. 304). You can add patches of pale color over existing detail to make a photograph look like a watercolor illustration (above and left). Or you can try converting the whole background, or a particular area, into flat, unreal color, leaving everything else photographic (above left and below).

Equipment for manipulations

To manipulate SX70 instant pictures you require a sharp knife to slit open the prints, and cotton balls to wipe away the backing. You should also have colored gouache, inks, and small and medium sized brushes for coloring. Rounded-profile objects of various sizes make good scribing tools. It is best to carry out your first experiments on unwanted or spoiled prints.

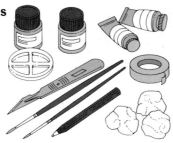

Integral color prints

You can scribe over prints from the front (see p. 302) or color them on the inside, as shown right. When you open a print you will see the image attached to the transparent plastic front, backed by an opaque, white layer. You must wipe off this layer if you intend to tint the image, or scrape it off along with the image if you want to form "windows" for flat color or montage.

1 *Slit along three sides of the black backing on an SX70 print. Peel it back and use a damp cotton ball to wipe away the white opaque layer.*

2 *Now paint over the back of the image layer to tint selected parts of your picture. This will produce a muted color effect.*

3 *In areas where you have removed the image (by rubbing harder) insert montage elements. Or apply paint for blocks of strong, flat color.*

Black and white peel-apart film

A 5 × 4 ins (12.5 × 10 cm) instant film packet consists of a sheet of negative material attached to a pod of chemicals, plus receiving paper and a waxed-paper picture mask. With practice, working in darkness, you will be able to slip the end cap off the packet, pull out and modify its contents, then re-assemble it to expose and process.

Tapping
To produce spots, as shown facing page, hit the packet hard and repeatedly with a blunt tool during processing.

Creasing
In darkness, pull out the negative material. Crinkle this sheet (do not damage chemical pod), straighten, re-assemble, and expose.

Crayoning
In darkness, remove the negative sheet. Lightly crayon it with a pale-colored wax pencil. Re-assemble, expose.

Color peel-apart film

Place an empty film pack, with a piece of white paper in the film plane, under your enlarger and focus your image. In darkness, substitute a full pack of film and make the exposure. Then insert this pack in your camera, pull the exposed material through the rollers, then time and peel apart your print according to film pack instructions. Now manipulate as shown on the right.

1 *For creased effects and image transfer, soak your color print for about five minutes in boiling water, then cut off the print margins.*

2 *Using your finger, push the emulsion around the print surface in order to crinkle it or to detach it completely from the paper (see p. 306).*

3 *To transfer the emulsion, stretch it from one edge of the print on to its new paper or acetate support. Then slide away the original backing.*

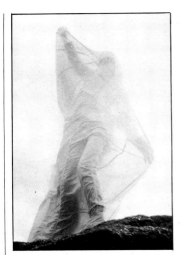

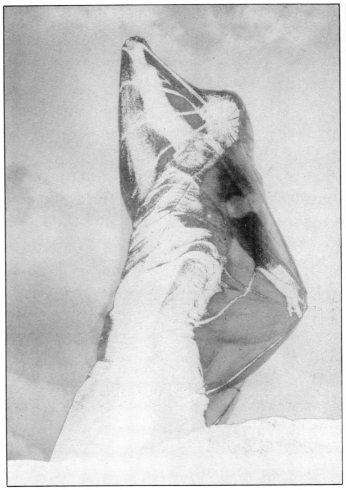

Using black and white materials

These pictures were all made from a 35 mm color slide, enlarged on to a 5×4 ins (12.5×10cm) Polaroid back placed under the enlarger. After exposing the film, pull the packet through pressure rollers, time it for processing, then open it and peel the positive paper print from its negative (see above). For the patterned version (below) the packet was hit during processing. For the image (below center) the negative was removed and creased before exposure. Or you could scribble over the negative with a pencil, bottom right. For the result right, an underexposed print was treated in etch bleach.

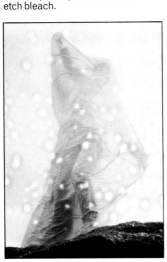

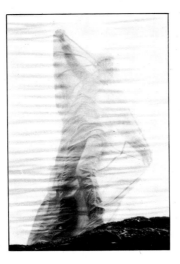

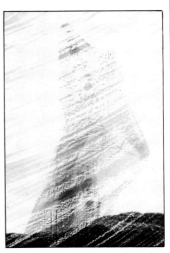

Soaking peel-apart color

Instant peel-apart color prints have an emulsion which you can easily frill and distort in hot water. Provided the print is no more than a day old you can soak it in boiling water, then detach the image layer and, after creasing or distorting it, transfer your result to any suitable opaque or transparent support. All the variations shown on this page were made from the color slide shown above, which was enlarged direct on to an instant peel-apart color film pack that was positioned on the enlarger baseboard (see *Reference box*). Use unwanted prints at first.

To make cracked and crinkled image distortions, like the one above, simply push the emulsion around after the print has soaked in hot water. Always try to relate the black

wrinkles to the lines of the image – shape distortion is particularly suitable for subjects such as portraits and architecture.

To remove a background, as in the result above, score the emulsion around the figure, then com-

pletely scratch off the background in hot water. In this picture the face was marked with a blunt tool.

To make a transparency, which you can project (see above) soak your print in hot water, then transfer its

emulsion to acetate. When you shoot a print to use in this way, slightly under-expose (darken) it.

Photocopy derivations

With most copying machines, the principle behind the formation of the image is based on static electricity–not light-sensitive emulsions (see p. 308). A lens forms an image on an electrically charged metal surface. Only the areas which have not received light have the ability to attract fine black powder which cascades down on to it. Paper then passes in contact with the plate and the powder transfers to it to form a permanent, positive image on ordinary paper. In this way you can reproduce drawings, photographic prints, slides (and slides enlarged by a projector attached to the machine), even faces and other three-dimensional objects placed in contact with the glass above the lens (see examples below and right). Color "photostatic" copying machines will print in color or black and white on paper, acetate or heat transfer film, which you can then iron on any fabrics. As well as producing line work, you can use the machine to make coarse reproductions of intermediate tones by operating the contrast control, which brings a half-tone screen into the system. If you have access to the color controls, various manipulations are possible. If you keep reproducing copies of a photograph made by the machine, image detail will steadily break up, destroying its photographic origins. A simple distortion is to alter the color controls to produce impossible colors. And since the machine produces color additively, making separate scans through red, green, and blue filters, you can shift or change originals between scans.

The color print above was made by projecting a color slide into a color photocopy machine, see p. 308. For the image below a hand-colored black and white print was reproduced on heat trans- fer film, then ironed on canvas. The result left, was produced by pressing hand, face, and plastic sheeting against the glass top. Depth of field is shallow on copies of three-dimensional objects.

How a photocopy machine works

When light from an original is transmitted via a lens, it hits a positively charged drum inside the machine (see right). Wherever the light hits, the drum loses its charge (see below). When negatively charged pigment powder (toner) tips over the plate, it is attracted to the still-charged areas only. Next, the drum rotates until it comes in contact with positively charged paper, which then attracts the toner to form a positive image. Finally the paper is heated to fuse toner and make the image permanent. For color, three scans are made—one with a blue filter (tones and transfers yellow), then a green filter (tones and transfers magenta), then red (tones and transfers cyan).

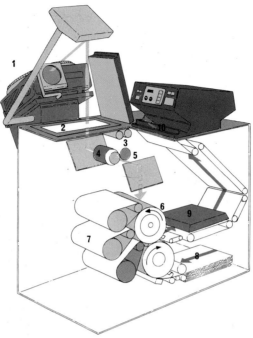

1 Projector
2 Document glass
3 Scanning lamp
4 Lens
5 Tri-color filters
6 Light-sensitive drum
7 Toner dispensers
8 Paper store
9 Heat fuser
10 Delivery tray

1 An electrical grid positively charges the light-responsive surface of the drum. The charge remains as long as the surface is dark.

2 When an original is placed face down on the document glass, the pre-focused lens and mirrors form a "wrong-reading" image on the drum.

3 Positive charges leak away in areas exposed to light. Negative-charged toner tips on to the drum and is held by static in remaining areas.

4 The paper is positively charged to draw the toner image from the metal surface. When the drum reaches the paper, heat fuses in the toner.

Copying routine

A color photocopy machine (see right) has several color controls. You can select multicolor (full tri-color) results, or you can press buttons to give yellow, magenta, or cyan alone. And, by selecting controls in pairs, you can obtain images in red, green, or blue. Inside the machine there is a lighten/darken control for each complementary color. Use these for color balance changes.

1 Place flat originals face down on the glass and close the lid. Leave the lid open for 3-dimensional objects or projected slides (see above).

2 Select the type of color result you require. Set the machine for the appropriate number of copies and then press the start button.

3 Prints reach the delivery tray in about 15-30 sec. If you print on a transparent base, give additional fusing with an accessory vapor unit.

308

Using separations

To produce a full-color result, the machine makes three separate exposures (see facing page). In the gaps between these exposures you can quickly change the originals. For false colors, or posterized-type results, prepare three tonally different separations. Position each on the document glass in exactly the same place, so that all three color images will be in register.

1 *Using resin-coated bromide paper, make several negative and positive prints with white borders. Cut out and montage elements you want.*

2 *Carefully cut out each of your prepared separation prints along two border lines. Use these two border edges for registering your prints.*

3 *Decide on the colors that you want and plan the order of the images (see p. 310). Change prints rapidly between exposures, aligning edges with glass.*

Separation A This image was made from the color slide used on p. 307. The background is a direct negative print. The figures were printed from a sandwich of slide and negative mask. They were cut out and stuck over the first (background) print.

Separation B Both parts of this print were enlarged directly from the slide. The figure was printed on soft-grade paper and the background (printed light) on hard-grade paper. When copied, this separation will form most color in originally light parts (see pp. 310-11).

Separation C This version was made by montaging dark and light prints from a black and white negative contact printed from the slide. This separation will form most color in the background and the top parts of the uniforms (see pp. 310-11).

Changing shapes

A copying machine exposes flat copy originals by scanning them with an evenly moving strip light source situated just below the glass. If you shift the original during exposure its shape will be distorted when printed. To stretch its shape, pull the original in the same direction as the scan. To compress it, pull it in the opposite direction. Pull at right angles for diagonal distortions.

1 *Measure the scan time for your size of original. Make an alignment mark on the back of the original and on the photocopy machine.*

2 *Keeping the top of the machine open, align the two marks. Shift the original at about half the scan speed during the first exposure.*

3 *Return the original to its alignment mark. Repeat shifting movement at the same speed and direction for the second and then third scans.*

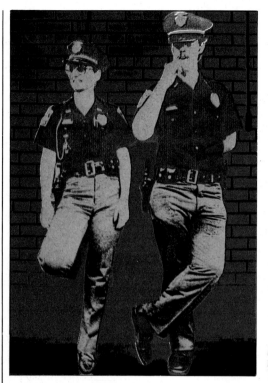

Printing the separations

You can now make photocopies of the three separations you have prepared (see p. 309). The machine prints in the order yellow, magenta and cyan (see p. 307), so results will vary according to the order in which you insert the separations. Practice changing them rapidly, as there is only a 2-3 sec pause between scans. For the effect above, first use separation B to print yellow. Next print magenta using separation A. Finally, print separation C, in cyan. For the result above left, print in the order CBA. Alternatively, you can compress the image by pulling the separations in the direction opposite to that of the scan. If you do this for all three scans, you will build up the image shown left. For the effect on the facing page, change the order to ACB. To enlarge the print, make photocopies on acetate film, then cut out the detail you want and mount it in the 35mm slide holder. Then project the image directly on to the document glass.

3D images

Because of the slight difference in viewpoint of our two eyes, when we look at objects with more than one plane they "stand out" in three dimensions. You can create this stereoscopic effect photographically by taking two pictures of the same subject, with the camera viewpoints about 2½ ins (6.5 cm) apart. You must prepare the resulting images so that your left and right eyes only see left and right images. The brain then "fuses" the two images into one three-dimensional picture. To take picture pairs that you can use in this way, either shift the camera between the two exposures, or fire two cameras side by side, or use a stereo camera (or attachment). Then make matched prints for use in a stereo viewer or matched slides for projection (you will have to use two projectors).

Preparing stereo images

Use two single lens reflex cameras taped baseplate to baseplate to make a pair of images, see below. You must press the shutters simultaneously. The distance between the center of each lens is similar to the distance between a pair of eyes. All the negatives from one camera are therefore left-hand images, while the other takes all the right-hand images. Buy an old stereoscope, or make one by placing two magnifying glasses at their sharp focus distance from a twin print holder (see below). Make small, matching black and white or color prints from each pair of negatives to fit your viewer. Mount pairs on cardboard.

Left image

Right image

Preparing offset images

You can also make stereoscopic pairs visible in 3D by filtering each image in strong opposing colors—then looking at them through a pair of filters exactly matching those colors. You will require two projectors (see below). Make your two pictures into positive slides (either black and white or color), and filter the projector lenses with tri-color red and green gelatin filters. When you look at the screen through identical filters, you will only see the green image through the eye with the green filter, and the red image through the red filter. This "image coding" by filters makes it unnecessary to direct each eye to its correct image with viewing lenses. For the full 3D effect, project the images overlapping and offset—matching the way you viewed the original subject.

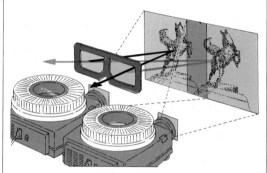

1 *Project the left and right images the correct way round on the screen. Sharply focus each image and match them in size.*

2 *Use deep green and red tri-color gelatin filters to color the two light beams in strong contrasting colors.*

3 *Pivot the projectors slightly to make their projected images overlap. Offset them by about 1/20 of their projected width.*

4 *View through matching pieces of the same filters. Adjust the degree of overlap, depending on your viewing distance.*

312

Color Key film

3M Color Key sheet film is designed for proofing in the printing industry. You can use it, though, to turn any line film or half-tone image into a high-contrast negative or positive in one of a range of strong colors. You will not require any special equipment or darkroom facilities to produce these effects. You can also convert a set of photographic separations made for posterization, solarization, dye transfer, silkscreen or 3D results into your chosen colors, then overlay them on a light box to preview your possible final results. Because the plastic film is extremely thin, you can color print from stacked and registered Color Keys, or photograph a set against a light box directly on color slide film (see p. 180). Changing the order of films produces dramatic differences.

Printing on Color Key

You can handle Color Key film in normal room lighting. There are two types—negative-acting or positive-acting (each one requires a different wipe-over "developer" after exposure). Solutions are highly volatile and dry very quickly. The film does not require washing.

1 *Use your original negative to prepare a final-size, high-contrast image on lith film.*

2 *Place this lith image on a sheet of negative- or positive-acting Color Key film.*

3 *Clamp the two sheets together under glass. Leave in bright sunlight for about 2-3 min.*

4 *Swab firmly with developer for your film until no further color comes away. Avoid scratching the surface.*

5 *Check the result immediately. If you wish, register it with Color Key images in other colors, made by repeating **1-3**.*

Originals for printing

The "diazo" compounds in Color Key materials are too slow for you to enlarge on directly. You must first make a final-size image on high-contrast black and white film. Screen continuous-tone images (see p. 158) unless they are very grainy (see bottom of p. 314). Alternatively, make two or more tone separations on lith film by printing at different exposures (see examples below).

Bromide print from original negative

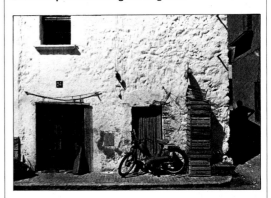

Lith film enlargement (12 sec)

Lith film enlargement (4 sec)

Building up color images

Once you have made your high-contrast intermediate films, Color Key proofs are quickly made. For the result above, the lighter lith film (see p. 313) was contact printed on magenta positive-acting Color Key, exposing for 1½ min to a UV lamp. For the result top right, the darker lith film, sand-wiched with the magenta result, was printed on cyan positive-acting film. The result right, used the same images, plus a print from the darker lith made on red negative-acting film. The picture below, was produced from one lith positive enlarged from a grainy 35 mm negative. This was then contact printed on **1** yellow positive, **2** cyan positive, and **3** magenta negative Color Key films. All three films were then sand-wiched and slightly offset.

Rediscovering old processes

Introduction

Long before silver bromide became the prime means of printing in black and white, a wide range of other chemical processes were in vogue. A photographer of the 1890s would be fully familiar with aristotype, kallitype, chromotype, cyanotype, fluorotype, and lenintype prints. He may have been using the milk process, coffee process, alabastrine or plumbago processes, or even the Rev. Beechey's Emulsion process. (These and dozens of others are all listed in a practical manual of that period.) Most were devised by the enthusiastic individual experimenters and gave very mixed results. They were intended to yield richer, more permanent images than were then possible with silver halides, but papers were often complicated to prepare and required chemicals too dangerous or too difficult to use today. Nevertheless, some of these early processes could give attractive results with their own particular qualities of image color and detail. They can still be used today, to create printing effects impossible to achieve on commercial black and white or color papers.

In this section, five such processes – all requiring minimal equipment and facilities – have been revived and tested. Since they were devised when most photographers had to work with large-format cameras and then print by contact, all these processes are too insensitive to use for enlarging. You must therefore start with a print-sized film negative, which can be prepared from today's small format films via an enlarged film positive, or by enlarging directly on a reversal film. When these old processes were in use, prints were exposed to daylight, rather than to artificial light, as the sensitive layer only responded to blue and ultra-violet illumination. When trying these processes you can use daylight too, but it will be far more convenient to have an ultraviolet sun lamp. (It is best to wear protective glasses of the type recommended for health tanning.)

The processes chosen for this section fall into two main groups. The gum bichromate and milk process both utilize the fact that colloids (gum, gelatin, glues) mixed with one of the bichromates (potassium dichromate, or bichromate) become hardened and insoluble when exposed to light. If you mix colored pigment in with the colloid, and then after exposure "develop" your paper in water, the unexposed areas will wash away and so leave a positive image in dye. This is also the principle behind the carbon process.

The other printing processes here use the light-sensitive properties of iron (ferric) salts. These break down into ferrous compounds, which either combine with potassium ferricyanide to give a blue image (cyanotype) or, if a little silver nitrate is present, to give black or brown (Van Dyke and kallitype prints).

Both groups of processes are exceedingly old – iron salts having been used by Sir John Herschel in 1842, and the bichromate process by Fox Talbot during the early 1850s.

To use these processes today, you must first be prepared to coat your own paper or other image support. This will probably mean sizing with a spray starch or similar substance, as suggested for each process. During the stages of both sizing and coating with light-sensitive chemicals you must make sure that the paper dries flat, otherwise it will not come into contact evenly with the negative. (Bichromate type chemicals should not be allowed to come into contact with the skin as they can create an allergic reaction known as "chromatic poisoning".)

Like coating liquid emulsion, you can brush on the sensitive layer leaving intentional brush marks, or go for an even coating over either the whole surface or an area that suits your particular image. Bichromate and dichromate coatings have the property of increasing in sensitivity as they dry – so although you can coat them in normal room lighting, you should let them dry in the darkroom. Even then sensitivity is less than one-thousandth of the speed of silver bromide emulsion. During exposure try to avoid allowing the material to heat up, as this will make it impossible to record the image. In each of these processes the "developing" stages are extremely simple and can generally be carried out in any room, if the paper surface is shaded from direct light.

Although having so many stages – sizing and drying, coating and drying, exposing, and then processing – sounds extremely time consuming, you can organize the work on a batch system. Size half a dozen or so sheets in one evening, sensitize them all on the next, and so on. The very making of your own materials brings home the applied chemistry aspects of photography, making it far easier to understand the trials and tribulations of photographers five generations ago. At the time when these processes were in everyday use, very few light-sensitive materials were actually manufactured. Photographers really had to be amateur chemists. Those who could handle the processes and still produce imaginative and original pictures were unusual people. And yet some magnificent nineteenth-century work on these and similar materials still remains. If possible try to examine original examples in museums or art galleries. Here you may find prints of almost every chromatic variation – their image colors being the result of paper base, printing process, chemical impurities, or the effects of time.

Several other old processes, also capable of extremely fine quality, are omitted here because of the difficulty today of obtaining the suitable chemicals or other essential items. Bromoil – an enlarging process in which pigment is dabbed on the paper in the form of greasy ink – is difficult in most countries owing to the lack of the old "non-supercoated" paper essential to make it work. Platinotype prints, which gave extraordinary deep black tones unobtainable with silver halide emulsions, used an iron-salt process much favored

by the Pictorialists at about the turn of the century. This printing material was, in fact, a manufactured product. Unfortunately the paper also contained a deposit of platinum, which made it prohibitively expensive. Photogravure also gave – and still does give – prints of superb quality, but you must have special equipment such as a rosin dusting box and engraving tools, as well as copper sheets, and special inks. Photogravure is also too slow and complicated for single prints today, although it is still used as a high-quality, expensive method of mechanical printing.

Of the five processes detailed in this section, gum bichromate offers the most flexibility of result. By building up several layers of subtly varied pigment colors, and by using different textured papers, you can achieve results that range in appearance from a monochrome water color to a drawing made in red chalk or charcoal. In addition, you can use any continuous-tone images without these first being screened or converted to line. Both the Van Dyke and the cyanotype are interesting for their ability to print on fabrics, and their relative simplicity. You will in fact find that once you have mastered one of these old processes, you will quickly gain the experience and the confidence to tackle the others.

In all of these process, the working temperature of solutions is 70°F (20°C), unless otherwise stated.

These three pictures are by well-known pictorialist photographers, taken at around the turn of the century. Although it is not possible in reproduction here to do justice to the quality and color of the original images, each print was made using a different process. The portrait above of the artist Aubrey Beardsley is by photographer Frederick Evans (taken in 1893), and was printed on platinum paper. Evans was so insistent on platinum that he gave up photography when this paper was discontinued in 1914. The A. L. Coburn study of Tower Bridge, London, left, taken in 1910 is a gum bichromate print. J. Dudley Johnston's "Daydreams" life study below was printed on commercially made chloro-bromide paper in 1927.

Gum bichromate

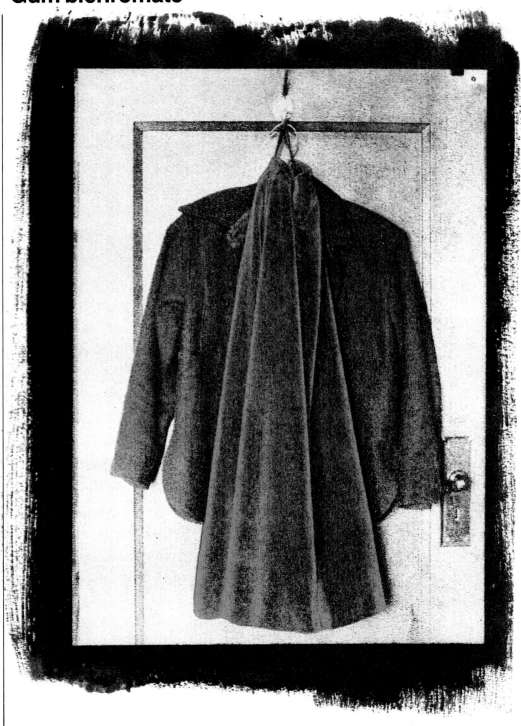

These prints were made on water color paper using the gum bichromate process. Light-sensitized gum (pigmented with lamp black) was brushed over the area chosen for the image. A black and white negative was contact printed and the paper developed (pp. 320-1). The clothing was hand colored (pp. 280-3).

Gum bichromate, introduced commercially in 1894, was used widely by the pictorialist photographers at about the turn of the century. Basically, it is a contact printing process that allows you to make images on any drawing paper of your choice, with complete freedom to control tone and color. You coat good-quality paper with a mixture of gum arabic and pigment, sensitized to light with potassium bichromate (or, more commonly, potassium dichromate), which hardens the gum if you give it a long exposure to ultraviolet light. You then expose the paper under a large negative, prepared on film or paper. Finally, you must "develop" the exposed print in water to wash away the pigment and gum from the unhardened highlight areas. By coating the sensitive layer on the paper with various types of brushes, you can form a range of different background marks. This, plus the texture of your paper, combine to produce an image that is very unlike a photograph. Your final picture will consist of water color pigment only–either in a single color or a multicolored result (see p. 322).

The gum bichromate process is chemically simple. You do, though, have to practice and exercise skill in preparing and coating the paper, and in the processing, to avoid damaging the image (see below and facing page). Potentially this process allows you to exploit every type of paper surface and shade of water color pigment. You can incorporate brushwork into the overall mood and design of the image you choose to use, which gives each separate print its own identity.

Materials and equipment

You will require sheets of good-quality drawing paper, with appropriate surface texture for your image. Have gum arabic, water color pigment, and potassium dichromate (or bichromate) crystals, as formulated below. (The dichromate formula is more light sensitive.) For a good range of colors, you will require tins of at least four water color powder pigments. Use a large camel hair brush for coating the paper and a 2 ins (5 cm) flat paint brush to give very prominent brushmarks. You will also require a glass-fronted printing frame and a UV light source for exposing the paper. For washing the prints have two deep trays, and use a large piece of hardboard and gummed tape to stretch the paper flat while it is drying (see right).

Essential formulae

Gum Powdered gum arabic 350 g
 Hot water to make 1 liter
Add powdered water color pigment, according to the image color and density required

Sensitizer Potassium dichromate
 (crystals) 50 g
 Warm water to make 500 ml
Store sensitizer in a dark-tinted container

Mix 2 parts gum to 1 part sensitizer just before use

Preparing the paper

Be careful not to wrinkle your receiving paper when coating it. If you pre-soak the paper first, and then stretch it on hardboard while it is still wet, it will contract as it dries and become tightly stretched. (You will have to "size" some papers first to stop them absorbing too much pigment–use a 10 per cent solution of household gelatin flakes.) If stored for more than 3-4 days, the gum solution acquires a fungus growth. Either coat the paper completely or just within a selected area, as shown below.

1 *Soak the paper for 5-10 min in water. Lay it on a sheet of hardboard. Tape it down along all four edges. Leave it to dry at room temperature.*

2 *Decide on the area of the paper that is to have the image printed on it. Then mark out your chosen area lightly using a soft pencil.*

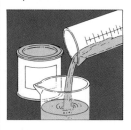

3 *Mix together gum and sensitizer solutions. (Carry out this step and step 4 under dim room lighting or orange safe-lighting.)*

4 *Coat the required area of your paper with the mixed solutions. Work quickly and evenly, brushing in a crosshatch pattern. Allow paper to dry in dark.*

Gum printing in one color

Coat and dry several sheets of paper–you will require some for testing. (The color of the sensitized layer is distorted by the orange dichromate at this stage–pure pigment color returns later in washing.) Choose an image that is softly but directionally lit, with strong tonal gradation. Make your print-size intermediate negative by enlarging the original negative on continuous-tone film, then contact printing this on another sheet of the same material. Or, enlarge and contact print on sheets of bromide printing paper.

Gum printing in three colors

Wait until you are proficient at gum printing in one color before you attempt a multicolored result. This involves contact printing from three enlarged separation negatives. You must coat the paper, expose, and process for one image after the other, all in register, and each using a different colored pigment. Water "develop" very thoroughly after each exposure, or your image will have dirty whites and degraded colors. You can make your separation negatives on either continuous-tone or line film (see p. 322).

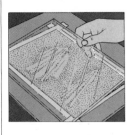

1 *Place your prepared intermediate negative (or a large-format original negative) in contact with the sensitized paper. Clamp them with glass.*

2 *Make test exposures to a bright UV light or daylight. Give about 30 sec to 2 min with film negatives. Paper negatives take several hours.*

1 *From a color slide, make three color separations through blue, green, and red filters. Use panchromatic film, either continuous tone or line.*

2 *Mix three pigmented gum solutions–in yellow, magenta, and cyan. (Add the dichromate sensitizer just before you apply each one to the paper.)*

3 *Cut paper from board. Cover paper in cold water (face down) for 20 min, until orange dichromate and unhardened gum pigment diffuses out.*

4 *Assess your results. Choose the time that produces the best results and expose a second sheet of prepared paper for that time. Repeat step **3** left.*

3 *Use smooth cardboard for tone, water color cardboard for line. Coat with sensitized yellow gum and expose to the blue separation.*

4 *Process and dry. Recoat in sensitized magenta gum to print the green separation. Repeat in cyan to print the red separation. Use register pins (p. 156).*

Advice and suggestions

- If you pre-size your paper you will find it easier to coat an even layer of gum. The dye image will also be tougher and you may spray it with cold water to speed up development.
- If you want to store pigmented gum for some time, add a few drops of oxalic acid. This will inhibit any fungus growth.
- A single-color gum print often lacks richness in mid-tone areas. You can improve results by re-sensitizing and repeating the same procedure one or more times–each printing will strengthen the tonal range of your print. Your negative must be in exactly the same position on the paper for each successive exposure.

5 *When you are processing the full print, you can brush away any unwanted shadows with a small soft water color brush. Blot image area.*

6 *Re-tape the wet print to the board. When it has dried flat, cut it away from the board. Unless you plan to hand color (pp. 318-9), the process is complete.*

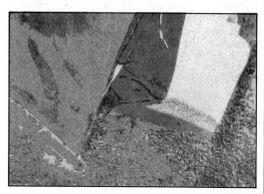

Three-color gum prints

All the prints on this page were made by the gum process (see pp. 320-1) from separation negatives. The picture above is a single printing only in Prussian blue from the red-filtered separation negative. The version above right shows the effect of coating each gum layer too thick. The shadows have spread badly and the highlights are veiled. The version on the right was printed from the three-color separations made on line film. The enlarged version below was printed using the same technique, but working from color separations made on continuous-tone film.

Van Dyke brown

The Van Dyke or "brown print" process uses the effect of light on iron (ferric) salts and silver nitrate to form a brown silver image. You can use either paper or cloth as a base material, but choose a textured surface that is appropriate to the image you intend to print. You first make up a light-sensitive solution (see p. 324), coat, and then dry your base material under orange or red safe-lighting. Expose your emulsion by contact printing a film negative on it using a light source rich in ultraviolet. You can only use this process to produce a limited range of tones, so it is best to work from a line negative, or at least choose images that do not rely on finely graduated tonal values (see right and below). After exposing the emulsion, you "develop" it, either by washing or treating it in a borax solution.

Van Dyke images do not have a heavy maximum density—results are generally delicate. The silver image merges into the base, giving a finish more like paper or fabric impregnated with dye, than an overlaid photographic emulsion.

Van Dyke images

The result right was printed on linen to form a decorative blind. Some coloring was added by hand to the finished image. The picture below, on crumpled and flattened tissue paper, was printed from a line negative. The warmer image color was formed by using an oxalic acid formula (see p. 324).

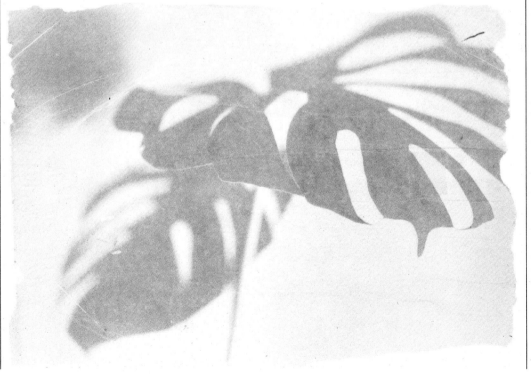

Preparing the Van Dyke process

You have a choice of two sensitizing solutions (do not use them together, each requires different development). Weigh out the raw chemicals and dissolve them in the order given. Only buy the quantity of silver nitrate you will be using, as this chemical is expensive. Mix the chemicals under orange safelight, and let the sensitizer stand for 24 hours before use. This allows the nitrate to dissolve fully. The brushes you use to apply the sensitizer must be free of all metal, or stains will form. Use all plastic foam pads to be safe. For exposing, you require a UV lamp or tube, and a masking frame or sheet of plate glass to sandwich together the negative and coated material (below).

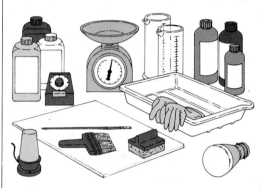

Brown-black sensitizer

Ferric ammonium citrate	30 g
Silver nitrate	10 g
Tartaric acid	5 g
Add distilled water to make 300 ml	

This formula does not color the image as much as the sensitizer below. To develop the image, wash it in warm water only (see right).

Warm-brown sensitizer

Ferric ammonium citrate	25 g
Oxalic acid	4 g
Silver nitrate	10 g
Add distilled water to make 300 ml	

This sensitizer produces a sepia-brown result. After exposure (see right) you must develop the base material in a 1 per cent borax solution.

Fixer

Sodium thiosulfate (hypo)	20 g
Add water to make 1 liter	

You must use this solution to fix the base material when you use either of the sensitizers above. Filter your tap water if it might contain particles of iron.

Coating, exposing, and processing

Coat enough base material for tests and several prints. The base may be sized or unsized (see p. 320). Sizing improves evenness as some bases are very absorbent. An image on unsized paper will be denser and possibly diffused slightly. Soak thin, unsized fabric in sensitizer for 5-10 min, then drain, dry and iron it smooth–all under orange safelighting. Allow other materials to dry completely (away from light) before printing. Use a regular hardener fixer, instead of hypo after development for a darker result.

1 *Mix the chosen sensitizer solution at least 24 hours before you intend to start printing. Prepare a final print-sized negative on film.*

2 *If necessary, size your base material using a 10% gelatin solution or an aerosol starch spray (of the type used for fabric). Allow it to dry completely.*

3 *Coat your base material evenly with sensitizing solution. Under safelighting, apply solution with a plastic pad or metalfree brush. Leave to dry.*

4 *Cover material with film negative and press under glass. Expose to UV light until the sensitized layer yellows to about half the correct final density.*

5 *Develop for 5 min in borax (oxalic acid formula) or 5-10 min in running warm water (tartaric acid formula). The image should look slightly flat.*

6 *Fix for 8 min in plain fixer, then wash completely. Hypo neutralizer will improve image permanence. Filter the wash water if necessary.*

Milk prints

You can make prints using most types of fatty material (for example, casein–the main protein in milk) combined with a dye and potassium dichromate. Use a weak acid solution to separate casein from milk–it will appear as a pale yellow solid. Next, dye and coat the casein (along with the sensitizing dichromate) on a suitable base, such as drawing paper. Sensitivity is extremely slow, and limited to the ultraviolet end of the spectrum. Detail from line images, however, is very good (see p. 326), and your results will resemble crude silk-screen prints. Evenness and texture will vary according to the porosity of the base (you control this by sizing). It is possible to print in several colors if you recoat and re-expose your base material for each color.

Preparing the casein

The easiest way to prepare casein is to make a solution of dried milk, then curdle this with acetic acid (see below). The fatty curds will form in the top part of the milk. Next, strain off the liquid, and wash curds free of acid (as shown bottom). To make a solution that is suitable for coating, you must dissolve curds slowly in dilute ammonia, and then add water. Proceed to dye and sensitize casein solution (as shown right). If you wish, you can refrigerate the casein solution for dyeing and sensitizing your paper later.

Curdling solution	
Instant dried milk	175 g
Add water to make 100 ml	
Acidify by adding 6-7 ml or 28 per cent acetic acid solution	

Dye solution	
Casein solution (prepared as shown below)	100 ml
Powder paint (chosen dilution)	100 ml

Sensitizing solution	
Potassium dichromate	25 g
Add water to make 100 ml	

Add equal parts of dye and sensitizing solutions just before coating

1 When curds have formed in your curdling solution, pour it through cheesecloth. Rinse curds in cold water until acid smell disappears.

2 Shake off surplus water. Crumble curds into a graduate with 55 ml of 1% ammonia. Leave for 2-3 hours, then add 100 ml of water.

Coating, exposing, and processing

For best results you should size most base materials before use. Sizing is essential if you intend to overprint additional colors. Use household spray starch or acrylic "gesso" diluted 1:5. When your sensitized material is dry, expose it by contact behind a line or coarse-screened film negative. Areas corresponding to clear parts of the negative will be hardened by ultraviolet light. Wash remaining casein away using water rinses interspersed with rinses in ammonia solution to prevent dye bleed.

1 Working in subdued room lighting, add your chosen dye color to the casein solution, then add dichromate sensitizer (see below left).

2 Using a soft, non-metallic brush, coat paper with solution. Make even vertical, horizontal, and diagonal strokes. Dry paper in the dark.

3 Place paper under glass. Expose a test strip to an ultraviolet sun lamp or tube. Then expose a full sheet of paper at the correct exposure.

4 Place exposed paper in a tray of cold water, face up. When unexposed dye areas begin to detach, transfer to cold water containing ammonia.

5 Spray gently with fine flow of water. (Image will appear clearly in white.) Resoak in ammonia. Repeat 3-4 times until you have required result.

6 Blot off surplus water very carefully. Then tape paper to a board along all four sides and leave it to air-dry (see p. 326 for results).

Casein print

The print on the left was made by the casein or milk process. Thick drawing paper was sized with spray starch, and then coated with green-dyed casein (see p. 325). The paper was given a 20-min exposure to an ultraviolet sun lamp. Finally, it was "developed" in alternating water and ammonia rinses for 25 min.

Cyanotype

The cyanotype process (also known as the blue-print process) is one of the cheapest methods of recording images. It was possibly the first document copying system (invented by Sir John Herschel in 1842 for recording complicated mathematical formulae he could not trust assistants to copy accurately). The process works on the principle that ferric (iron) salts of citric and other organic compounds change to ferrous salts when exposed to ultraviolet light. Ferrous salts combine with potassium ferricyanide (if also present in the coating) to form Prussian blue. It is therefore a negative/positive process for printing by contact from a line negative. The paper grows darker as exposure proceeds, and you can "process" the result by washing in cold water. You can make cyanotype prints on most types of papers, and on fabrics ranging from heavy canvas to lightweight cotton. There is no fully effective fixing process, so you will find that results fade in bright light.

The three cyanotype pictures here were printed from solarized line negatives. They were exposed by contact on prepared drawing paper, using the oxalic acid formula on p. 328. You cannot form a range of tones using the blue-print process, and whites are often tinted blue as well. For strong results you should work from negative images that are extremely contrasty and bold in their design.

Practical procedure

There are two alternative solutions for sensitizing your base material (see right and below). The oxalic acid formula gives slightly richer results. After sizing, allow your base material to dry, then expose it behind the film negative in a frame with a divided back. This should be hinged to allow you to open half the back and check the darkening of the material part way through the long exposure necessary. "Processing" is effectively fixing, as you wash out the yellow-orange sensitizing chemicals, leaving only Prussian blue in areas affected by light. Image color varies slightly according to the base you use – different papers have trace minerals which react with the ferric salts.

1 You should size most base materials (using spray starch, for example). Otherwise, highly absorbent bases require excessive processing time.

2 Mix equal quantities of A and B sensitizer solutions. Work in yellow safe-lighting. 10ml is sufficient to coat 80 sq ins (516 sq cm) of sized paper.

3 Coat your base material using a non-metallic brush or a foam pad (or soak it in sensitizer solution). Allow material to dry thoroughly in darkness.

4 Position your negative in face contact with the material under clean glass, in a hinged-back frame. Expose them to UV light from a sun lamp or tube.

5 Assess the progress of exposure by opening half the back (shaded from direct light). Check to see how much the sensitized material has darkened.

6 When print looks dark enough, remove it from the frame. Process by agitating it in changes of cold water in a tray, until the yellow stain disappears.

7 You can lighten color or remove it from any part of the image using household bleach diluted 1:32 with water. Apply bleach locally with a metal-free brush.

8 Wash for about 10-15 min. Filter the faucet to prevent stains from any metal particles in the water. Excesssive washing may weaken the image color.

Simplified process

It is possible to make cyanotype prints using a simpler light-sensitive coating (see right). It still uses the principle of ferric salts changing to ferrous under the action of ultra-violet light. The ferrous (but not ferric) compounds react with ferri-cyanide to give an insoluble blue salt. You coat this on sized material, expose, and process as described above. On some base materials sensitized this way, results show slight "bleed" of blue color into adjacent white areas. You can improve image whites by adding 1-2 drops of hydrochloric acid per liter of final wash water.

Kallitype

This process, like Van Dyke brown (see pp. 323-4), is based on the use of a combination of ferric and silver salts. Unlike the brown-print process, however, you have a choice of three developing solutions, each giving a different image color (see examples on pp. 330-1). The silver content of the Kallitype means that it produces prints with a richer range of tones than the Cyanotype process (see pp. 327-8). Kallitypes were popular in the late nineteenth century, but were eventually abandoned because no way could be found to remove various chemical by-products, which eventually attacked the image. Today's acid-free papers and use of hypo eliminator make a more permanent result possible. You must work from a print-sized negative on film, and choose a contrasty original.

Chemical solutions required

Sensitizer	
Ferric oxalate	50g
Oxalic acid	3g
Silver nitrate	25g
Add distilled water to make 300ml	

Mix the sensitizer under yellow safelighting. Dissolve the first two in- gredients in water at 100°F (38°C). Then add the silver nitrate.

Developers			
Sepia tones	Rochelle salt	45	g
	Potassium dichromate	1.5g	
	Add distilled water to make 950ml		
Blue-black tones	Borax	24	g
	Rochelle salt	90	g
	Potassium dichromate	1.5g	
	Add distilled water to make 950ml		
Neutral-black tones	Borax	90	g
	Rochelle salt	68	g
	Potassium dichromate	1.2g	
	Add distilled water to make 950ml		

All development times are 5 min. Image results between these three colors are possible by adjusting the ratio of borax to Rochelle salt.

Fixer	
Sodium thiosulfate (hypo)	50g
Ammonia (0.88)	12ml
Add distilled water to make 1 liter	

First dissolve the hypo completely in hot water. Add the ammonia only when the solution has cooled. Fixing time is approximately 5-10 min.

Practical procedure

For best results, choose good-quality drawing paper sized with starch. You should sensitize and dry (in yellow safelighting or dim normal lighting) the paper just before exposing. The image, after correct exposure but before development, should look pale brown on a yellow background, with detail visible in the shadows. If you can only see detail in mid-tones and highlights your print is overexposed. The Kallitype image is sufficiently tough for you to use normal handling procedures. Do not omit the hypo eliminator stage.

1 *First size your paper base. Use a household spray starch, spraying and then wiping over to make sure of even application. Allow paper to dry.*

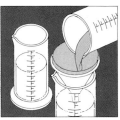

2 *Prepare your sensitizer solution, as formulated on the left. Filter the solution containing the first two ingredients before adding the silver nitrate.*

3 *Apply the sensitizer using a metal-free brush or plastic pad. Use vertical, horizontal, then cross-hatched strokes. Dry paper in darkness.*

4 *Place film negative in face contact with your paper under glass. Expose to a UV lamp or strip tube until image tone looks correct (see above).*

5 *Place the paper in your chosen developer (you can carry out this stage in ordinary room lighting). The image appears quickly. You cannot overdevelop.*

6 *Wash for 2 min, then fix in the Kallitype fixer. Rinse, and treat in hypo eliminator as for doubleweight regular prints. Wash thoroughly and then dry.*

Kallitype prints

Both prints on this page were made by the Kallitype process, from hard, continuous-tone negatives. For the result on the facing page, the paper was processed in borax-free sepia-forming developer (see p. 329). The picture on the left was developed in the solution for blue-black image tones. The picture above had neutral-black development. For all three pictures, prints are on drawing paper sized with starch. You can use the process to resolve a limited range of intermediate tones—but in a coarsened form. It is best to choose images like these, which are improved by the simplification of tonal range.

Appendix

This appendix contains additional practical information and advice for the darkroom worker. It covers a selection of purchased materials as well as do-it-yourself formulae for chemical solutions. These lists are intended as a representative guide only; there are other materials and formulae available. Materials and processes change, so always examine the leaflet packed with your product for the most up-to-date information.

The appendix also contains information on techniques – sheet film processing, archival processing and chemical aftertreatment of slides– which are not covered in the main sections of the book. And it includes information on procedures to ensure safety in the darkroom and checks you can perform on your safelights.

Using chemicals safely

In general, photographic chemicals are no more (or less) dangerous than household chemicals. Take sensible precautions, just as you would when using cleaning liquids and disinfectants. Read the warnings on labels, and keep all solutions away from your eyes and mouth, and any open cuts or grazes. (This applies particularly to stabilizer, acid fixer, lith developer, and solutions such as bleachers that contain strong acids.)

Because tray processing requires constant handling of wet and dry paper, most photographers still carry out black and white printing with their bare hands. However, you should try to use print tongs as much as possible. A few people have a skin allergy to developing agents–if your hands show signs of inflammation or cracking, you should always wear gloves. Gloves are essential for color print processing, and convenient for all tank film processing.

Mix chemicals in a well-ventilated area, preferably not the darkroom. Never pour water on to powdered or liquid concentrated chemicals, always add them to the water. If you add water to acid it will generate enough heat to make the liquid boil and spit out in all directions. And if you add water to powder it may turn rock-hard and become very difficult to dissolve. Always use a funnel to avoid spills when pouring your solutions into bottles. Mop up spilt liquids immediately as droplets dry into a fine, possibly unhealthy chemical dust which may contaminate your materials. And, if you fail to mop up spilt solutions, they may soak into the walls or floor and begin to erode brickwork, wood, and even concrete. Label every bottle of solution clearly in waterproof ink. Dilute all photographic chemicals that you pour down the drain with generous quantities of water, and use neutralizers if supplied.

Never mix or use chemicals in food-preparation areas, or store chemicals in old food containers, or leave them in food cupboards. And avoid eating in the darkroom– apart from soiling your work surfaces, your food may pick up traces of chemicals.

Mixing chemical formulae

You can purchase photographic chemicals either as concentrated liquids or as pre-mixed powders ready to dissolve. Powders are the cheapest, but liquids are easier and quicker to mix. And you can divide up liquid chemicals accurately for techniques such as "one-shot" processing. Always follow the mixing instructions with your chemical pack or kit, mixing the components in the exact order and within the temperature limits specified. Take great care not to contaminate one chemical solution with another, particularly when you are using color processing kits. Contamination can easily occur if you swap bottle tops accidentally, or fail to rinse a mixing rod or graduate properly.

In the early years of photography, solutions were always mixed from the basic component chemicals. You can still use this method to save money or to make up certain developers or toners that you cannot buy ready-packaged. However, this is not always practical for complex color solutions. To make up a solution you will require the printed formula (see facing page), a pair of small scales, and a set of weights. You must also obtain reasonably small quantities of each chemical. Some chemicals are made in either crystaline or anhydrous form. Anhydrous chemical (a dry powder) is the more concentrated of the two. You will require less of a chemical if you buy it in anhydrous rather than crystaline form. If the chemical is available in both forms, the formula will stipulate which one you should use, giving the abbreviations "anhy" or "cryst". Use letter scales or a balance to weigh out each component. When you have each quantity of chemical ready, fill a graduate with warm (75-85°F/24-29°C) tap water equivalent to about two-thirds of the final volume of the solution. Dissolve the chemicals in turn, in formula order. Trickle powder in slowly, keeping the solution moving with a plastic mixing rod. Take special care if you are mixing in an acid (see *Using chemicals safely*). When you have all the components in your solution, add further water to bring the total volume up to the final specified amount. Leave the solution for several hours to dissolve completely, and to cool to the correct working temperature.

Often a formula makes up as a stock solution, which you must then dilute for actual use. The instructions may say "dilute 1:5"; this means that you must take one part of the stock solution and add water until the final volume is five parts. (10 ml of stock solution, with water added to give a total of 50 ml, is a 1:5 solution.) Sometimes the formula will simply quote a percentage figure instead of a set quantity. A 10 per cent solution of acetic acid means one part in ten–1 ml of acid added to 9 ml of water, or 50 ml added to 450 ml of water. And you can have a percentage solution of a dry chemical. A 20 per cent table salt solution could be 20g of salt made up to 100 ml with water.

Developers

D-76 (Fine grain)

Metol	2 g
Hydroquinone	5 g
Sodium sulfite (anhy)	100 g
Borax	2 g
Water to make 1 liter	
Typical time at 68°F/20°C	8-15 min

D-163 (Print)

Metol	2.2 g
Hydroquinone	17 g
Sodium sulfite (anhy)	75 g
Sodium carbonate (anhy)	65 g
Potassium bromide	2.8 g
Water to make 1 liter	
Typical time at 68°F/20°C (diluted 1:3)	2 min

D-8 (Line)

Hydroquinone	22 g
Sodium sulfite (anhy)	45 g
Potassium/sodium hydroxide	19 g
Borax	15 g
Water to make 1 liter	
Typical time at 68°F/20°C	2 min

Variable contrast print developer (Dr Beers)

Mix two stock solutions in varying proportions to give different levels of contrast with the same (graded) printing paper (2 min at 68°F/20°C).

Stock solution A

Water at 122°F/50°C	750 ml
Metol	8 g
Sodium sulfite (anhy)	23 g
Potassium carbonate (anhy)	20 g
Potassium bromide	1 g
Water to make 1 liter	

Stock solution B

Water at 122°F/50°C	750 ml
Hydroquinone	8 g
Sodium sulfite (anhy)	23 g
Potassium carbonate (anhy)	27 g
Potassium bromide (anhy)	2 g
Water to make 1 liter	

Contrast	Parts A	Parts B	Parts water
Low	8	0	8
Normal	5	3	8
High	2	14	0

Lith developer (AN-79b)

Stock solution A

Sodium sulfite (anhy)	1 g
Paraformaldehyde	30 g
Potassium metabisulfite	10.5 g
Water to make 1 liter	

Stock solution B

Sodium sulfite (anhy)	120 g
Boric acid (cryst)	30 g
Hydroquinone	90 g
Potassium bromide	6 g
Water to make 1 liter	

Mix one part A to 3 parts B just before use (2 min at 68°F/20°C)

Monobath developer

This is a combined developer and fixer in a single solution which gives a fixed degree of development to films–contrast will vary with film type.

Water at 203°F/95°C	750 ml
Sodium sulfite (anhy)	60 g
Hydroquinone	30 g
Sodium hydroxide	25 g
"Phenidone"	3 g
Sodium thiosulfate (cryst)	150 g
Cooled water to make 1 liter	
(Add 10 ml of 40 per cent formaldehyde before use)	

Process until development stops (4-6 min at 68°F/20°C)

Stop bath

For films

Acetic acid/citric acid	30 ml
Water to make 1 liter	

For papers

Acetic acid/citric acid	15 ml
Water to make 1 liter	

Fixers

Use undiluted for films, dilute 1:1 for prints
Fix for 5-15 mins

Plain fixer

Sodium thiosulfate (cryst)	300 g
Water to make 1 liter	

Acid fixer

Sodium thiosulfate (cryst)	300 g
Sodium sulfite (anhy)	10 g
Acetic acid (glacial)	15 ml
Water to make 1 liter	

Acid hardening fixer

Sodium thiosulfate (cryst)	250 g
Sodium sulfite (anhy)	15 g
Acetic acid (glacial)	17 ml
Boric acid (cryst)	7.5 g
Potassium alum	15 g
Water to make 1 liter	

Rapid fixer

Ammonium thiosulfate	200 g
Sodium sulfite (anhy)	15 g
Acetic acid (glacial)	21 ml
Boric acid (cryst)	7.5 g
Potassium alum	25 g
Water to make 1 liter	

Checking safelights

If fogging occurs when you are using the correct safelight for your material, bulb wattage may be too high, or the safelight too near, or you may have exposed sensitive materials to safelights for too long. To test safelighting **1** make a straight print. Then **2** expose another sheet of paper normally, and process it with the safelight on but with cardboard over the developing dish. Compare the two prints for signs of fog. If fogging occurs, repeat **2** but keep the safelight on between exposure and processing, covering sections of paper with cardboard for 30 sec, 1 min, and 2 min. Then decide the maximum safe handling period under your particular safelighting set up.

Films, papers and chemicals

The lists on these pages and overleaf contain a representative selection of branded products which were all available from larger photographic stores at the time that this book was printed. However, manufacturers replace processes, films, and papers with improved versions at regular intervals. You should check with your local supplier that the material that you want to use is currently available.

You can rate the new variable ASA films shown in table 1 below at speeds between 125 (or 400) and 1600 ASA (ISO). And you can use more than one rating on a single film, which you can then develop normaly.

Black and white film (table 1)

Brand	Speed (ASA)	Sensitivity	35mm	Roll	Sheet	Special points
Normal contrast						
Adox KB17	40	Ortho	●			100ft (30m) rolls
Ilford Pan F	50	P	●			Final image in dye
Kodak Panatomic X	32	P	●	●		
Adox KB 21	100	P	●			100ft (30m) rolls
Agfapan 100	100	P	●	●	●	
Ilford FP4	125	P	●	●	●	
Kodak Plus X	125	P	●	●	●	
Agfapan 400	400	P	●	●	●	
Ilford HP5	400	P	●	●	●	
Ilford XP1	400	P	●			Final image in dye
	(Variable)					
Kodak Tri X	400	P	●	●		
Kodak Recording 2475	4000	P	●			
Kodak Royal X Pan	1250	P		●		
Kodak Prof Copy	25	Ortho			●	Available USA only
Kodak Gravure Pos	20	Ortho			●	
Agfapan Vario-XL Prof	Variable	P	●			Final image in dye
High contrast						
Kodalith type 3	12	Ortho	●		●	35mm in bulk rolls
Kodalith Pan	40	P			●	
Specials						
Agfacontour		Ortho			●	Special effects
Agfa Dia-direct	100	P	●			Reversal slide film

Black and white papers (table 2)

Brand	Grade	Weight			Surfaces			Special points
		SW	MW	DW	G	L	M	
Fiber base								
Agfa Brovira	0-5	●		●	●	●		
Ilfobrom	0-5	●		●	●	●	●	
Ilfobrom Galerie	1-3			●	●	●		
Kodak Azo	0-5	●		●	●	●		Contact paper, USA only
Kodabromide	1-5	●		●	●	●		
Kodak Polycontrast	Variable	●		●	●	●		
Luminos Bromide	2-4	●		●	●	●	●	
Agfa Portriga	1-3			●	●	●	●	Warm-tone
Kodak Ektalure	2			●	●		●	Warm-tone, USA only
Resin-coated base								
Agfa Brovira 310S	1-5	●			●		●	
Ilford Ilfospeed	0-5	●			●	●	●	
Ilford Multigrade	Variable	●			●	●	●	
Kodak Polycontrast	Variable	●			●	●		Warm-tone, USA only
Kodabrome II	Variable	●			●	●		Warm-tone, Europe only
Luminos Bromide RD	1-4	●			●	●	●	
Kentmere Kenthene	1-4	●			●	●		

G = Glossy **L** = Luster **M** = Matte

Color film (table 3)

Brand	Speed (ASA)	Process	35mm	Roll	Sheet	Special points
Slide films	25	K-14	•			No user processing
Kodachrome 25	50	Agfa 41	•	•		
Agfachrome 50	100	E-6	•			
Fujichrome 100RD	160	E-6	•	•		Tungsten balance
Ektachrome 160	200	E-6	•	•		Tungsten balance
Ektachrome 200	400	E-6	•	•		
Extachrome 400						
						False colors
Special slide film	100	E-4	•			
Ektachrome IR	4	E-6	•		•	
Ektachrome slide dupe		Agfa 41			•	
Agfa Duplichrome						
Color negative films	80	Agfa N	•	•	•	
Agfacolor 80	100	C-41	•	•		
Fujicolor F-11	100	C-41	•	•		
Kodacolor II	100	C-41	•	•		
3M color print	400	C-41	•	•		
Kodacolor 400	100	C-41	•	•	•	
Kodak Vericolor II	400	C-41	•	•		
Sakuracolor 400						
Special negative film	5	C-41			•	
Vericolor interneg		C-41			•	For prints from color negs
Kodak Vericolor print					•	
Kodak Vericolor slide		C-41		•	•	
Agfacolor print		Agfa 85			•	

Color papers (all resin-coated) (table 4)

Brand	Process	Surface			Special points
		G	L	M	
Negative/Positive					
Agfacolor PE Type 4	Agfa 81/85	•	•	•	
Agfacolor PE Type 5	Agfa 90/88/P	•	•	•	
Kodak Ektacolor 78 RC	Ektaprint 2	•	•	•	
Unicolor type RB	Unicolor R2	•	•	•	
Positive/positive					
Kodak Ektachrome 14 RC	Ektaprint R14	•	•		Chromogenic, Europe only
Kodak Ektachrome 2203	Ektaprint R-1000	•	•		Chromogenic, USA only
Agfacolor MCN 310	61R	•	•	•	Chromogenic
Ilford Cibachrome A	P-12	•	•		

G = Glossy **L** = Luster **M** = Matte

Special papers (table 5)

Brand	Features
Autone	Colored base bromide paper (fiber or resin-coated)
Opaline	Opalescent triacetate (polyester) film
Tura Photolinen	Bromide coated linen
Kentint	Colored base bromide paper
Kodak Mural	Panchromatic bromide paper, Grade 2 resin-coated
Kodak Panalure	Fiber-based paper for making large bromide prints
Kodak Ektamatic SC	Stabilizator machine processing (variable contrast)
Kodagraph Transtar (USA) Kodaprove (Europe)	Direct reversal high contrast paper
Metone	Bromide coated aluminum
Tura Report Rapid	Warm-tone chlorobromide paper

Black and white film developers (table 6)

Brand	Type	Form	Remarks
Agfa Rodinal	General fine-grain	Liquid	One-shot
Ilford Microphen	General fine-grain	Powder	Some speed increase
Kodak D-76	General fine-grain	Powder	Replenishable
Kodak Versatol (USA)	Films and paper	Liquid	One-shot
Kodak Universal (Europe)	Films and paper	Liquid	One-shot
Paterson Acuspeed	Speed-enhancing	Liquid	One-shot
Ilford Perceptol	Extreme fine-grain	Powder	Replenishable
Tetenal Neofin	Acutance	Liquid	One-shot
Kodalith	Lith	Liquid/Powder	One-shot
Kodak D-8	High contrast line	Powder	One-shot
Paterson Acutol	Acutance	Liquid	One-shot

Special black and white film developers (table 7)

Brand	Features
Kodak DP film developing outfit	For reversal processing suitable black and white films
Tetenol reversal kit	For reversal processing suitable black and white films
Kodak Tanning developer	Forms relief image on dye transfer matrix film

Black and white paper developers (table 8)

Brand	Image color	Form	Remarks
Agfa Neutrol NE	Neutral	Liquid/Powder	
Ilford Bromophen	Neutral	Powder	
Kodak Dektol/D163	Neutral	Powder	
Ilford Ilfospeed	Neutral	Liquid	Fast-working
Kodak Selectol	Warm-tone	Powder	
Agfa Neutrol WA	Warm-tone	Liquid/Powder	
Kodalith	Neutral/brown	Liquid/Powder	Lith paper only

Color film developer kits (table 9)

Brand	Film/Process	35mm films per small kit	Remarks
Agfa process N	Neg/Agfa	6	Type-B chemistry films only
Kodak Flexicolor	Neg/C-41	10	
Paterson Acucolor Universal	Neg/C-41	8	
Kodak Ektachrome E-6	Slide/E-6	10	
Agfa process 41	Slide/Agfa	12	Type-B chemistry films only
Tetenal/Beseler E-6	Slide/E-6	4	
Unicolor E-6	Slide/E-6	8	

Color print developer kits (table 10)

Brand	Processes	N/P or P/P	Form	Remarks
Agfa process 85	Agfacolor	N/P	Powder	Type-B chemistry papers only
Tetenal high-speed PA	Agfacolor	N/P	Liquid	Type-B chemistry papers only
Kodak Ektaprint 2	Kodak 78	N/P	Liquid	
Beseler Two-step	Kodak 78	N/P	Powder	
Kodak Ektaprint R100	Ektachrome 2203	P/P	Liquid	
Unicolor RP-1000	Kodak R14	P/P	Liquid	
Ilford Ciba P12	Cibachrome	P/P	Liquid/Powder	SDB papers only
Agfa 61R	Agfa MCN 310	P/P	Powder	

Dual role	Features
Unicolor Totalcolor	Kit contains units which can be combined to process both negatives and neg/pos color paper

ANSI paper speed numbers

Some manufacturers show ANSI speed ratings on their boxes of black and white printing paper. ANSI numbers are akin to film speeds – they indicate the relative sensitivity to light of different papers. These numbers are useful when you change from one brand to another, or when you change grade on an unfamiliar paper. For example, a normal grade paper may have ANSI speed 300, hard grade 200. Therefore, exposure of 6 sec on normal paper would change to 9 sec for a print on the harder grade. Enlarging exposure meters or analyzers also use ANSI ratings. In practice, however, you will find that, because you become familiar with the papers you use, you rarely need to refer to ANSI speeds. In any case, it is a simple, visually informative task to make test strip exposures for each new negative, and essential for really accurate enlargements.

Divided type negative developers

Some fine-grain developers are formulated as two separate working solutions. Generally, the first solution contains developing agents, while the second contains the alkali (or accelerator) part of the developer. Soak the film in the first solution to absorb developing agent (which at this stage remains inactive). Transfer the film to a tank of the second solution and agitate gently. If you apply accelerator separately in this way, it encourages heavily-exposed parts of the image to exhaust their developing agents well before shadow areas. This gives negatives with increased shadow detail, without creating dense highlights. The resulting print should show a good range of well-separated tones.

Chemical aftertreatment of color slides

Chemical aftertreatment kits for color slides enable you to reduce density overall, or to lighten one dye layer at a time. You can correct up to one stop underexposure by treatment for about 3 min. Use selective reducers to remove overall color casts, or give a final adjustment after general reduction. Always pre-test your solution on a scrap frame of the same brand of film. Stick self-adhesive tape over one half of the emulsion and submerge film in reducer for a timed period. After washing and drying, remove the tape and compare treated and untreated areas for strength of reduction. This test will help you to decide the correct time for your color slide. To reduce your slide, submerge it in reducer for the estimated time (or less). Then rinse and sponge both sides of the slide to remove chemical traces. If the density is now correct, wash your slide in water and wetting agent for 5 min. Finally, hang it up to dry in a dust-free place.

Paper sizes

Sheet		Roll (widths)	
Ins	Cm	Ins	Cm
3½ x 5	8.9 x 12.7	20	50.8
5 x 7	12.7 x 17.8	30	76.2
8 x 10	20.3 x 25.4	41	106.7
9½ x 11¾	24.0 x 30.5	55	142.0
11 x 14	27.9 x 35.6	Length usually 33 ft	
11¾ x 16	30.5 x 40.6	(10 m) or 98½ ft (30 m)	
16 x 20	40.6 x 50.8		
20 x 24	50.8 x 61.0		

Processing sheet film

You can process sheet film in trays, like paper, or in tanks. Trays are less expensive, and may save on chemicals. However, if you tray-process several sheets at a time, you have to stack them loosely under solution and move each one to the top of the pile in sequence ("interleaving"). For regular sheet film processing use 3½ gallon (13.5 liter) PVC tanks and have one tank for each solution. Set up tanks on duckboards in a flat-bottomed photographic sink (this allows split solutions to drain away). If your darkroom is not temperature controlled, use a deeper sink and fill it with water so that it acts as a tempering bath. Each tank has a light-tight lid, and the developer tank also has an internal lid to reduce oxidation. Film sheets clip into individual hangers. Process large quantities of films in a tank-size rack loaded with several hangers. Move the rack from tank to tank as one unit. Processing must take place in the darkroom because you have to withdraw and replace hangers to agitate the film. Since you have to make up large quantities of solution, choose a long-life developer which you can repeatedly re-use and replenish. The final processing tank is a wash tank with jets, which you connect to the faucet. Always keep dry hangers away from the wet bench to avoid marking exposed film with liquid prior to processing.

Permanence of results

The long-term survival of your photographic images will depend on the materials that you used, how you processed them, and how you store them. Photocopy, dye transfer and silkscreen prints are the most permanent because the final image is applied as pigment to ordinary paper. The fully formed dyes of SDB color materials are more permanent than the chemically-generated dyes in chromogenic papers or films.

For permanent black and white prints or negatives, fixing and washing stages must leave the emulsion free of unstable salts and by-products. Avoid over-using a fixing bath – when dissolved silver reaches a certain level, compounds form which washing will not remove. (Check fixer by adding five drops of a 19 per cent solution of potassium iodide to five drops of fixer and five drops of water. Discard fixer if an immediate yellowish curd forms.) Use a hypo clearing agent during washing (p.58) to keep fiber-based papers clearer from chemical by-products. After washing and drying, test for residual fixer (see p. 95). Sepia-toned (p. 268) or selenium-toned prints are more stable and resistant to atmospheric contamination. And a fiber-based print will not deteriorate as fast as a resin-coated one.

If you store photographic images for long periods where relative humidity is high, they will absorb moisture from the air, and, because they still contain gelatin, become a spawning ground for fungi. Fading is another danger – for example 160 ASA color slides fade just perceptibly after showing for 20 min on a 250 watt projector. (This improves to 90 min with 25 ASA films.) You can display color prints safely out of direct sunlight for 5-10 months (chromogenic) or 5-6 years (SDB or dye transfer). Even if you store them in the dark, chromogenic images will gradually fade, beginning with the yellow layer. At 40 per cent relative humidity and a temperature of 75°F (24°C), slight change occurs to negatives, prints and to slides on fast film after 6-20 years. Slides on slow film remain stable for about five times as long. You can increase the life of materials 100 fold if you store work at 14°F (–10°C).

Glossary

Abstract Originally an artistic term, denoting a subjective, non-realistic image. An abstract photograph generally consists of a design of patterns or shapes where the purpose and identity of the subject is not evident.

Acetate A non-inflammable material used as a base for film. Clear acetate sheets are also used for graphic purposes such as screens. In dyed form they are used as color filters for light sources.

Acetic acid Chemical used in acid stop baths to stop development and neutralize developer prior to fixation. A 2 per cent solution is usually recommended for negative and print stop baths. Also used to acidify fixing baths (with a "buffer" of sodium sulfate, which prevents acid from decomposing the thiosulfate used for fixation).

Acid fixer Fixing solution which contains an acid to neutralize any carry-over of alkaline developer on the negative or print, or from a contaminated stop bath.

Acid hardener Acidifying solution which also contains a chemical to strengthen the physical characteristics of an emulsion. Often used with a fixing bath.

Acutance Objective, physical measurement of the sharpness of a processed photographic image. The steepness of the angle of the edge gradient between density boundaries in an image is used to express its degree of sharpness. The steeper the angle between these boundaries the greater the sharpness. As the angle becomes less acute the difference between the two densities becomes more diffuse, and the image less sharp. Such measurements do not always correlate with subjective judgments because other factors (for example, contrast and brightness) play a part in the final effect.

Additive printing Printing process employing the principle of additive synthesis. Most early color photographs were additive prints. Now used for certain manipulations.

Additive synthesis A method of producing full color images by mixing light of the three primary color wavelengths, blue, green, and red. Mixed in equal proportions they produce white. Mixed in varying proportions they can produce all the colors of the spectrum. Early color photography was based on the use of this synthesis.

Agitation Method used to keep fresh processing solution in contact with the emulsion surface during photographic processing. The manufacturer's recommendations for the degree of agitation required for particular materials must be followed, because agitation can markedly affect the contrast of a result.

Air bells Bubbles of air formed on the emulsion surface during processing. If the manufacturer's recommended agitation times are followed, air bells can be avoided.

Alcohol thermometer Instrument used for measuring temperature. Inexpensive, but less accurate version of the mercury thermometer.

Alkalinity Denotes the degree of alkali in a solution. Measured by the pH values. All values above pH 7 are alkaline. Most color developers contain alkali to increase the rate of color development.

Analyzer Chart or (more expensive but more accurate) instrument used to determine correct color filtration when making color prints.

Angstrom Unit of length equal to one millionth of a millimeter.

ANSI speed Speed rating system for photographic papers. Devised by the American National Standards Institute. The higher the ANSI number, the higher the speed of the paper.

Antihalation backing Light-absorbing dye coating within, or on the back of, most film bases, or between the base and the emulsion. It absorbs any light which passes straight through the emulsion layer, and prevents this extraneous light being reflected back through the film layers.

Aperture Opening in front of, or within, a lens which controls the amount of light that passes through the lens to the photographic material. Aperture is usually variable, and calibrated by f numbers.

Archival permanence treatments Various treatments (such as special washes, selenium or gold toning) given to prints to make them fade-resistant. These expensive processes are used by museums and galleries.

ASA Speed rating denoting the sensitivity to light of photographic films. Devised by the American Standards Association. The rating is based on an arithmetical progression using an average gradient system. Films are classified by ASA number: the higher the number, the higher the speed of the film.

Assembly printing Method of printing using image separations. For example, yellow, magenta, and cyan (or blue, green, and red) films are combined to make a final full-color print.

Azo dyes Collective term for a group of synthetic coloring agents.

Baryta pigment Coating of barium sulfate applied as a foundation layer in fiber-based printing papers to give a smooth white, chemically inert base for the emulsion.

Base Support for a photographic emulsion. It is usually made from paper, plastic, fabric, or glass.

Batch numbers Sets of serial numbers printed on packets of sensitive materials to indicate the production batch of emulsion with which they are coated. Slight variations of contrast and speed occur between batches of the same type of photographic material. With color printing paper, filtration recommendations are also given and are of particular importance when changing from one pack of paper to another during a print session. To keep print results consistent, a new filtration pack must be prepared for each new batch of paper.

Bi-refringence Splitting of light passing through crystals into two rays at right-angles to each other. Produces polarized light.

Black silver Metallic silver formed from silver halides by exposure and development.

Bleach Chemical bath used to remove all or part of an image. For

example, it can convert a silver image into a halide, which may then be fixed away or toned.

Bleach/fix Chemical bath in which the bleach and fixer have been combined. Used in many color processes.

Bleeding (1) Spread of color or tone into an adjoining area. (2) Term used to describe a print that extends to one or more edges of the paper, without borders.

Blix solution Alternative term for bleach/fix.

Blue-sensitive (of certain silver halides) Sensitive to blue light only. All silver halides used in black and white emulsions are sensitive to blue light. But early photographic materials possessed only this sensitivity. In 1880 Dr Vogel evolved a method of making silver halides sensitive to other colors. This discovery eventually led to the orthochromatic and panchromatic materials in use today.

Brilliance The intensity of light reflected from a surface. Alternative term for luminosity.

Bromide paper Most common type of photographic printing paper. It is coated with a (normally panchromatic) light-sensitive emulsion of silver bromide to reproduce black and white images.

Bulk film Film purchased in long lengths. Used in a bulk camera back (on occasions that demand fast, extensive use of film) or with a bulk film loader (to reload cassettes cheaply).

Burning in Method of increasing printing exposure in specific areas of an image. Alternative term for printing in.

Camera obscura Aid to drawing. The origin of the present-day camera. Consisted of a light-tight box or room with a small hole or lens at one end. Light rays pass through the hole, transmitting an inverted image of the scene outside on to a screen.

Cartridge Pre-packed, sealed film container for quick, drop-in loading. Used in 110 and 126 cameras.

Cassette Cylindrical metal or plastic film spool container. A light-trap allows handling and camera loading in daylight. Commonly used in 35mm cameras.

Cast Overall bias toward one color in a color photograph.

CC filters Color correction or conversion filters, used in various hues and degrees of saturation primarily for balancing color in subtractive color printing processes. The color shift values are calibrated, and the filters are available in sets of yellow, magenta, and cyan.

Changing bag Opaque, light-tight fabric bag. Light-excluding sleeves allow the safe handling of light-sensitive photographic materials inside.

Chemical reducer Solution capable of diminishing density, lightening, and/or altering contrast on a photographic emulsion, usually by reducing silver, e.g. Farmer's reducer.

Chlorobromide paper Photographic printing paper coated with a light-sensitive emulsion containing a mixture of silver bromide and silver chloride halides. Produces warm-tone images with normal development.

Chromogenic development Process in which oxidation products of color developer combine with color couplers to form dyes of precise and known character. Used to develop many color photographic materials.

Clip test Test to determine accurate development, using a short length of sample film.

Cold-light enlarger A diffuser enlarger equipped with a low-temperature fluorescent light source. Inclined to reduce contrast and edge definition.

Color balance Adjustment in color photographic processes ensuring that a neutral scale of gray tones is reproduced accurately, i.e. a gray subject will have no particular color bias.

Color developer Common term for a developer which combines with color couplers to form specific dyes, allowing color development.

Color head Term for an enlarger illumination system which has built-in adjustable filters for color printing.

Color sensitivity The response of a light-sensitive material to colors of different wavelengths.

Color separation Process of photographing an image through filters to produce three black and white negatives which represent the red, green, and blue content. Used in photomechanical color printing, dye transfer printing, and some manipulative processes.

Color temperature Way of expressing the color quality (content) of a light source. The color temperature scale is usually measured in Kelvins.

Color toning A system of changing the color of a black and white photographic image by converting black metallic silver into a colored compound or dye. Sepia toning is the most common color toning process.

Complementary color The color of light which, when combined with another already specified color in the correct proportion, will form gray or white: i.e. the two colors together will form the whole visible spectrum. The term is mostly used in photography to describe the colors yellow, magenta, and cyan, because each is complementary to one of the primaries, blue, green, and red.

Condenser Optical system which concentrates diverging light rays from a light source into a beam, in order to illuminate evenly the negative in an enlarger.

Contact paper Printing paper used for contact printing with a bright light source. It is usually coated with silver chloride emulsion of very slow speed.

Contact printing Making one or more negative-size photographs by placing the printing paper in direct contact with the negative.

Continuous tone Term applied to black and white negatives and prints that possess a gradation of gray tones—from white through to black—representing varying luminances in the subject.

Contrast Subjective judgment on the differences in brightness and density between shadow and highlight areas in the subject, negative or print. Contrast control is affected by the inherent subject contrast, subject lighting ratio, lens flare, type of film, degree of development, enlarger type, and contrast grade and surface quality of the printing paper used.

Contrasty Term describing a negative or print which has a greater difference in the tonal range than normal. May be caused by the contrast of the emulsion, harsh subject and lighting conditions, or overdevelopment.

Coupler (1) Chemical present in different forms in all three layers of subtractive color material. Each coupler is combined with oxidation by-products of the color development process to form yellow, magenta or cyan dye. (2) Chemical incorporated in developer solution which develops all halides into one color, as with some forms of toning.

CP filters Color printing filters. These are types of color compensating filters made of acetate

instead of glass or gelatin. They are used in the filter drawer of the enlarger, *not* under the lens.

Cropping Framing an image so that unwanted parts of the scene are not included on the final print. Pictures not cropped in the camera viewfinder can be cropped at the enlarging stage.

Cut film Alternative name for sheet film.

Cyan Blue-green subtractive color complementary to red. Transmits the blue and green, but not the red, components of white light.

Darkroom Light-tight room used for handling, processing, and printing light-sensitive materials in darkness, or under safelighting to which the material is not appreciably sensitive.

Daylight film Color film designed for use with daylight or a light source of equivalent color temperature, which includes flashbulbs and electronic flash. The film is balanced to 5400K.

Daylight tank Light-tight plastic or steel container for film processing. Film is loaded in the dark, after which all regular processing steps are carried out in normal light.

Definition Subjective term for the clarity of a photographic image. Not just the result of sharpness or the resolving power of the lens, but also the combined effects of graininess, contrast, and tone reproduction.

Density General descriptive term for the amount of photographic (silver or dye) deposit produced in an emulsion by exposure and development. Strictly, measurement is based on light-stopping ability (opacity) and is usually expressed as the logarithm of this opacity.

Depth of field The distance between the nearest and furthest point from the camera within which subject details record with acceptable sharpness at any one focus setting.

Depth of focus In enlarging, the distance between surfaces nearest and furthest to the lens on which an image can be formed with acceptable sharpness at any one focus setting. Increases at small lens apertures.

Development The chemical or physical treatment that converts a photograpic, invisible latent image into a visible form.

Diapositive Positive image produced on a transparent base for viewing by transmitted light i.e. a transparency.

Diazo Abbreviation for diazonium compounds, which decompose under the action of blue or ultra-violet radiation, forming an image in an azo dye.

Dichroic Displaying two colors– one by transmitted, the other by reflected light.

Dichroic filters Filters produced by surface coatings on glass to form colors by interference of light. Part of the separation is transmitted, the remainder reflected. Since they contain no dye, these filters are fade-free, but are more expensive than dyed filters. Used in best quality color enlarger heads.

Diffuser Any substance capable of scattering light. The effect is to soften the quality of the light. Diffusion may take place by reflection (e.g. white cardboard) or transmission (e.g. tracing paper).

Dilution Reduction in strength of a liquid by mixing it with an appropriate quantity of water. Dilution is often specified in "parts", see p. 332.

DIN Abbreviation for Deutsche Industrie Norm (German standards organization). The German system of rating film sensitivity to light. A change of +3 in the DIN rating indicates a doubling of film speed, e.g. 21 DIN is twice as fast as 18 DIN.

Distortion Alteration in the shape and/or proportions of an image. May occur at any stage in the photographic process. Can be produced deliberately via darkroom manipulation for unusual effects.

Dodging Local control of density in photographic printing achieved by shading to reduce the exposure to specific areas of the printing paper.

Drying cabinet Cabinet equipped with suspending rods for drying films. Air is drawn into the cabinet by an electric fan, passed over the films and emitted from the top of the cabinet.

Dry mounting Method of attaching prints to mounting surfaces by heating a shellac layer between the print and the mount.

Dye Chemical coloring agent employing the principle of molecular absorption (unlike pigment, which colors by coating a substance with solid matter). Used in emulsions, toners, filters, and film.

Dye coupling Formation of colored photographic images by the reaction between the oxidized color developers and the couplers

incorporated in the developing solution or emulsion.

Dye-image monochrome films Black and white negative films designed for color processing. Introduced in 1980. The final image is formed in a warm-colored dye, free of silver. These films offer better resolution and much greater exposure latitude than traditional silver image film.

Dye transfer Transfer of dyes from three separately prepared images in register on to a single sheet of paper.

Easel Alternative name for masking frame. Flat board on which printing papers are held during enlargement.

Emulsion In photography, a mixture of light-sensitive silver halides in gelatin (plus color couplers for color materials). In this form the chemicals can be coated on various bases to make films and printing papers.

Enlargement A print which is larger than the negative used to produce it. It is sometimes referred to as a projection print.

Ergonomic Of machines and conditions in the working environment, adapted to enable the individual to work efficiently.

Etch bleach Bleaching solution used after development. It not only dissolves away the silver image, but also the gelatin in these areas, leaving the base only. Remaining halides and gelatin form a relief image.

Etching Scraping or dissolving away unwanted areas from an image or image printing surface.

Exposure Exposure in the photographic sense is the product of the intensity of light that reaches the film or paper (controlled by lens aperture), and the length of time this intensity of light is allowed to act (controlled by camera shutter or enlarger timer).

Exposure latitude The amount by which you can over- or under-expose a light-sensitive material and, with standard processing, still produce an acceptable result. Least latitude occurs with high-contrast materials.

F numbers Number sequence indicating aperture settings on lens barrel. Equivalent to the focal length

of the lens divided by the effective diameter of the aperture, giving a scale constant for all lenses. Each setting progressively halves or doubles the brightness of the image.

Fast film Film which has an emulsion that is very sensitive to light. Such films have high ASA ratings.

Ferrotype plate Sheet of highly-polished steel used for glazing prints.

Film Photographic material consisting of a thin, transparent plastic base coated with light-sensitive emulsion. Black and white film has effectively one emulsion layer, while color film has at least three, each sensitive to a different color of light.

Film leader Trimmed, fogged section of film at the beginning of the cassette. Used for loading the film into the camera.

Film plane In an enlarger, the flat plane of the negative carrier aperture, across which the film lies. Normally parallel to the baseboard.

Filter Transparent material such as acetate, colored glass or gelatin, which modifies light passing through it, usually in terms of color content.

Filtration In color printing, the use of color filters to control the color balance of the enlarged image, and so of the resulting print.

Fine-grain developer Film developer used to keep grain size in the photographic image to a minimum by reducing the tendency of the image-forming silver to join together in clumps. Most modern fine-grain developers are capable of achieving excellent results without loss of film speed.

Fixation Removal of unexposed and undeveloped halides by converting them to soluble salts which may be washed from the emulsion. Makes image permanent in white light.

Fixer Chemical solution used for fixation.

Flare Non-image-forming light scattered by reflections within a lens or enlarger/camera interior. It reduces image contrast and shadow detail. The problem is offset in modern lenses by a coating technique known as blooming.

Flashlight Alternative term for a battery-operated hand torch.

Flat gradation Subjective term used to describe low contrast values. May refer to the original lighting, or to a negative or positive photographic image.

Focal length The light-bending power of a lens, defined as the distance between the rear nodal point of a lens and the focal plane, when the focus is set at infinity. In enlarging, focal length determines image magnification at a set column height.

Focus The condition in which rays of light from the negative transmitted by an enlarging lens, converge to form a clear and sharply defined image on, for example, the masking frame. Hence, lens adjustment necessary for sharp focus.

Focusing Method of moving the lens in relation to the negative carrier and masking frame, so that rays of light from the negative are brought into sharp focus as an image on the paper.

Fog Area or veil of density on a photographic negative or print, which does not form part of the image. It can be caused by chemicals or exposure to light.

Format Size and shape of negative, slide, printing paper or camera viewing area.

Frilling Wrinkling and separation of the emulsion along the edges of its support material.

Gelatin Natural protein used as the transparent medium to hold light-sensitive silver halide crystals in suspension, binding them to the printing paper or film, yet allowing entry of processing solutions.

Gelatin filters Relatively inexpensive filters made from dyed gelatin (as opposed to glass).

Gesso White fluid coating consisting of whiting mixed with glue. Traditionally used by artists as a foundation, or size, on wood or similar absorbent material.

Gradation Contrast range found in the tones of an image, from white through gray to black. It is described in terms of "soft", where the tonal contrast is low; "normal"; and "hard" or "contrasty", where the contrast is great.

Grade number Numerical indication of the contrast characteristics of a printing paper. Paper numbers range from 0 to 5, i.e. very soft to very hard. (Similar grade numbers from different manufacturers do not necessarily have the equivalent contrast characteristics.)

Graduate Vessel with a scale of etched figures used for measuring liquids.

Grain Pattern of minute particles of black metallic silver, often clumped together, which are formed in an emulsion when silver halides

have been exposed and developed. A similar irregular pattern is formed in dye images chromogenically developed from silver halides.

Gray scale Print or transparency with regular steps of tone from white (or clear) to black (or opaque). Used for judging accurate exposure or color balance. Also known as a step wedge.

Gum arabic Widely used gum obtained from Acacia trees.

Halation "Halos" formed around bright parts of an image. Sometimes caused in enlarging on film which is not backed up with black paper. Light passes through the emulsion, strikes the white masking frame, and is reflected back to the light-sensitive layer again, spreading slightly around the original recorded image.

Half-tone process System of producing an optical illusion of continuous tone with a black dot formation representing the image. Main application is in photo-mechanical printing of newspapers, books, and magazines.

Hand coloring Application of color to a photographic image by hand, usually with a brush or swab. Also known as hand tinting.

Hardener Chemical used in film manufacture, and as a bath in some processing sequences, to strengthen the physical characteristics of gelatin. This is especially important with high-temperature processing. The most common chemicals used are potassium or chrome alum.

Hard gradation Term used to describe a quality of harsh contrast in a photograph. Also used to describe a light source which produces this quality in the subject.

Heat filter Optical attachment, usually made of thick glass, used to absorb heat radiation from a light beam without diminishing its output of light.

Herschel effect Destruction of a surface latent image (previously formed by light) by red or infrared radiation. Occurs on silver halide emulsions that are otherwise insensitive to this region of the spectrum.

High-contrast film and developers Solutions and materials used to produce high-contrast images.

Highlights Brightest, lightest parts of the subject. They appear as dark, dense areas on the negative

and reproduce as light areas on the positive.

Holding back Decreasing the exposure given to certain areas of a print by selective shading or masking during the process of enlargement.

Hue Title of a color. The property (color wavelength) that distinguishes one pure color from any other, i.e. red as distinct from purple.

Hypo Historical but still common name for the fixing agent, sodium thiosulfate (originally hyposulfite of soda). Often used as a general term for fixing solutions.

Hypo eliminator Chemical bath used to destroy fixing agent from an emulsion, and so reduce the washing time.

Image Two-dimensional representation of a real object, produced by focusing rays of light.

Infrared Band of wavelengths beyond the red end of the electromagnetic spectrum. They are invisible to the human eye, but can be recorded on suitably sensitized film.

Intensification Chemical method of increasing the density of a photographic image. Normally used for improving negatives.

Interleaving Method of agitating more than one sheet of photographic paper in the same tray. The bottom sheet is rotated to the top continuously.

Internegative Negative made of special color film designed for making copy prints from color slides. Film is manufactured with a built-in mask to control color and contrast.

Intersection of thirds Classical rule of composition. Division of frame horizontally and vertically into thirds, with the subject placed at one of the four intersections. Also known as the "rule of thirds".

ISO International Standards Organization. The ISO film speed system is gradually replacing the ASA index. Both systems use identical numbers.

Kelvin Unit of measurement used to indicate the color temperature of light sources. The Kelvin scale is numerically equal to the Absolute scale (calculated by adding 273 to degrees centigrade).

Lamp black A pure carbon pigment, made from soot deposited from burning oils.

Lamphouse Ventilated light-tight housing which contains the light source on an enlarger or projector.

Latent image Invisible image formed in the emulsion by exposure to light but which can be developed into a visible form.

Latitude (of exposure) The degree by which exposure level can be varied and still produce an acceptable result. Lower contrast papers and films generally have greater latitude than hard materials.

Lens Optical device made of glass, capable of bending light. In enlarging, lenses are used to gather together light rays transmitted by a negative to form an image on the baseboard or masking frame. There are two basic types of simple lens: convex (positive), which causes rays to converge to a point, and concave (negative), which causes rays to diverge. Both are used in compound lens constructions in which several elements are combined to give an overall converging effect.

Light Form of energy that makes up the visible part of the electromagnetic spectrum. It has a range of wavelengths from 400-700 nanometers, representing a change in color from violet to dark red.

Light box Box of fluorescent tubes balanced for white light and covered with translucent glass. Used for viewing, registering, or correcting film negatives and positives.

Light source General term applied to any source of light used in photography, e.g. sun, tungsten filament, or enlarger lamp.

Light-tight Impervious to light.

Light trap System of entry to a darkroom which allows easy access, but prevents unwanted light entering. Similarly, in a daylight developing tank a light-trapped lid allows entry and exit of processing solutions.

Line film High-contrast film which, after correct development, gives negatives of black and white only (with no grays).

Lith film An extreme form of line film, which produces very high-contrast images but only when used in conjunction with a special lith developer. It is used as an intermediate process in creating a number of photographic color effects in the darkroom.

Local control In printing, the system of controlling the final quality of a print by burning-in or dodging selected areas of the image.

Luminosity See *Brilliance*.

Mackie line On a negative or print, an effect in which a light line forms along the boundaries of the darkest image areas. It can be caused during processing by diffusion of exhausted developer, or by solarization.

Magenta Purple-red color composed of blue and red light. Magenta is the complementary color to the primary color green.

Magnification The ratio of print size to negative size i.e. enlargement. It refers to the ratio of the height of the projected image to the height of the negative; or the ratio of the lens-image distance to the negative-lens distance. When a negative and its projected image are the same size magnification is x1.

Mask (1) Opaque material used to cover the edges of the printing paper and so produce borders. (2) Weak positive image on film which, when registered with a negative, adds density to the shadow areas and so reduces contrast. (3) Dyes incorporated in the non-image areas of color negatives to improve color accuracy when printed.

Masking System of controlling negative density range or color saturation through the use of light-blocking masks (usually unsharp).

Matrix In photography, a relief image, usually made from gelatin, used for processes such as dye transfer printing.

Matte Term used to describe a surface finish that is non-textured and non-reflective.

Modular enlarger Type of enlarger that has interchangeable filtration heads and/or illumination systems.

Monobath Single solution which combines developer and fixer for processing black and white negatives. It is a quick, simple system but it does not allow for development control.

Monochrome Strictly, comprising light rays of a single wavelength, i.e. of a single, pure color. Also used, less accurately, to describe a range of tones of one color, or a black and white photograph.

Montage Composite picture made from a number of prints, or parts of prints, either overlaid or set side by side.

Mordant Dye-absorbing substance. Used in some forms of toning in which the silver image is converted into a mordant, then soaked in dye.

Mottle Fault characterized by random print density differences.

Mounts Frames and/or backing used to support and protect prints or slides. Composed of cardboard (prints and slides) or plastic (slides).

Nanometer Unit of measurement of light wavelengths. One nanometer is one-millionth of a millimeter.

Naptha A volatile petroleum-based solvent such as benzine or gasoline (but not kerosene).

Negative Developed photographic image with reversed tones: subject highlights appear dark and shadows appear light. With color material, each subject color is represented by its complementary hue. A negative is usually made on a transparent base, so that light can be passed through it to expose another sensitive material, and so form a positive image.

Negative carrier Metal or plastic hinged frame that supports the negative between the light source and the lens in the enlarger.

Negative/positive paper Paper used to print a positive image from a color negative.

Neutral Having no hue. A neutral color is gray.

Neutral density Gray, colorless density. In color printing, caused by using some filters of all three subtractive colors at once. The color pack should be simplified by removing the filter of the lowest value, which indicates the level of neutral density within the pack. The other two color values are adjusted by subtracting an equal value from each.

Neutral density filter Gray filter which reduces the amount of light passing through an optical system without affecting the colors in the final image.

Neutralizer Normally a chemical designed to counteract and make inactive another chemical solution.

Newton's rings Concentric rings of colored light produced when two flat, transparent surfaces are laid together in partial contact. Often seen in glass negative carriers and glass transparency mounts.

Non-silver processes Image-making processes that, unlike conventional methods, do not require the use of metallic silver. Gum bichromate and cyanotype are non-silver processes.

One-shot developer A developer that is used on a single occasion and then discarded.

Opacity The light-stopping power of a material. The greater the opacity of a substance, the more light it stops. In photography, opacity is expressed as a ratio of the amount of light falling on the surface of the material to the amount of light transmitted by it.

Opalescence Describes a material having a cloudy-white, milky appearance; translucent.

Opaque, liquid Dense red or black pigment dissolved in water. Forms liquid paint used to fill in film areas that should be opaque. Can be removed and re-applied if necessary.

Opening up Increasing the size of the lens aperture.

Orthochromatic Of a photographic emulsion, sensitive to blue and green light, and insensitive to red.

Overdevelopment The result of exceeding the degree of development recommended by the manufacturer. It can be caused by prolonged development time, increased temperature or over-agitation. It results in an increase of density and contrast, leading to fog and stains.

Overexposure The result of giving a light-sensitive material excessive exposure. On negative/positive materials this increases density, and often reduces contrast.

Oxidation In development, the exhaustion of developing agents due to reaction with air, or when in use, with silver halides. In color developer, oxidation products (formed as the result of the conversion of exposed halides to black metallic silver) produce a chemical that combines with color couplers to form color dyes.

Panchromatic Of a photographic emulsion, sensitive to all colors of the visible spectrum, although it may not react in a uniform way.

Paper base Support for the photographic emulsion. May be plain fiber or resin coated. Resin coating is water-repellent – allowing quicker processing, less washing, and faster drying.

Paper grade Numerical and terminological description of paper contrast characteristics: numbers 0-1 soft; number 2 normal; number 3 hard; numbers 4-5 very hard. It should not be assumed that similar grade numbers from different manufacturers have equivalent characteristics.

Paper safe A light-tight container for photographic papers. Fitted with an easy opening, positive closing lid for use in the dark.

Patch-chart Term used to describe the squared pattern test-strip often made when color printing by the additive method.

Perspective System of representing three-dimensional objects on a two-dimensional surface to give a realistic impression of depth.

Phenol varnish Resin that sets when warmed. Used as a hard, durable, protective top surface.

Photogram Pattern or design produced by placing opaque or transparent objects between a light-sensitive emulsion and a light source. By this method, images can be produced direct on to printing paper without the use of a camera. After exposure to light, the photographic material is developed normally.

Photo linen Linen coated with photographic emulsion. Usually purchased in lengths from rolls. Used for techniques such as hand embroidery of prints.

Pigment Insoluble colored material, such as paint or poster color.

Plane Imaginary surface considered in terms of a straight line, within which points or lines of subjects lie.

Point source lamp Strictly, an arc type lamp producing light in a color similar to a tungsten filament lamp. In practice, most compact filament, clear-glass slide projector lamps act as point sources. A point source lamp provides hard shadows. In an enlarger, it gives maximum contrast and grain.

Polarization Light is said to travel in a wave motion along a straight path, vibrating in all directions at right angles to this plane. Polarization can be brought about with a polarizing filter which causes light to vibrate in a single plane only, reducing its strength. Polarizing filters are used over light sources or camera lenses to reduce or remove specular reflection from certain types of surface.

Positive Photographic image (on paper or film) in which light and dark areas correspond to the highlights and shadows of the original subject, and, in a color image, subject colors are represented truly. The tones and colors of a positive are opposite to those of a negative.

Positive/positive printing Process for printing a color transparency direct on paper to produce a color print. Positive/positive paper is either silver dye-bleach or reversal type.

Pre-hardener Chemical solution used to harden gelatin of an emulsion prior to processing. Helps to protect emulsion against damage when high processing temperatures are used.

Pre-soak Preparatory water bath for film or paper prior to processing. Prevents uneven development. Pre-soak is essential in certain color processes.

Print In photography, an image (normally positive) which has been produced by the action of light (usually passed through a negative or slide) on paper or similar material coated with a light-sensitive emulsion.

Printing Process employed to make an image on paper or similar material. The sensitized material is exposed to light passed through a negative or positive.

Printing in Technique for giving additional exposure to selected areas when making a print. Other areas are shaded from the light during printing in.

Printing out Printing by light on a material which visibly darkens during exposure. The result may then require fixing only.

Processing General term used to describe the sequence of steps whereby a latent image is converted into a visible, permanent image.

Protective toning Toning process used to protect black and white prints from fading. Usually carried out with selenium or gold toners. See also *Archival permanence treatments*.

Pushing Giving a prolonged development period to film that has been underexposed (rated at a higher ASA then that recommended by the manufacturer).

Quartz-iodine lamp Lamp designed to maintain its color temperature and light intensity throughout its life.

Rapid fixer Fixing solution which uses ammonium thiocyanate or thiosulfate instead of hypo (sodium thiosulfate). Allows greatly reduced fixing time.

Rebate Margin on photographic film not used in recording the image. Often notched.

Reciprocity failure The increasing loss of sensitivity of photographic emulsion when exposures are very brief or very long. In color materials, this failure may vary according to color layer, giving a shift of color balance. Often occurs in color papers given 60 sec or more exposure.

Reducer Solution which reduces some of the silver from ngatives or prints. Used to lighten the image by reducing density and altering contrast on the photographic emulsion.

Register Exact alignment when overlaying several separate single-color sheets or over-printing several images, to make an accurately combined image. See also *Assembly printing.*

Register punch Punch used to make alignment holes for registration purposes.

Re-halogenizing Process by which black metallic silver is converted back to silver halides. It is used in bleaching for toners, and for intensification.

Replenishment The addition of extra chemicals to a processing solution to compensate largely for its partial exhaustion due to repeated use.

Resin coated Of printing paper, having a water-repellent base. RC papers can be processed faster, require less washing, and dry more quickly than regular fiber-based papers.

Resist Protective layer applied to a surface in the form of a pattern or image. Used to prevent chemical solutions reaching covered areas. After the rest of the surface has been treated with chemical, the resist is removed leaving an in-grained, reversed image.

Resolution The quality of the final image as a result of the resolving power (ability to determine fine detail) of the lens and the sensitive emulsion. Resolution is expressed in terms of the lines per millimeter which are distinctly recorded or visually separable in the final image.

Reticulation Minute wrinkling of an emulsion surface giving a cracked appearance to film. Caused by sudden gelatin shrinkage at extreme changes of

temperature, or an acidity/alkalinity excess during processing.

Retouching Aftertreatment of negatives, slide or prints by hand to remove blemishes and/or change tonal values.

Reversal material Photographic materials specifically designed to give a direct positive after only one exposure (i.e. without producing a separate negative), by suitable processing.

Ring-around A series of color prints from one negative or positive at various color filtrations, mounted to display the effects of filtration changes. The ring-around is compared with other prints when assessing filtration.

Rinse Brief clean water wash between steps of a processing cycle. Removes residual chemicals and reduces carry-over of one solution into another.

Roll film 120/620, or 127 camera film which has an opaque paper backing and is wound on a metal spool. The backing paper is numbered to indicate frames, and is longer than the film to provide a light-tight wrapping for daylight loading and unloading. Sometimes applied to all camera films in roll form, including 35 mm.

Sabattier effect (pseudo-solarization) The part-positive, part-negative effect formed when an emulsion is briefly re-exposed to white light during development, and then allowed to continue development.

Safelight Darkroom light of a color and intensity that will not noticeably affect particular light-sensitive photographic materials. Film and paper manufacturers' safelight recommendations are readily available and should be followed.

Sandwiching The combination of two or more negatives in the negative carrier or on the masking frame when printing. Transparencies can also be combined for projection.

Saturated color Pure color hue, undiluted by black and white.

SDB process See *Silver dye-bleach.*

Secondary color See *Complementary color.*

Separation negatives Black and white negatives (usually prepared in threes on panchromatic film). Made by photographing a full color original through primary color

filters. Each analyzes the original in terms of blue, green, or red content. The three negatives can be synthesized in primary or subtractive color dyes to produce a copy of the original.

Shading Method of controlling the final quality of a print by varying the exposure given to different areas of the print through selective masking during enlarging.

Shadow detail Detail visible in areas that are darkest in the subject; these appear as the lightest parts of a negative.

Shadows Darker, less detailed areas in a photograph, corresponding to parts of the original subject that were not so strongly illuminated by the light source.

Sheet film Large-format film sold in sheets of specific size rather than in roll form. Also called cut film.

Silicon release paper Thin, heat-resistant interleaving paper. Used between a photographic print and textured material in a heated press. Allows remolding of the print surface, yet prevents the two materials sticking together.

Silver dye-bleach material Integral tripack printing material in which fully-formed yellow, magenta and cyan dyes are incorporated in the blue-, green-, and red-sensitive emulsion layers during manufacture. During processing, dye areas unwanted for the image are bleached away. Used to produce single-stage positive prints from slides.

Silver halides Compounds formed between silver and alkali salts of halogen chemicals such as bromine, chlorine, and iodine. Silver bromide, silver chloride, and silver iodide are the light-sensitive silver halides used in photographic emulsions to record the image. Halides change from white to black when exposed to light, by forming metallic silver.

Silver recovery Reclamation of silver salts deposited by films (or papers) during processing, by treatment of exhausted solutions. Economic only on a large scale.

Silver salts Compounds of silver.

Sizing Very dilute, gluey solution used to prepare surface for substances such as paint by filling in pores and giving even absorbency.

Slide Alternative term for projection transparency.

Slow film Film which has an emulsion that is not very sensitive to light. Such films have low ASA speeds (e.g. ASA 25 or 32).

Sodium thiosulfate The chemical most commonly used in fixation to convert unused silver halides into a soluble form.

Soft focus Purposely diffused image definition. This is achieved at the enlarging stage with special attachments or a soft focus lens. (It can also be achieved at the camera stage.)

Soft gradation Term used to describe a quality of low tonal contrast in a photograph. Also used to describe the quality of lighting which produces this subject appearance.

Solarization (1) Reversal or partial reversal of the tones of a photographic image caused by extreme overexposure. (2) Term commonly applied to partial reversal effects caused by fogging photographic material to light during development (strictly the Sabattier or pseudo-solarization effect).

Spectrum Commonly, that part of the electromagnetic spectrum—between wavelengths 400 and 700 nanometers—to which the human eye is sensitive. It appears as colored bands which are produced by refracting white light with a prism, arranged according to wavelengths.

Speed Sensitivity of a photographic emulsion to light. Films are given ASA/DIN/ISO numbers to indicate their relative characteristics. The higher the number, the faster the film reacts to light.

Spotting The retouching of small white or black specks on prints, and sometimes negatives, using water-color, dye or pencil.

Squeegee Implement used to squeeze water out of wet prints or to press prints into contact with a glazing sheet. May be a roller, or a flat rubber type which functions like a windscreen wiper blade.

Stabilization Alternative method of fixing where unused silver halides are converted to near stable compounds. These are not sensitive to light and washing is not required.

Stabilizer Processing solution used in color photography which makes the dyes produced by chemical development more stable and fade-resistant.

Static marks Fog marks on negatives as a result of a very dry film being wound or unwound too rapidly. Creates sparks which fog the emulsion. Caused by static electricity.

Step wedge Printed series of density increases, in regular steps from the transparent to the opaque. A method of making exposure tests prior to enlarging.

Stock solution Chemical stored in concentrated form ready for diluting just before use.

Stop bath Chemical bath which stops development by neutralizing the developer. This prevents active developer from contaminating further processing solutions.

Stopping down Reducing the size of the lens aperture.

Subbing Layer applied to a photographic support as a foundation to the emulsion.

Subtractive color process Process of producing a color image by subtracting appropriate amounts of unwanted primary colors from white light, using yellow, magenta, and cyan filters.

Surge marks Streaks near the sprocket holes of 35 mm film or at the edge of sheet film. Caused by excessive agitation.

Surrealism Originally a nineteenth century artistic movement. Production of unreal images which defy reason and are generally derived from the subconscious.

Tacking iron Heated tool used to stick part of the dry-mounting tissue to a print and its mounting board.

Tanks Plastic or stainless steel containers used to hold chemical solutions in which films or photographic papers are processed.

Tanning developer Type of developer used for processes which require a relief image. Tans or hardens the gelatin only in areas where the silver image is formed.

Tempering bath Large tank or deep tray filled with water maintained at the correct temperature for processing by means of a thermostatic control. Used to house tanks, drums or trays. Also known as a water jacket.

Test strip Strip of printing paper or film, which is given a range of exposures and/or filtrations by shading to test for correct image density and color.

Texture The character of surfaces. This usually means their roughness or smoothness. In photography, careful control of lighting can be used to describe a surface by adding a tactile quality in terms of depth, shape, and tone, suggesting three dimensions.

Texture screen Transparent film or glass printed with a fine background pattern. Screens are interposed between the image and the paper (either sandwiched with

the negative or placed in contact with the paper) to break up large areas of tone.

Thick negative Colloquial term used to describe a dense negative image.

Thin negative Negative lacking in density, having been under-exposed or underdeveloped.

Time and temperature Controlling factors of a chemical photographic process. Depend on timing for an exact period, and accurately maintaining the correct solution temperature.

Timer Clock used to control processing or exposure. May be linked directly to the enlarger, switching off the light source automatically.

Tinting See *Hand coloring.*

Tone On a print or negative, an area which has a uniform density and which can be distinguished from darker or lighter parts.

Tone-line process Technique used to reproduce a photographic image so that it resembles a pen and ink drawing.

Toner Chemical used to change the color of a black and white photographic image. System of bleaching and dyeing converts the black metallic silver image to a dye image.

Tone values Various shades of gray between the extremes of black and white in a photographic image.

Transparency Positive image in black and white or color produced on transparent film. Includes slides and also large transparencies used for display.

Tri-color filters Filters in deep primary colors (generally a set of three: one blue, one green, and one red) used to make color prints by the additive method, or to expose three separation negatives.

Tripack materials Light-sensitive materials that have been coated with three emulsions, usually of different characters, superimposed and integrated on one base. Each layer is sensitive to one of the three primary colors. Mainly found in color negative, transparency, and color print materials.

Tungsten light film Usually, a camera color film balanced to light sources with a temperature of 3200K, i.e. type-B color film. May also refer to type-A color film, now seldom used.

Two-bath development Development of negatives in two stages. Developer without alkali is followed by an alkali bath, which activates development. The material can be alternated between the two, allowing fine control over the degree of development given.

Ultraviolet Wavelengths of the electromagnetic spectrum between about 5 and 400 nanometers. Ultraviolet light is invisible to the human eye. However, most photographic materials are sensitive to the longer UV radiations.

Ultraviolet light source Illumination such as sunlight, UV sun lamp, or "black light" fluorescent tube, radiating wavelengths between 10-400 nanometers.

Underdevelopment The result of too little development time or a decrease in the development temperature. Underdevelopment reduces density and contrast in the image.

Underexposure The result of too little exposure in the camera or at the enlargement stage. On negative/positive materials, under-exposure reduces density and may reduce contrast in the processed image.

Universal developers Developer solutions that are suitable (at different dilutions) for both negative and print processing.

Variable-contrast paper Printing paper in which grade (contrast) can be varied during enlarging by changing the color of the printing light using different color filters.

Vignetting Printing technique where the edges of the picture are gradually faded out to black or to white.

Voltage stabilizer Electrical device that keeps the voltage flow to the enlarger constant. Prevents fluctuations in the current from affecting exposure or filtration.

Washing Final part of the processing cycle, which removes the residual chemicals and soluble silver compounds from the emulsion.

Water bath Large water-filled container used to keep processing trays, tanks, or chemicals at the correct temperature. See also *Tempering bath.*

Wavelength Method of identifying particular electromagnetic radiation, considered as rays progressing in wave-like form. Wavelength is the distance between one wavecrest and the next. Different types of electromagnetic radiation have different wavelengths. In the case of light, wavelength is measured in nanometers or angstrom units. Different wavelengths of radiation in the visible spectrum are seen as colors.

Wetting agents Detergent-type chemicals, which, when used in minute quantities, reduce the surface tension of water. They are usually added to the final wash of films and plates to improve draining and thus prevent drying marks from forming. Their use speeds up drying.

White light Continuous spectrum of all the visible wavelengths. When these wavelengths are separated out by reflection and absorption, they are seen as colors.

White light control Lever on a color head enlarger which instantly removes filtration.

Working solution Liquid chemical that has been mixed or diluted ready for use.

Index

Acknowledgments

Author's acknowledgments
Preparing this book has been essentially a team job.
First, I would like to thank art editor Michelle Stamp for
the enormous care she took to make each "spread" of
this book varied and attractive. Its final visual appearance
is for the most part due to the standards she set for
herself and others. Second, my thanks go to project
editor Jonathan Hilton for his considerate, always
constructive treatment of my text, and for keeping us all
on the rails. Both were backed by a great team of editors,
designers, and illustrators.

Outside the Dorling Kindersley organization, the
major contributor to the team was Tim Stephens, who
had the task of initiating, testing, and carrying through
dozens of techniques – particularly in color printing. He
introduced or discovered a wide range of other creative
photographers, expert, or at least enthusiastic to
experiment, in various processes. Many of these people
were once students at the London College of Printing or
Royal College of Art, London.

Special appreciation goes to Michael Burman of
F. E. Burman Ltd. who had responsibility for reproducing
the often very odd-looking illustrations exactly as we
wanted them to appear. His positive and knowledgeable
approach to the problems of each page was a great help.

Michael Langford

Dorling Kindersley would like to thank the following
individuals and organizations for their help in producing
this book: Andrew de Lory (for his assistance with the
photography), F. E. Burman Ltd., Image Bank, Ken
Oberg (Kodak), George Ashton (Paterson), Gerry Puttick
(Ilford), Terry Lown and Philip Miller (Agfa), Jeff
Thompson (Vivitar), Mike Allen (Durst), Ed Beale (3M),
Owl Creative Services Ltd., Mark Richards, Alan Suttie,
Kuo Kang Chen, Andrew Watson, Pete Truckel, Mari
Mahr, Rosamund Gendle, Professor Scime, and Alex
Maskell. Our special thanks go to Qwerty Typesetting
Ltd. who took over typesetting the book at a very critical
stage and saw it through to completion.

Photographic credits
Ansel Adams 12
Astrid 24
A & M Records 19
Cecil Beaton 31(T)
John Blakemore 13
Erwin Blumenfeld 26
Bill Brandt 151
Dennis Brokaw 14
Bob Carlos Clarke 22,
287, 291(B), 292
Amanda Currey 232, 283
Bob Dainton 192, 326-7,
330-1
Fred Dustin 222-3, 234-5
Carole Edwards 295
Per Eide 106-7
Mark Fiennes 108-9
James Fisk 248
Sue Forsythe 294
Clive Frost 259
John Goto 11, 17(T)
Geoffrey Gove 210(B)
Mark Grant 185(T),
193(B)
Richard and Sally
Greenhill 124, 307(T),
310-11 (Pete Truckel
manip.)
Richard Hamilton 27(T)
Hag 8, 224
David Henderson 193(T),
244-7, 261-3, 276-7
Jonathan Hilton 163
John Joly 15(L)
Michael Langford 102(C),
103, 184, 188-9, 193(C),
207, 240-2 (Tim Stephens
manip.), 313-14
Robin Laurence 140
Lawrence Lawry 173-4,
268, 270-1, 273-5, 305-6
Andrew de Lory 101,
102(B), 131, 146(L),
154(T), 185(B)
Mari Mahr 204-5, 278-9,
290(L), 299, 300-3, 218-19,
322
Henk Meyer 29
Moholy Nagy 17(B)
Steven Nash 280-2
Paul de Nooijer 10
Ceri Norman 31(B)
David Pearson 123, 285-6
(Alun Jones manip.)

Joss Pearson 144, 145,
203 (Tim Stephens
manip.)
Annette Platts 307(BR),
323
Ken Randall 141, 171,
178-9 (Frank Thomas
manip.)
Man Ray 25
Jean Ruiter 23
Royal Photographic
Society 183, 317
George Schwarz 291(T)
Carol Sharp 166-8, 170
Richard Shirtcliffe 15(B),
210(R)
Tony Sindon 146(R), 147
Martin Smith 149-50
Michael Smith 16
Tim Stephens 2-3, 119,
142-3, 152-3, 154(B),
155, 159-62, 164-5, 172,
186-7, 190-1, 194-9, 202,
206, 208-9, 212-19, 226-7,
230-1, 238-9, 249-51, 258,
290(R)
Giuliana Traverso 30
Pete Truckel 175, 177,
307(L)
Pete Turner 27(B)
Richard Tucker 243
Jerry N. Uelsmann 20-1,
228-9
Luigi Veronesi 18
Todd Walker 28, 32, 298
Andrew Watson 15(T),
210(L), 211, 252-6
E. Wheater 236
G. G. Winkley 169

Jacket (front)
TL Ken Randall (Frank
Thomas manip.)
TR Michael Langford
(Tim Stephens manip.)
BL David Henderson
BR Fred Dustin
Jacket (back)
Tim Stephens

B = bottom, T = top,
R = right, L = left,
C = center

Illustrations by:
Alan Suttie
Kuo Kang Chen
Alun Jones
Russell Barnett
Les Smith MSIAD
Mike Saunders
Richard Draper
Marilyn Bruce
Sean MacGarry

Photographic services
Lens
Pelling and Cross
Negs
W. Photoprint
Ron Bagley

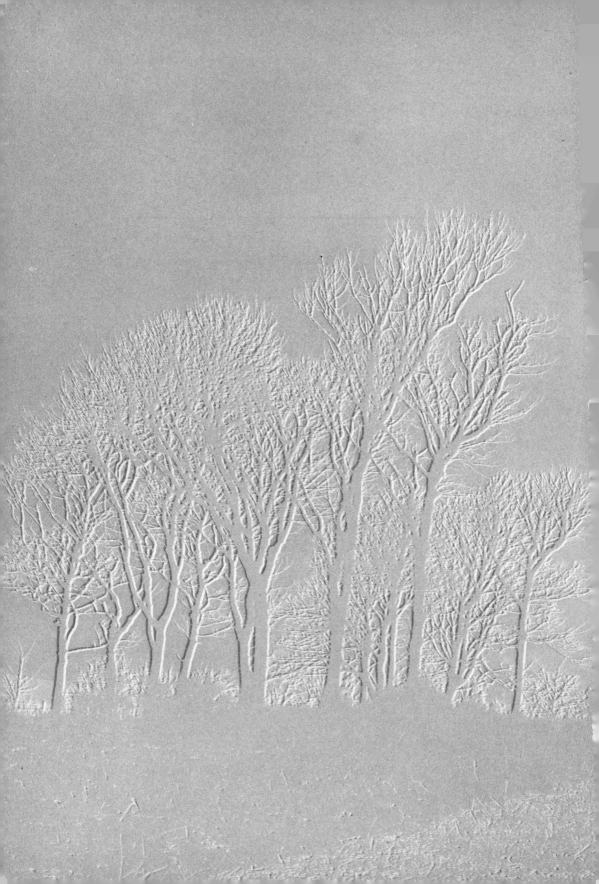